LUXURY AIRLINE DESIGN

LUXURY AIRLINE DESIGN

edited by Peter Delius & Jacek Slaski

teNeues

Editor:	Peter Delius & Jacek Slaski
Text:	Brad Steiner
Editorial coordination:	Jeannine Anders, Brad Steiner
Layout & Prepress:	Dirk Brauns
Translations:	Elena and Constanze Alvarez (Spanish)
	Michele Caliari (Italian)
	Christian Muguet (French)
	Rebecca Thomas (English)

Published by teNeues Publishing Group

teNeues Book Division
Kaistraße 18, 40221 Düsseldorf, Germany
Tel.: 0049 / 211 / 99 45 97 0, Fax: 0049 / 211 / 99 45 97 40
E-mail: books@teneues.de
Press department: arehn@teneues.de
Tel.: 0049 / 2152 / 916 202

teNeues Publishing Company
16 West 22nd Street, New York, N.Y. 10010, USA
Tel.: 001 / 212 / 627 / 9090, Fax: 001 / 212 / 627 / 9511

teNeues Publishing UK Ltd.
P.O. Box 402, West Byfleet, KT14 7ZF, Great Britain
Tel.: 0044 / 1932 / 403 509, Fax: 0044 / 1932 / 403 514

teNeues France S.A.R.L.
4, rue de Valence, 75005 Paris, France
Tel.: 0033 / 1 / 55 76 62 05, Fax: 0033 / 1 / 55 76 64 19

teNeues Iberica S.L.
Pso. Juan de la Encina 2-48, Urb. Club de Campo, 28700 S.S.R.R.,
Madrid, Spain
Tel./Fax: 0034 / 91 / 65 95 876

www.teneues.com

ISBN-10:	3-8327-9063-2
ISBN-13:	978-3-8327-9063-9

Printed in Italy

Bibliographic information published by Die Deutsche Bibliothek.
Die Deutsche Bibliothek lists this publication in the Deutsche
Nationalbibliografie; detailed bibliographic data is available in the
Internet at http://dnb.ddb.de

CONTENTS

Flying Well—The Luxuries of Space and Time

The development of air travel is one of the marvels of the last century. When the public first took to the skies in early aircraft in the 1920s and 1930s, the high cost of flying meant only the very rich could take advantage. The flights were relatively slow and uncomfortable by today's standards, but celebrities and socialites brought their own sense of style and theatre, matched by planes with smoking lounges, bartenders and well-appointed cabins. More than just a convenient way to travel, flying became the signature feature of a globetrotting jet-set lifestyle.

As planes grew in size, and travel times shrank, flying became a form of international mass transit. It is a part of our lives, and has made the world smaller like no other technology. While travelling in economy class can often feel like riding in a city bus for twelf hours, for those who must travel often, or those who simply desire to fly well, comfort and personal space are premium commodities. Whether in a roomy First-Class cabin or a private jet, style and convenience can be tailored to each traveller's wishes.

Time is also something we never have enough of. For a busy executive, it is in exceptionally short supply. The ability to continue working undisturbed throughout a hectic travel schedule, or to show up well rested to a meeting on the other side of the globe, can be priceless. Providing a pleasant experience for the discriminating traveller among the surge in passengers is a competitive business. In raw numbers, premium passengers have declined on the major airlines, to around four percent of travellers, but their tickets still account for about half of total revenue. Innovative architects, fashionable clothing designers, gourmet chefs and aerospace engineers all come together to provide a complete aesthetic experience from the broad, sweeping forms of the terminal to the opulence of the airport lounge, to a three-star in-flight meal.

This book takes a visual tour of those elements which make elite air travel a unique experience, including the convenience of a door-to-plane limousine service, an elegant stewardess who already knows your favourite films, the absolute privacy of a bedroom suite on your own private jet, and the technological developments which produce increasingly spacious and efficient aircraft. Innovation may be born of necessity—for people to travel faster and farther, but we might just as well posit that luxury is born of desire—to simply travel better.

Cessna Citation Sovereign

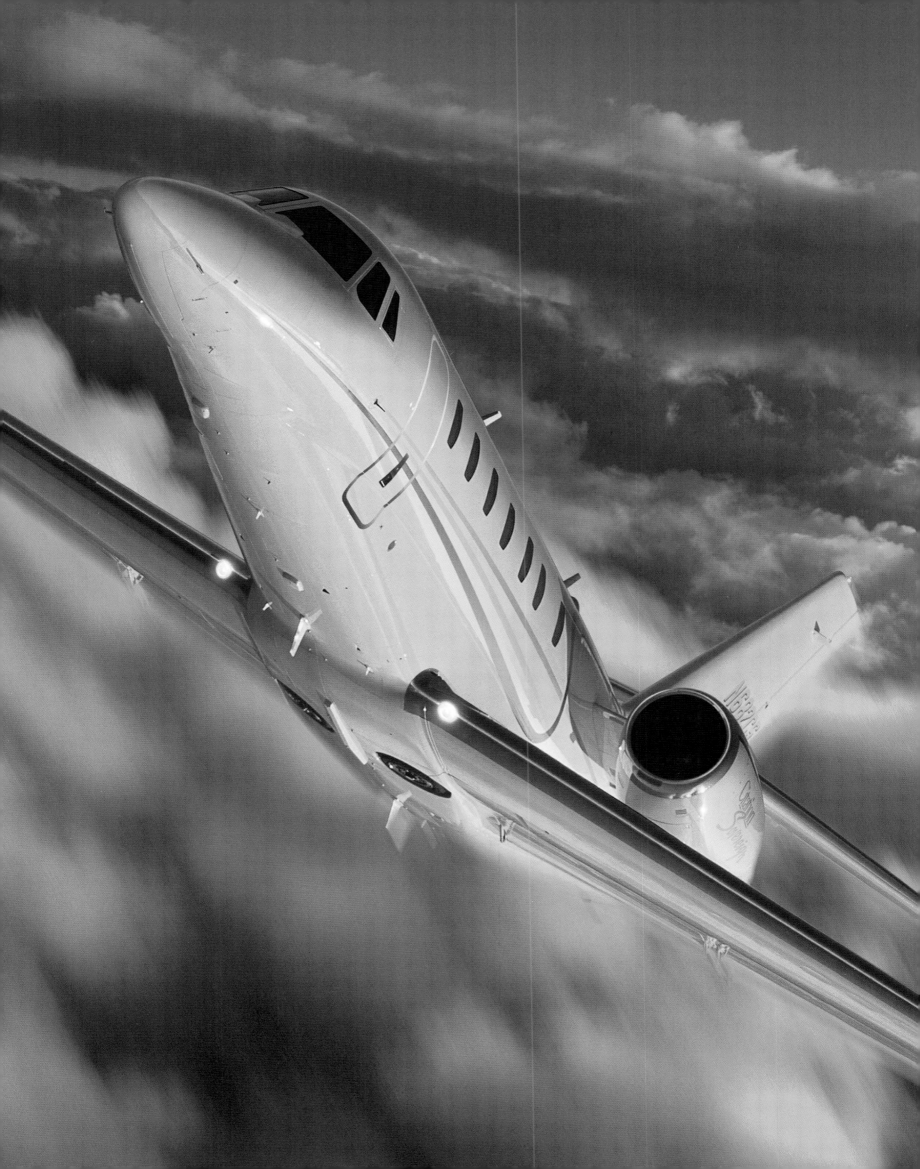

Angenehmes Fliegen – Der Luxus von Raum und Zeit

Die Entwicklung der zivilen Luftfahrt ist eines der Wunder des vergangenen Jahrhunderts. In den 20er- und 30er-Jahren, als die ersten Flüge für Zivilisten möglich wurden, war die teure Reise mit dem Luftschiff nur sehr vermögenden Passagieren vorbehalten. Die Flüge waren unbequem und dauerten sehr lange. Das Fliegen war jedoch Ausdruck von Stil für die Reichen und Berühmten jener Ära. Der Schick und der mondäne Charakter des Fliegens äußerte sich in der Einrichtung der Luftschiffe. Salons, Bars und gut ausgestattete Kabinen boten den betuchten Passagieren den Standard, den sie gewohnt waren. Das Fliegen wurde zum Kennzeichen des Globetrotters und des Jetset-Lebens.

Mit der Entwicklung immer größerer und schnellerer Flugzeuge wurde die Flugreise international für viele Menschen erschwinglich. Heute ist sie Teil des modernen Lebens und lässt die Welt wie kaum eine andere Technologie zusammenwachsen. Während ein Flug in der Economyclass etwas von einer zwölfstündigen Busreise hat, gibt es auch heute noch die Möglichkeit, das Fliegen komfortabel und luxuriös zu erleben. Ob in der geräumigen Ersten Klasse oder im Privatjet, die Ausstattung wird hier auf die Wünsche der Reisenden zugeschnitten und verbindet Stil und Komfort.

Zeit ist gerade heute ein kostbares Gut, und besonders für viele Geschäftsleute, die die Flugzeit zum Arbeiten nutzen müssen. Sie schätzen die Möglichkeit, die Arbeit auf dem Flug ungestört fortsetzen zu können, oder einfach ausgeruht bei einem Termin am Ziel zu erscheinen. Diese Annehmlichkeiten bieten viele Fluggesellschaften, die vor allem um diese Gruppe werben. Heute gibt es weniger Erster-Klasse-Passagiere bei den großen Fluggesellschaften, es sind etwa vier Prozent der Flugreisenden. Aber die Ticketverkäufe für die Erste Klasse erbringen über die Hälfte der Gesamteinnahmen der Fluggesellschaften. Kreative Architekten und Modedesigner, Gourmetköche und Flugzeugingenieure machen die Flugreise zu einer besonderen Erfahrung auch der Sinne: von den weiten, fließenden Formen der Flughafengebäude, der luxuriösen Einrichtung vieler Lounges, bis hin zum Dreisternedinner an Bord.

Dieses Buch gewährt einen Blick in die Welt der luxuriösen Luftfahrt. Sie umfasst den Komfort eines Limousinenservices ebenso wie elegante Stewardessen, die immer Ihren Lieblingsfilm kennen. Der eigene Jet bietet mit einer Schlafsuite und eigenem Badezimmer viel Privatsphäre. Die technischen Fortschritte ermöglichen die Konstruktion immer größerer und effizienterer Flugzeuge. Während die Innovationen in der Luftfahrt aus der Notwendigkeit entstanden, Passagiere immer schneller und weiter zu befördern, machen Luxus und Komfort das Fliegen einfach angenehmer und zu einem einzigartigen Erlebnis.

Dassault Falcon 50EX

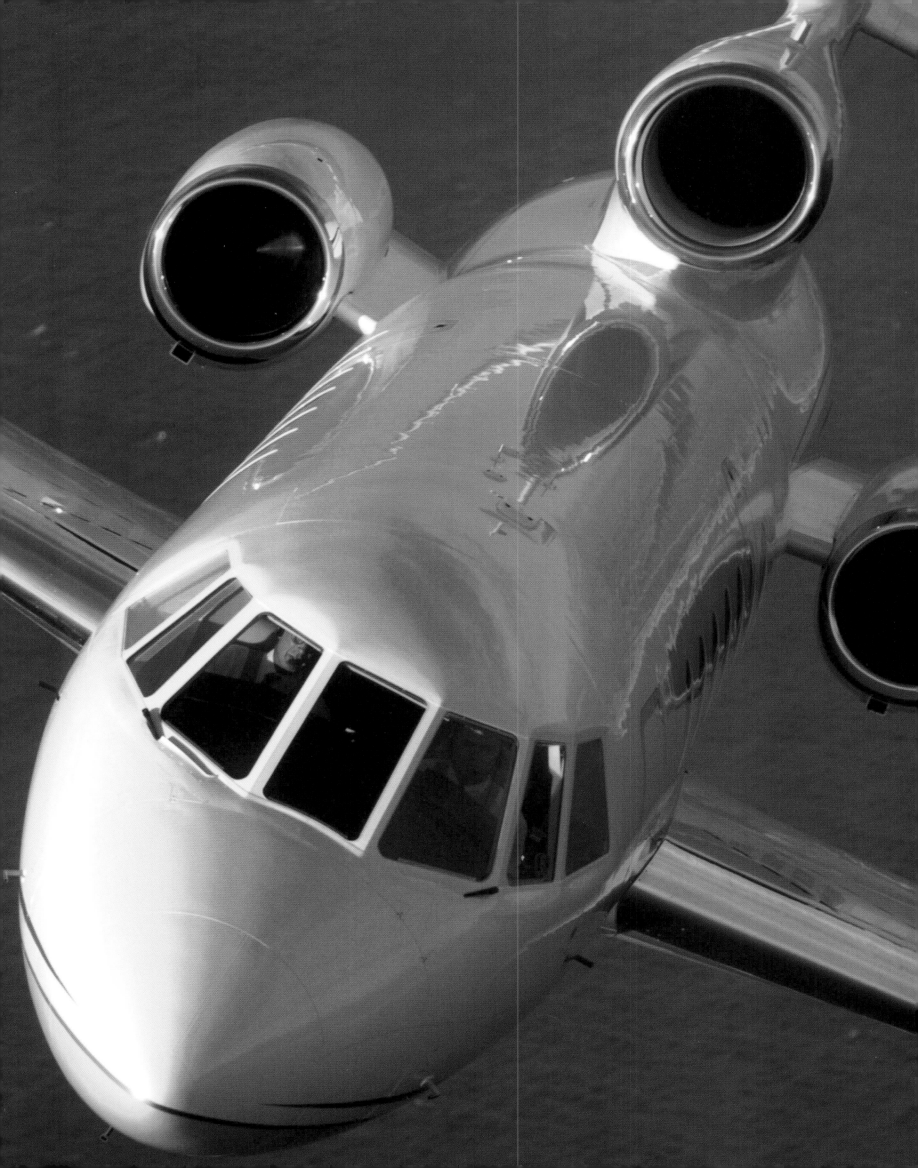

Voler dans le confort – le luxe de l'espace et du temps

Le développement de l'aviation civile est l'un des miracles du siècle passé. Lors des premiers vols civils, qui datent des années 20 et 30, voler en avion était une opération coûteuse uniquement réservée à une clientèle particulièrement fortunée. Les vols étaient longs et relativement inconfortables. Mais voler était en définitive l'attribut des gens riches et des célébrités de cette époque. Le côté chic et le caractère mondain de prendre l'avion trouvaient leur expression dans l'aménagement des dirigeables. Des salons, des bars et des cabines bien équipées offraient aux passagers aisés le standard auquel ils étaient accoutumés. Voler devint désormais partie intégrante du type de vie jet-set globe-trotter.

Le développement d'avions de plus en plus gros et de plus en plus rapides a permis au plus grand nombre d'accéder au transport aérien international. Les avions font maintenant complètement partie de la vie moderne et ils sont au centre des moyens technologiques qui donnent à notre monde cette impression de village planétaire. Si un vol en classe économique s'apparente aujourd'hui à un voyage en bus d'une douzaine d'heures, il est possible d'expérimenter le confort et le luxe dans le transport aérien. Que ce soit dans une spacieuse première classe ou dans un jet privé, l'espace est adapté aux désirs du passager et allie style et confort.

Le temps est de nos jours un bien précieux, en particulier pour beaucoup d'hommes d'affaires. Ils apprécient de pouvoir à travailler en vol, ou de pouvoir être frais et dispos à leur rendez-vous quand ils arrivent à destination. De nombreuses compagnies aériennes qui ont les hommes d'affaires pour cible, offrent ce genre d'agréments. Aujourd'hui, les grandes compagnies aériennes n'ont plus beaucoup de passagers de première classe, ces derniers ne constituant plus que quatre pour cent des passagers. Mais les ventes de billets de première classe représentent plus de la moitié des recettes globales des compagnies aériennes. Des architectes et des designers créatifs, des chefs s'adressant à des gourmets et des ingénieurs aéronautiques ont transformé le transport aérien en une expérience particulière qui sait aussi solliciter les sens : cela va des formes généreuses et fluides des bâtiments des aéroports et des luxueuses installations de leurs salons jusqu'au dîner trois étoiles à bord de l'avion.

Ce livre vous fait découvrir le monde de l'aviation de luxe qui englobe aussi bien le service de limousine que les élégantes hôtesses qui devinnent quels sont vos films préférés. Le jet privé offre, avec sa suite comprenant une salle de bain individuelle, un large espace à la sphère privée. Les progrès technologiques permettent de construire des avions de plus en plus grand et performants. Alors que les innovations dans le domaine aéronautique étaient nées de la nécessité de pouvoir transporter des passagers de plus en plus vite et de plus en plus loin, le luxe et le confort sont en train de faire du transport aérien une expérience simplement agréable mais aussi unique en son genre.

Cessna Citation Mustang

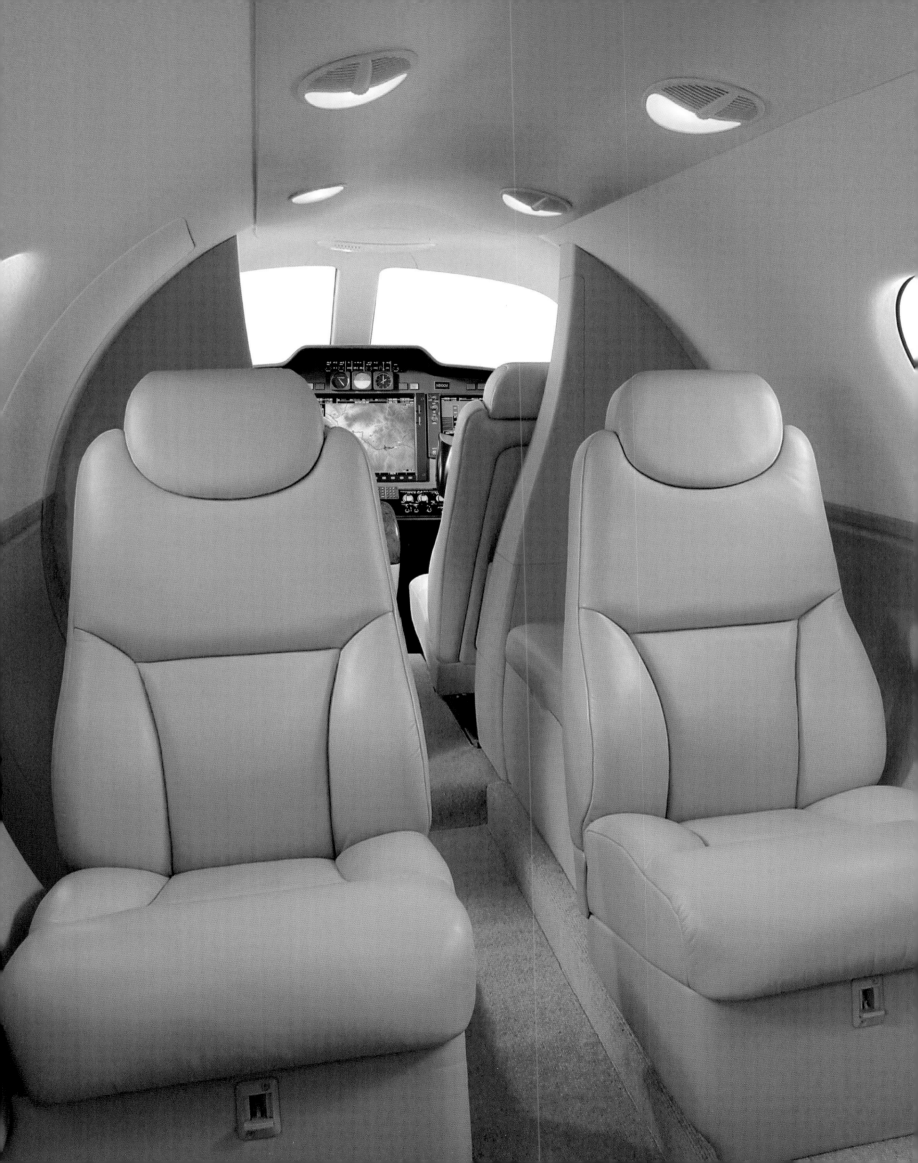

Volar con comodidad –el lujo del espacio y del tiempo

El desarrollo de la aeronáutica es una de las maravillas del siglo pasado. En los años 20 y 30, cuando se realizaron los primeros vuelos civiles, viajar en aeróstato dirigible era costoso y estaba reservado exclusivamente a personas muy solventes. Los vuelos eran incómodos y duraban mucho tiempo. Sin embargo, para los ricos y famosos de aquella época, volar era manifestar estilo. El carácter chic y mundano de volar se plasmaba en los interiores de los aviones. Salones, bares y exquisitas cabinas ofrecían a los pasajeros el estándar al que estaban acostumbrados. Volar caracterizaba exclusivamente a trotamundos y la vida jet-set.

Con el desarrollo de aviones cada vez más grandes y rápidos, volar se puso al alcance de un gran número de personas a nivel internacional. Hoy forma parte de la vida cotidiana, uniendo el mundo como ninguna otra tecnología. Mientras que volar en clase economy recuerda a un viaje de doce horas en autobús, todavía existe la posibilidad de viajar en avión cómoda y lujosamente. Tanto en la espaciosa primera clase como en un jet privado, la ambientación se adapta a los deseos de los pasajer os, combinando estilo y confort.

El tiempo es oro, hoy más que nunca, ante todo para los hombres de negocios, obligados a trabajar durante el vuelo. Valoran la posibilidad de seguir trabajando en el avión, o simplemente de acudir descansados a la reunión en el lugar de destino. Son muchas las compañías aéreas que ofrecen estas comodidades compitiendo por esta clientela. Hoy día el número de plazas de primera clase en las grandes compañías se ha reducido a un cuatro por ciento de los pasajeros. Sin embargo, las ventas de billetes de primera clase suponen más de la mitad de los ingresos totales alcanzados por las compañías aéreas. Arquitectos creativos, diseñadores de moda, chefs de la alta cocina e ingenieros de aviación convierten viajar en avión en una experiencia sensual: empezando por los amplios espacios fluidos de los aeropuertos, pasando por la lujosa ambientación de los salones lounge, hasta el menú de tres estrellas a bordo.

Este libro ofrece una mirada hacia el interior del mundo de los aviones de lujo incluyendo tanto el confort del servicio de una limusina como elegantes azafatas, conocedoras de su película favorita. El jet particular ofrece una gran privacidad con dormitorio y baño de lujo propios. El avance técnico permite la construcción de aviones cada vez más grandes y potentes. Mientras las innovaciones en la aviación se deben a la necesidad de transportar cada vez a más gente de forma más rápida, el lujo y la comodidad sencillamente convierten el volar en una experiencia única y maravillosa.

Airbus A380

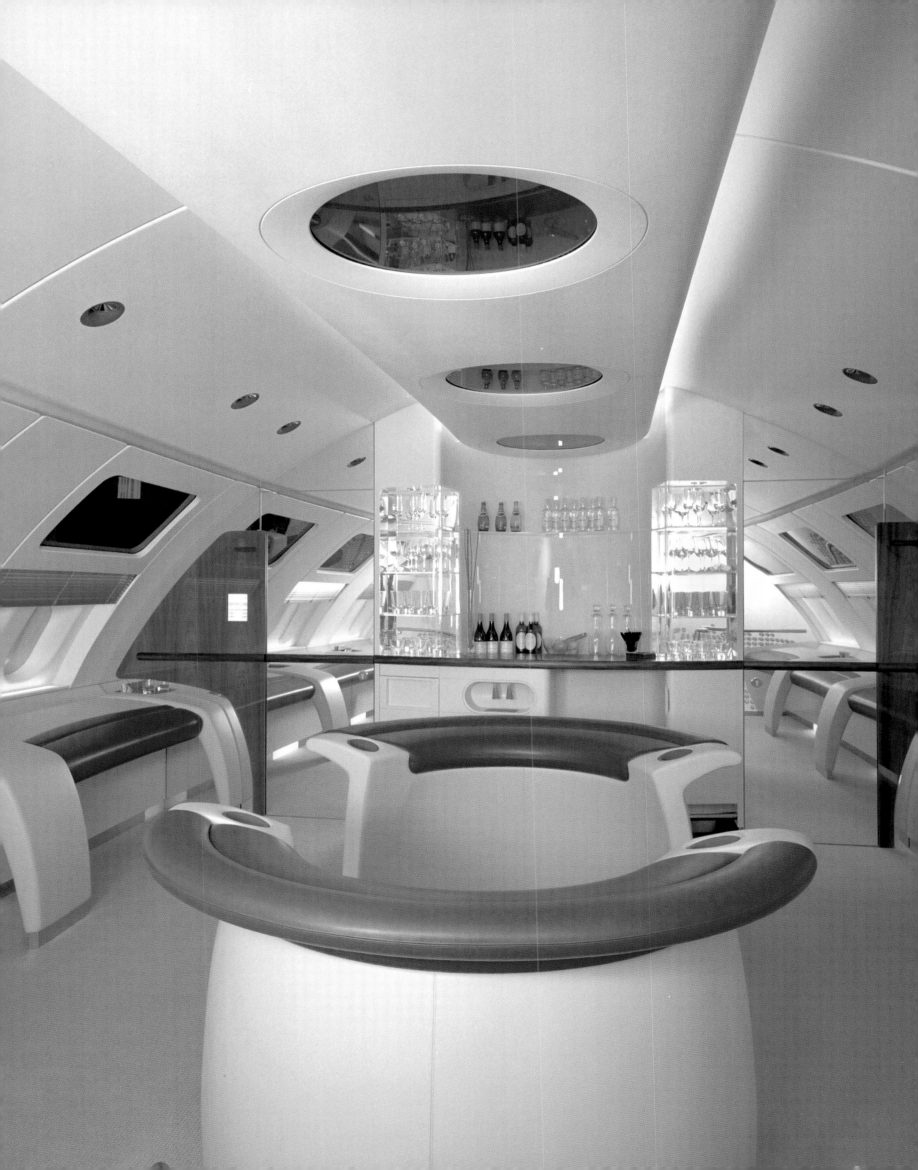

Un volo piacevole – il lusso dello spazio e del tempo

Lo sviluppo dell'aeronautica civile è uno dei miracoli del secolo trascorso. Quando negli anni venti e trenta iniziarono i primi voli civili, i viaggi con le aeronavi erano estremamente costosi e riservati a passeggeri facoltosi. I lunghissimi voli erano molto scomodi, ma per le persone ricche e famose volare era una questione di stile. Il carattere mondano ed elegante del volo si esprimeva anche nell'arredamento delle aeronavi. Saloni, bar e cabine di lusso garantivano lo standard a cui erano abituati passeggeri prominenti. Volare divenne sinonimo di giramondo e delle vita del jet-set.

Lo sviluppo di aerei sempre più grandi e veloci rese il viaggio in aereo un'attività internazionale e alla portata di tutti. Oggi fa esso parte integrante della nostra esistenza e permette, più di qualsiasi altra tecnologia, l'abbattimento delle distanze sul pianeta. Anche se un volo nella Economy Class assomiglia ad un viaggio di dodici ore in autobus, è pur sempre ancora possibile fare un volo confortevole e lussuoso. Si tratti di una spaziosa cabina di prima classe o di quella di un jet privato, l'arredamento è realizzato in base ai desideri dei viaggiatori ed é espresso attraverso gusto e comfort.

Il tempo è un bene prezioso, soprattutto oggi e soprattutto per molti uomini d'affari, i quali devono sfruttare il tempo del volo per lavorare ed apprezzano quindi la possibilità di proseguire indisturbati la propria attività a bordo, o desiderano semplicemente giungere ben riposati all'appuntamento cui sono diretti. Questo genere di comodità fa parte del servizio di molte compagnie aeree ed in particolar modo di quelle interessate a questo tipo di clientela. Presso le grandi compagnie sempre meno sono i passeggeri che viaggiano in prima classe: oggi all'incirca il cinque per cento dei viaggiatori. Ciò nonostante, per una compagnia, la vendita dei biglietti di prima classe costituisce a più della metà delle entrate complessive. Architetti e creativi disegnatori di moda, cuochi, gourmet e ingegneri aeronautici possono trasformare il volo in un'esperienza particolarmente sensuale, dalle forme vaste e fluttuanti degli edifici aeroportuali, all'arredamento lussuoso di molte lounge, fino alla cena impeccabile a bordo.

Con questo libro getteremo uno sguardo nel lussuoso mondo dell'aviazione, un'esperienza che abbraccia il comfort di un viaggio in Limousine non meno che il fascino di hostess eleganti e che conoscono sempre il nostro film preferito. Con suite e bagno privato il jet personale è un paradiso della privacy. I progressi tecnologici rendono oggi possibile la costruzione di apparecchi sempre più grandi ed efficienti. Mentre le innovazioni in campo aeronautico sono determinate dalla necessità di trasportare i passeggeri sempre più lontano e sempre più velocemente, il lusso e il comfort non fanno altro che rendere il viaggio più piacevole, trasformandolo in un'esperienza unica.

Cessna Citation XLS

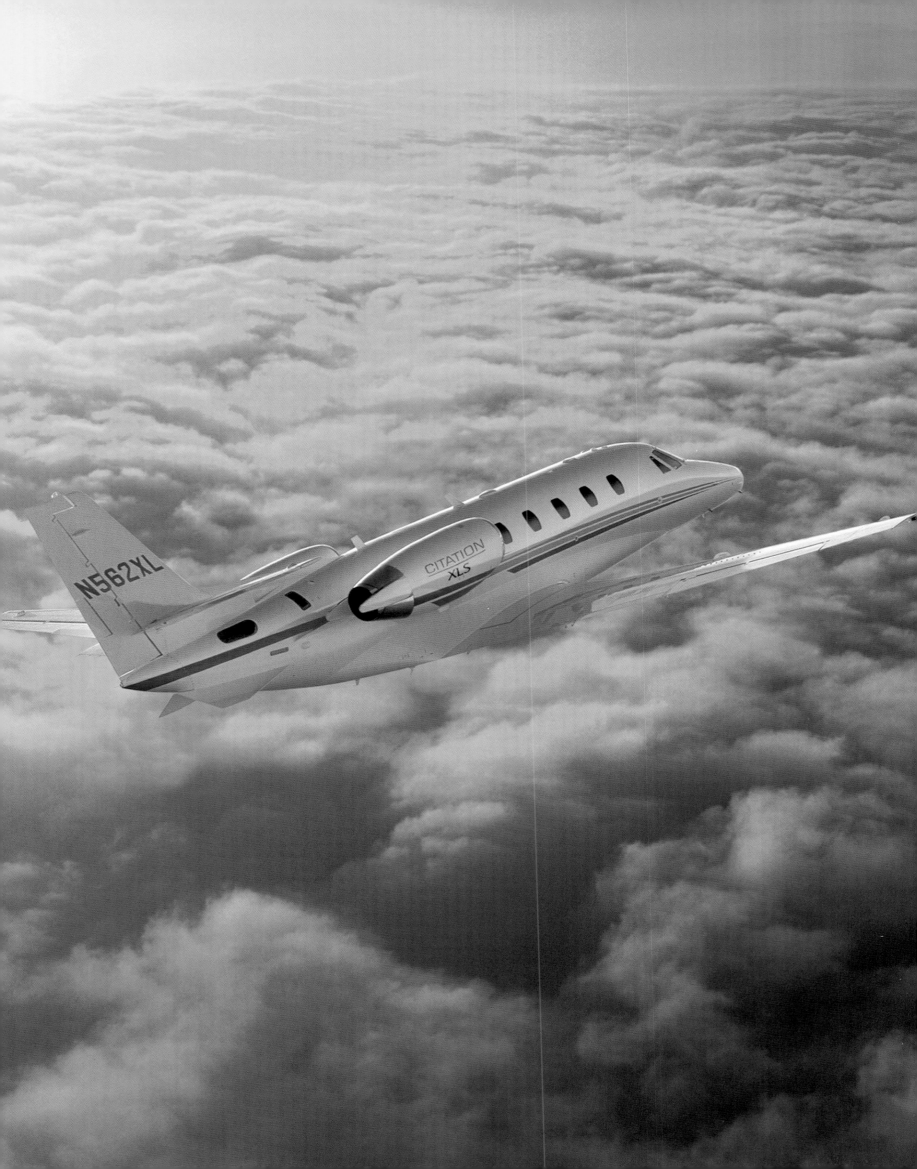

Airport

Airport

The first commercial flights were with "flying boats", as airports were not widely available. Once construction flourished from the 1930s onward, the airport became a place not only of mass transit but also of beauty and imagination. The wide-open spaces required for airfields, combined with their role as status symbols of the city they serve, has given architects the opportunity to create grand spaces, often with flowing and transparent forms reminiscent of the flight itself.

Die ersten kommerziellen Flugreisen konnten Passagiere mit Luftschiffen unternehmen, denn der Bau von Flughäfen war noch nicht vorbereitet. Erst in den 30er-Jahren erlebten die Flughäfen eine Blütezeit. Sie wurden nicht nur ein Ort der Reiseabfertigung, sondern auch der Schönheit und Fantasie. Die großen Flächen, die für die Flugbahnen benötigt werden, aber auch die jeweilige Stadt repräsentieren, eröffnen den Architekten die Möglichkeit großangelegte Entwürfe umzusetzen, oft mit fließenden Formen und einer Transparenz, die an das Fliegen selbst erinnert.

A l'époque où les aéroports était encore rares, les vols commerciaux s'apparentaient surtout à des voyages en « bateaux volants ». Ce n'est que dans les années 30 que les aéroports ont pris leur essor. Ils ne s'agissait pas que de lieux d'embarquement, la beauté et l'imagination y avaient droit de cité. Les grandes superficies requises pour les pistes d'envol, et leur rôle symbolique dans les villes où ils sont présents, offrent alors aux architectes la possibilité de réaliser de grands projets, en recourant souvent à des formes fluides et à une transparence qui rappelle le fait même de voler.

Antes de que la construcción de aeropuertos fuera algo habitual, los vuelos comerciales daban la sensación de estar viajando en "barcos voladores". Fue a partir de los años 30 del siglo XX cuando los aeropuertos pasaron por una época de esplendor. No sólo se convirtieron en lugares de facturación de viajeros y equipajes, sino en verdaderos templos de belleza e ingenio. Los grandes espacios, imprescindibles para las pistas de aterrizaje, representan igualmente la ciudad, permitiendo a los arquitectos realizar conceptos de gran envergadura, a menudo caracterizados por formas fluidas y una transparencia propia del arte de volar.

Quando la costruzione di aeroporti era ancora un fatto raro, gli apparecchi per i voli commerciali avevano l'aspetto di "aeronavi". L'epoca d'oro degli aeroporti iniziò solo negli anni 30 del ventesimo secolo e, fin da subito, da semplici punti di smistamento essi si trasformarono in luoghi di sogno e centrali della fantasia. Le grandi superfici necessarie alla costruzione di un aeroporto ed il suo forte carattere rappresentativo offrirono agli architetti la possibilità di mettere in pratica progetti grandiosi, le cui forme erano spesso fluttuanti e trasparenti, quasi a voler ricordare l'essenza del volo stesso.

Edward Lawrence Logan International, Boston

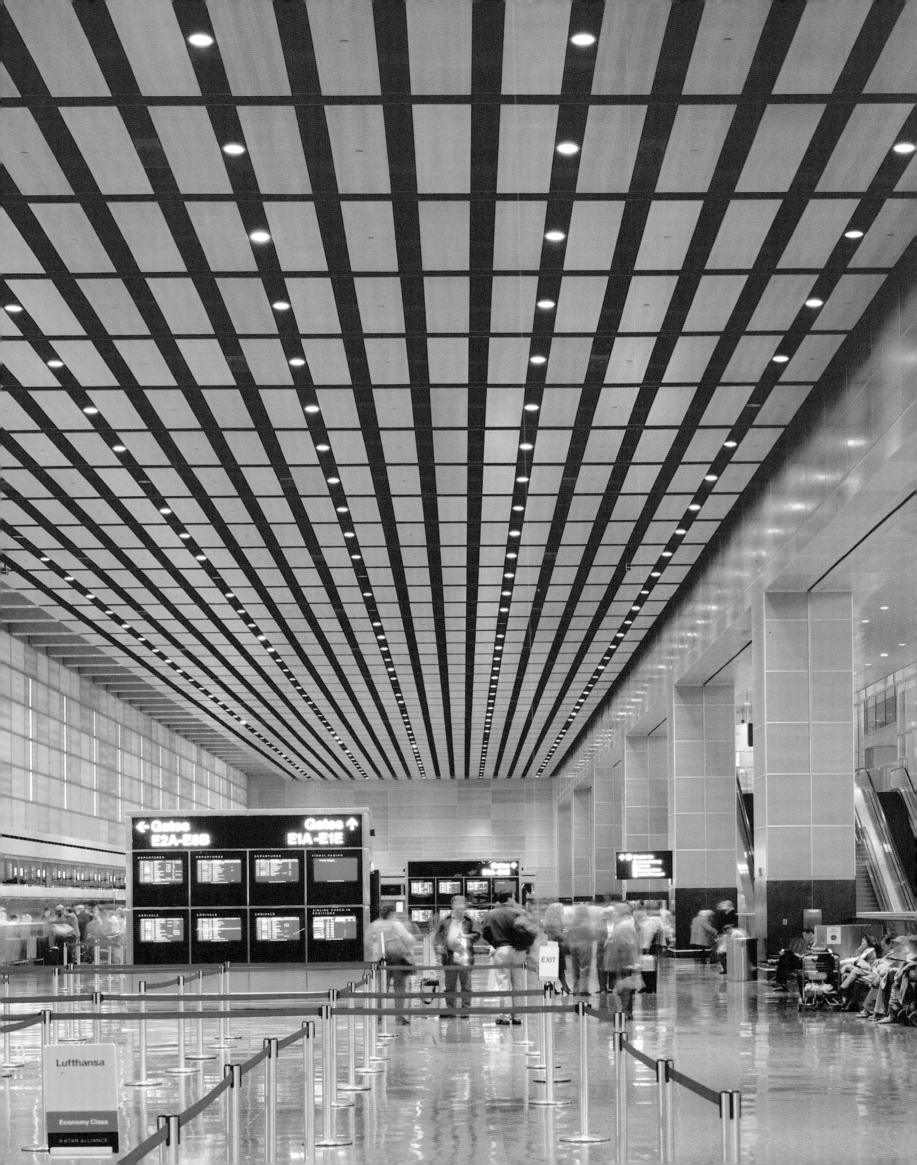

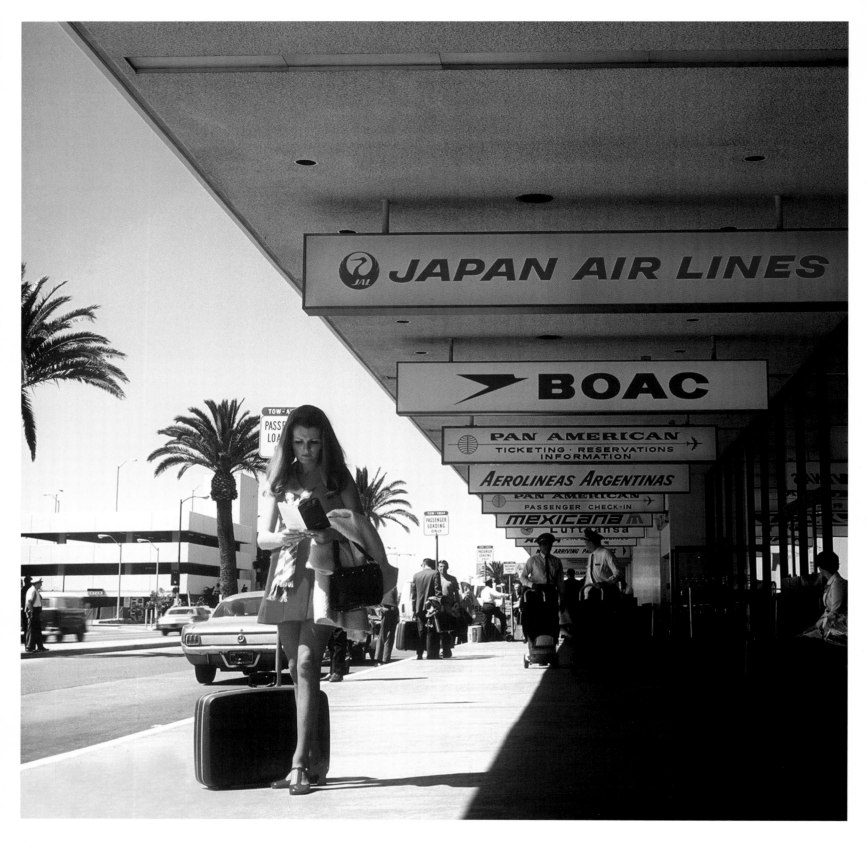

Los Angeles International

Pages 22/23: Los Angeles International

Pages 24/25: Bilbao Airport

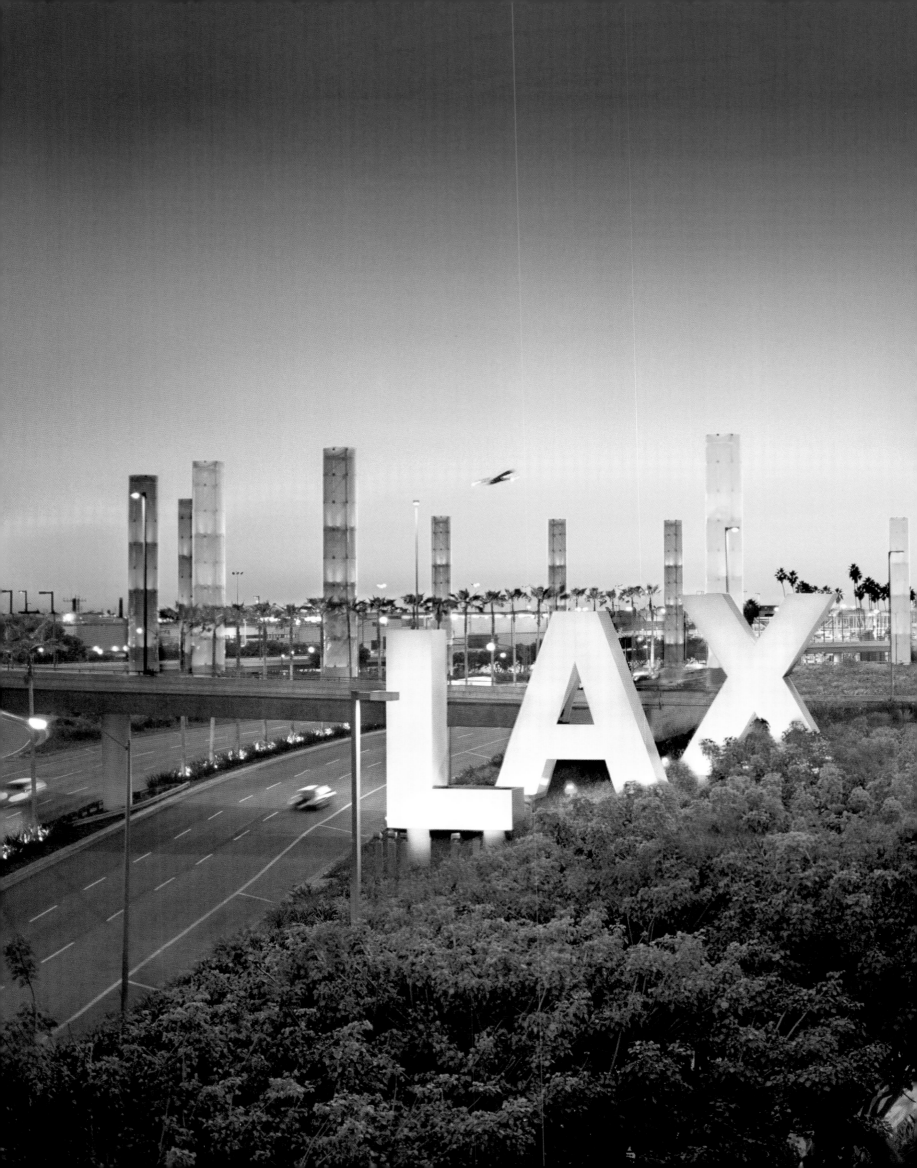

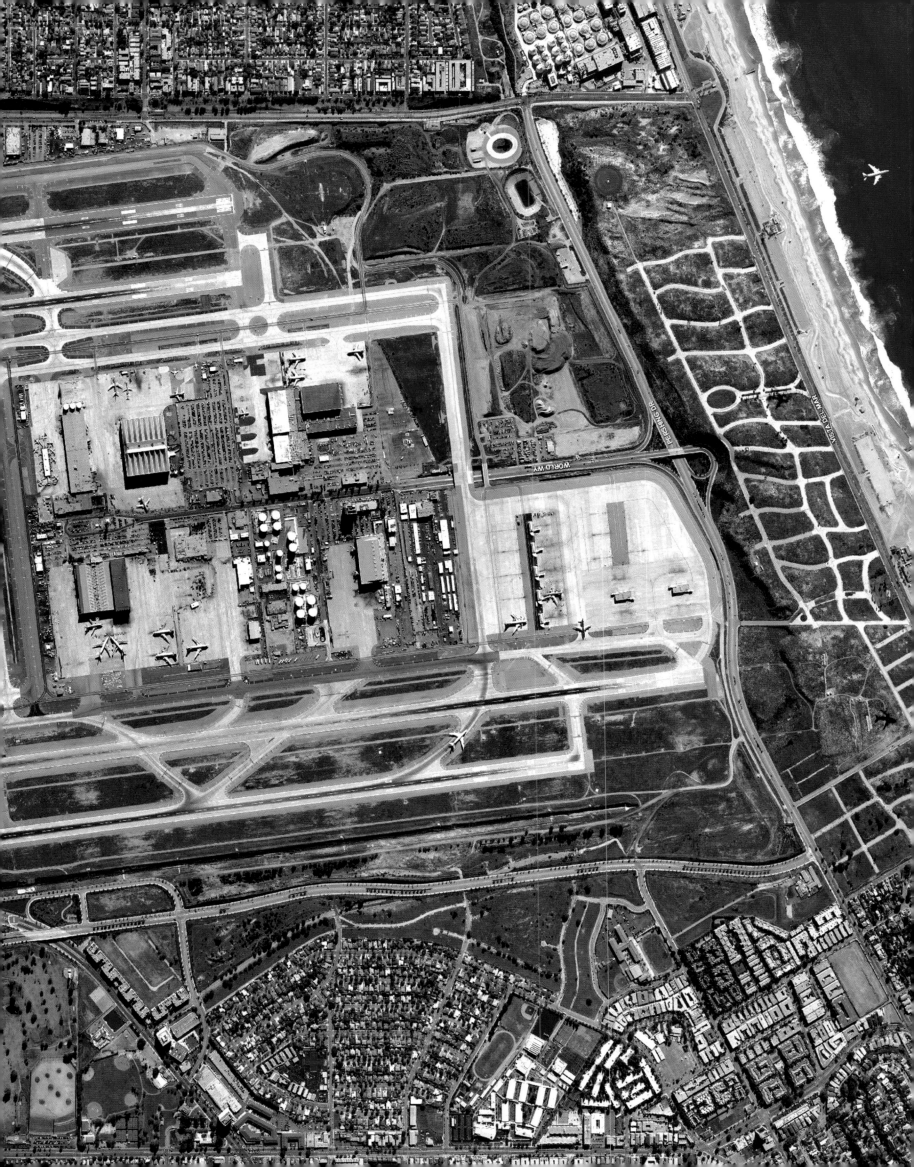

Kastrup, Copenhagen Airport

right above: John Foster Dulles International, Washington, DC

right below: Edward Lawrence Logan International, Boston

Pages 28/29: Madrid Barajas International

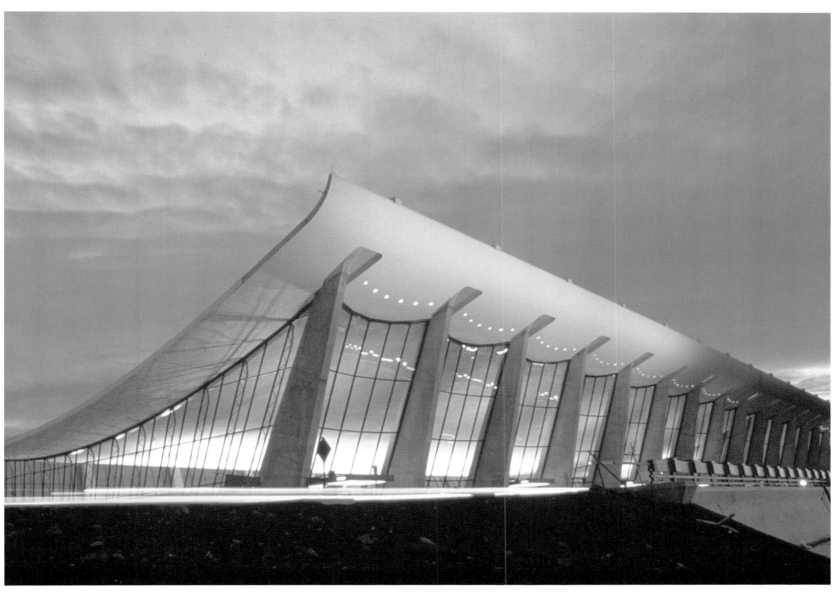

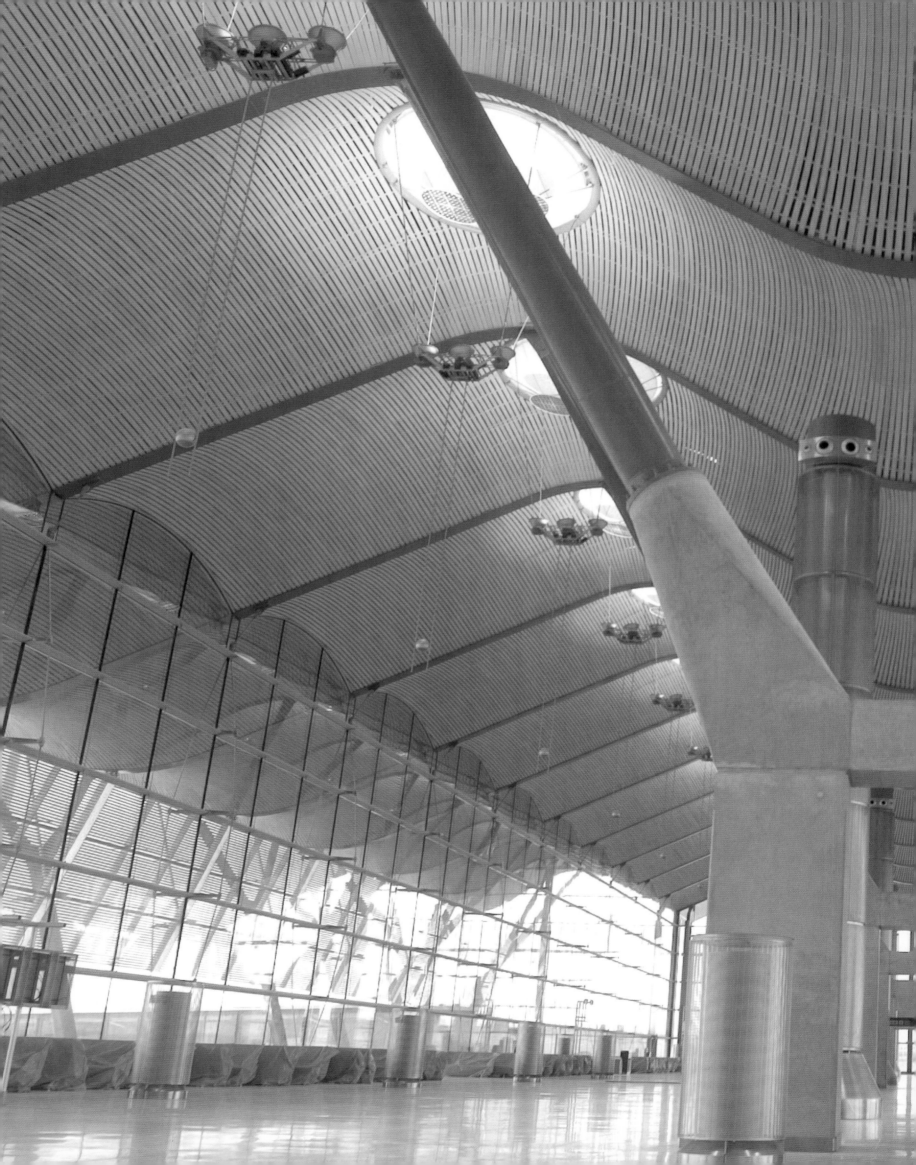

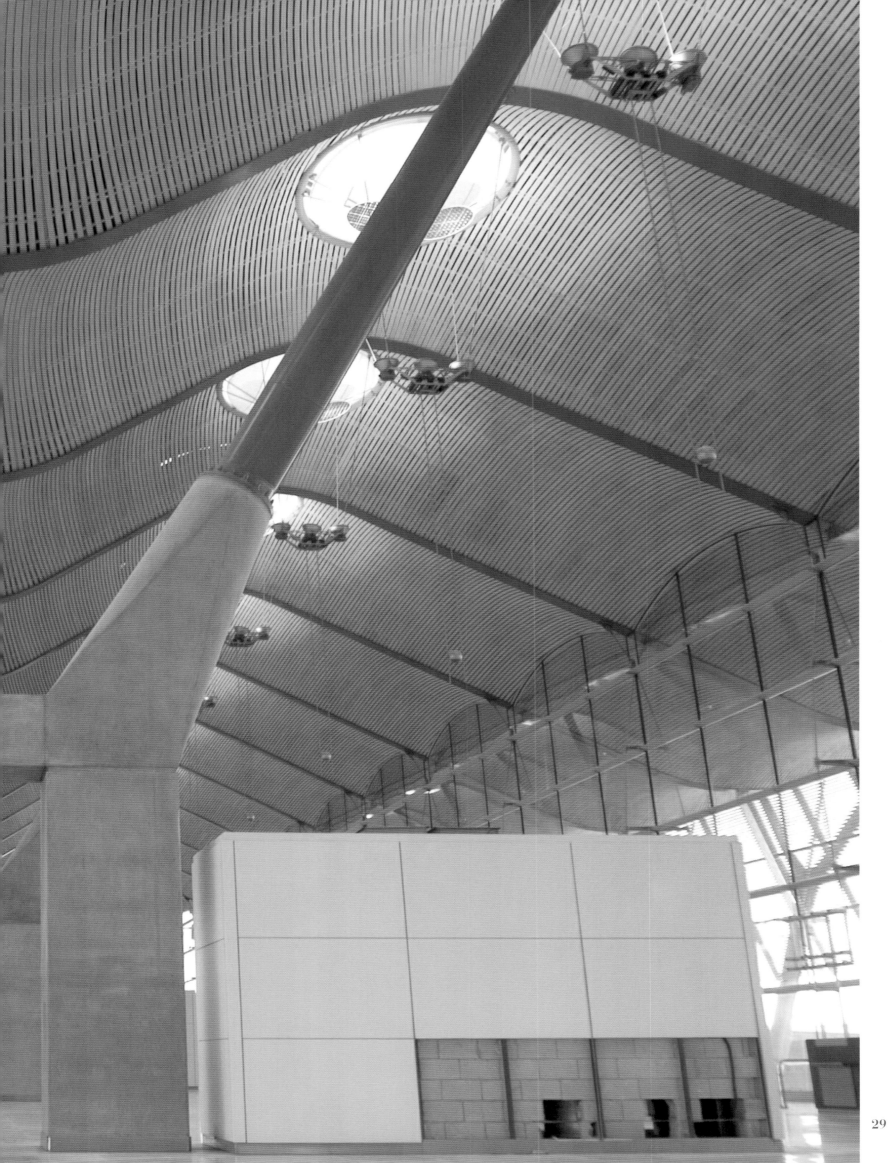

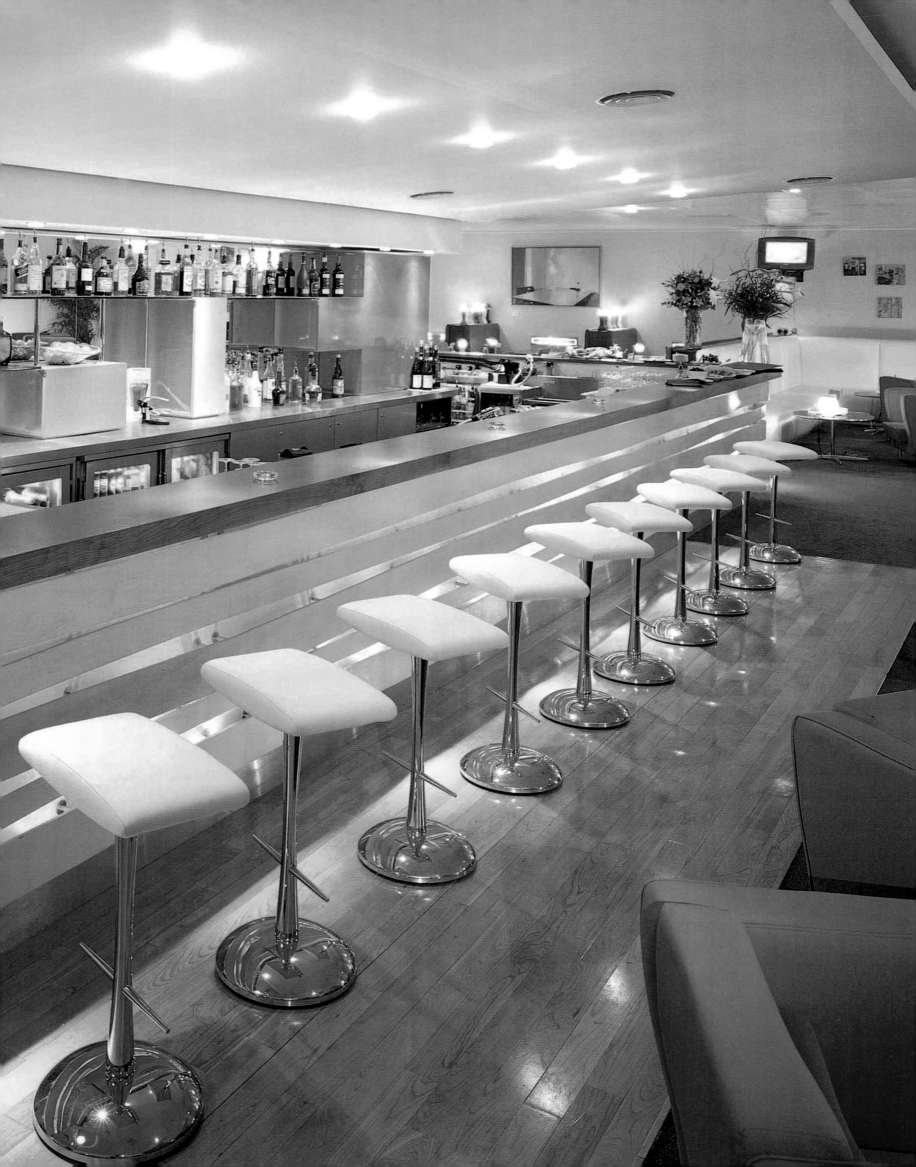

First-Class Maple Leaf Lounge offered by Air Canada, Toronto International Airport

left: *Virgin Atlantic Lounge*

As airport crowds increased, frequent travellers demanded a quiet, comfortable place to relax or continue working. Airlines quickly responded with the private airport lounge. With design and service on a par with the finest hotels, the environment is integrated closely with First-Class treatment in the air. From massages to sending an urgent email, the lounge is a place of luxury and convenience.

Als die Flughäfen immer überfüllter wurden, wünschten sich vor allem Vielflieger einen ruhigen und komfortablen Ort, um sich zu entspannen oder zu arbeiten. Die Fluggesellschaften reagierten schnell und führten erste private Lounges ein. Mit der Kombination von Design und Service entsprach die Umgebung dem Anspruch der Ersten Klasse in der Luft. Ob Massagen oder die Möglichkeit E-Mails zu versenden – Lounges sind Orte des Luxus und Komforts.

Alors que le transport aérien augmentait, la demande pour des lieux calmes et confortables pour se détendre ou travailler se fit sentir. Les compagnies aériennes réagirent rapidement et mirent en place des salons privés. La combinaison de design et de service a permis d'offrir un environnement au sol à la hauteur des attentes des passagers de première classe. Qu'il s'agisse de la possibilité de se faire masser ou d'envoyer des e-mails – les salons des aéroports sont des espaces de luxe et de confort.

A medida que los aeropuertos se iban congestionando cada vez más, fueron ante todo los viajeros frecuentes, los que reclamaban un lugar tranquilo y confortable para descansar o trabajar. Las compañías aéreas no tardaron en reaccionar y crearon las primeras salas privadas estilo lounge. Combinando diseño y servicio, el entorno correspondía al estándar de primera clase en el aire. Recibir un masaje o disponer de correo electrónico –las salas estilo lounge son lugares de lujo y confort.

Dal momento in cui gli aeroporti hanno iniziato a popolarsi oltre misura, i clienti – ed in particolar modo quelli che viaggiavano spesso – hanno espresso il desiderio di un luogo in cui poter riposare o lavorare. La reazione delle compagnie non si è fatta attendere e sono state così create le prime lounge private, nelle quali la combinazione tra design e servizio corrisponde al livello di un volo in prima classe. Che si tratti di un massaggio o della possibilità di inviare un'e-mail, le lounge sono luoghi ricchi di lusso e di comfort.

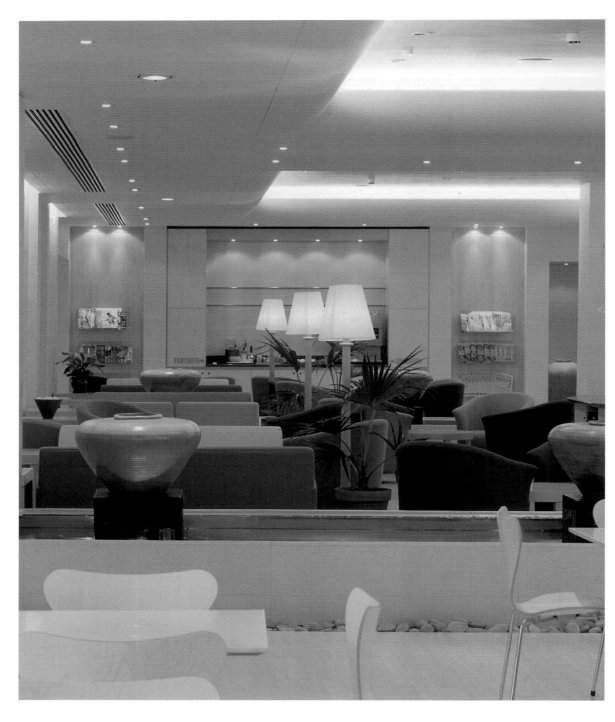

Lounges designed by the Czarska Group for Malaysia Airlines at London Heathrow (above) and Frankfurt (right)

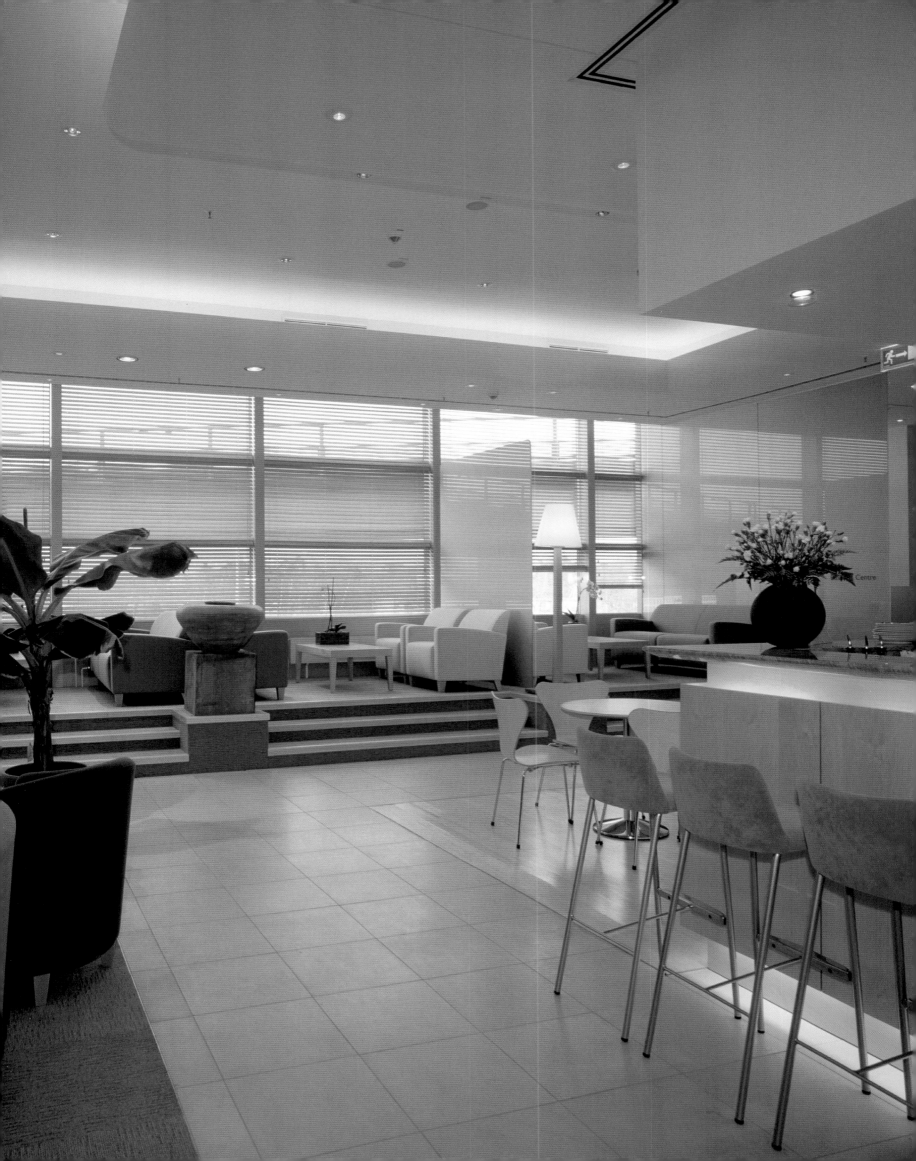

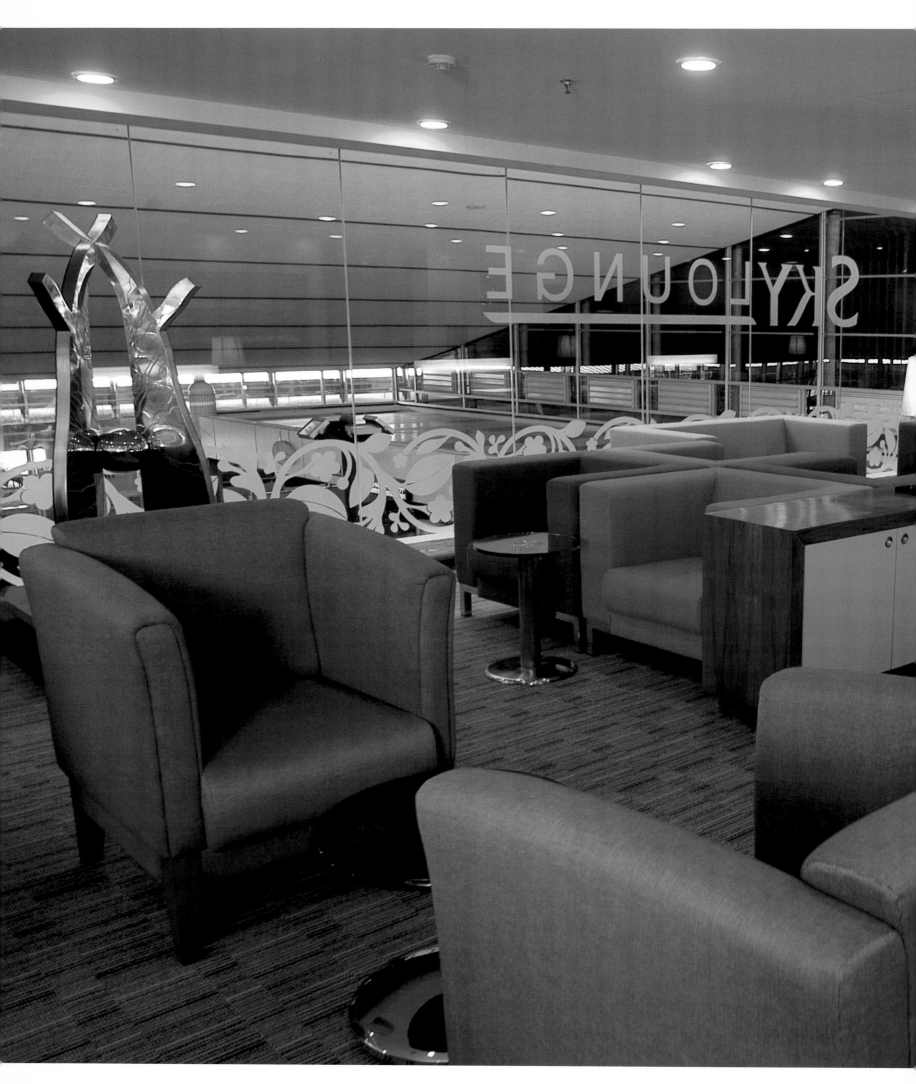

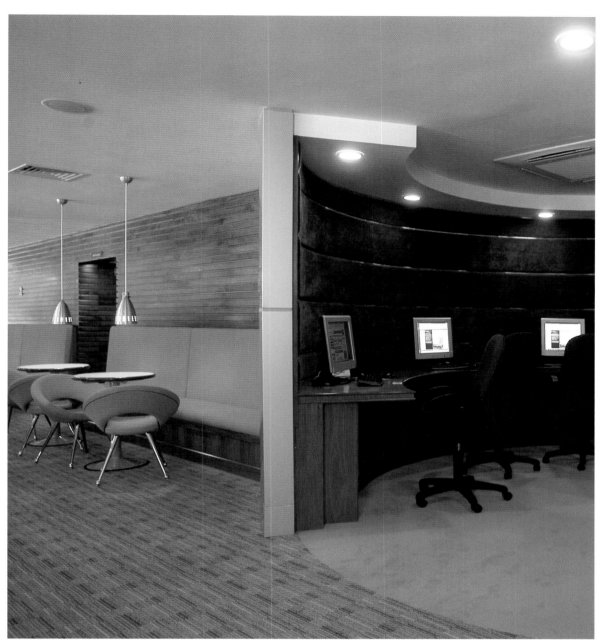

Royal Brunei's new Skylounge at Brunei International Airport

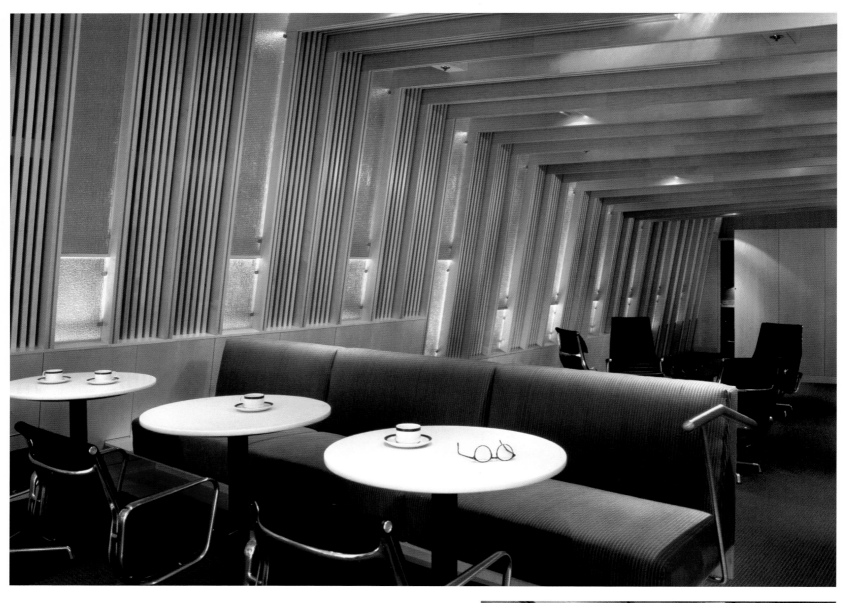

Air Canada International lounge (designed by Patkau Architects Inc)

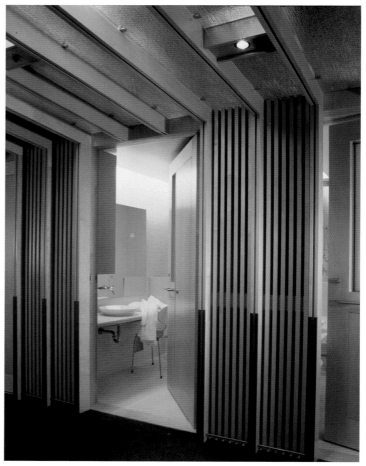

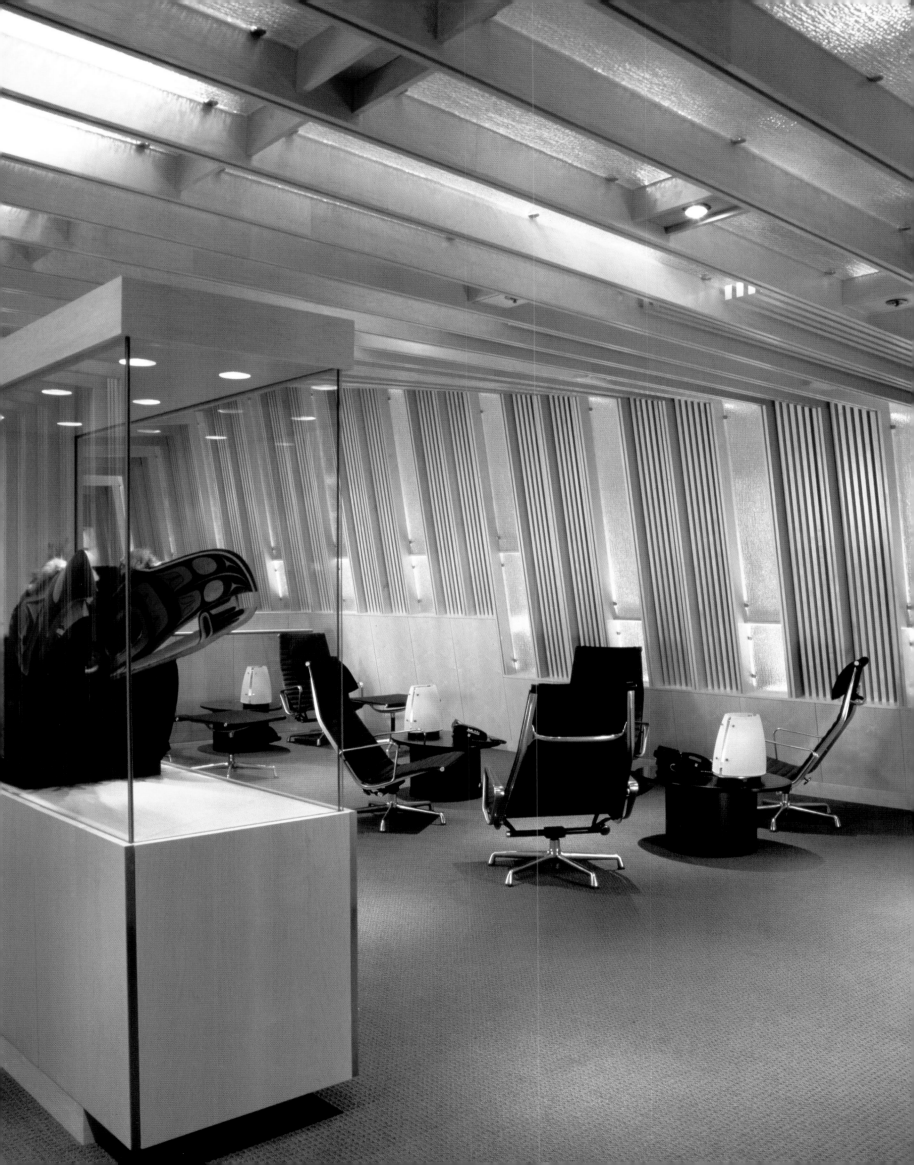

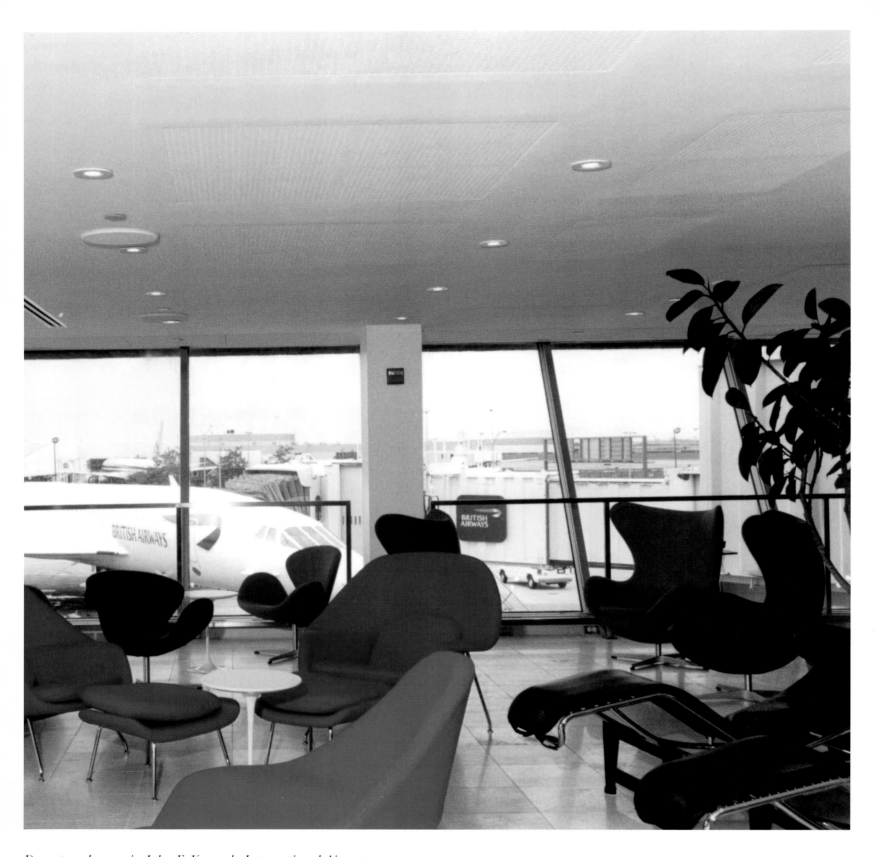

Departure lounge in John F. Kennedy International Airport

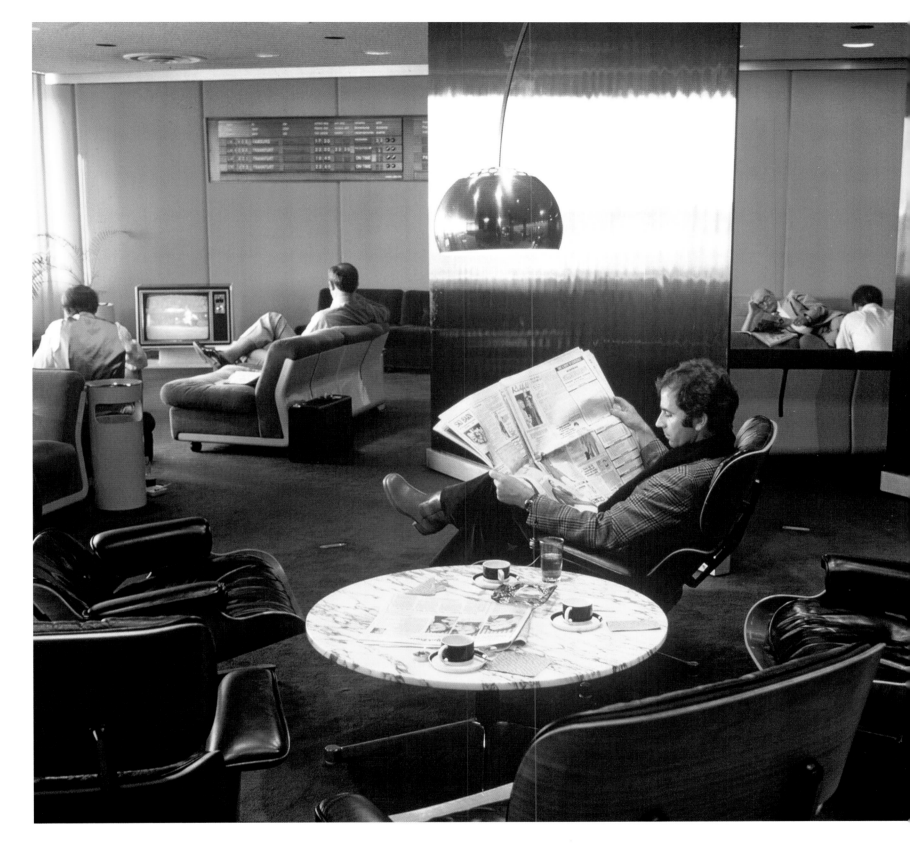

Lufthansa Senator Lounge in Frankfurt International Airport circa 1973

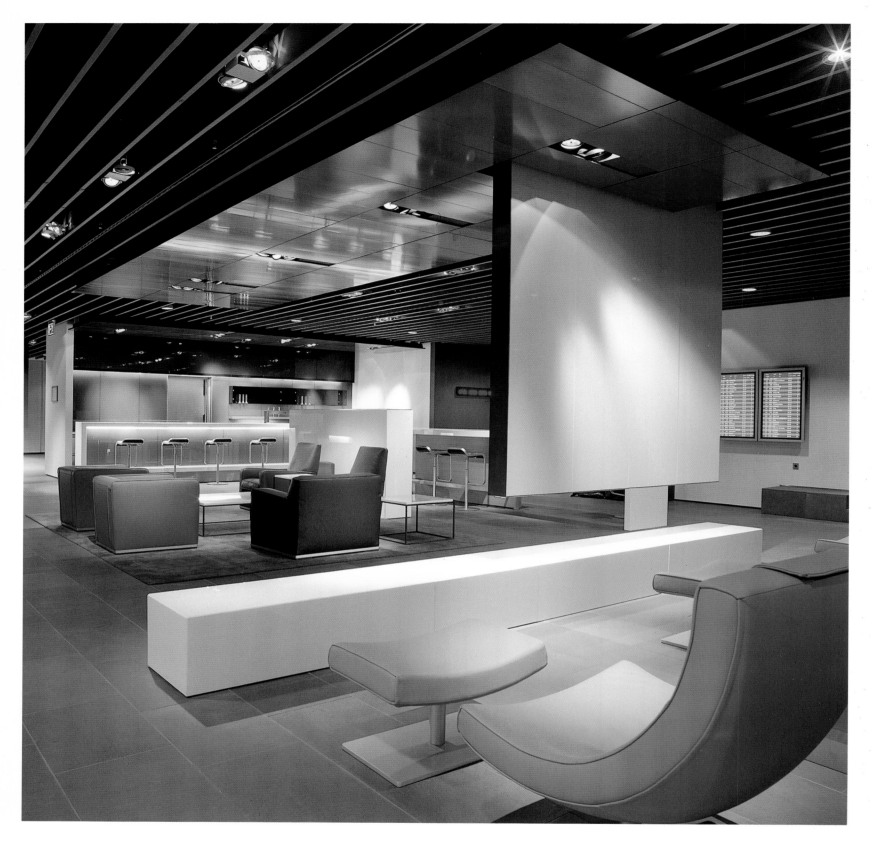

Club area of the Lufthansa First-Class Lounge in Frankfurt designed by Hollin Radoske Architekten

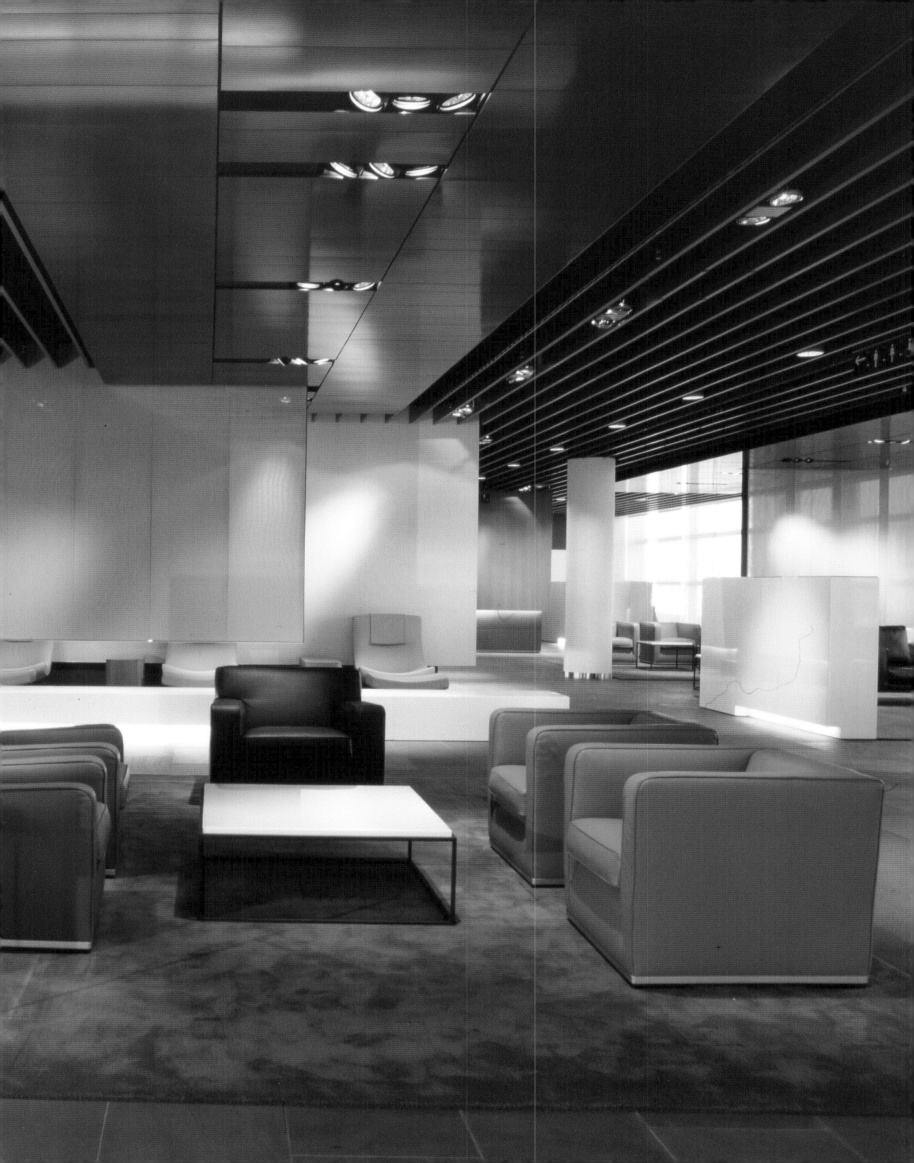

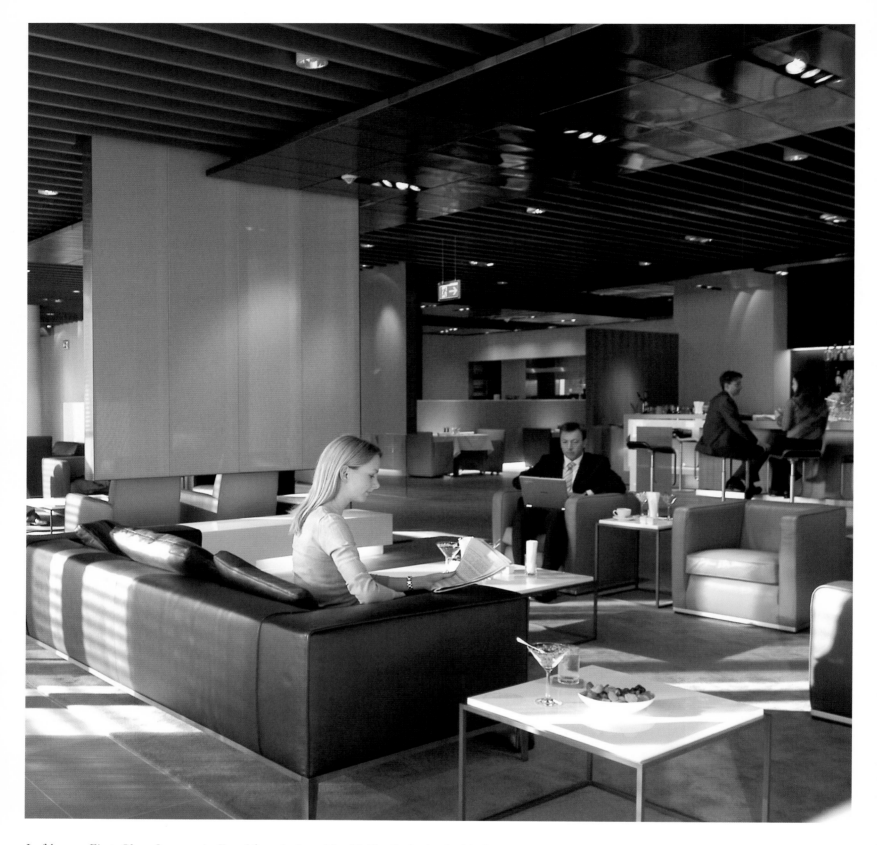

Lufthansa First-Class Lounge in Frankfurt designed by Hollin Radoske Architekten

Pages 44/45: *Lufthansa First-Class Lounge in Frankfurt*

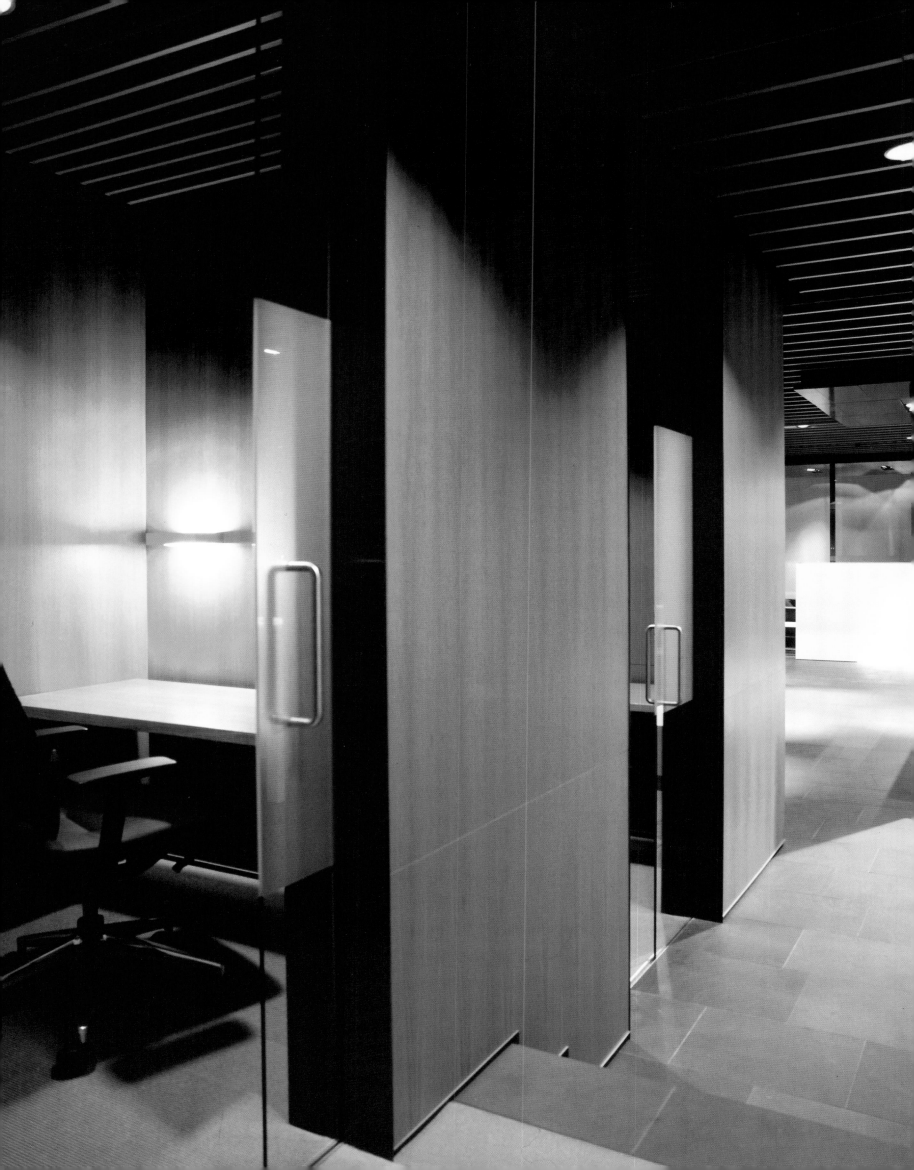

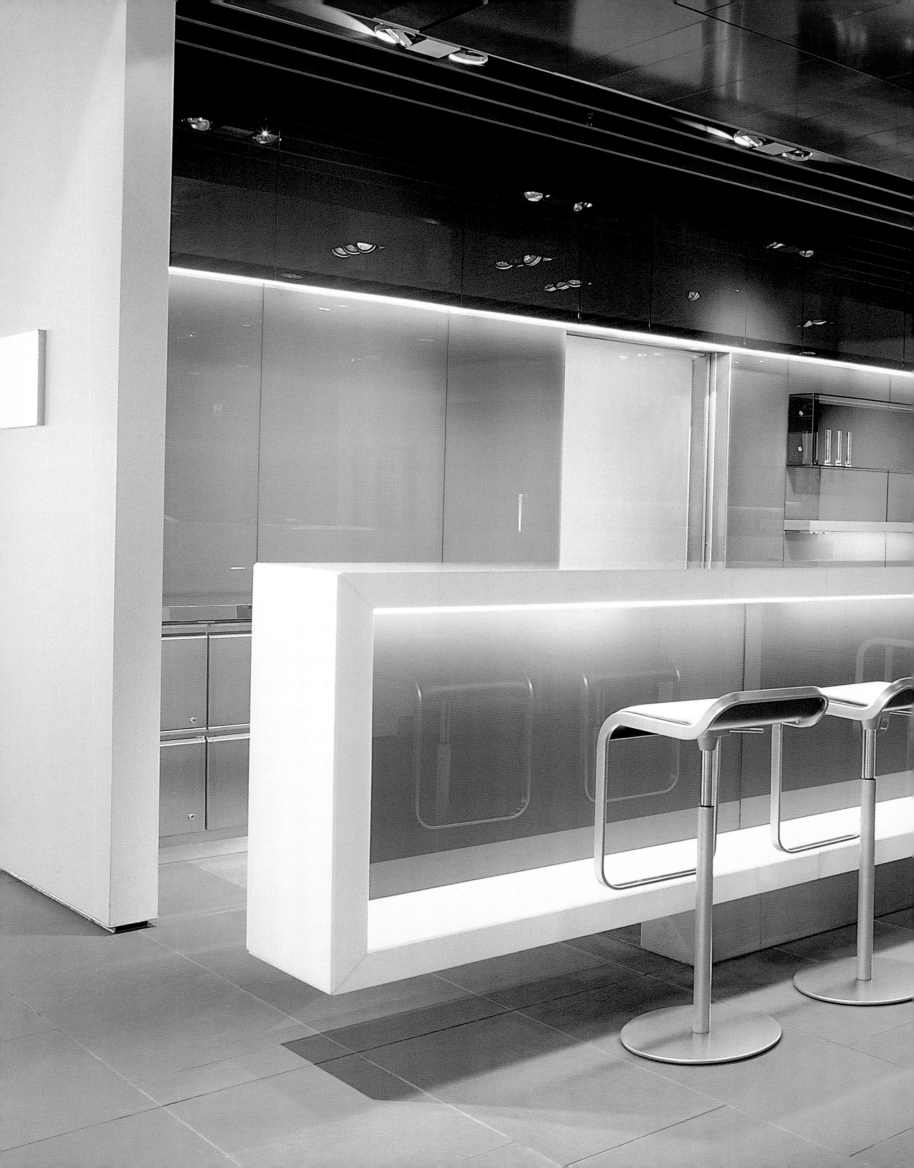

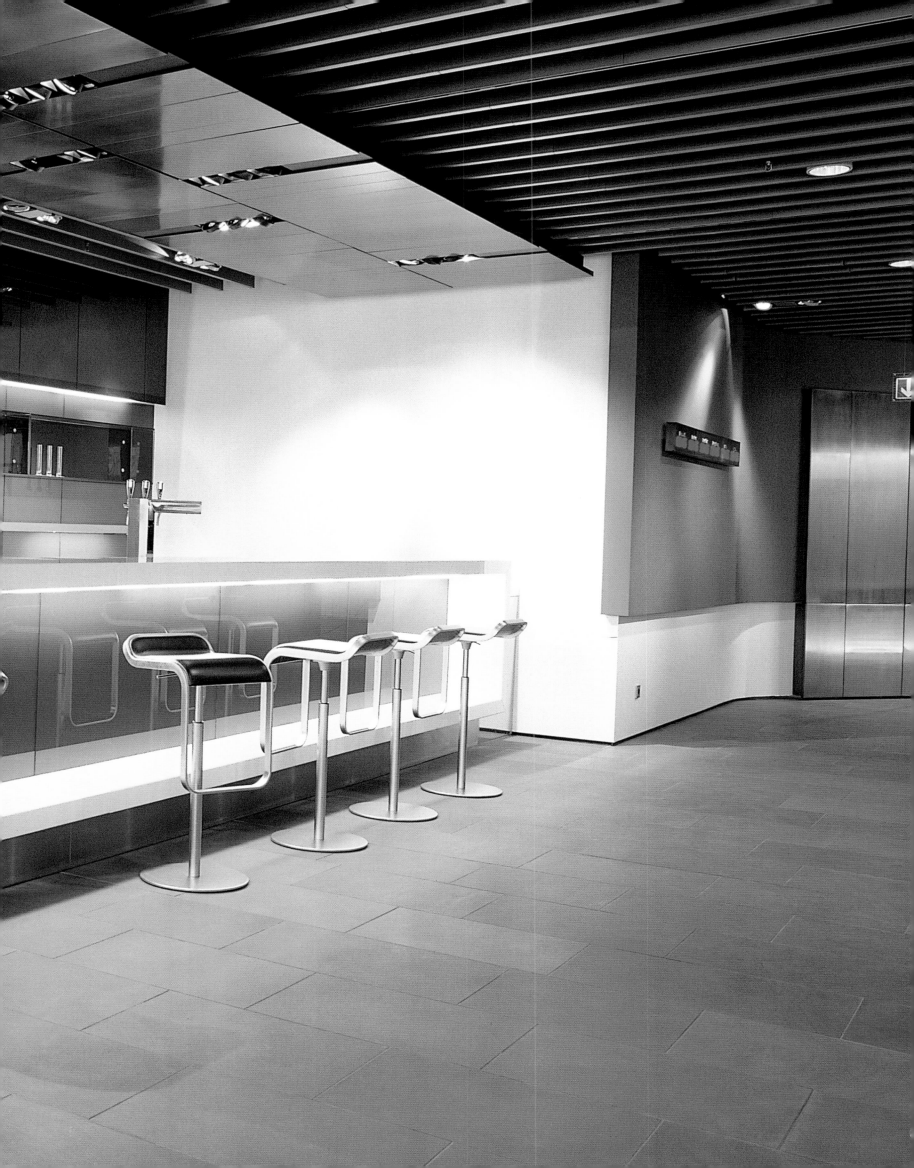

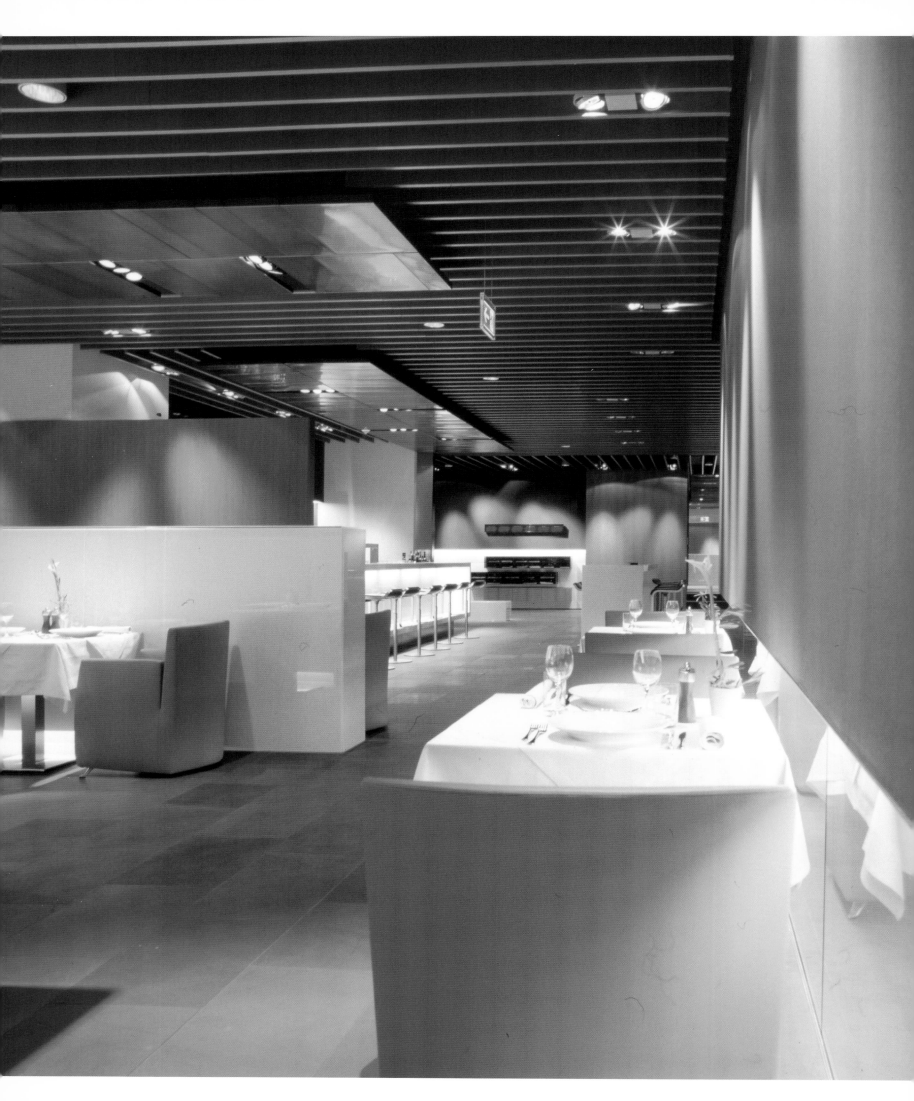

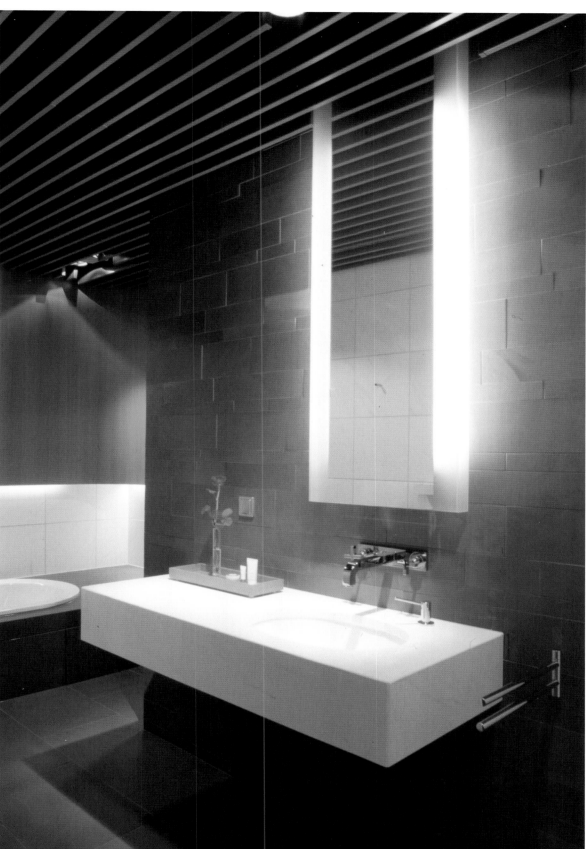

Dining area and bathroom in the Lufthansa First Class Lounge in Frankfurt

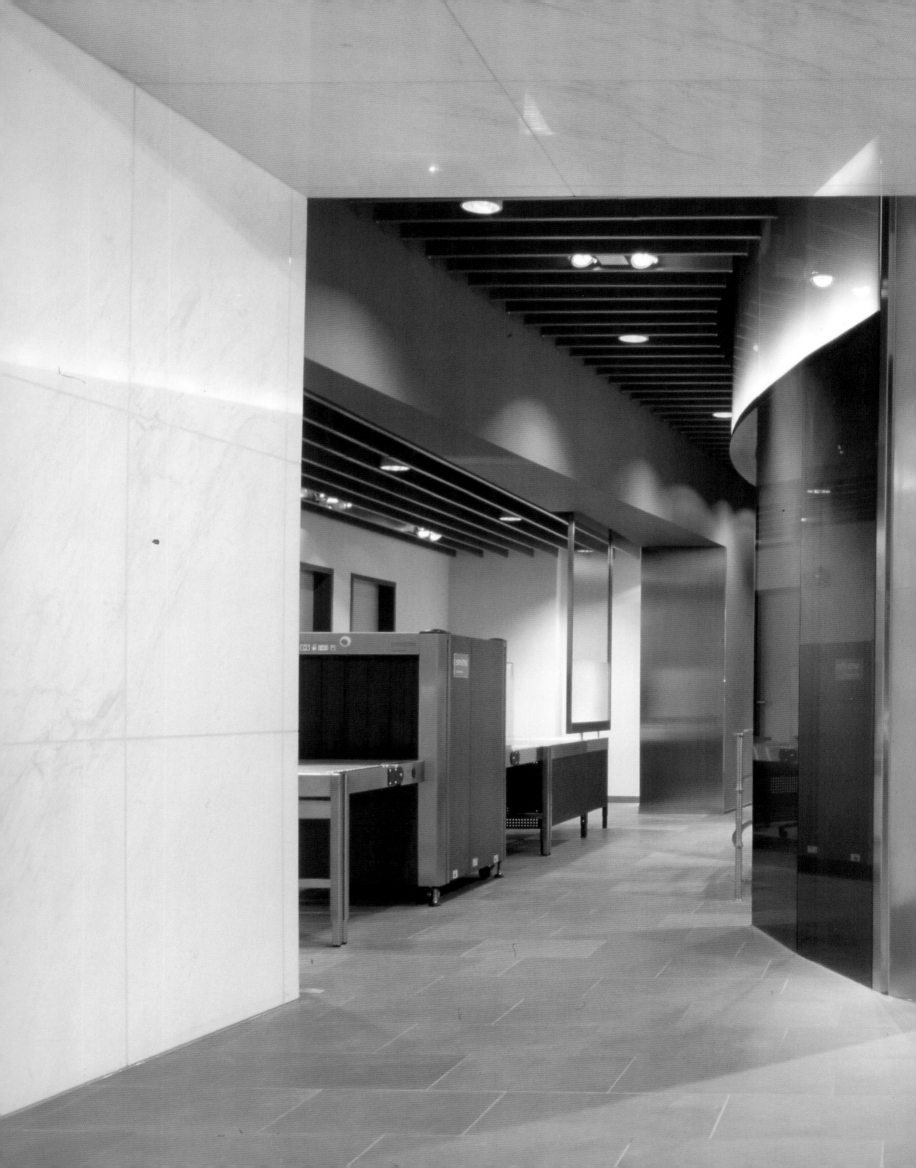

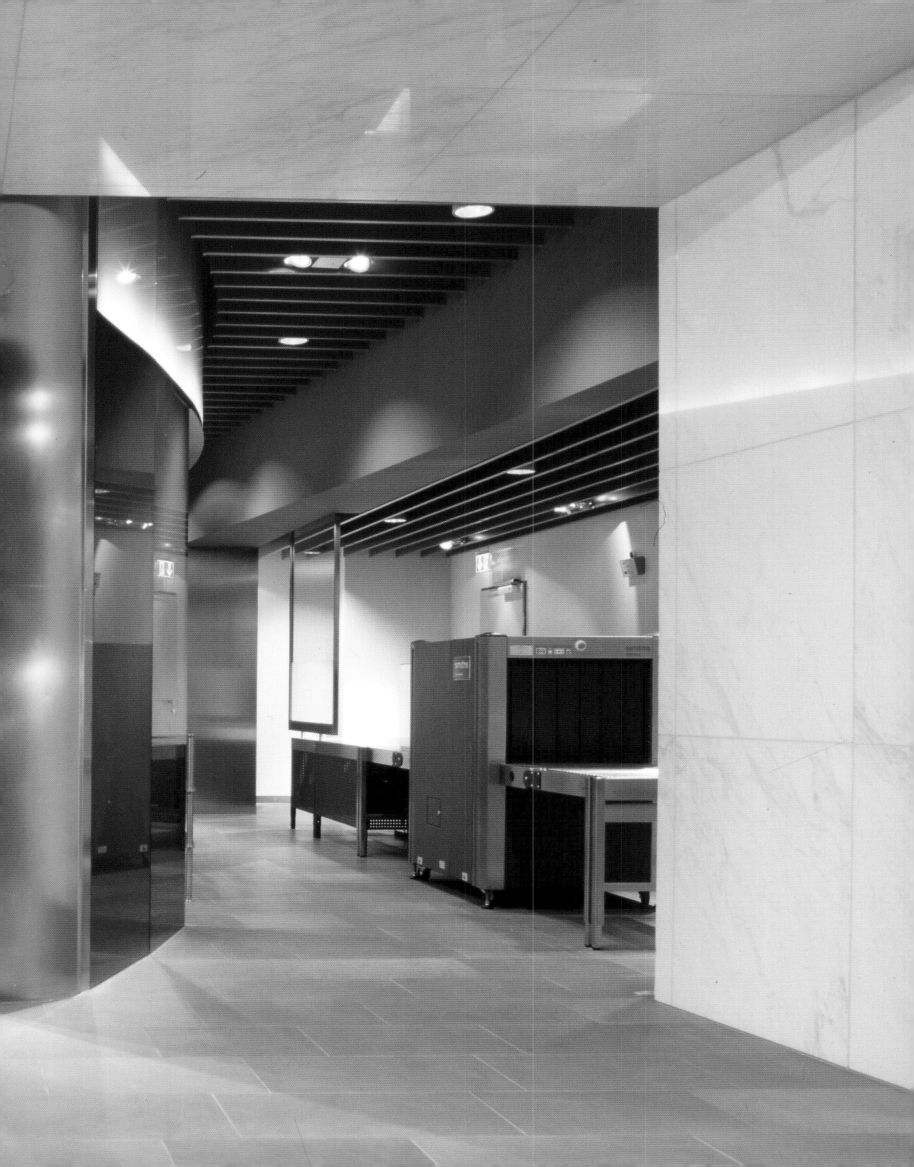

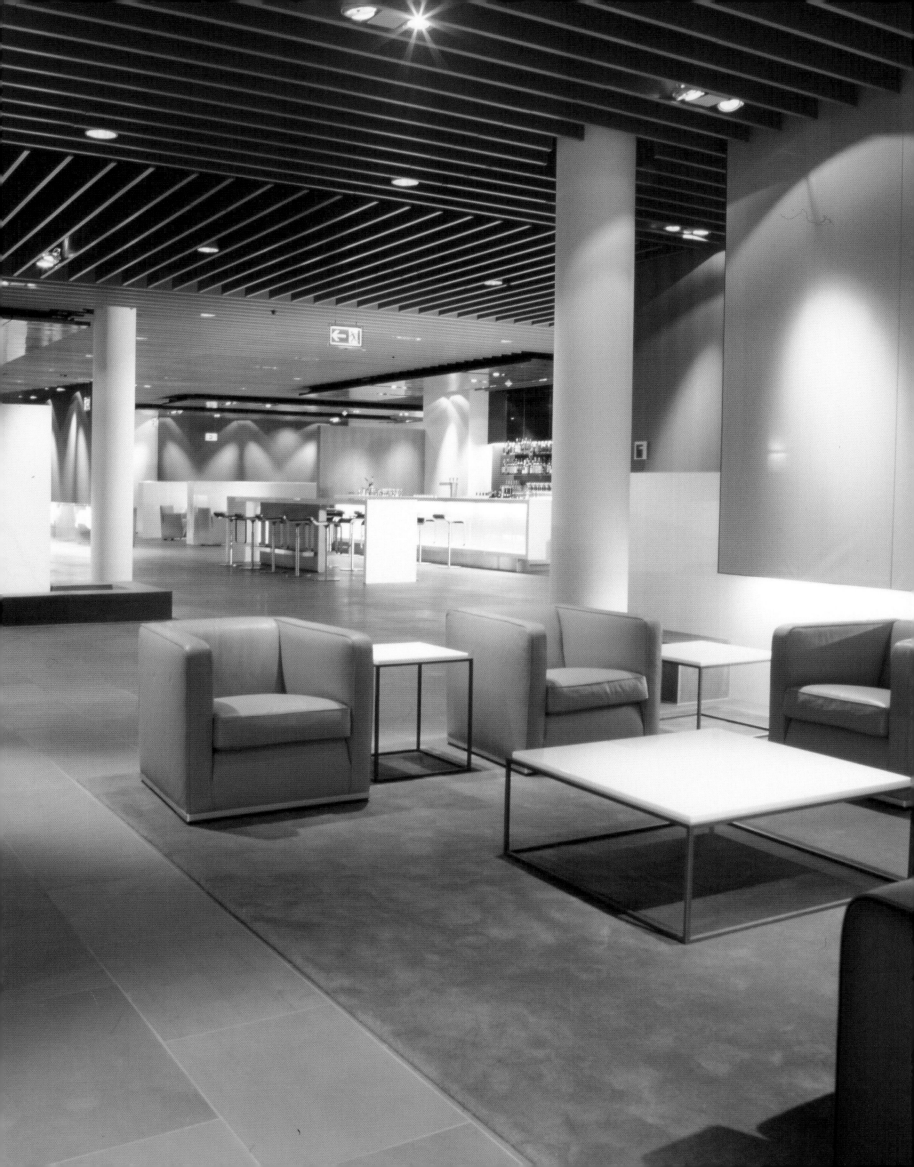

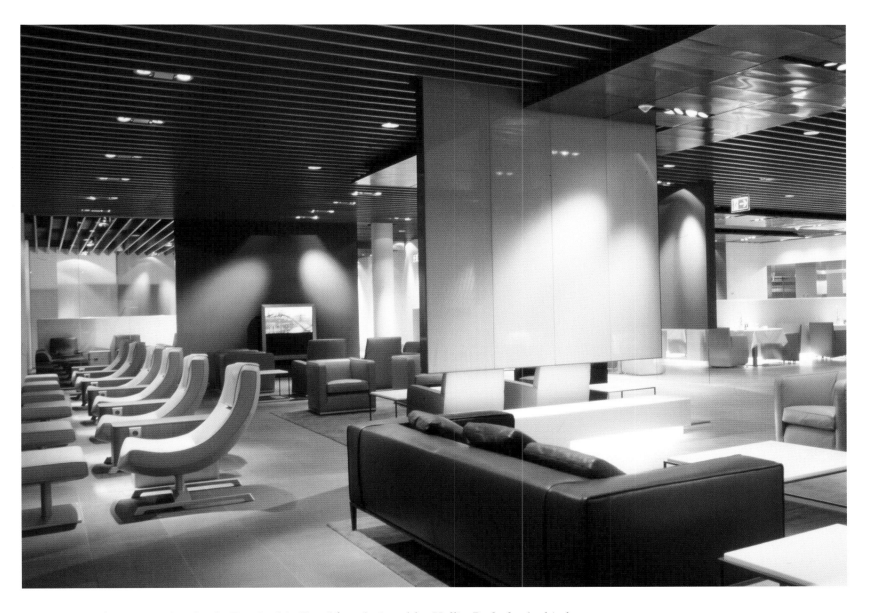

Lounge in Lufthansa's HON Circle Terminal in Frankfurt designed by Hollin Radoske Architekten

Lufthansa commissioned the world's first First-Class terminal, which is only available to premium clients (HON Circle Members). The terminal has its own security gate (pages 48/49) through which the passenger reaches the lounge area which lies behind it.

Im Frankfurter Flughafen ließ sich Lufthansa den weltweit ersten First-Class-Terminal einrichten, der nur Premiumkunden (HON Circle Members) offen steht. Der Terminal verfügt über eine eigene Sicherheitsschleuse (Seiten 48/49), durch die der Passagier den dahinter liegenden Lounge-Bereich erreicht.

A l'aéroport de Francfort, la Lufthansa a fait construire le premier terminal « First Class » au monde. Seuls les clients détenteurs d'une carte Premium (membres du HON Circle) peuvent y accéder. Ce terminal dispose de sa propre passerelle de contrôle (pages 48/49) qui permet ensuite d'accéder à l'espace salons qui se situe juste derrière.

En el aeropuerto de Francfort la Lufthansa mandó construir la primera terminal de primera clase del mundo, accesible únicamente por clientes Premium (HON Circle Members). La terminal dispone de un control de seguridad propio (páginas 48/49) a través del cual el pasajero tiene acceso a la sala lounge situada en el lado posterior.

La Lufthansa ha fatto costruire nell'aeroporto di Francoforte il primo First-Class-Terminal del mondo, accessibile solo ai membri dell'HON Circle. Il terminal dispone di un proprio settore di sicurezza (pagine 48/49) adiacente la lounge e attraverso il quale i passeggeri possono quindi raggiungere direttamente la zona a loro riservata.

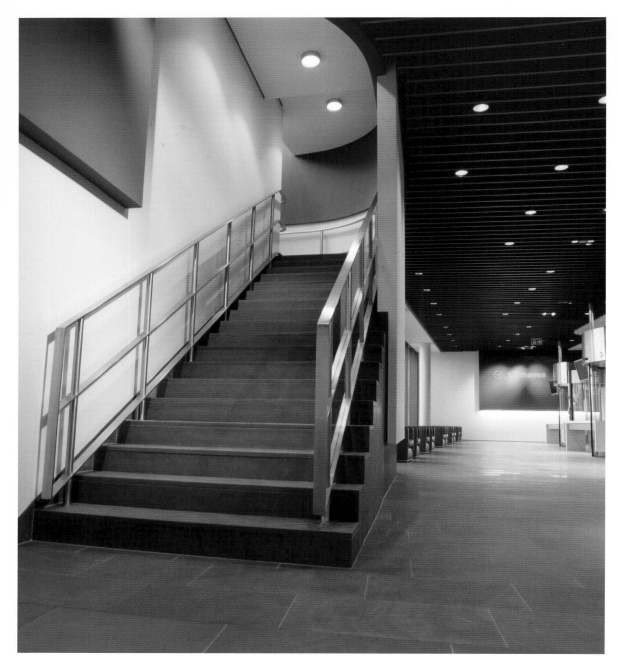

Lufthansa's HON Circle Terminal in Frankfurt

The traveller reaches the boarding area on the ground floor of the building from the lounge in a minimal amount of time by stair or by lift.

Über eine Treppe oder mit dem Fahrstuhl gelangt der Reisende von der Lounge ohne Zeitverlust zum Boarding-Bereich im Erdgeschoss des Gebäudes.

Le passager peut se rendre par un escalier ou un ascenseur de l'espace salons à la zone d'embarquement située au rez-de-chaussée du bâtiment en un temps minimal.

A través de una escalera o ascensor el viajero se desplaza sin pérdida de tiempo de la sala lounge a la zona de embarque situada en la planta baja del edificio.

Infine i passeggeri non dovranno che passare per la scala o l'ascensore e raggiungere così, senza ulteriori indugi, il settore per l'imbarco al primo piano.

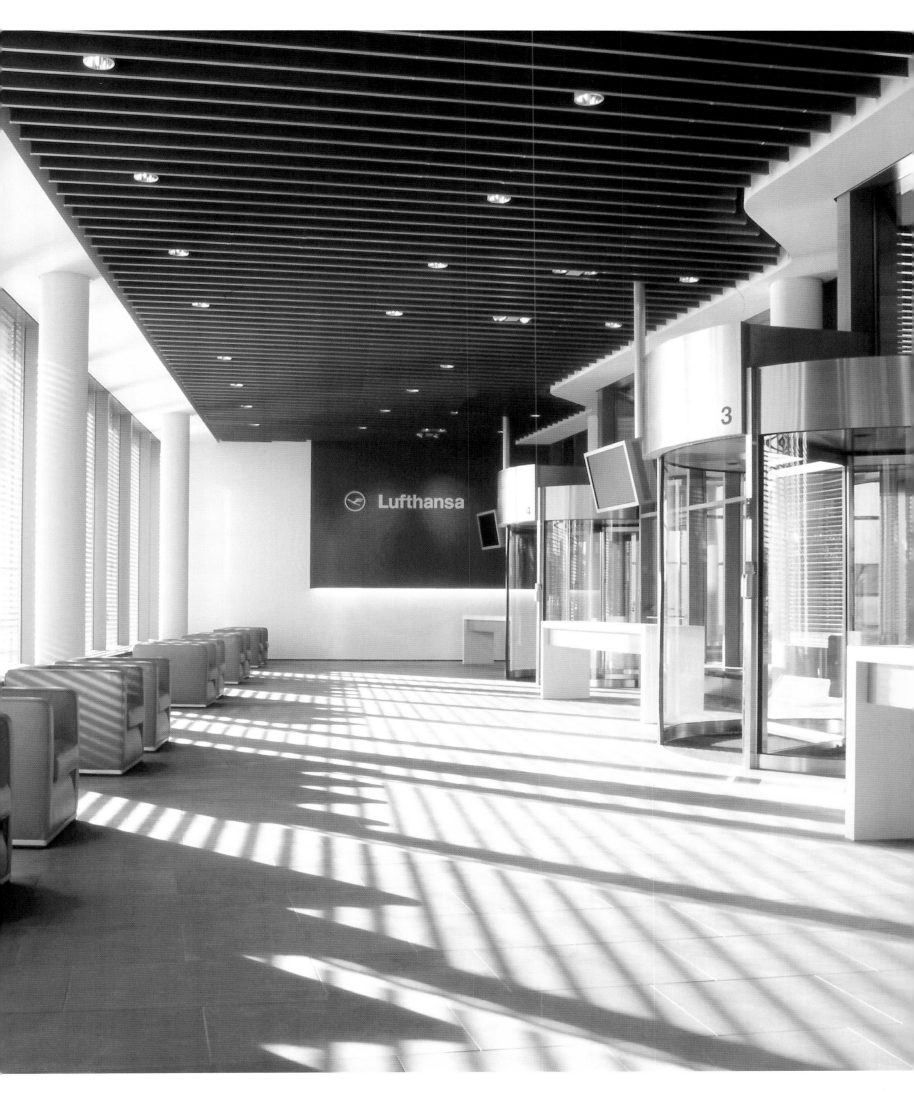

Fashion

Fashion

Before the advent of in-flight meals, the first cabin crews were trained nurses in case of an emergency. As the number of passengers and their demand for services increased, the stewardess became the public face of the airline. Realising this, airlines used the stewardess uniform for the dual purpose of brand identification and sex appeal. Young, attractive women were recruited to serve passengers, and famous apparel designers were employed to clothe them in fashionable and increasingly revealing uniforms. Jackets, hats, and the ever-shorter skirt are common elements that have been re-interpreted countless times to reflect contemporary fashion and the corporate identity of an airline.

Bevor Mahlzeiten während des Fluges eingeführt worden waren, hatte das Flugbegleitpersonal die Aufgabe, die Passagiere in Notfällen zu versorgen. Als die Zahl der Flugreisenden und damit auch das Bedürfnis nach bestimmten Dienstleistungen zunahm, wurden die Stewardessen zum Aushängeschild der Fluggesellschaften. Die Uniform unterstrich nicht nur ihren Sexappeal, sondern wurde auch zum Markenzeichen der Airline. Deshalb wurden junge attraktive Frauen eingestellt, und berühmte Designer entwarfen die Uniformen. Die Jacken, Hüte und immer kürzer werdenden Röcke wurden im Laufe der Zeit immer wieder dem aktuellen modischen Geschmack und dem Image der Fluggesellschaften angepasst.

Avant que la restauration à bord ne soit introduite, le personnel de bord avait pour mission de s'occuper des passagers en cas de problèmes graves. Lorsque le nombre de passagers a augmenté, la demande pour certains services à bord est apparue. Les hôtesses de l'air sont devenues la vitrine des compagnies aériennes. Leurs uniformes ne se contentaient pas de souligner leur sex appeal, ils sont aussi devenus l'insigne distinctif de la compagnie. De jeunes femmes attirantes ont été embauchées, et de célèbres stylistes ont été mandatés pour concevoir leurs uniformes. Les vestes, les chapeaux, et des jupes de plus en plus courtes, se sont adaptées au fil du temps à la mode du moment et à l'image de marque des différentes compagnies aériennes.

Antes de ofrecer comidas en los vuelos, la tarea del personal de cabina consistía en atender a los pasajeros en caso de emergencia. Al aumentar el número de viajeros también creció la demanda de ciertas prestaciones de servicio, convirtiendo a las azafatas en la identidad visual de las compañías aéreas. El uniforme no sólo realzaba su sex-appeal, sino que creaba la identidad de marca de la línea aérea. Las azafatas habían de ser jóvenes y atractivas y los uniformes salían de los talleres de famosos diseñadores. Chaquetas, sombreros y faldas, cada vez más cortas, a lo largo del tiempo fueron adaptadas a la moda actual y a la imagen de la compañía aérea.

Prima dell'introduzione del pranzo a bordo degli aerei, il personale di bordo aveva principalmente il compito di assistere i passeggeri in caso di bisogno. Una clientela sempre più numerosa incominciò però presto ad avere anche altre esigenze. In questo quadro le hostess divennero il biglietto da visita delle compagnie e la loro divisa non evidenziava semplicemente il sex appeal, bensì diventò presto un segno di riconoscimento per il marchio della società. A questo scopo vennero assunte donne giovani ed attraenti, le cui divise erano ideate da designer famosi. Le linee di giacche, cappelli e gonne sempre più corte, venivano di volta in volta aggiornate in base al gusto del momento ed all'immagine della compagnia.

Stewardesses for Braniff International on board a Boeing 747

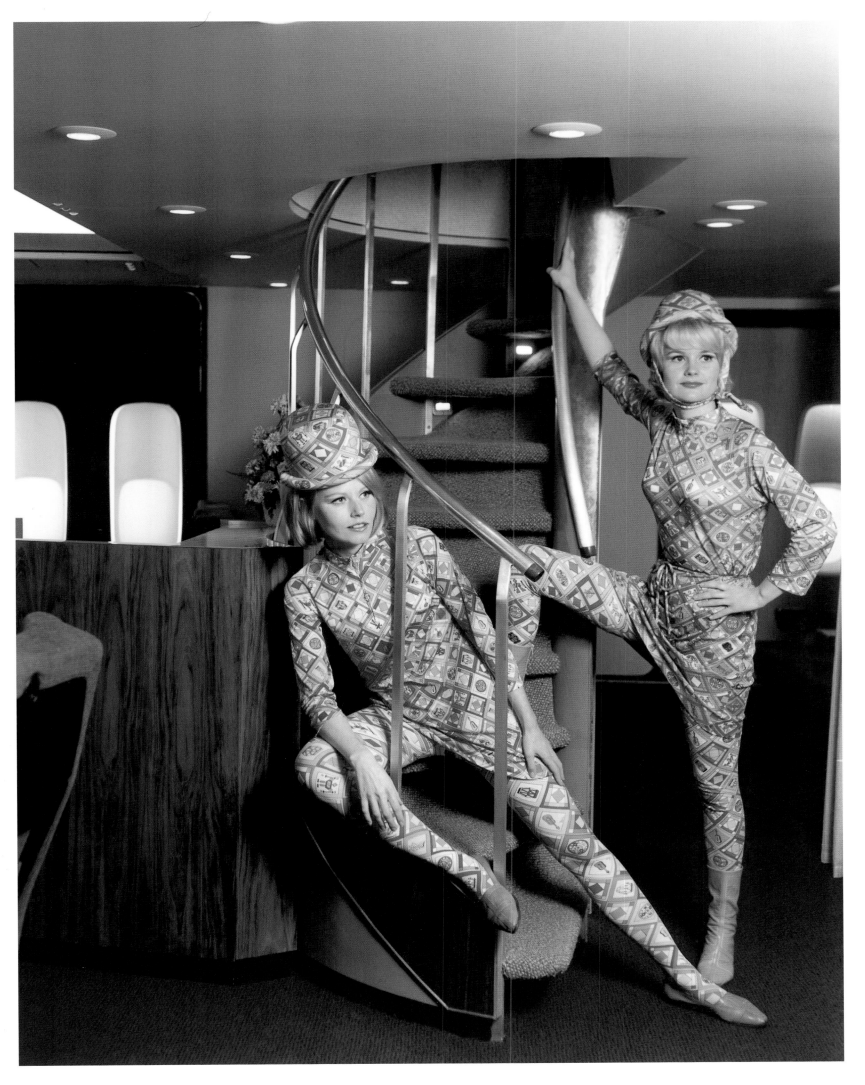

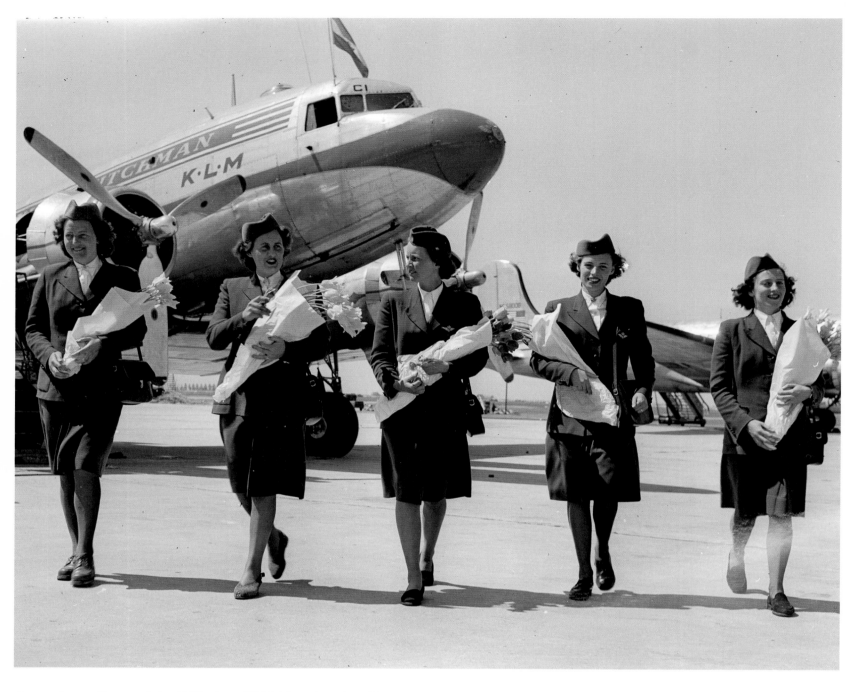

Stewardess uniforms of the 1950s from KLM (above) and Lufthansa (right)

Pages 60/61: *United Airlines stewardesses from the 1960s*

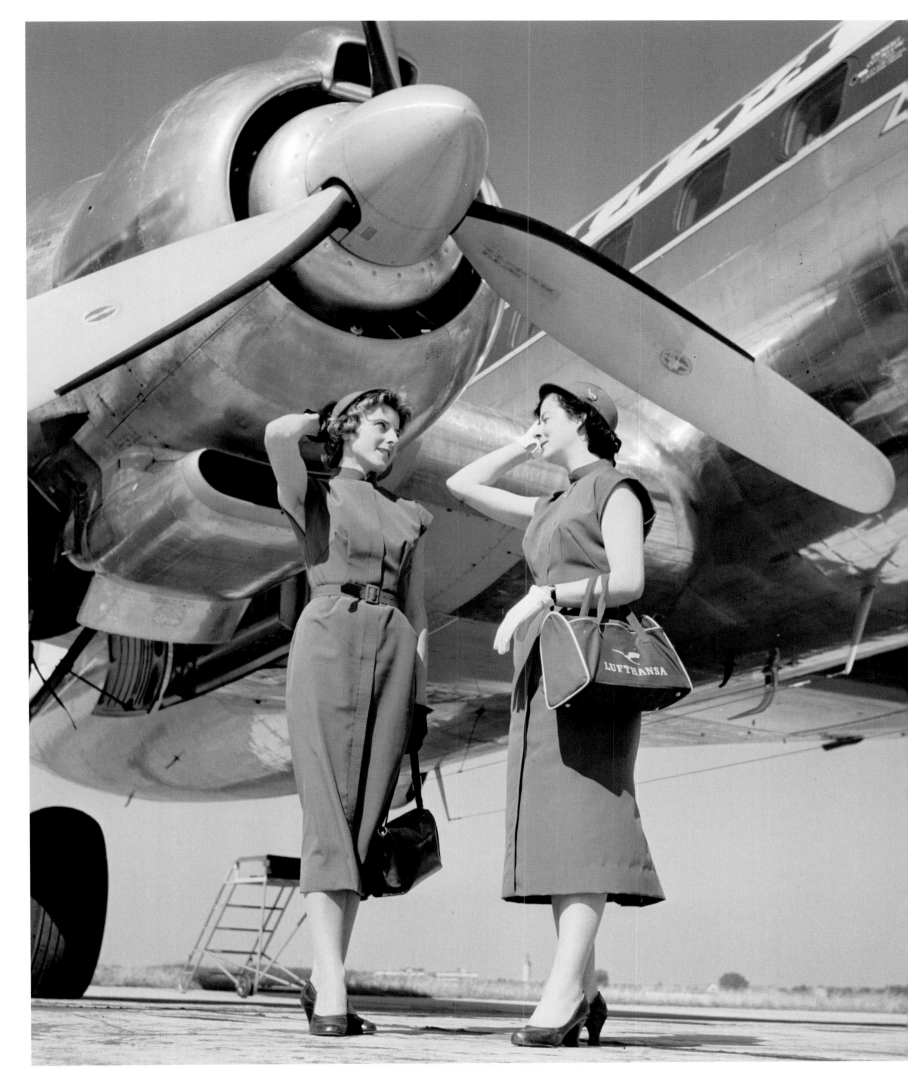

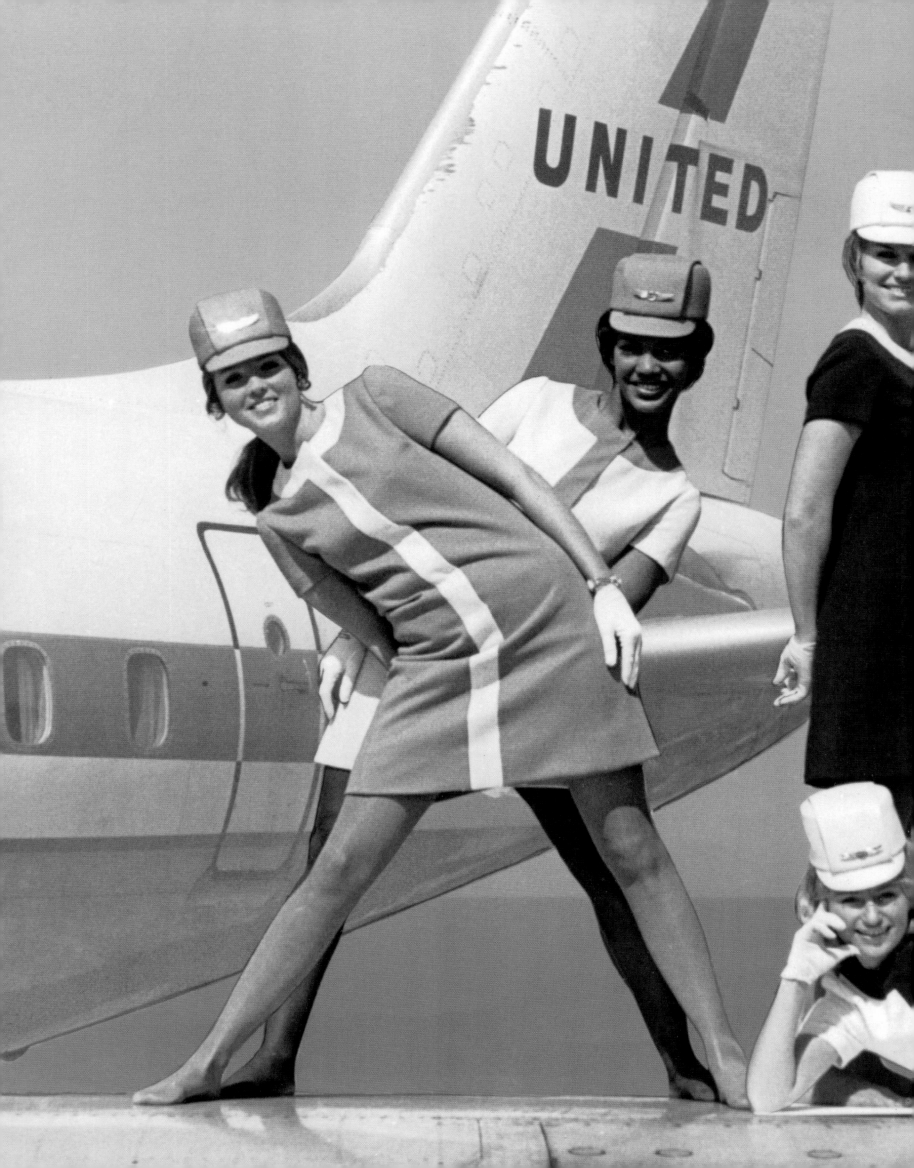

Uniforms for Braniff International from the 1960s

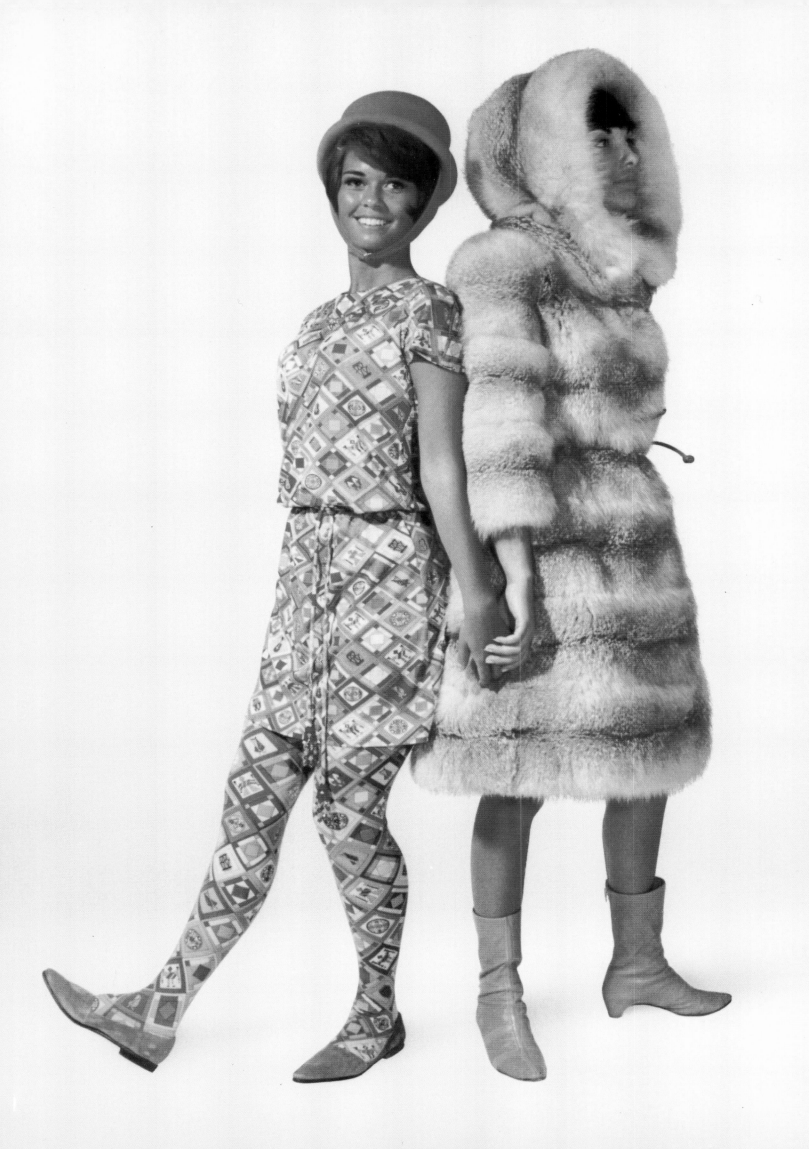

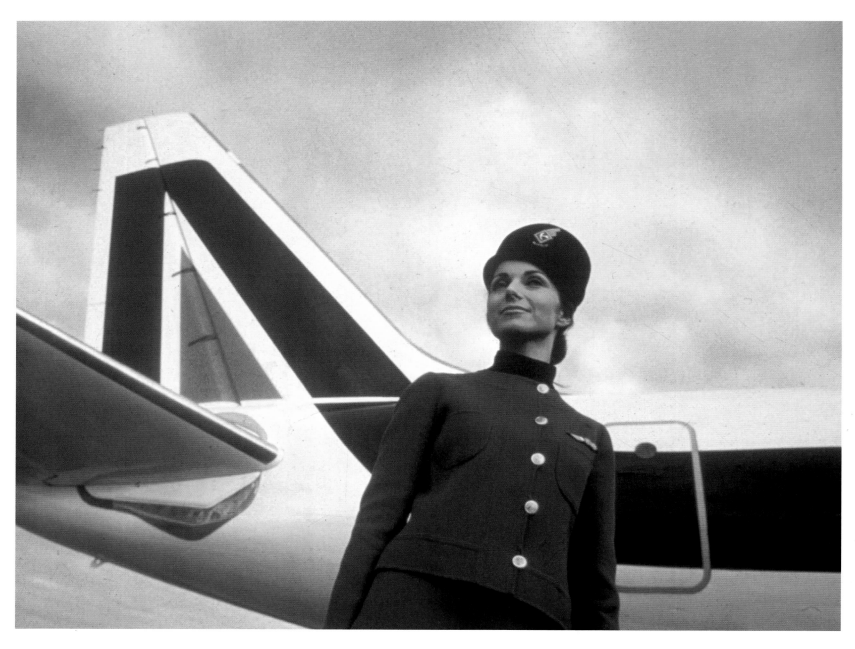

Alitalia, 1960s

right: *Air France, 1960s*

Young, smartly dressed stewardesses became the symbol of international jet-setting in the 1960s and 1970s with uniforms re-designed every two years to match current trends and the airline's image. Alitalia commissioned designer Mila Schoen in 1968 to create a graceful, fashionable, and yet practical uniform.

Junge, elegant gekleidete Stewardessen wurden vor allem in den 60er- und 70er-Jahren zum Aushängeschild der internationalen Luftfahrt. Die Uniformen wurden alle zwei Jahre den aktuellen Trends und dem Image der Fluggesellschaften angepasst. Alitalia beauftragte den Modemacher Mila Schoen 1968, eine elegante, modische und zugleich praktische Uniform zu entwerfen.

De jeunes hôtesses de l'air élégamment habillées sont devenues la vitrine des compagnies aériennes dans les années 60 et 70. Leurs uniformes, redessinés tous les deux ans, étaient adaptés aux tendances de la mode et à l'image de marque de la compagnie. Alitalia a par exemple confié en 1968 au styliste Mila Schoen le soin de réaliser un uniforme élégant, à la mode, et, qui soit en même temps pratique.

Jóvenes y elegantes azafatas se convierten en la insignia de la aviación internacional en los años 60 y 70. Los uniformes modificaban se modifican según las actuales tendencias de la moda y los cambios de imagen de las compañías aéreas. En 1968 Alitalia encargó al creador de moda Mila Schoen el diseño de un uniforme elegante, moderno y práctico a la vez.

Negli anni sessanta ed settanta, giovani hostess eleganti divennero il simbolo dell'aeronautica internazionale. Le divise venivano adattate ogni due anni ai trend del momento ed all'immagine della compagnia. Nel 1968 Alitalia commissionò per esempio alla creatrice di moda Mila Schoen una nuova linea di uniformi che fossero eleganti, pratiche e contemporaneamente, alla moda.

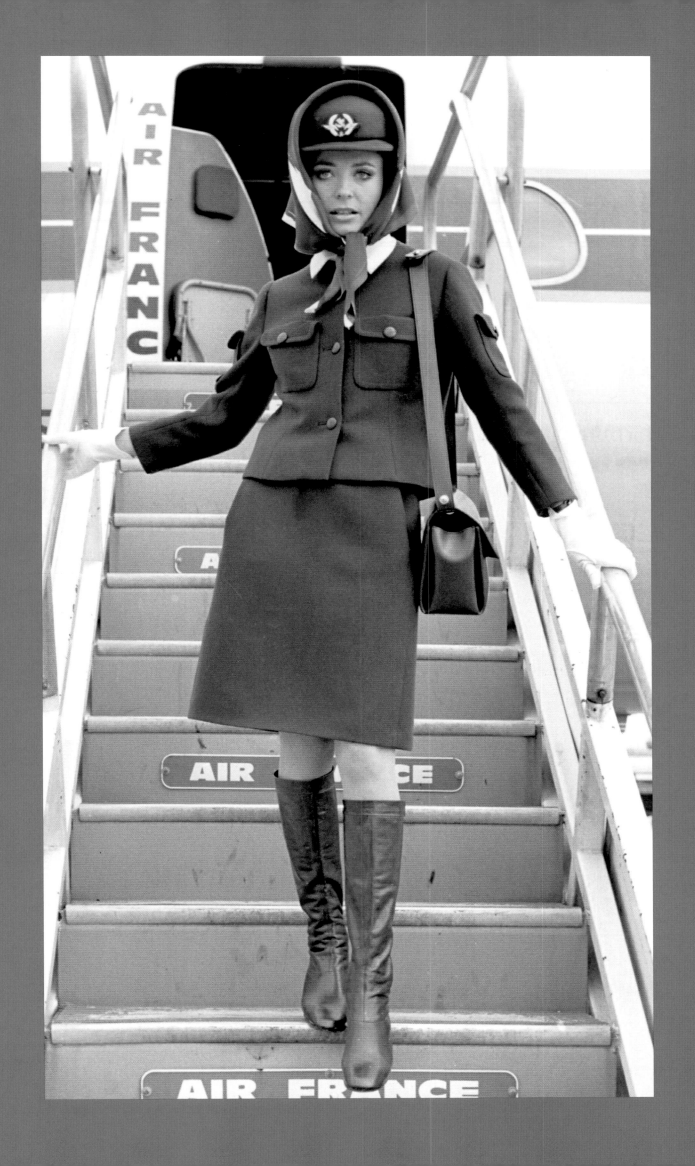

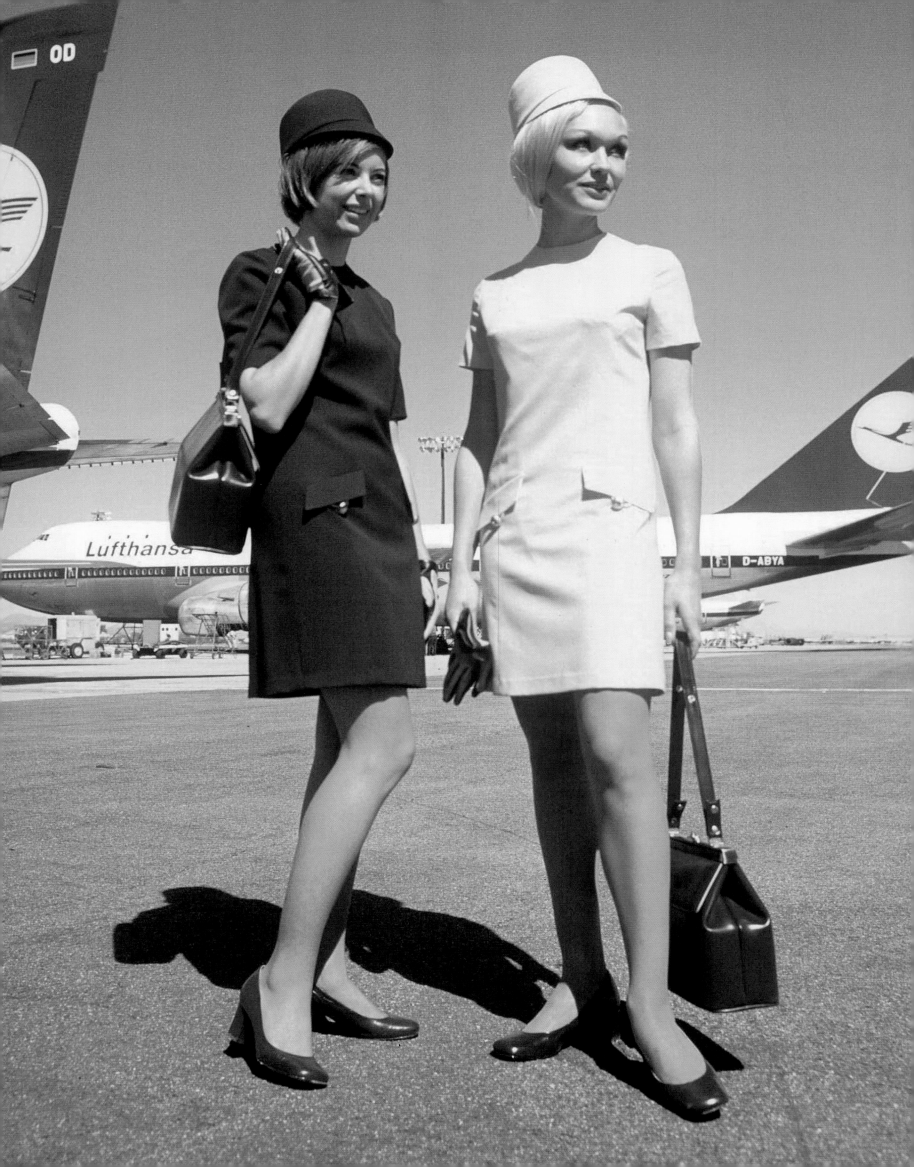

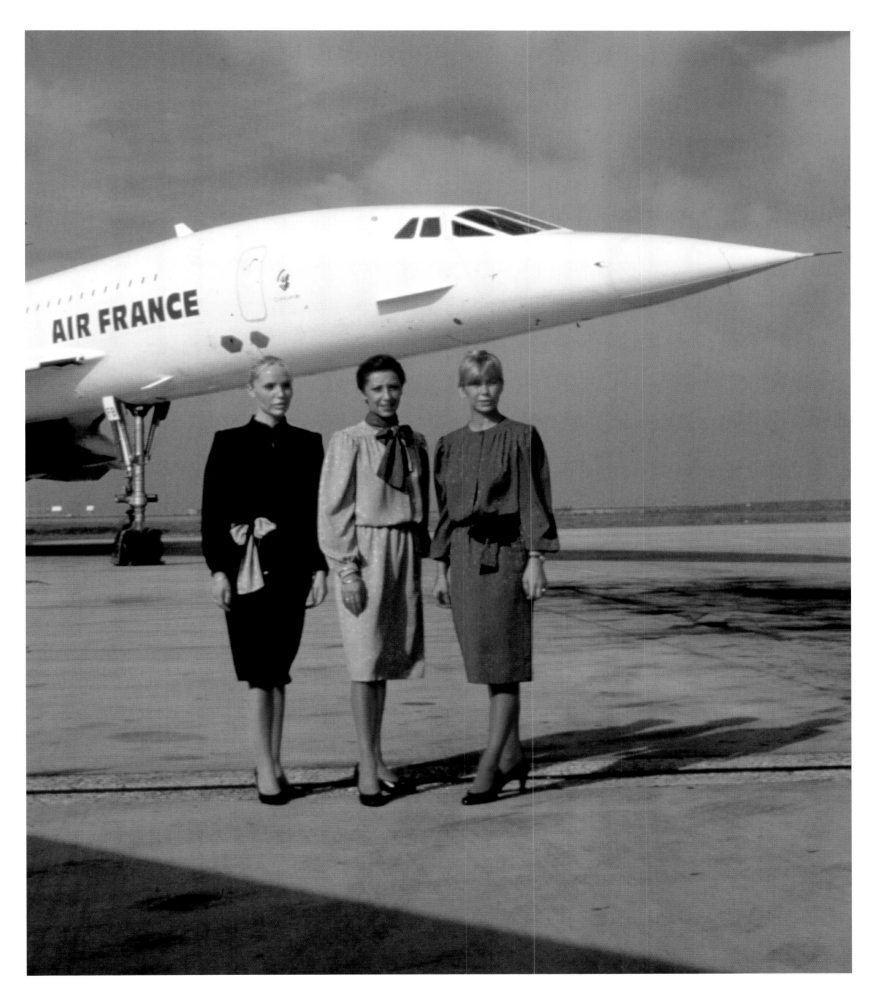

Air France, 1980s

left and pages 68/69: *Lufthansa, 1970s*

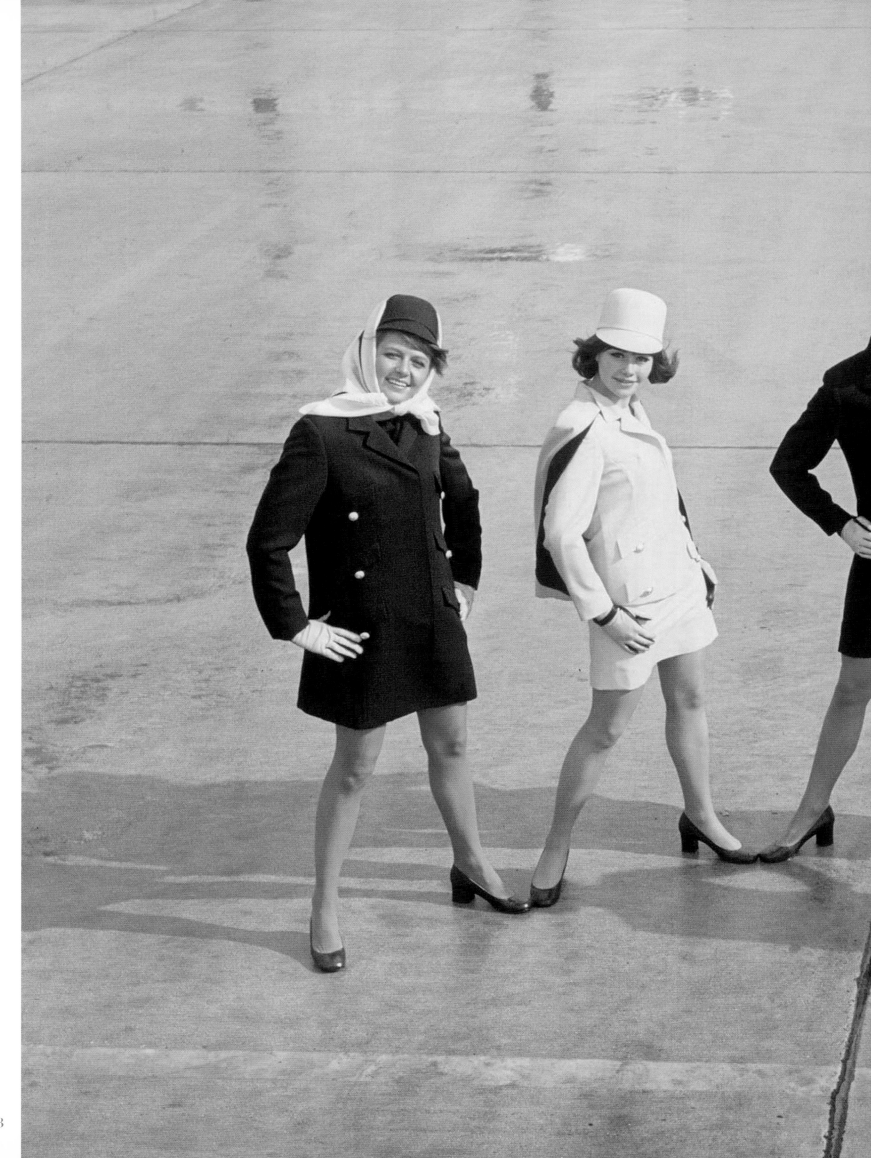

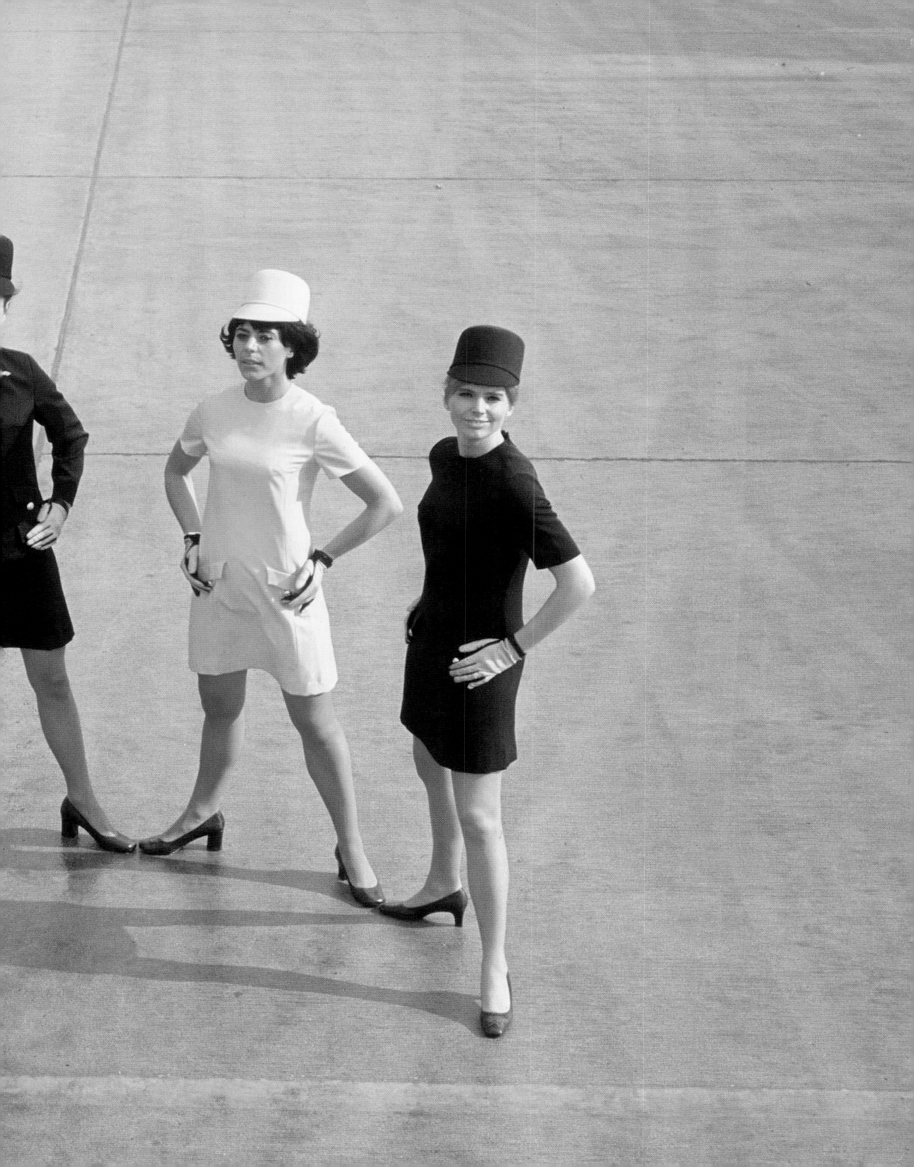

Flying in Style

Flying in Style

The first long-distance airliners, designed as "flying boats" before the proliferation of airfields, were outfitted much like overland trains with dining areas, lounges, and fold-down beds. Modern first-class travel has maintained and improved on this level of service, with wide leather seats that convert into beds, gourmet food and wine, and a plethora of personalized entertainment and services. While space and privacy remain prime considerations, airlines are ever imaginative in their quest to provide customers with a unique experience, from door-to-plane limousine service to an in-flight violin performance.

Die ersten Langstreckenflugzeuge, vor der Verbreitung von Flughäfen waren es Luftschiffe, ähnelten eher Eisenbahnwagons – mit Speiseabteil, Lounges und Klappbetten. Der moderne Erster-Klasse-Service hat den Komfort der Reisen im Laufe der Zeit verbessert: große Ledersitze, die in Betten umgewandelt werden können, Gourmetspeisen und Wein, persönliche Unterhaltung und ein Fülle weiterer Dienstleistungen. Geräumigkeit und Privatsphäre sind die Prämissen, und die Fluggesellschaften denken sich immer wieder neue Dinge aus – vom Limousinenservice bis zum Violinenkonzert an Bord –, die sie einzigartig für den Passagier machen.

Avant l'apparition des aéroports, les premiers avions à long rayon d'action construits comme des « bateaux volants » avaient en réalité tout du wagon de chemin de fer – avec des compartiments restaurant, des salons et des couchettes. Le service de première classe moderne a amélioré le confort des voyages au fil du temps : de grands fauteuils en cuir facilement transformables en lits, des repas de gourmet et du vin, un divertissement à la carte et une foule de prestations diverses. L'espace dont dispose le passager et la sphère privée qui lui est réservée ne constituent que les prémisses d'évolutions encore à venir : les compagnies aériennes ne cessent d'imaginer de nouvelles prestations – du service de limousine au concert à bord de l'avion – qui les rendront unique aux yeux du client.

Los primeros aviones de largo alcance, concebidos como "barcos voladores" antes de la construcción de aeropuertos, parecían vagones de tren con restaurante, salas de estar y camas plegables. El servicio moderno de primera clase ha aumentado el confort a lo largo del tiempo: grandes butacas de cuero convertibles en camas, alta cocina, vinos de primera categoría, sistemas de entretenimiento y una multitud de prestaciones más. Espacio y privacidad son la premisa: las compañías aéreas desarrollan nuevas ideas constantemente –desde servicio de limusina hasta un concierto de violín a bordo– todo para volverse inconfundibles para el pasajero.

Prima della diffusione degli aeroporti, gli aerei a lungo raggio erano simili alle "aeronavi" ed assomigliavano più ai vagoni del treno – con scompartimento ristorante, lounge e cuccette – che a un aereo. Nel corso degli anni, il moderno servizio di prima classe ha migliorato il livello del comfort, con grandi sedili di pelle che si possono trasformare in un letto, pietanze e vini da buongustaio, intrattenimento individuale ed una serie di altri servizi. A cominciare dalle due premesse fondamentali, spaziosità e sfera privata, le compagnie aeree s'inventano di tutto – dal servizio Limousine fino al concerto d'archi in cabina – per imprimere nei passeggeri il ricordo di un'esperienza inimitabile. La riduzione del rumore e del tempo di volo hanno oggi reso il volo un'esperienza rilassante, da gustare e sfruttare in modo proficuo.

British Airways Concorde

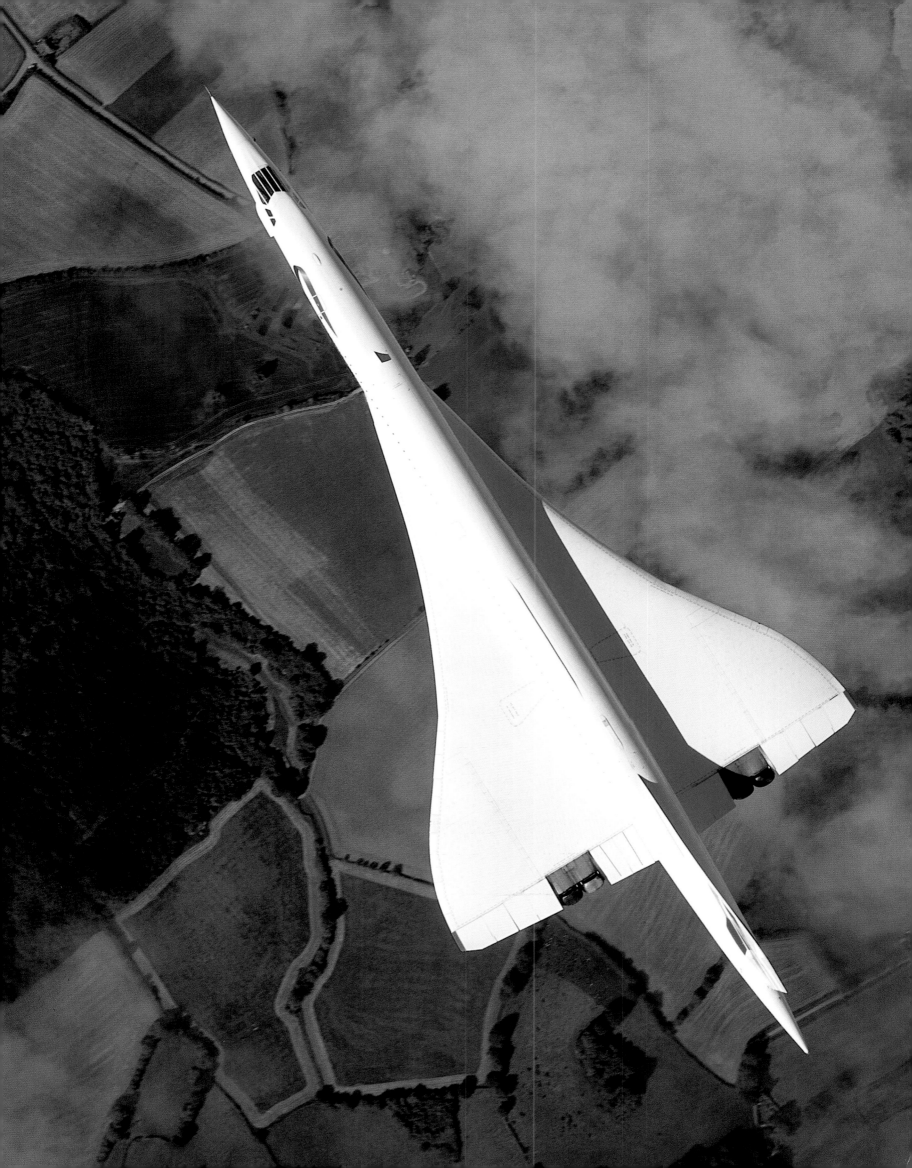

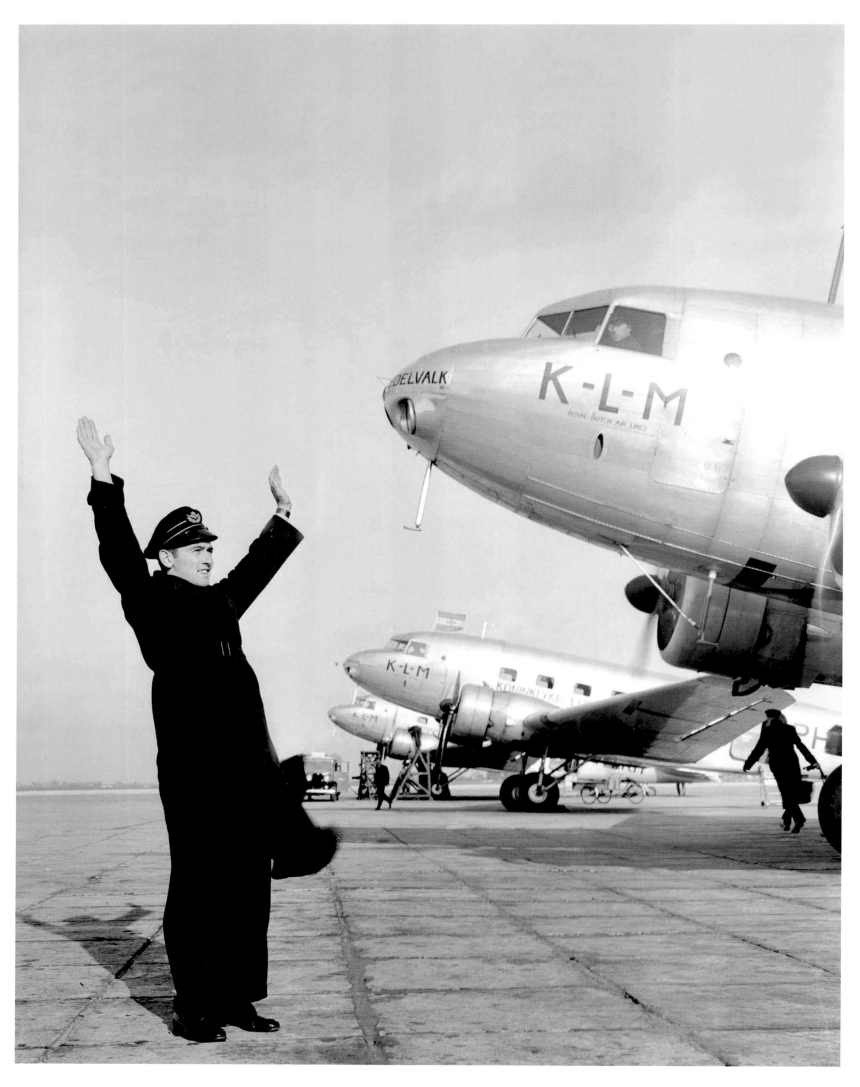

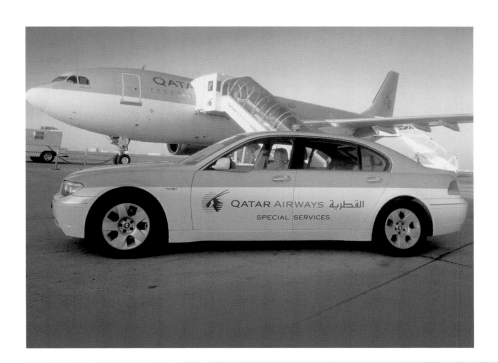

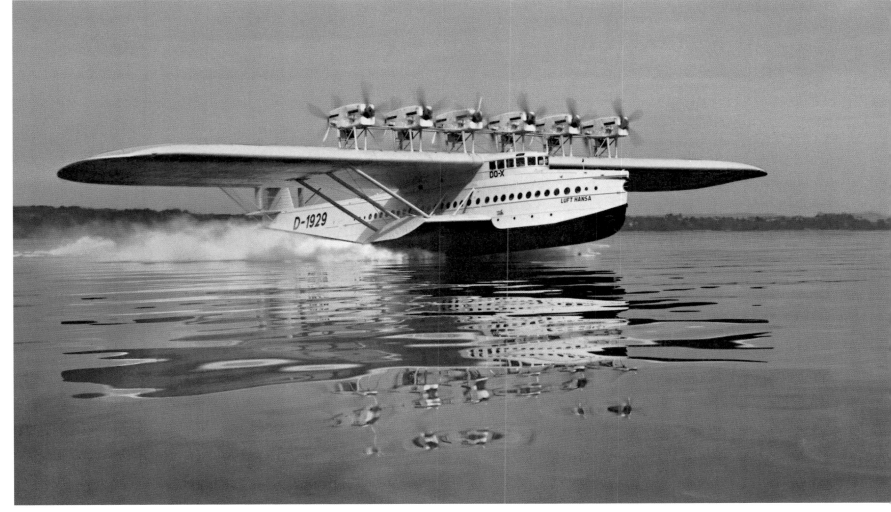

top: Qatar Airlines door-to-plane service

above: Lufthansa Dornier DO-X

left: a row of KLM DC-2s

Pages 76/77: Lockheed Super Constellation

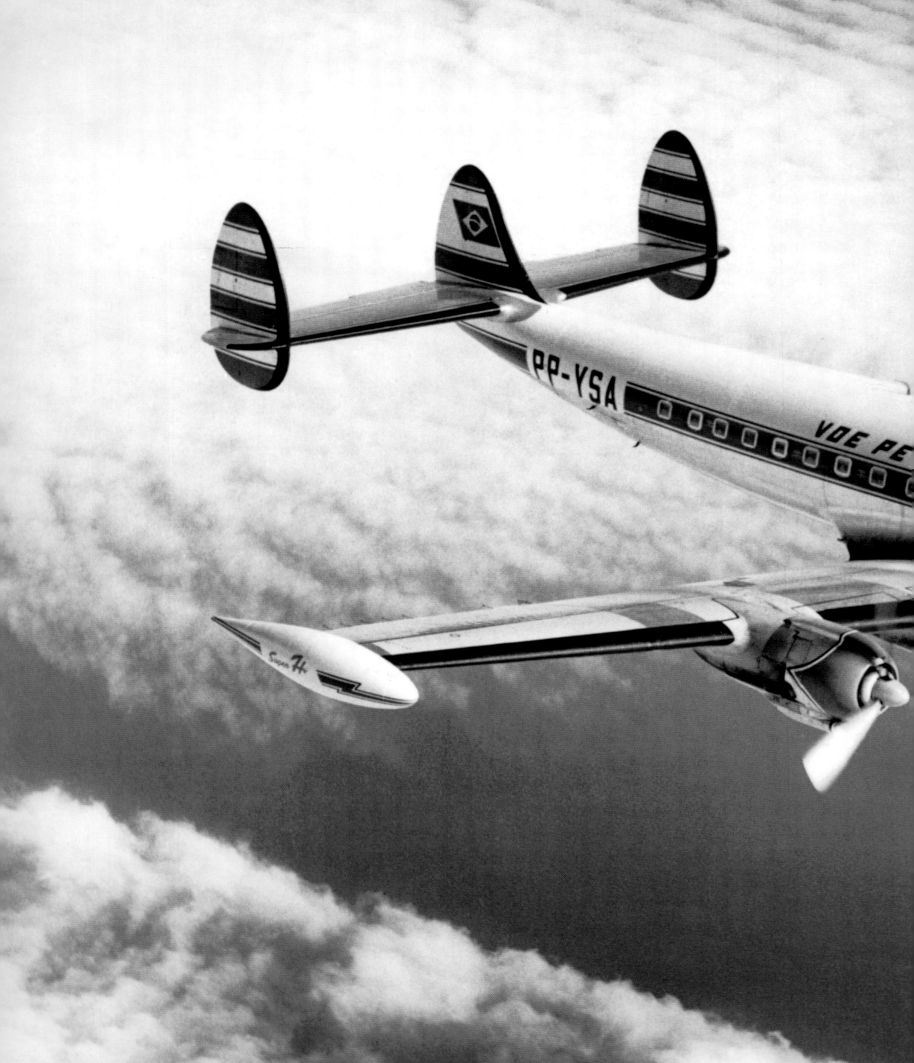

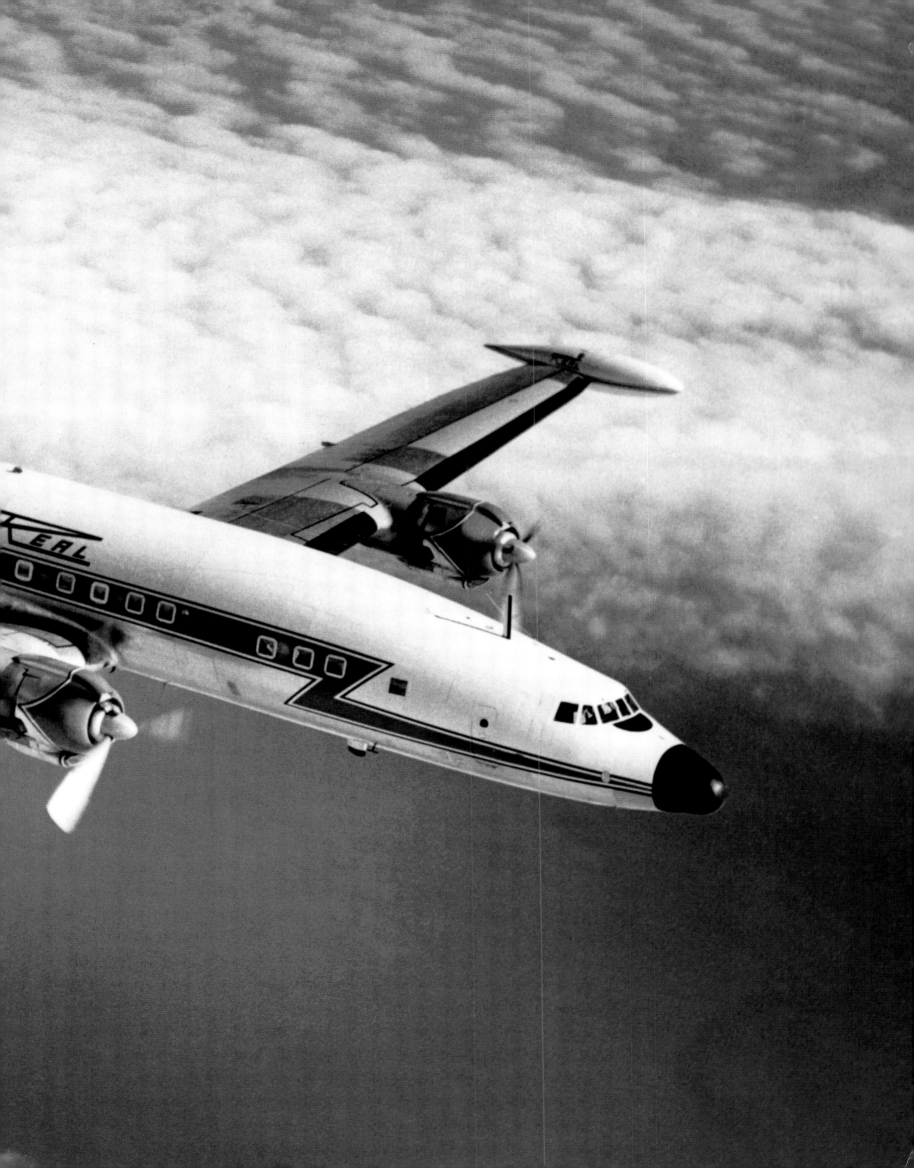

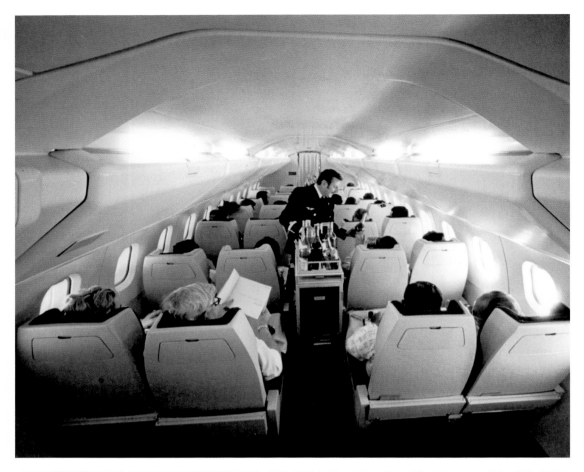

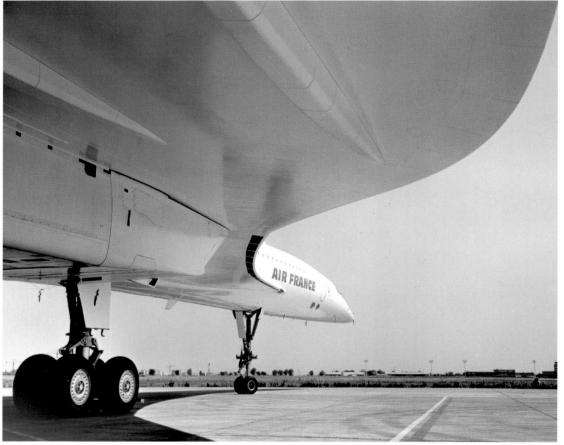

Concorde

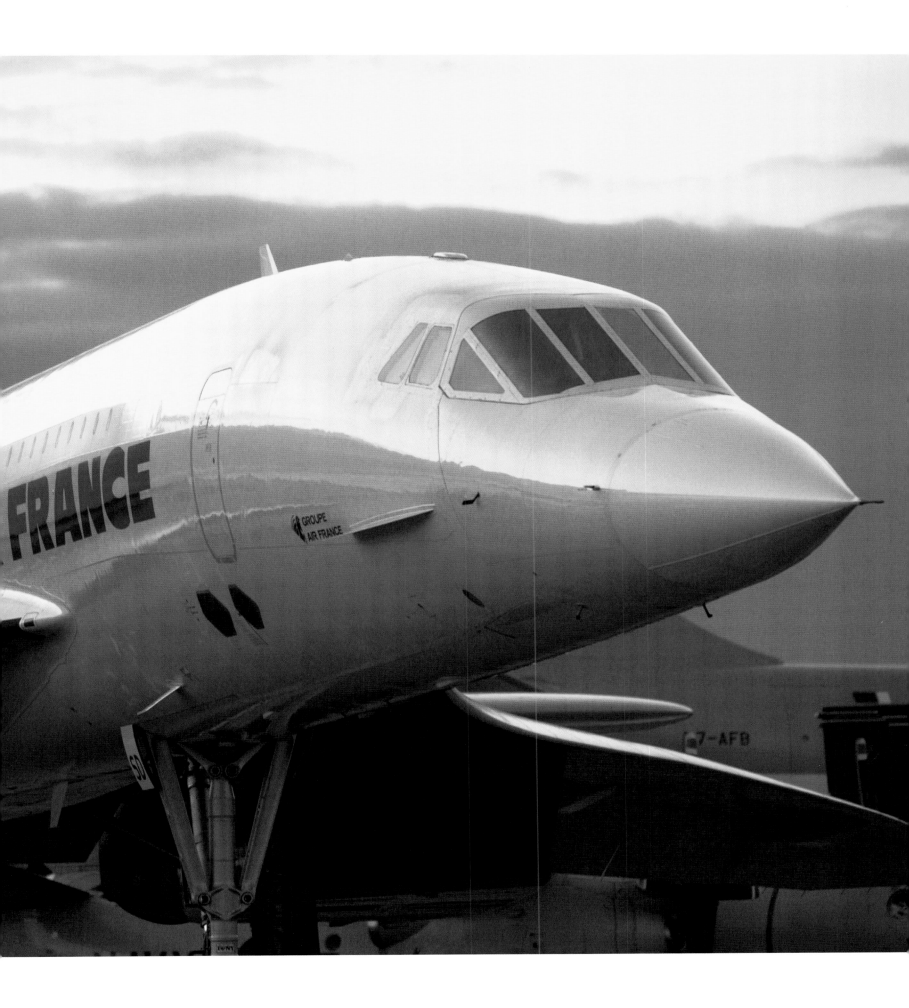

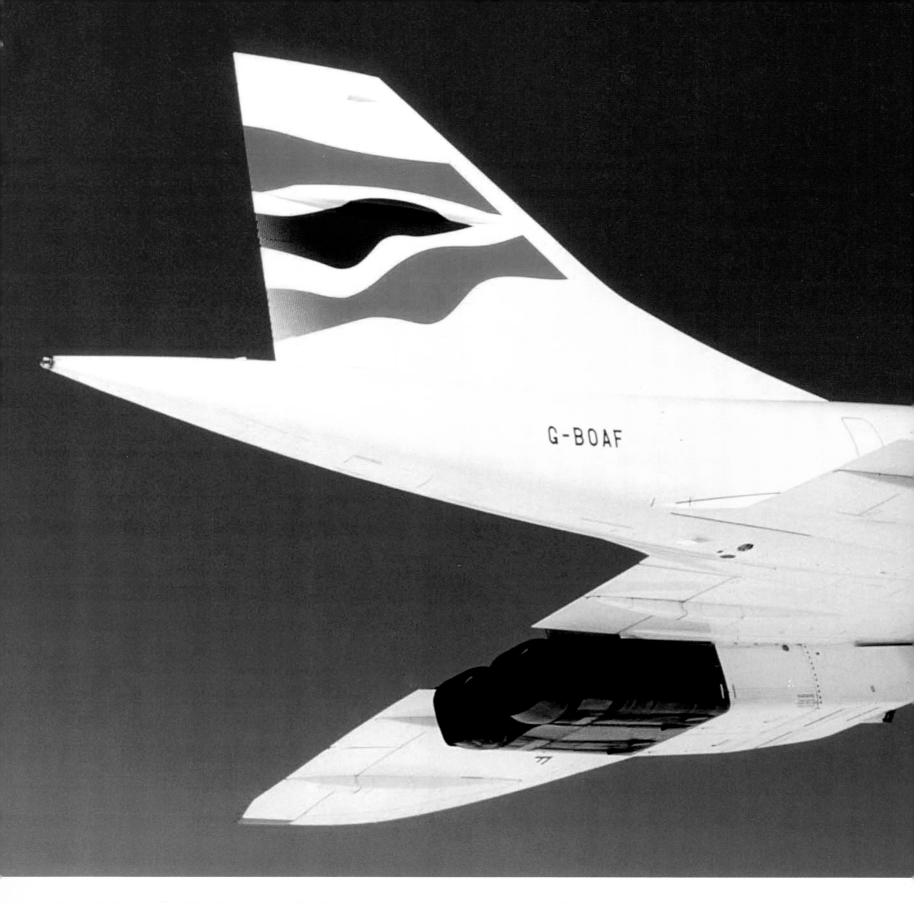

Concorde (pages 78–82) is the pinnacle of airline design and function, with many new factors taken into account due to the high speed of travel: fuel is transferred between tanks during flight to maintain even pressure, surfaces are capable of withstanding extreme heat, and the famous variable geometry nose drops for added visibility during take off and landing.

Die Concorde (Seiten 78–82) ist einzigartig in Design und Funktionalität. Sie hat das Reisen verändert und neue technische Entwicklungen in die zivile Luftfahrt eingeführt. Mit der Concorde verbindet man die Möglichkeit, während des Fluges Treibstoff tanken zu können, Oberflächen, die extremsten Witterungsbedingungen standhalten und natürlich die charakteristische nach unten zeigende Nase.

Le Concorde (pages 78–82) est unique au niveau de son design comme de sa fonctionnalité. Il a changé la notion de voyage et introduit de nouvelles technologies dans l'aviation civile. Cet nom est associé en particulier à la possibilité de ravitailler en vol un avion de ligne, au revêtement d'une voilure pouvant résister à des conditions météorologiques extrêmes et, naturellement, à ce nez caractéristique orientable vers le bas.

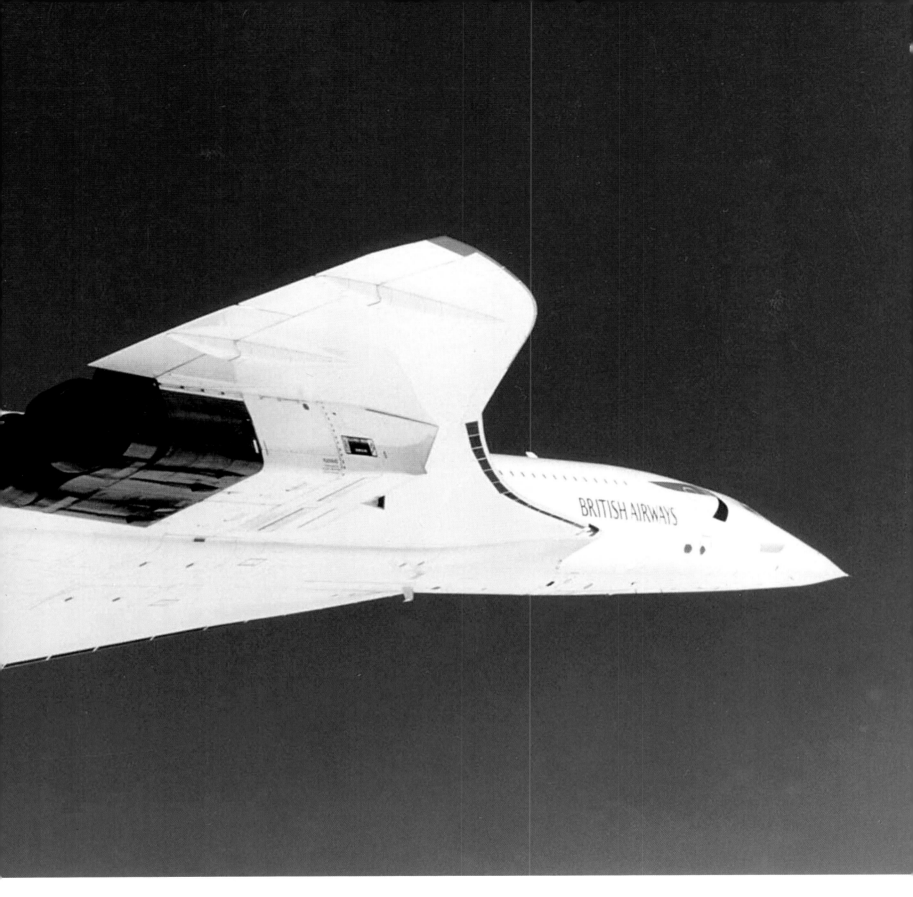

La Concorde (páginas 78–82) es única en su diseño y funcionalidad. Ha cambiado la forma de viajar introduciendo nuevos desarrollos técnicos en la aviación civil. Con la Concorde se asocia la posibilidad de repostar combustible durante el vuelo, superficies resistibles a las más extremas condiciones climáticas y naturalmente el morro inclinado hacia abajo.

Il Concorde (pagine 78–82) è inimitabile per design e funzionalità. Esso ha cambiato il significato del viaggio in aereo ed introdotto nuovi sviluppi tecnologici nell'aeronautica civile. Con il nome concorde sono collegate – oltre, naturalmente, al caratteristico naso all'ingiù – nuove soluzioni tecniche, quali la possibilità di effettuare rifornimenti in volo ed una struttura esterna in grado di far fronte a condizioni atmosferiche estremamente avverse.

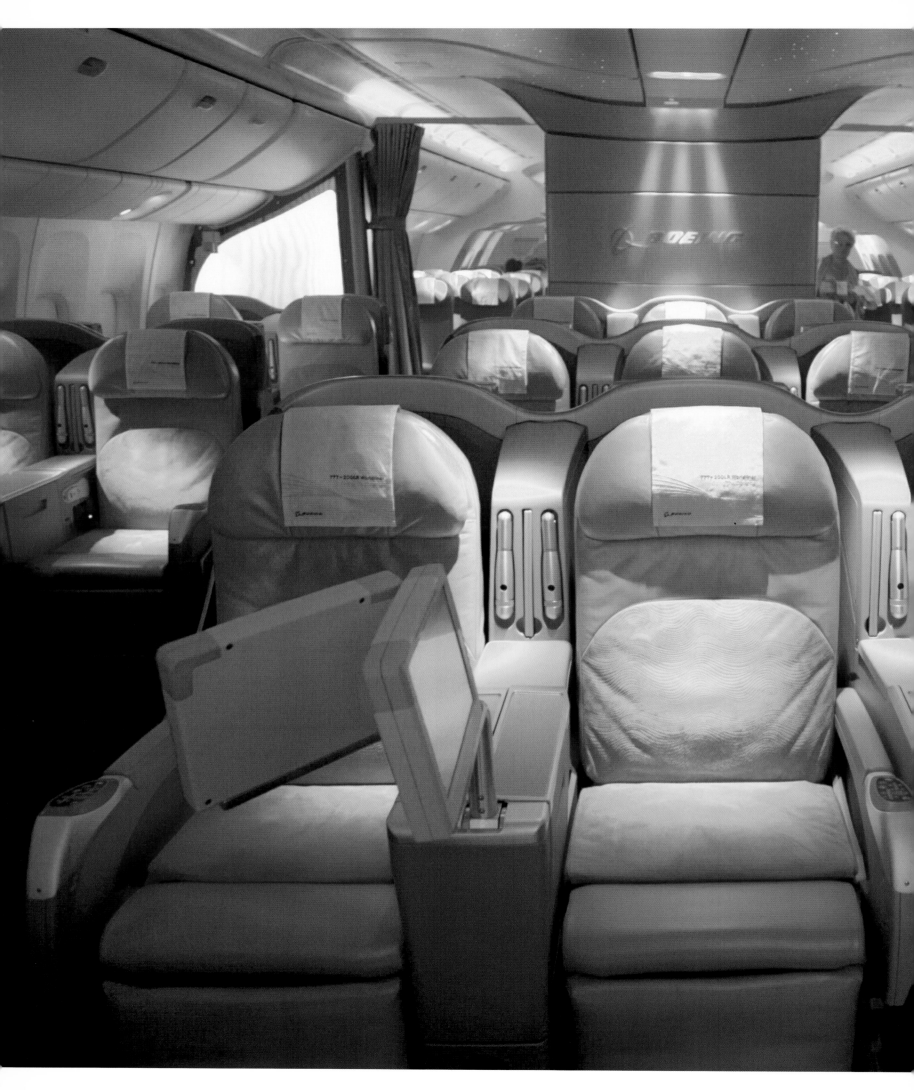

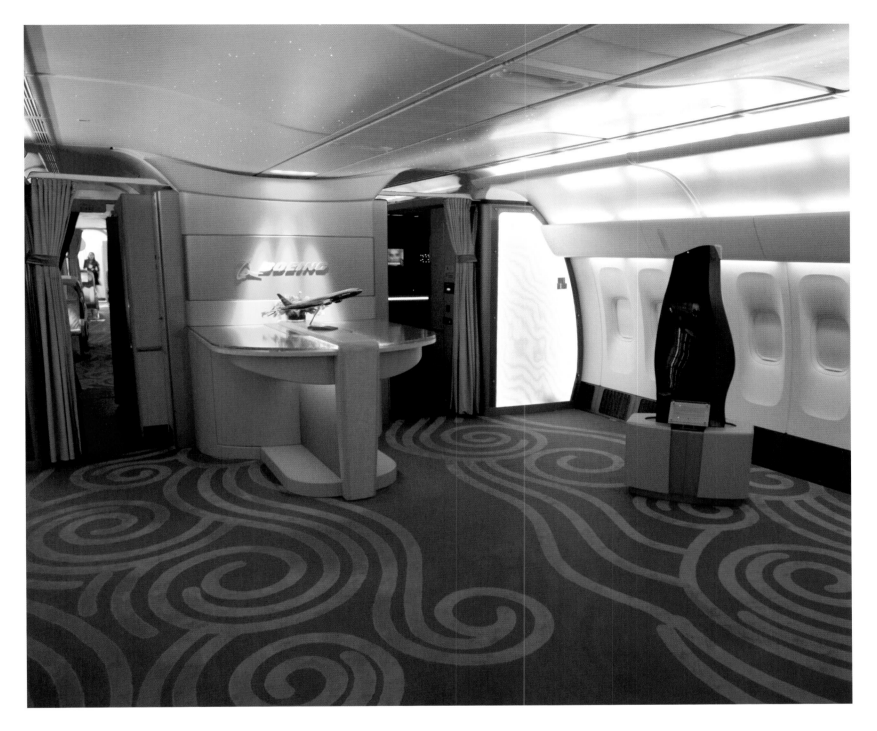

left and above: Boeing 777

Pages 84/85: *Thai Airlines Business Class*

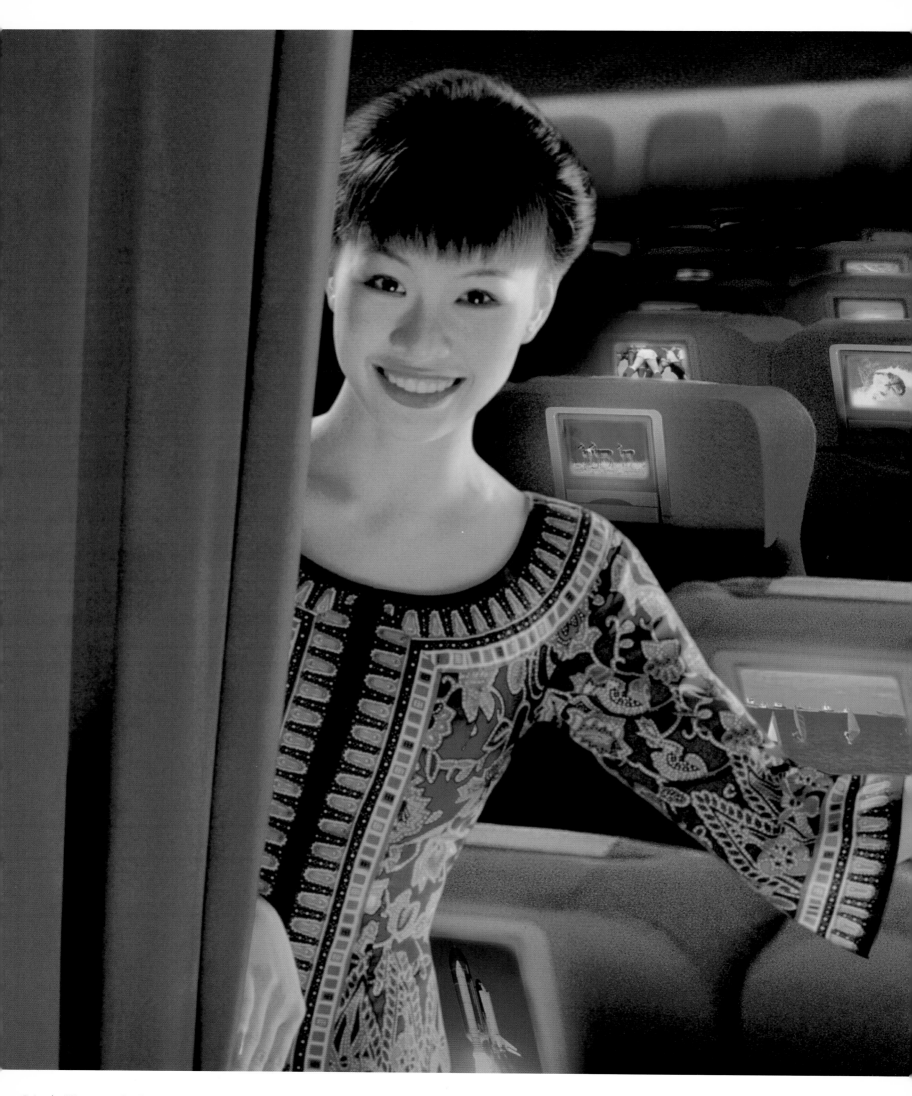

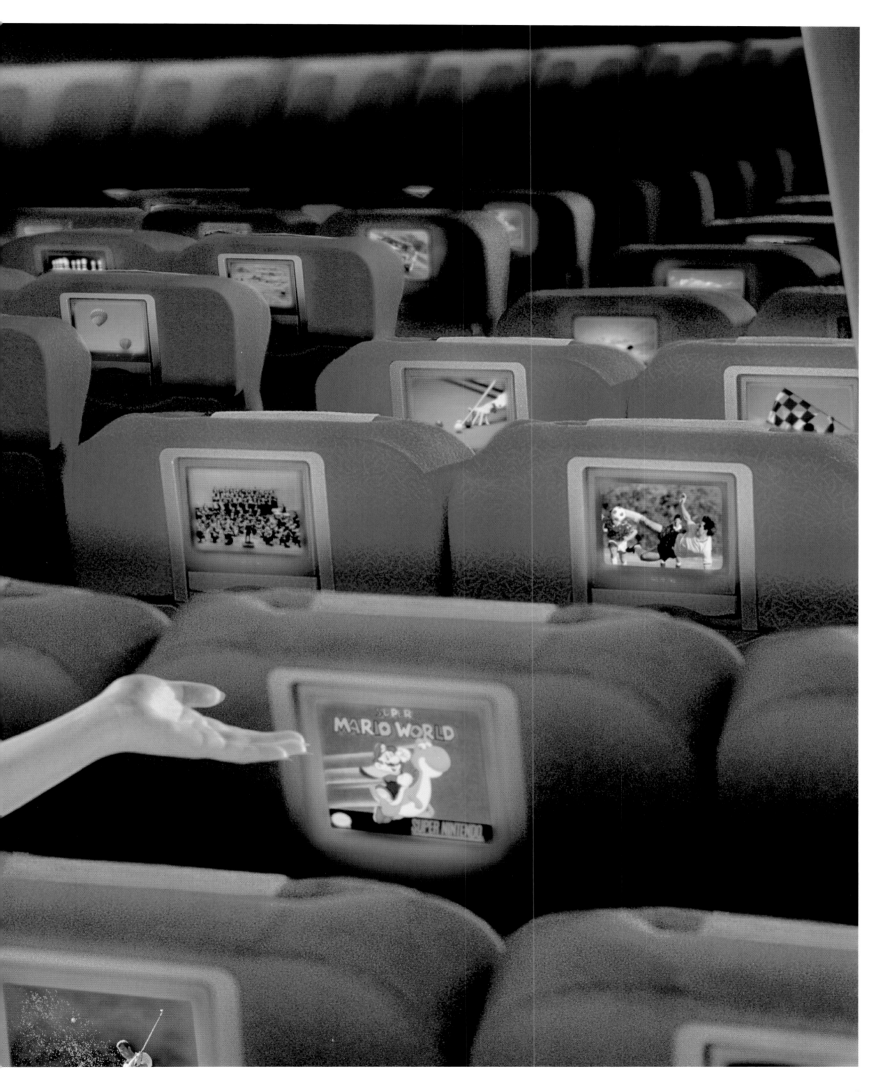

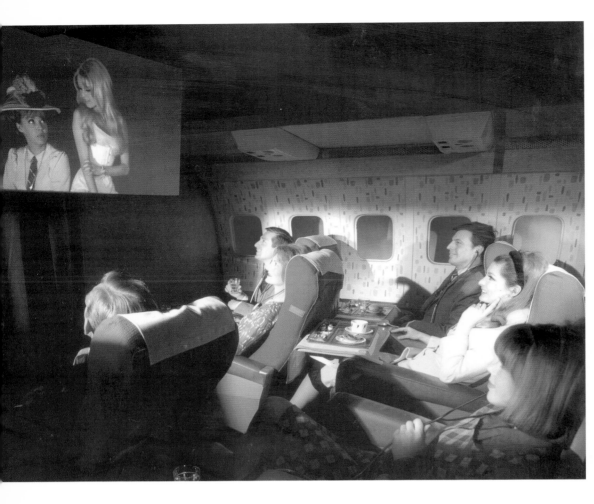

From in-flight movies to the flat bed

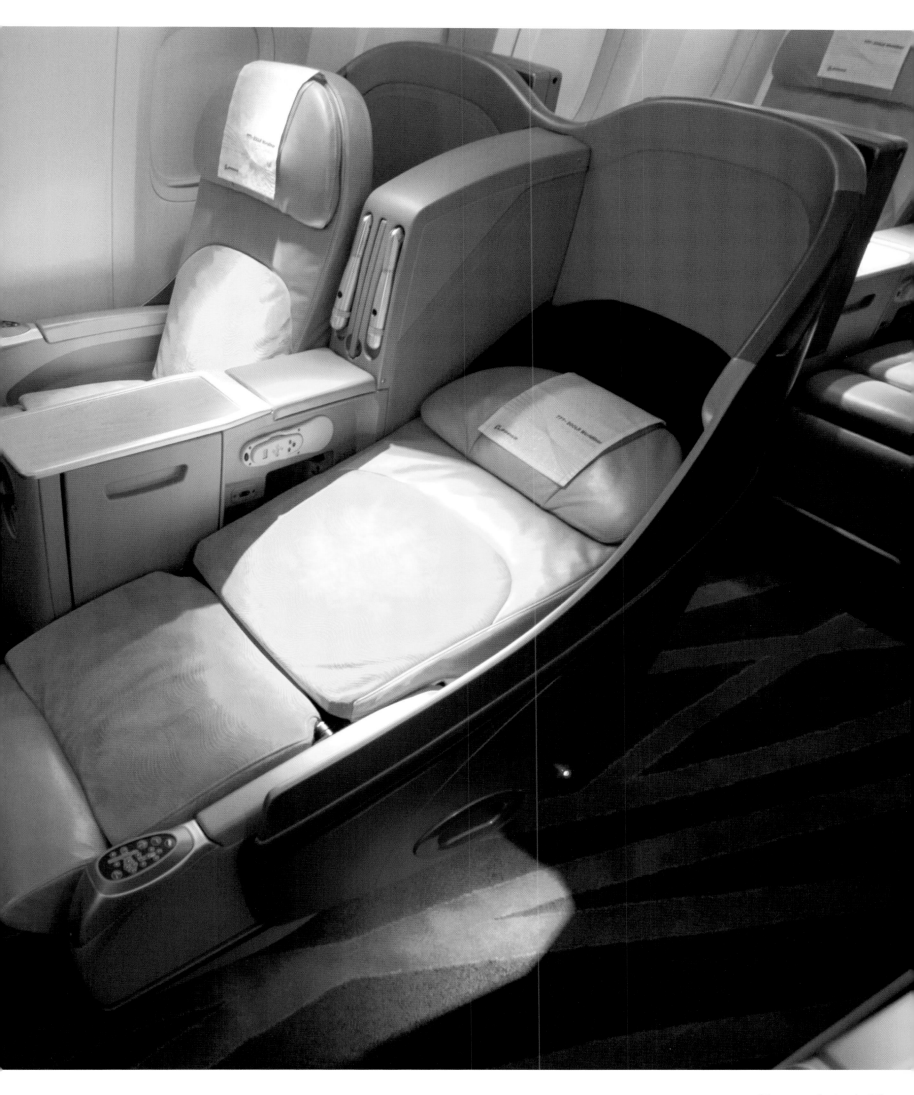

The interaction of technological advances in aviation and the demand for fast, inexpensive worldwide travel has led to the development of ever-larger airliners. With the introduction of the 747 Jumbo Jet in 1970, flying became not only affordable, but the safest and most convenient form of long-distance travel.
For First-Class travellers the Boeing 747 combines the luxury of early aviation with the comfort and speed of modern airplanes.

Die technologischen Fortschritte in der Luftfahrt und die steigende Nachfrage nach günstigen Reisen in die ganze Welt führten zur Entwicklung immer größerer Flugzeuge. Mit der Einführung der Boeing 747 im Jahr 1970 wurde das Fliegen nicht nur erschwinglich, sondern auch die sicherste und bequemste Art, weite Strecken zurückzulegen.
Für Reisende der Ersten Klasse verbindet die Boeing 747 Luxus aus der Zeit der frühen Luftfahrt mit dem Komfort und der Geschwindigkeit moderner Flugzeuge.

Les progrès technologiques en aéronautique et la demande croissante de voyages à bas prix ont eu pour conséquence la mise au point d'appareils de plus en plus gros. La mise en service du Boeing 747 en 1970 a non seulement démocratisé le transport aérien, mais aussi permis de franchir de grandes distances dans des conditions de confort et de sécurité inconnues jusque-là.
Pour les passagers de première classe, le Boeing 747 allie le luxe de l'époque initiale du transport aérien au confort et à la vitesse des avions modernes.

El progreso técnico en la aviación y la creciente demanda de vuelos económicos al mundo entero trajeron consigo el desarrollo de aviones cada vez más grandes. Con la introducción del Boeing 747 en el año 1970, volar no sólo se volvió algo asequible sino también la forma más segura y cómoda de atravesar largas distancias.
Para viajeros de primera clase, el Boeing 747 combina el lujo que caracteriza los comienzos de la aviación con el confort y la rapidez de los aviones modernos.

Dato lo sviluppo tecnologico dell'aeronautica e la domanda crescente di voli economici per tutte le destinazioni, le dimensioni degli aeroplani sono cresciute continuamente.
Con l'introduzione, nel 1970, del Boeing 747 l'aereo divenne un mezzo di trasporto accessibile a tutti, il mezzo più comodo e sicuro per percorrere grandi distanze.
La prima classe del Boeing 747 unisce il comfort e la velocità degli aerei moderni al lusso tipico degli inizi dell'aviazione.

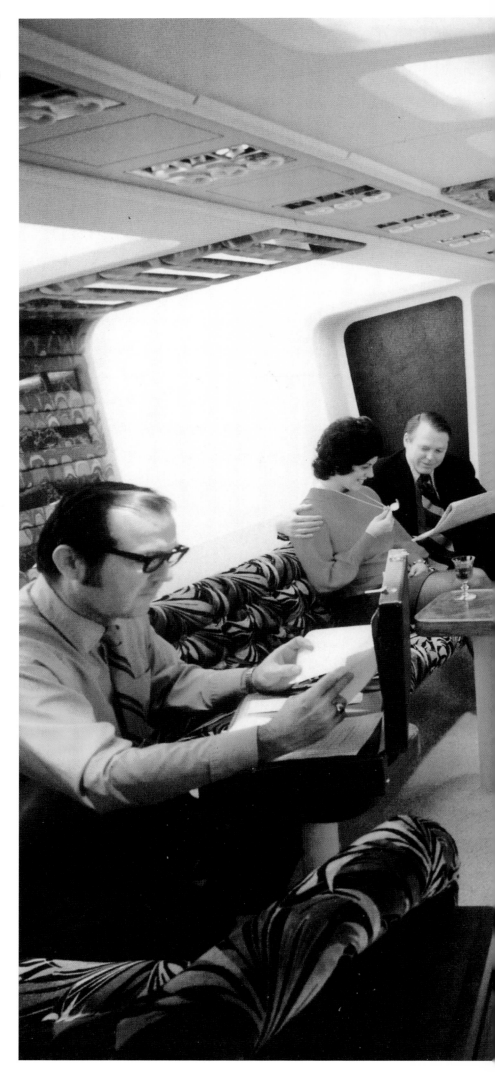

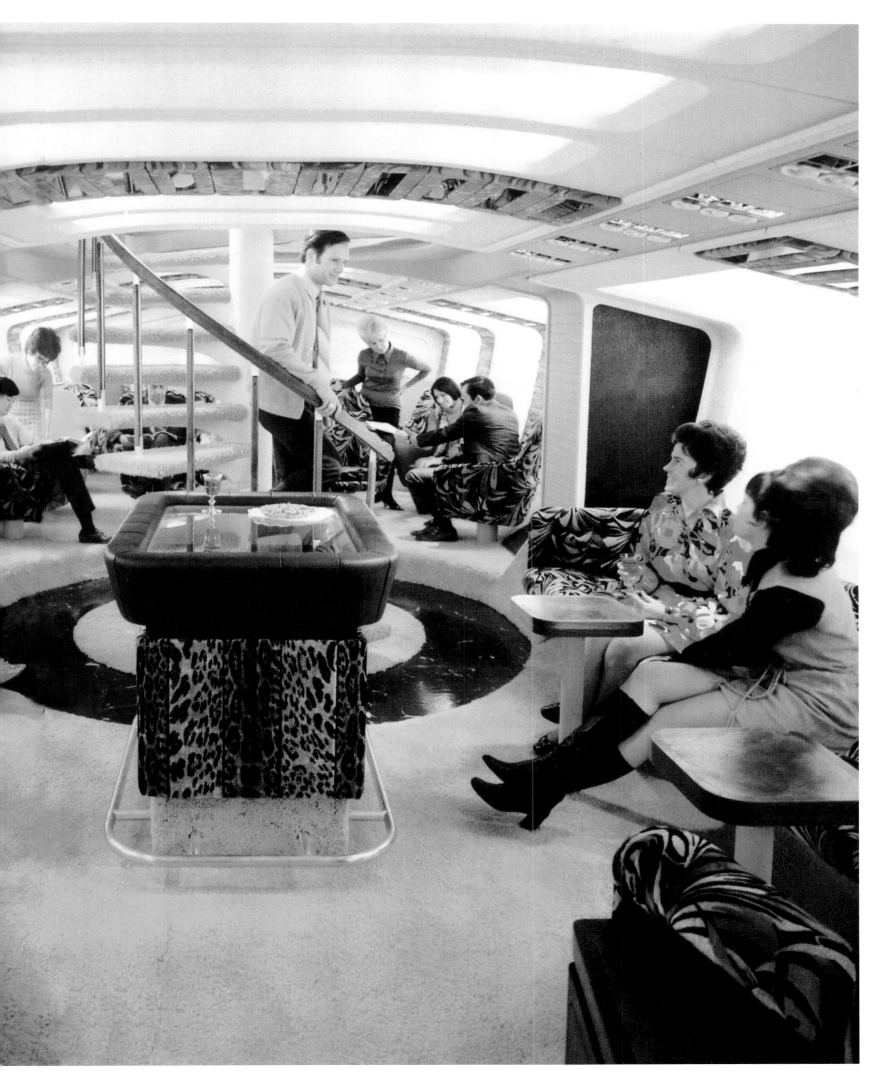

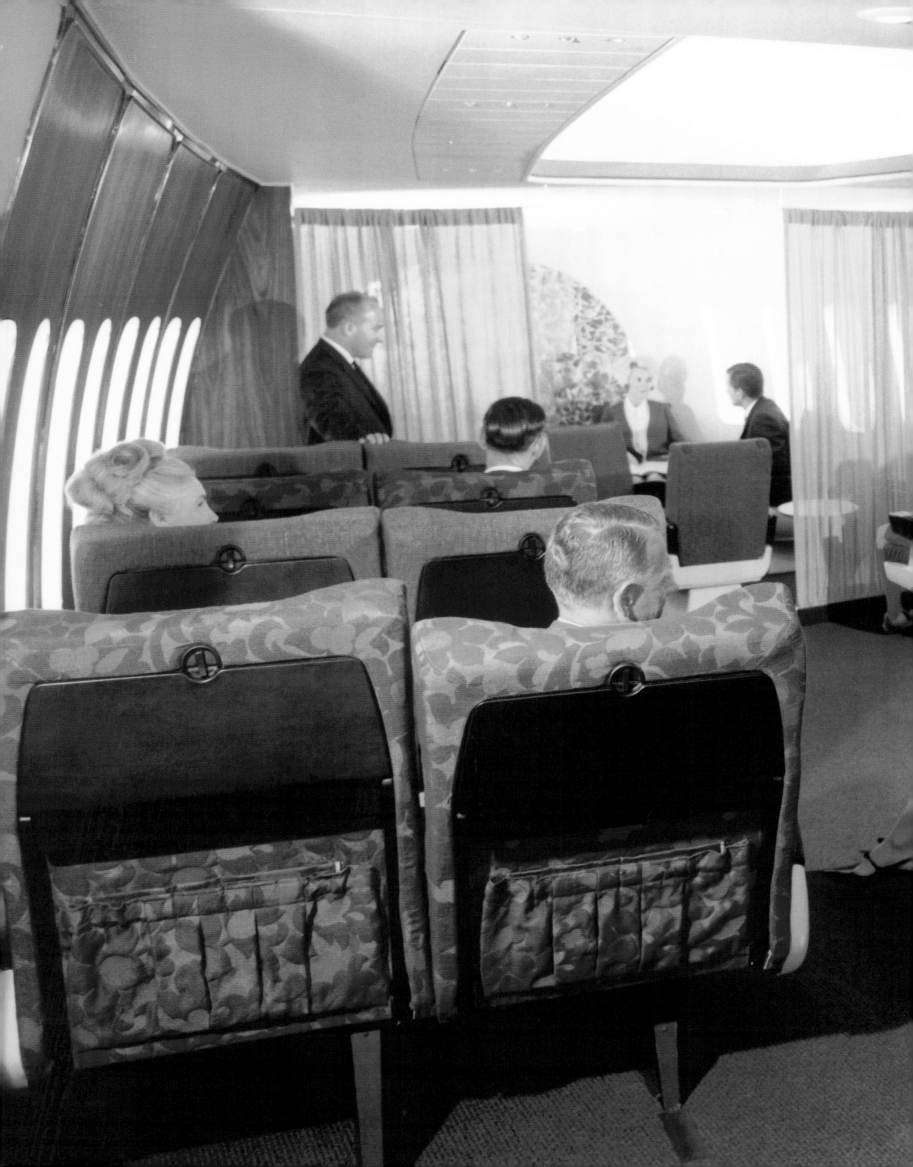

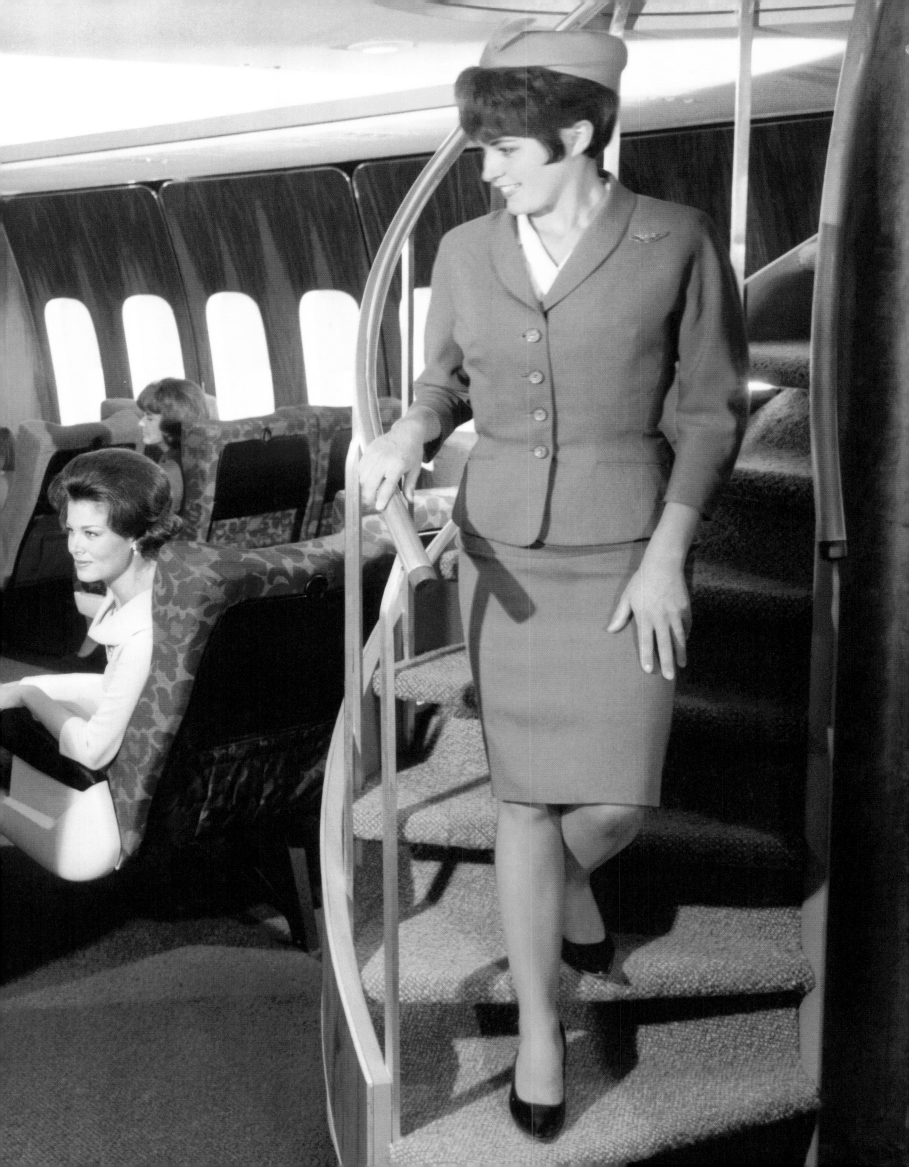

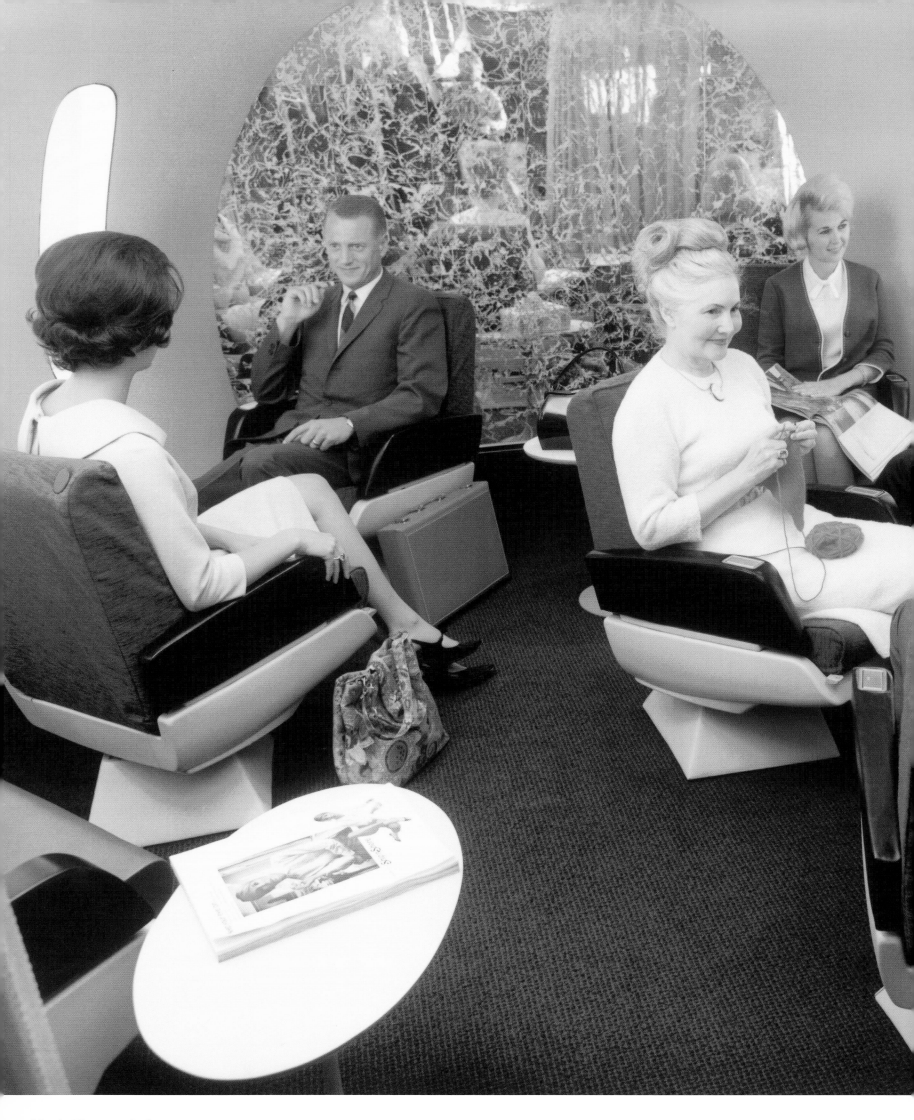

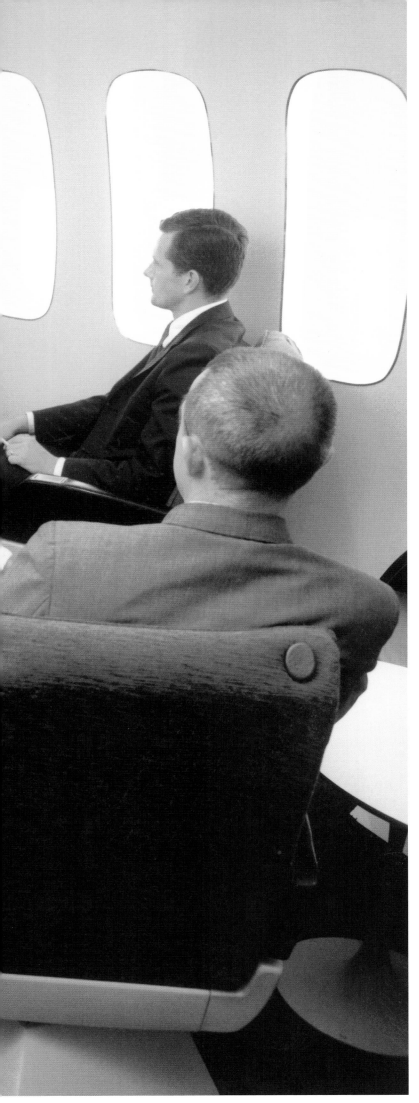

Pages 90-93: First-class lounge of a Boeing 747

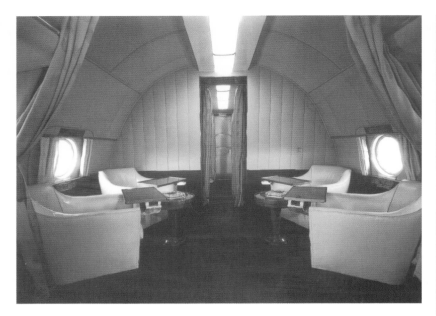

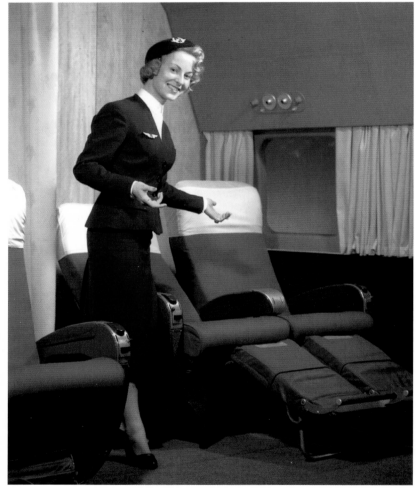

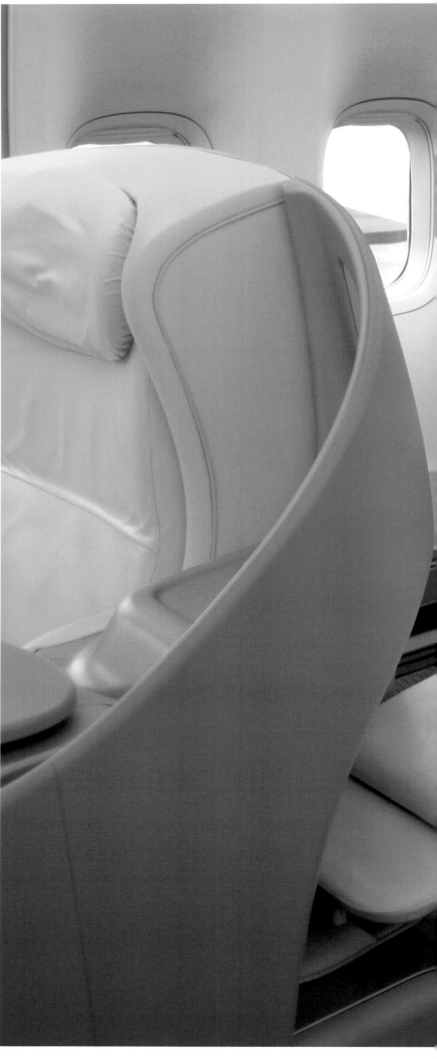

From smoking lounges to the modern environment on a Japan
Airlines 747.

Von Raucher Lounges bis hin zur modernen Innenausstattung einer
Boeing 747 von Japan Airlines.

Des salons fumeurs aux agencements intérieurs modernes d'un
Boeing 747 de la Japan Airlines.

Desde las salas de estar hasta el entorno moderno de una Boeing
747 de Japan Airlines.

Dalle prime lounge per fumatori all'ambiente moderno di un 747
della Japan Airlines.

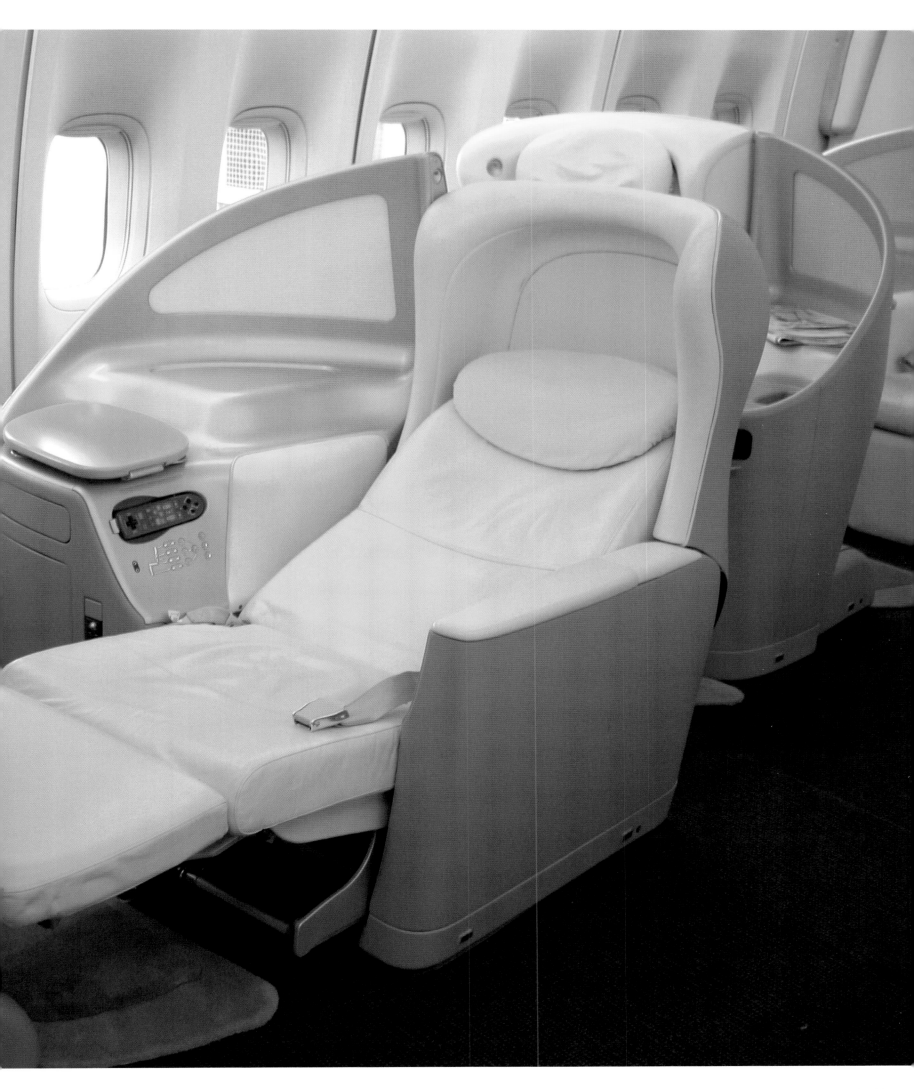

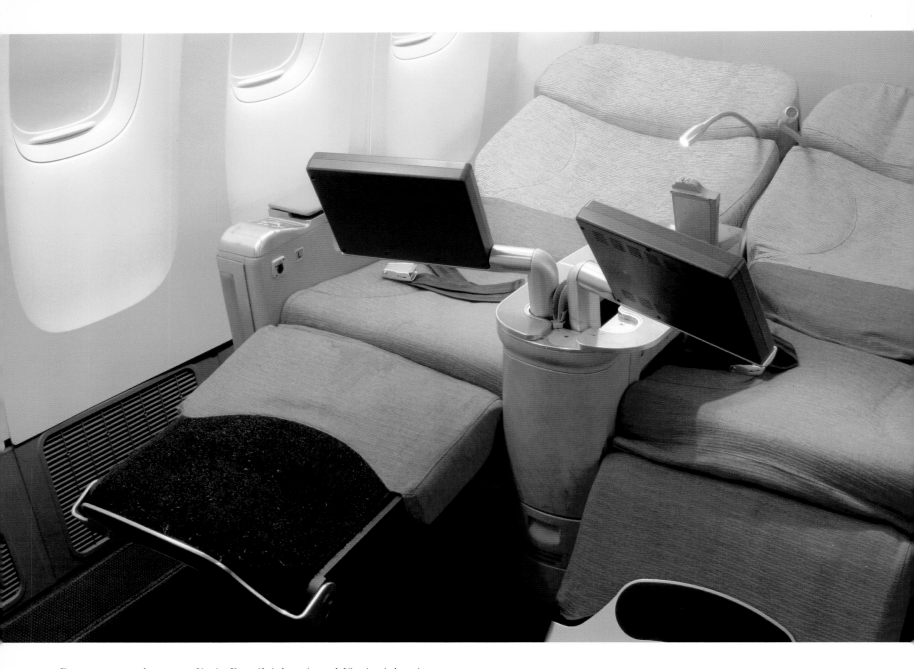

Room to stretch out on Varig Brazil (above) and Virgin Atlantic

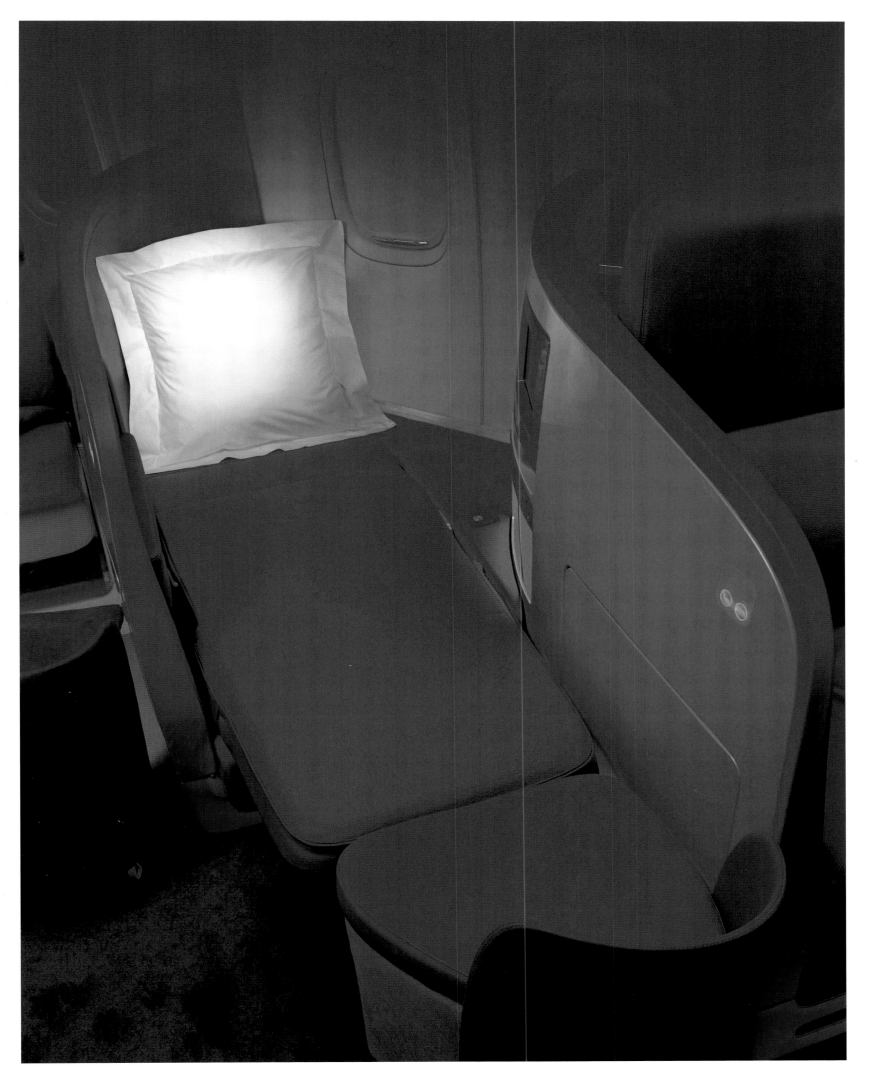

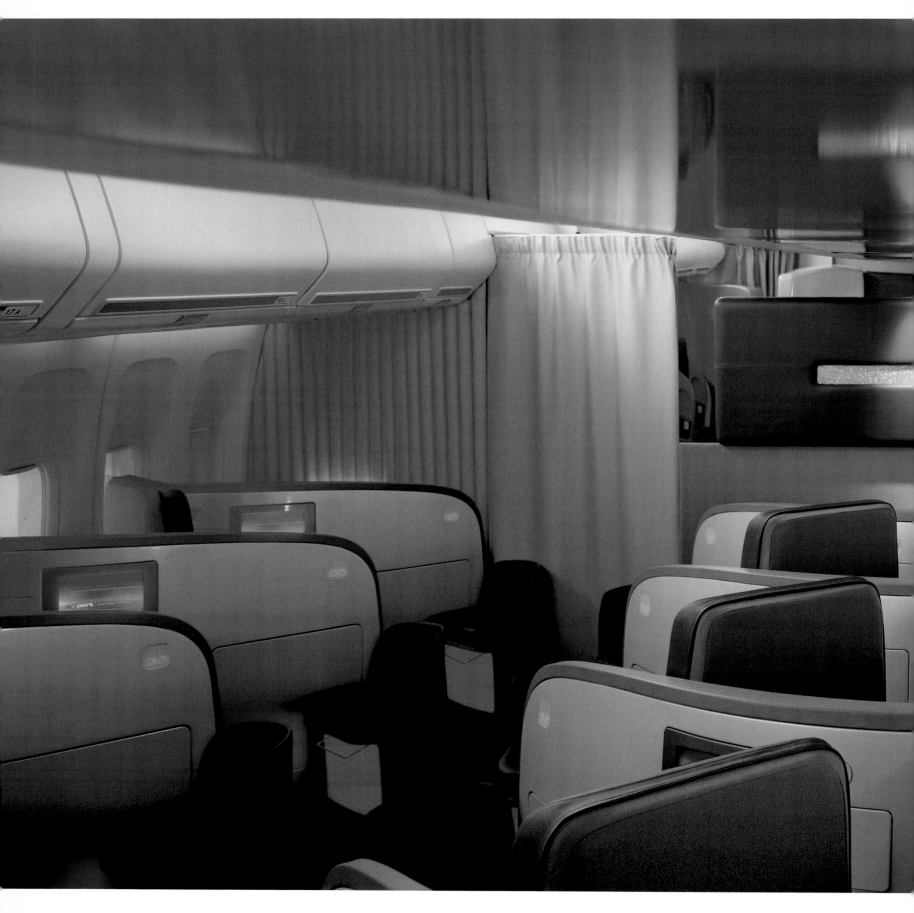

"Upper Class" cabin on Virgin Atlantic

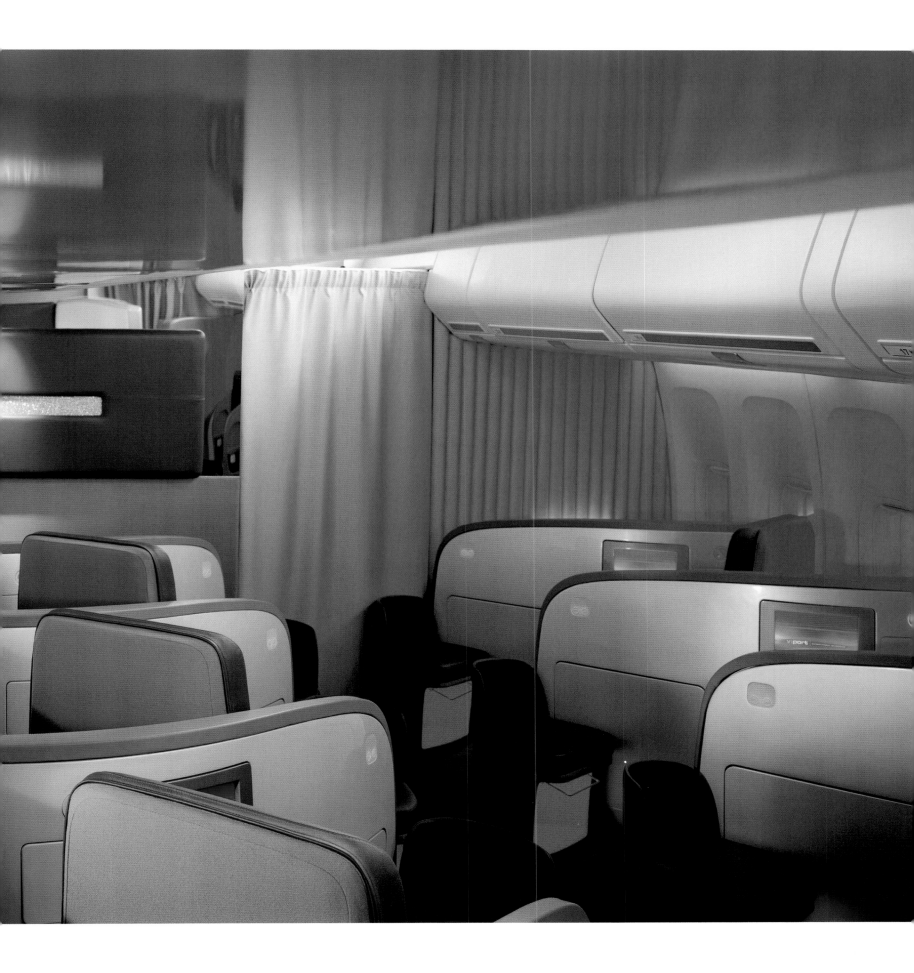

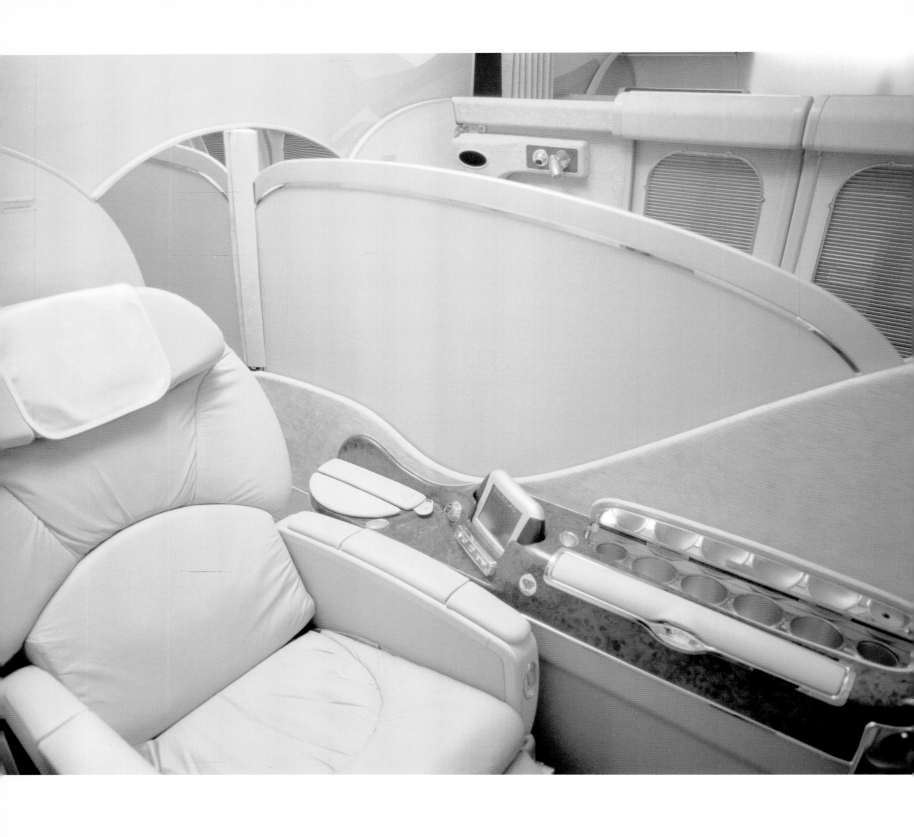

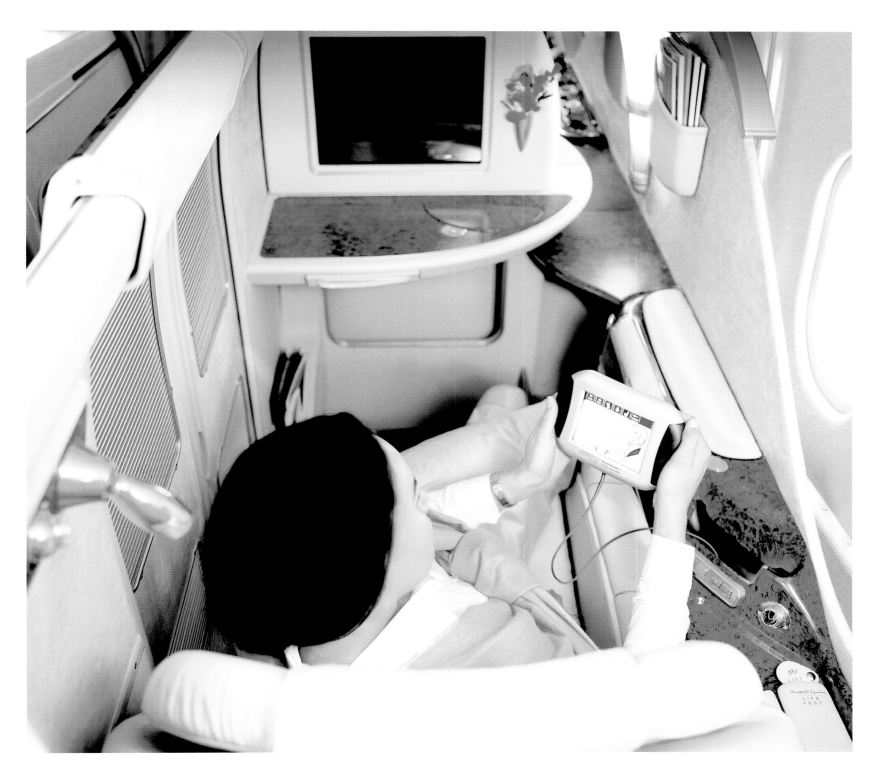

The luxury of large windows and generous leg room is further enhanced by greater privacy and personal amenities in the first-class cabin of this Emirates Airbus A340-500.

Der Luxus großer Fenster und von Beinfreiheit findet eine Steigerung durch mehr Privatsphäre und andere Annehmlichkeiten in diesem Airbus A340-500 von Emirates.

La cabine de cet Airbus A340-500 des Emirats Arabes Unis dispose de fenêtres de grande dimension et de plus de place pour pouvoir allonger ses jambes, tout en associant un généreux espace privatif à des aménagements personnalisés.

El lujo de grandes ventanas y amplio espacio para estirar las piernas destaca aún más por una mayor privacidad y otras prestaciones de confort en este Airbus A340-500 de Emirates.

Nella cabina di prima classe di questo Emirates Airbus A340-500, la cura della sfera privata e di altre comodità si sposano al lusso della libertà dei movimenti e degli ampi oblò.

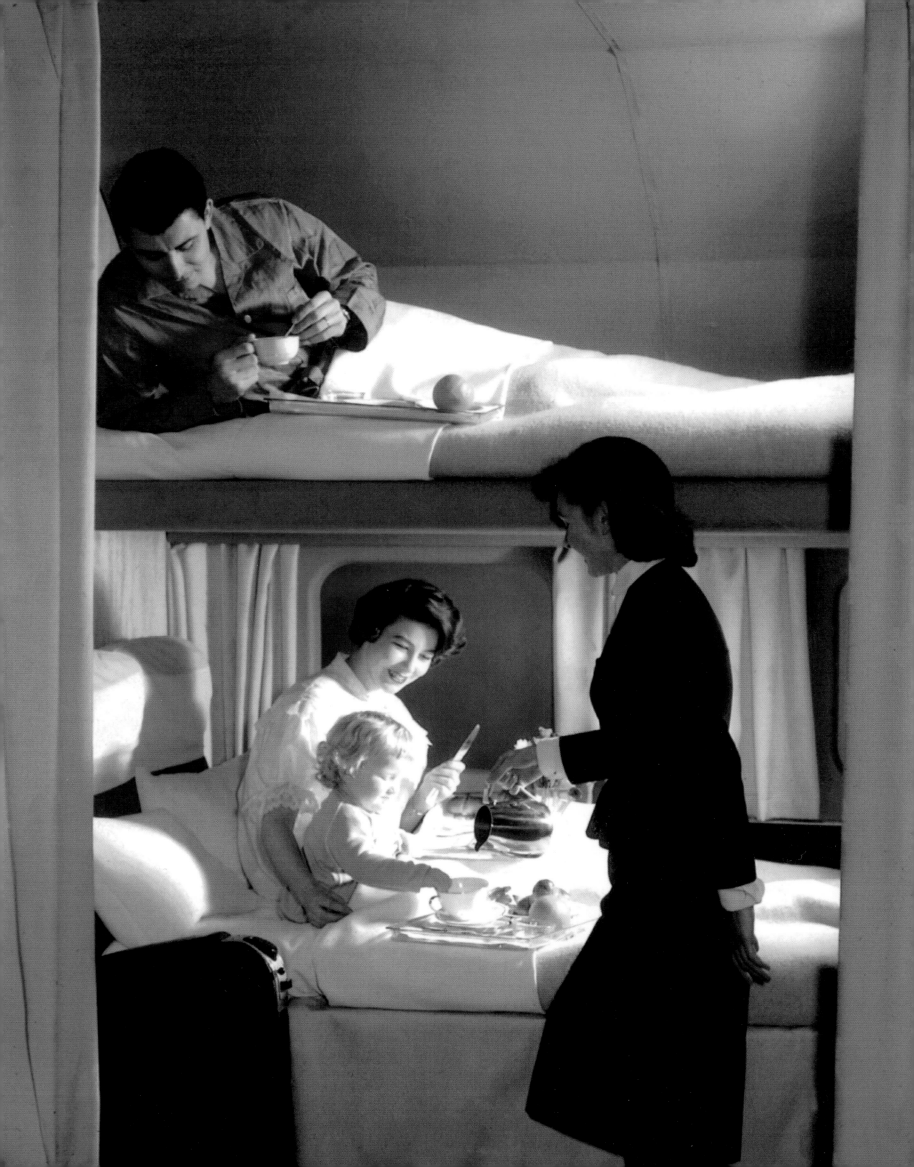

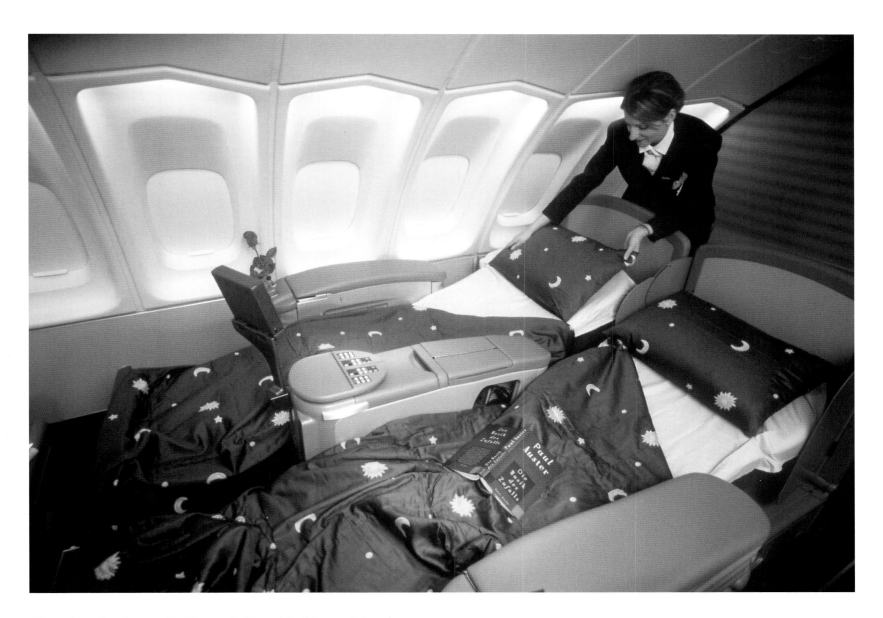

First-class sleeping on Air France (left) and Lufthansa (above)

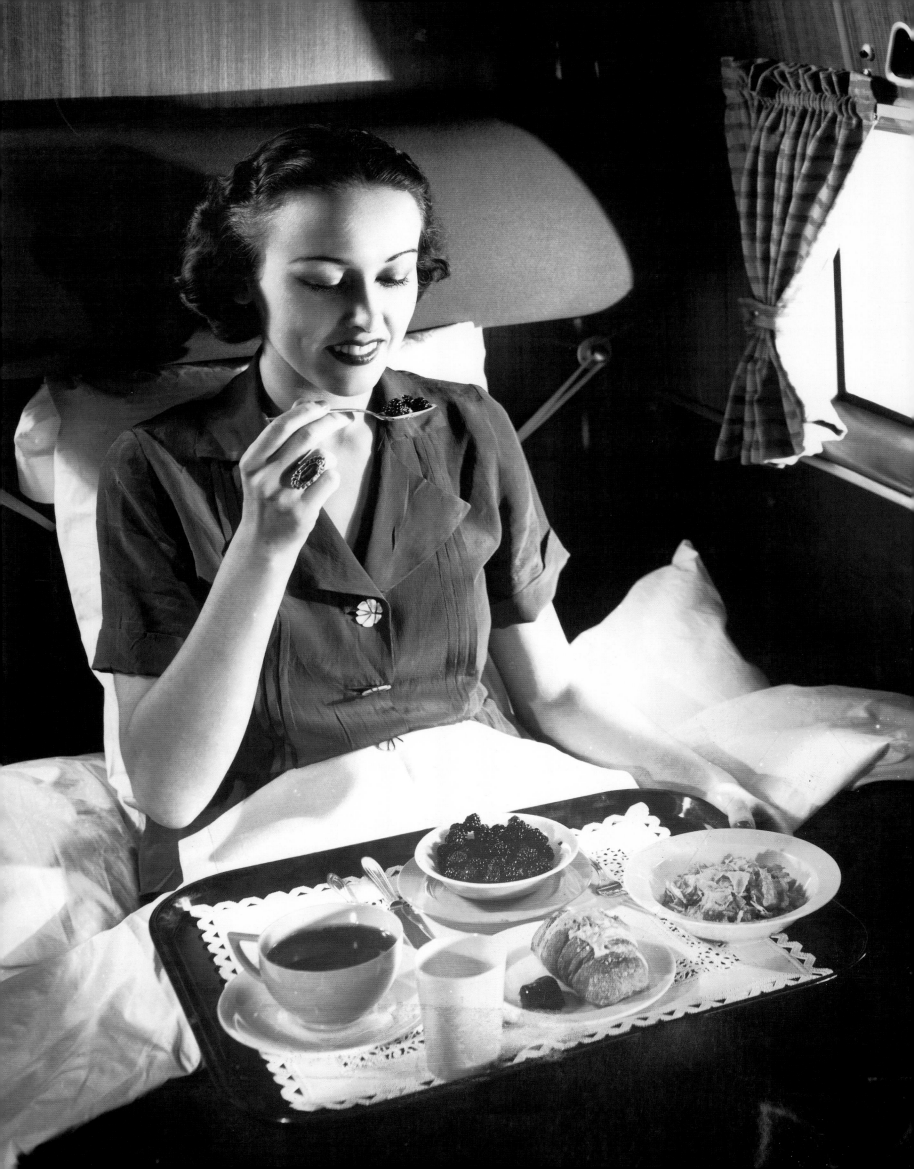

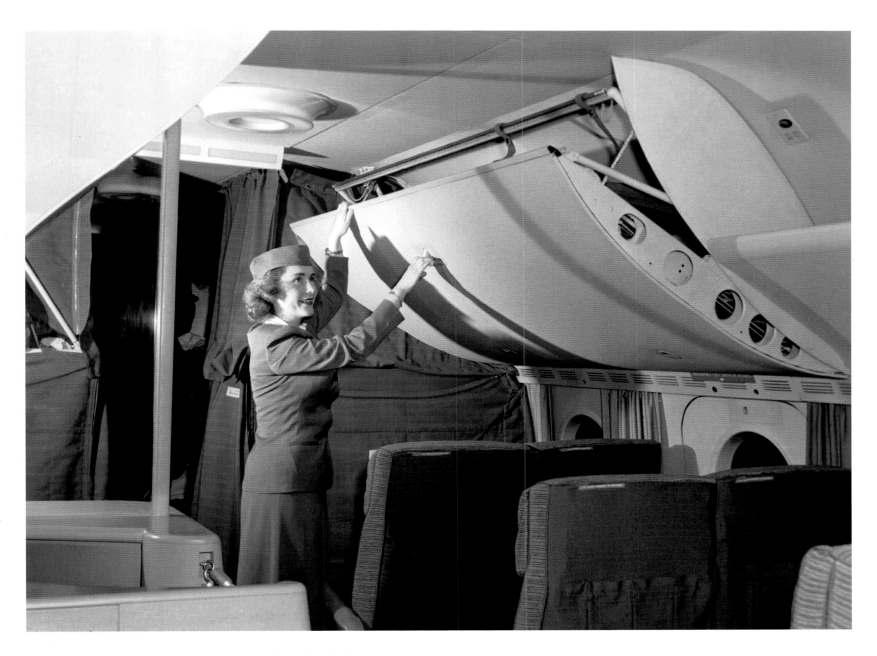

First class dining (left) and sleeping (above) in the 1940s

While planes continue to fly faster, travellers' desire to fly to ever more distant destinations means the need for passengers to sleep remains. On early flights with few passengers, entire cabins would convert from day to night configurations. The introduction of the individual flat bed in 1996 and the development of increasingly private compartments allow each passenger to choose how they will spend their flight.

Auch wenn die Flugzeuge immer schneller werden, erfordert der Wunsch der Reisenden nach immer weiter entfernten Zielen eine Möglichkeit zum Schlafen. Auf frühen Flügen mit wenig Passagieren konnten ganze Kabinen für die Nacht hergerichtet werden. Die Einführung des Klappbettes 1996 und die Entwicklung privater Bereiche erlauben jedem Passagier seinen Flug individuell zu gestalten.

Même si les avions sont de plus en plus rapides, le souhait des passagers d'aller vers des destinations de plus en plus lointaines nécessite de pouvoir dormir. Jadis, sur les vols avec peu de passagers, on pouvait installer des cabines entières pour y dormir. L'introduction de couchettes rabattables en 1996 et le développement d'espaces privatifs permettent à présent à chaque passager de façonner son vol comme il le veut.

Pese a que los aviones cada vez son más rápidos, el deseo de viajar a lugares cada vez más lejanos sigue planteando la necesidad de dormir. En vuelos con pocos pasajeros se pueden instalar dormitorios en las cabinas. La introducción de camas plegables en 1996 y el desarrollo de espacios privados permiten a cada pasajero realizar su vuelo según su gusto individual.

Anche se gli aerei diventano sempre più veloci, un sonno salutare è, per chi viaggia verso mete sempre più lontane un desiderio pienamente comprensibile. Nei primi voli, con pochi passeggeri, intere cabine potevano venire attrezzate per questa eventualità. L'introduzione, nel 1996, di cuccette ribaltabili, e lo sviluppo di compartimenti privati permettono oggi ad ogni passeggero di sfruttare in modo individuale il tempo trascorso a bordo.

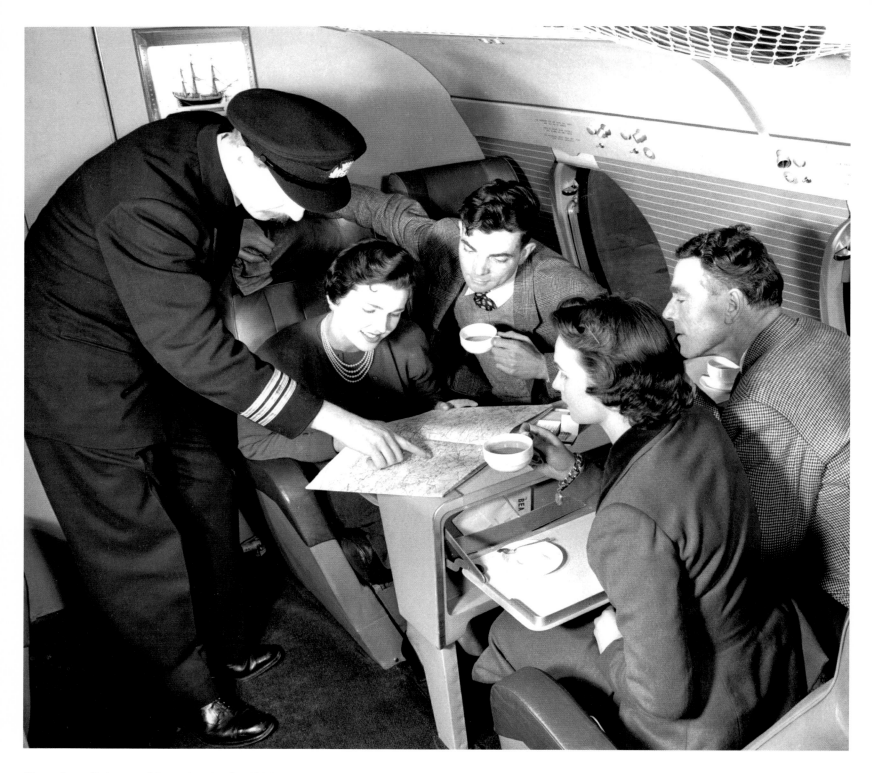

First-class dining and lounging in the 1950s

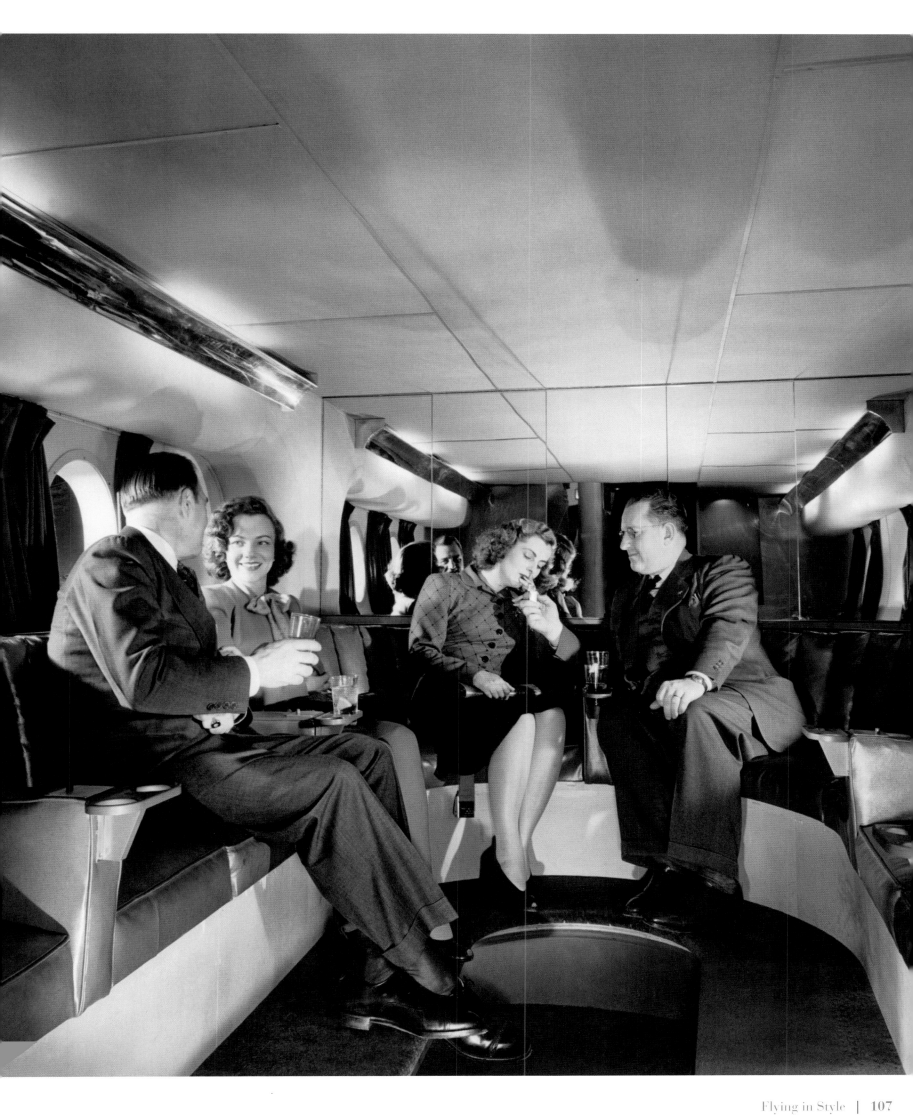

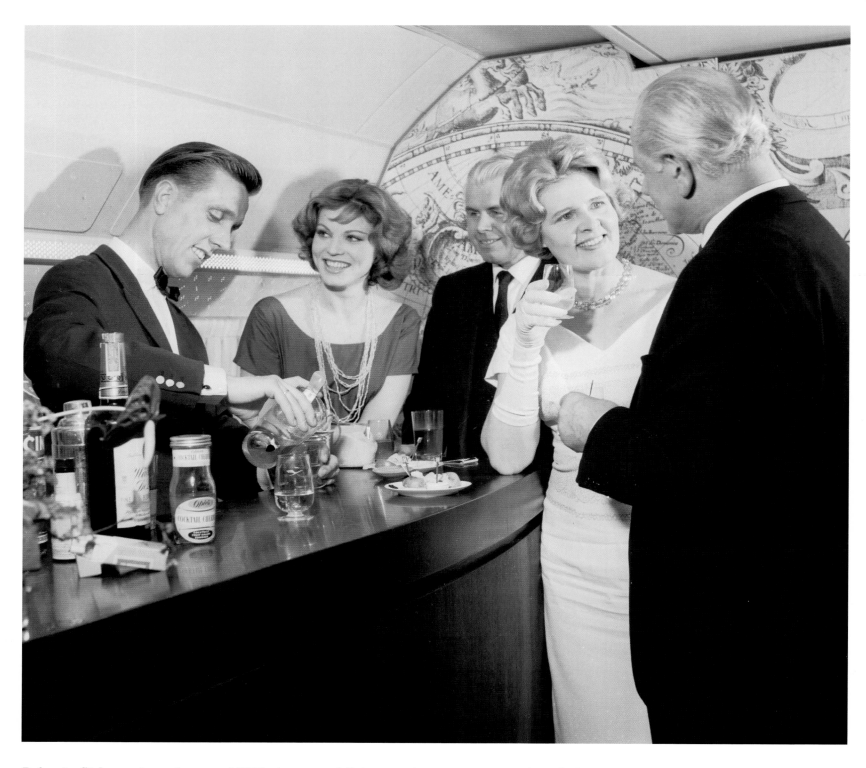

Before in-flight movies and personal DVD players, socializing was the main activity on long flights—conversation or a game of cards accompanied by a well mixed drink and a cigarette.

Schon bevor Filme während des Fluges gezeigt wurden, legten die Fluggesellschaften Wert auf Unterhaltung gerade bei langen Flügen – bei Gesprächen und beim Kartenspielen konnten die Passagiere Mixgetränke und Zigaretten genießen.

Avant qu'on ne propose des films pendant le vol, les compagnies aériennes accordaient beaucoup d'importance au divertissement surtout pour les vols long courrier – les passagers pouvaient boire des cocktails ou fumer un cigare en discutant ou en jouant aux cartes.

Mucho antes de proyectar películas, las compañías aéreas se esmeraban en entretener a los pasajeros, especialmente durante vuelos largos. Charlando y jugando a las cartas los viajeros disfrutaban de cócteles y tabaco.

Anche prima di mostrare dei film durante il volo, le compagnie aeree hanno sempre attribuito molta importanza all'intrattenimento, in particolar modo durante i voli molto lunghi. Mentre giocano a carte o fanno conversazione, i passeggeri possono gustare un cocktail o una sigaretta.

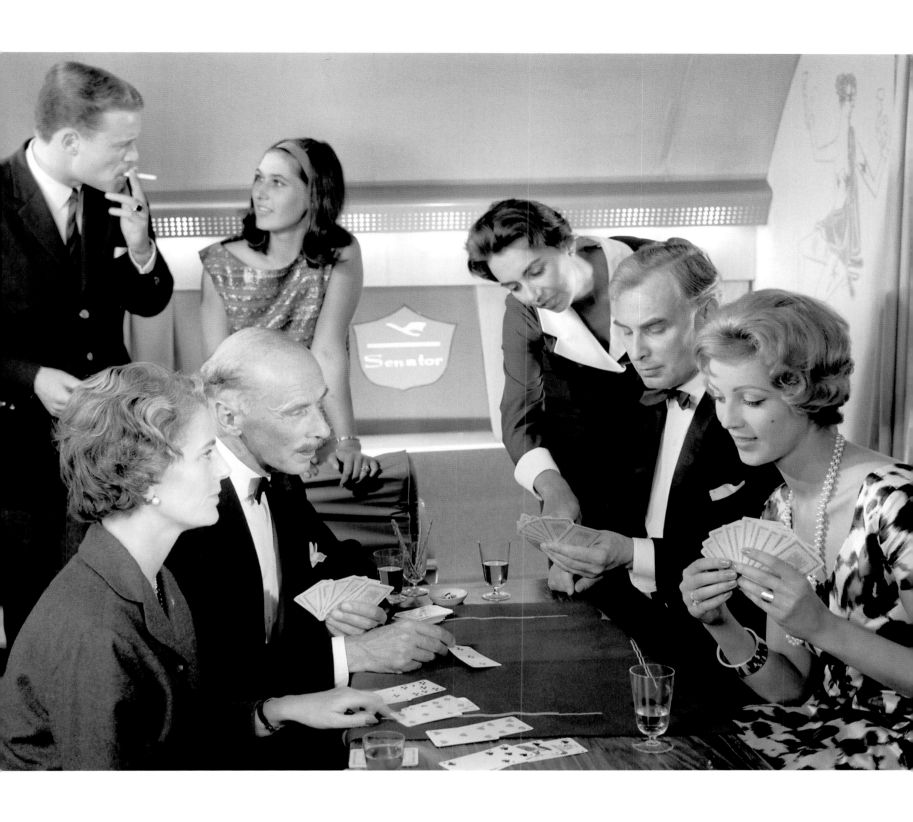

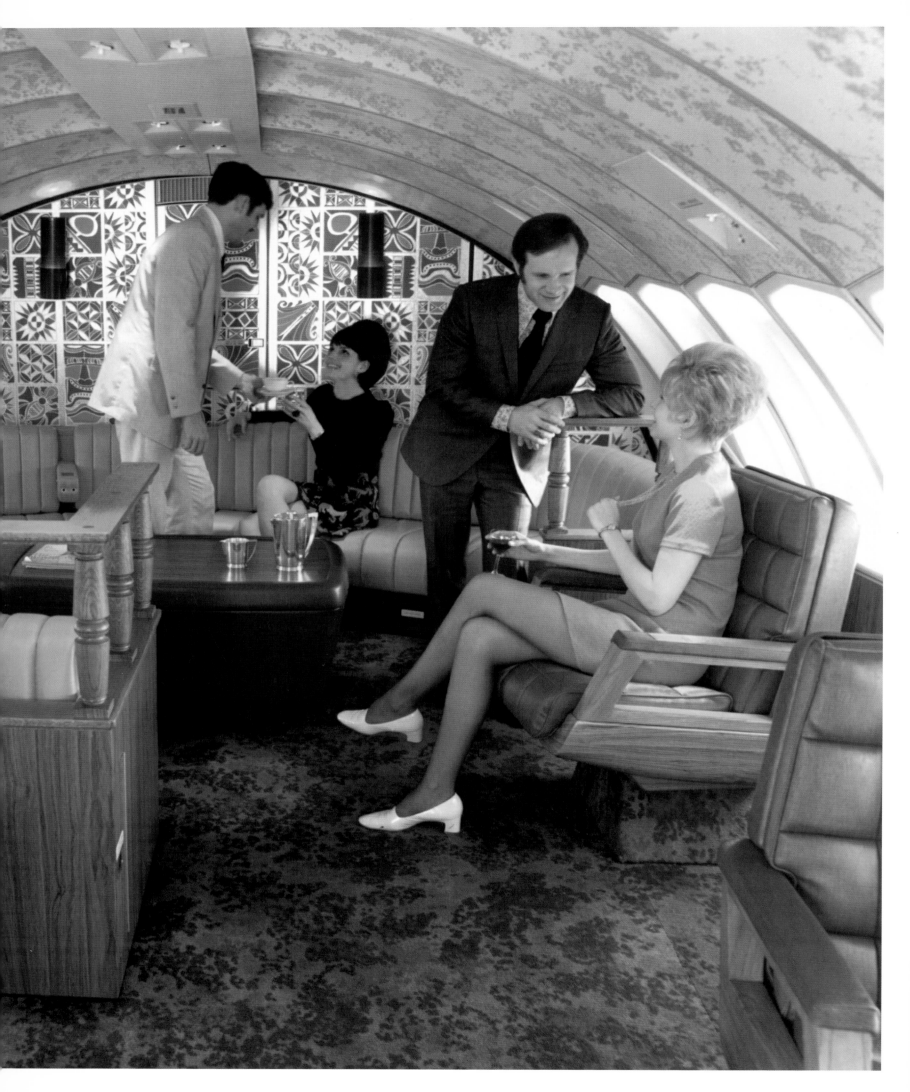

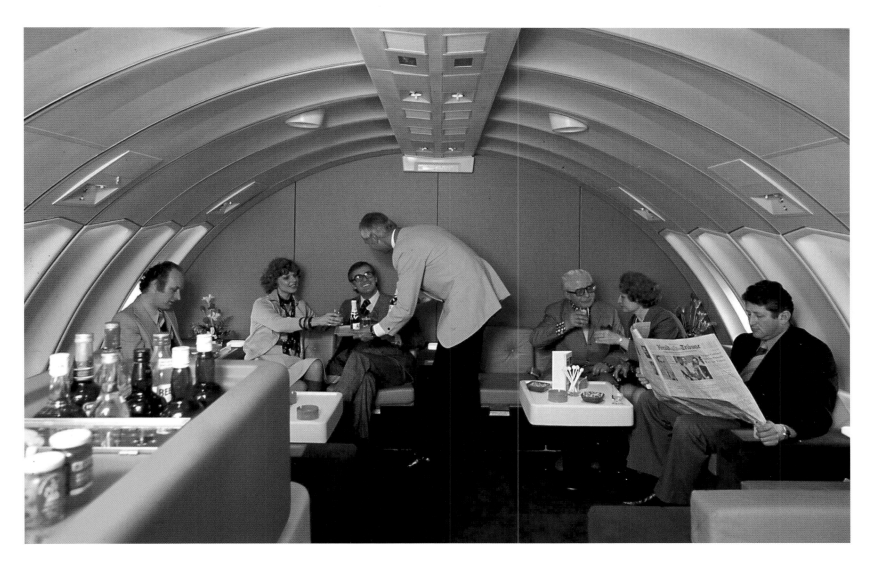

Boeing 747

The upper deck of the 747 was originally designed as a lounge for First-Class passengers to relax during long flights. After the oil crisis of the 1970s, the space was largely converted to revenue-generating First-Class and business-class seating.

Im oberen Deck der Boeing 747 sollte ursprünglich eine Lounge für Passagiere der Ersten Klasse eingerichtet werden, um sich hier während langer Flüge in Ruhe entspannen zu können. Nach der Ölkrise der 70er-Jahre wurde der Platz zur Einrichtung von Business- und First-Class-Bereichen genutzt.

Sur le pont supérieur du Boeing 747, il était prévu à l'origine d'aménager un salon pour les passagers de première classe afin qu'ils viennent s'y détendre en toute tranquillité. Après la crise pétrolière des années 70, cet étage a été utilisé pour y créer des espaces sièges aux premières classes et à la classe affaires.

Originalmente se había planeado poner un salón en la cubierta superior del Boeing 747 para que los pasajeros de primera clase pudieran relajarse durante los vuelos de larga distancia. Tras la crisis del petróleo en los años 70 se utilizó para acomodar las zonas reservadas a la clase Business y la primera clase.

Il ponte superiore del Boeing 747 doveva originariamente venire adibito a lounge, in modo da permettere ai passeggeri di prima classe di rilassarsi durante i lunghi voli. Dopo la crisi petrolifera degli anni settanta lo spazio fu invece sfruttato a favore di settori per la First e la Business Class.

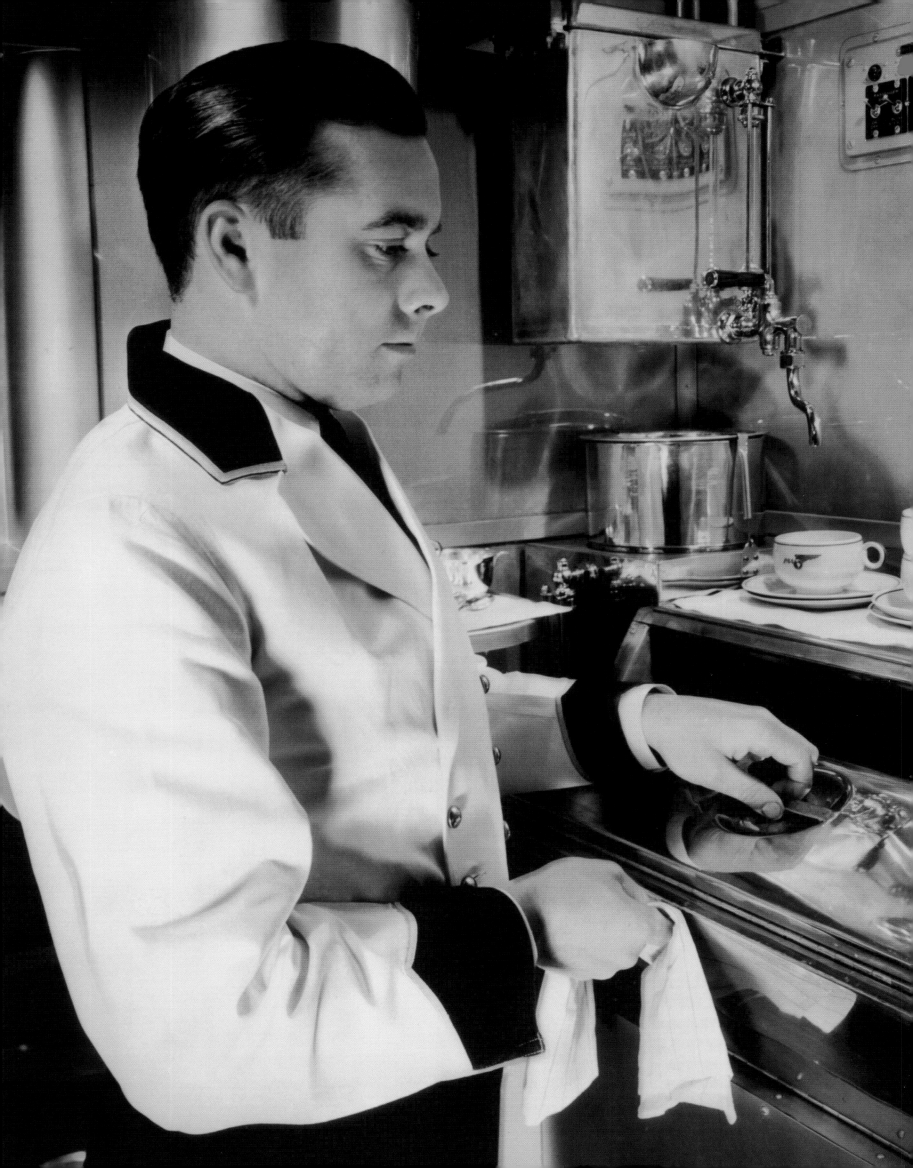

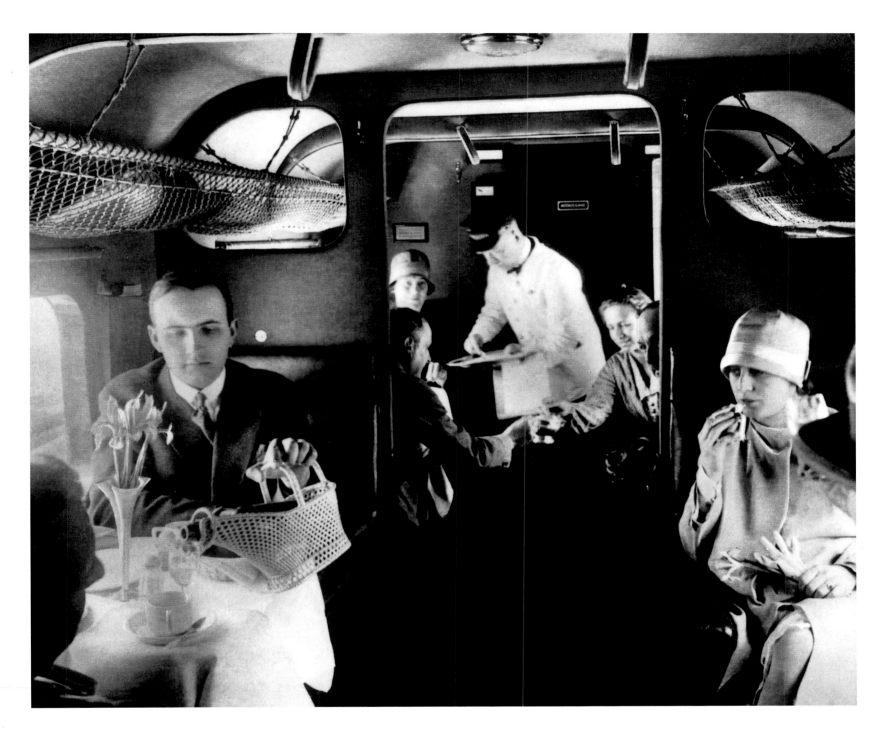

Lufthansa first class, 1928

left: *Pan American Airways galley, 1940s*

Fine in-flight dining has been important since the early days of flight.

Ein gutes Essen während des Fluges ist schon seit den Anfängen der Luftfahrt wichtig.

Une restauration de qualité a toujours été un aspect essentiel du transport aérien depuis ses débuts.

La buena comida durante el vuelo ha sido importante desde los comienzos de la aviación.

Fin dai primi voli. un buon pasto a bordo è sempre stato importante.

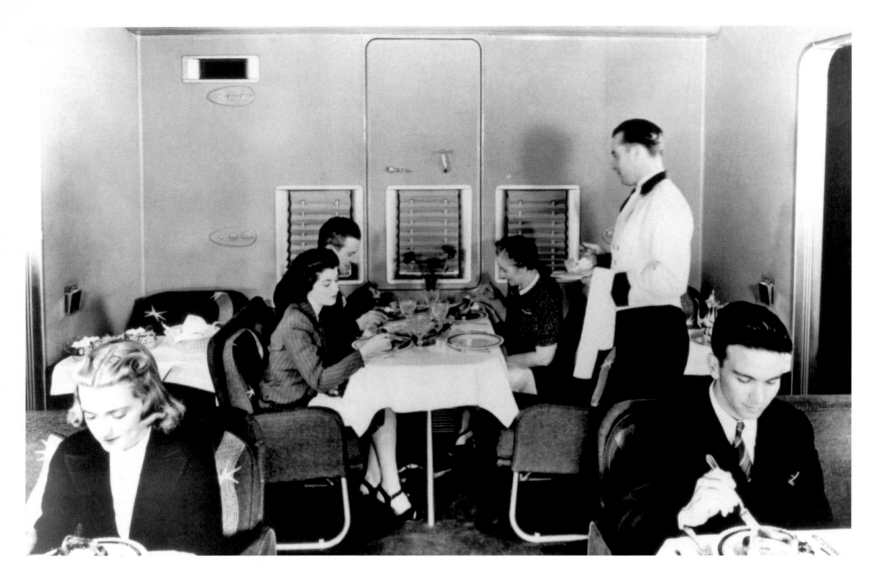

Early Boeing in-flight dining

right: *Airbus A380*

In-flight dining began in the 1940s, when longer-range aircraft eliminated stopovers at hotels en route. With fewer passengers, early planes had space for dining rooms similar to restaurants. While in recent years even First-Class passengers have become accustomed to eating in their seats, the new Airbus A380 again includes room for an elegant dining area.

Seit den 40-er Jahren werden im Flugzeug Mahlzeiten serviert, denn die langen Strecken erforderten keinen Zwischenstopp mehr. In jener Zeit hatten die Flugzeuge, die weniger Passagiere beförderten, genug Platz für Speiseräume ähnlich Restaurants. Während in den vergangenen Jahrzehnten auch Passagiere der Ersten Klasse ihre Mahlzeit am Platz einnahmen, bietet der neue Airbus A380 nun wieder Platz für einen eleganten Speiseraum.

Depuis les années 40, il n'était plus nécessaire de faire des escales sur les longs trajets. On se mit alors à servir des repas dans les avions. A cette époque, ces derniers, qui transportaient moins de passagers, avaient suffisamment de place pour disposer d'une sorte de salle de restaurant. Alors que dans une période récente, même les passagers de première classe devaient prendre leur repas à leur place, le nouvel Airbus A380 offre aux passagers une élégante salle de restauration.

Desde los años 40 se sirven comidas en los vuelos, ya que se había vuelto innecesario hacer escala a larga distancia. En aquella época, los aviones transportaban menos pasajeros y disponían de espacio para comedores parecidos a restaurantes. Mientras que en décadas anteriores hasta los pasajeros de primera clase almorzaban en su asiento, el nuevo Airbus A380 dispone de espacio para un elegante salón-comedor.

Dagli anni quaranta, ovvero da quando sono possibili grandi attraversate senza scali intermedi, sugli aerei viene servito il pranzo. Dato che all'epoca gli aerei trasportavano meno passeggeri, disponevano anche di spazio in abbondanza per l'allestimento di settori per il pranzo simili a ristoranti. Mentre negli ultimi decenni anche i passeggeri della prima classe pranzavano al proprio posto, il nuovo Airbus A380 ha spazio sufficiente per un' elegante zona ristorazione.

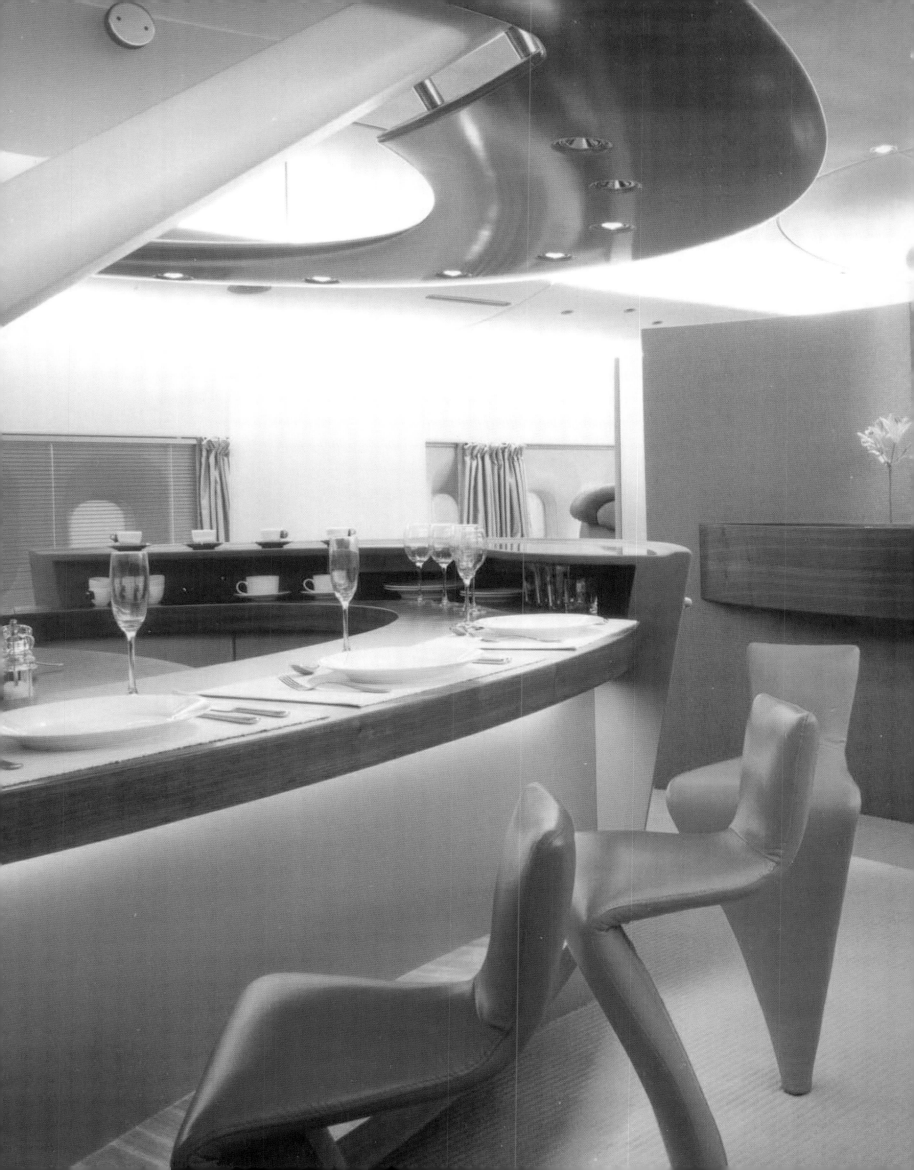

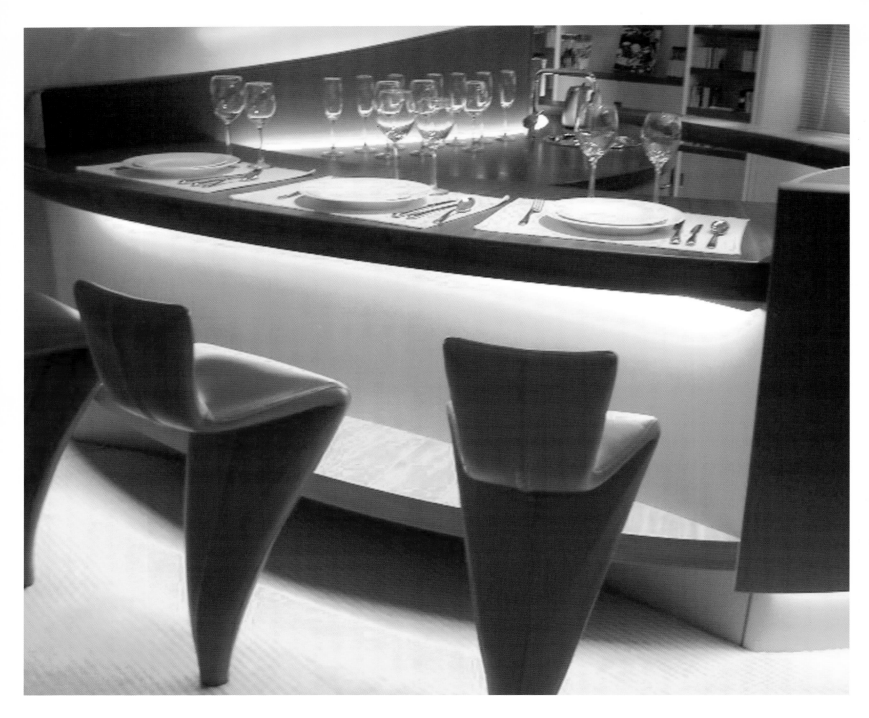

Airbus A380

Pages 118/119: *Airbus A380*

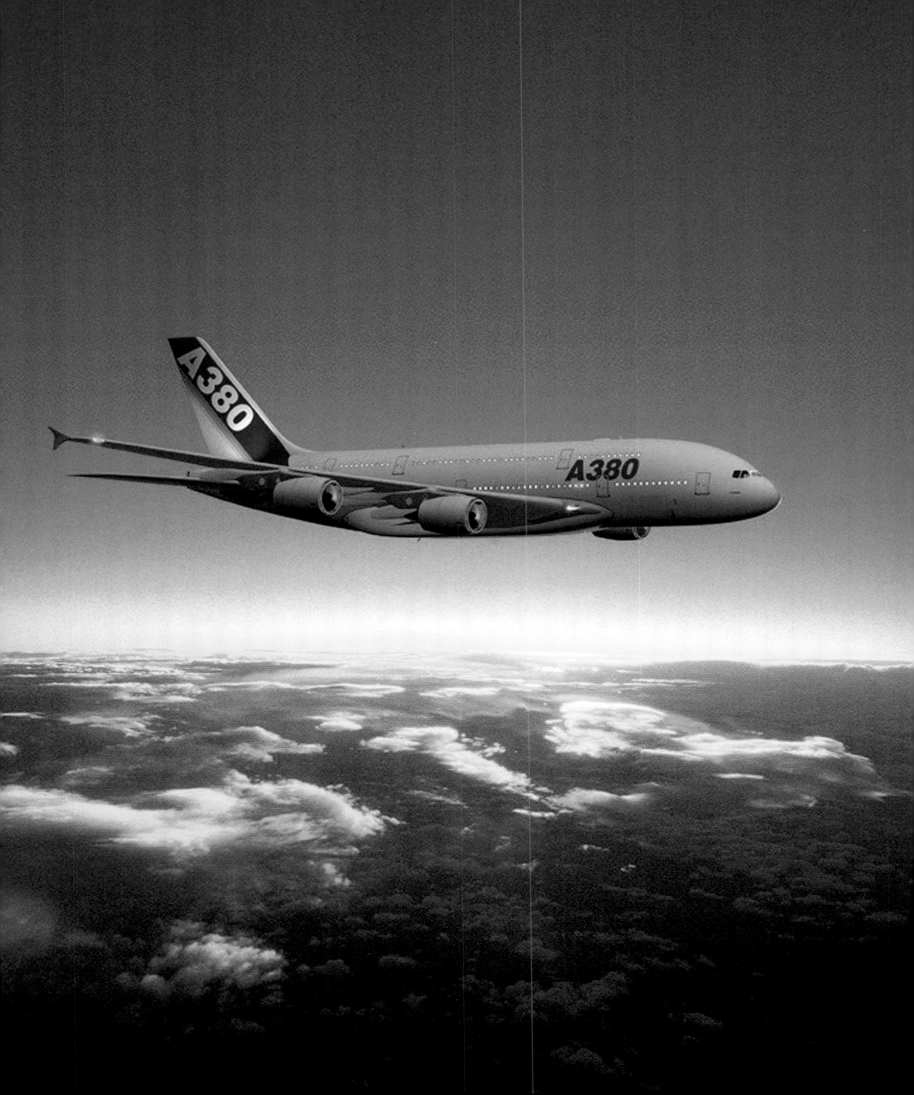

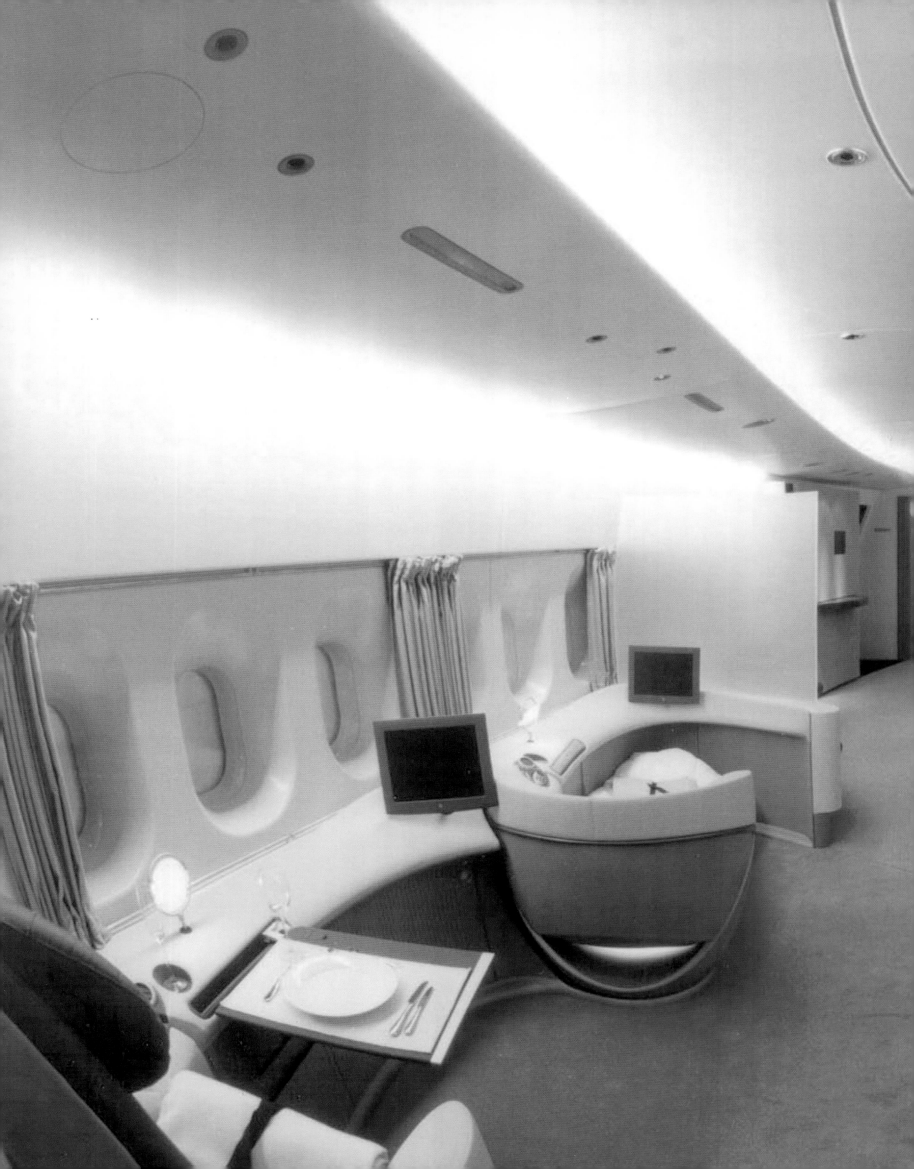

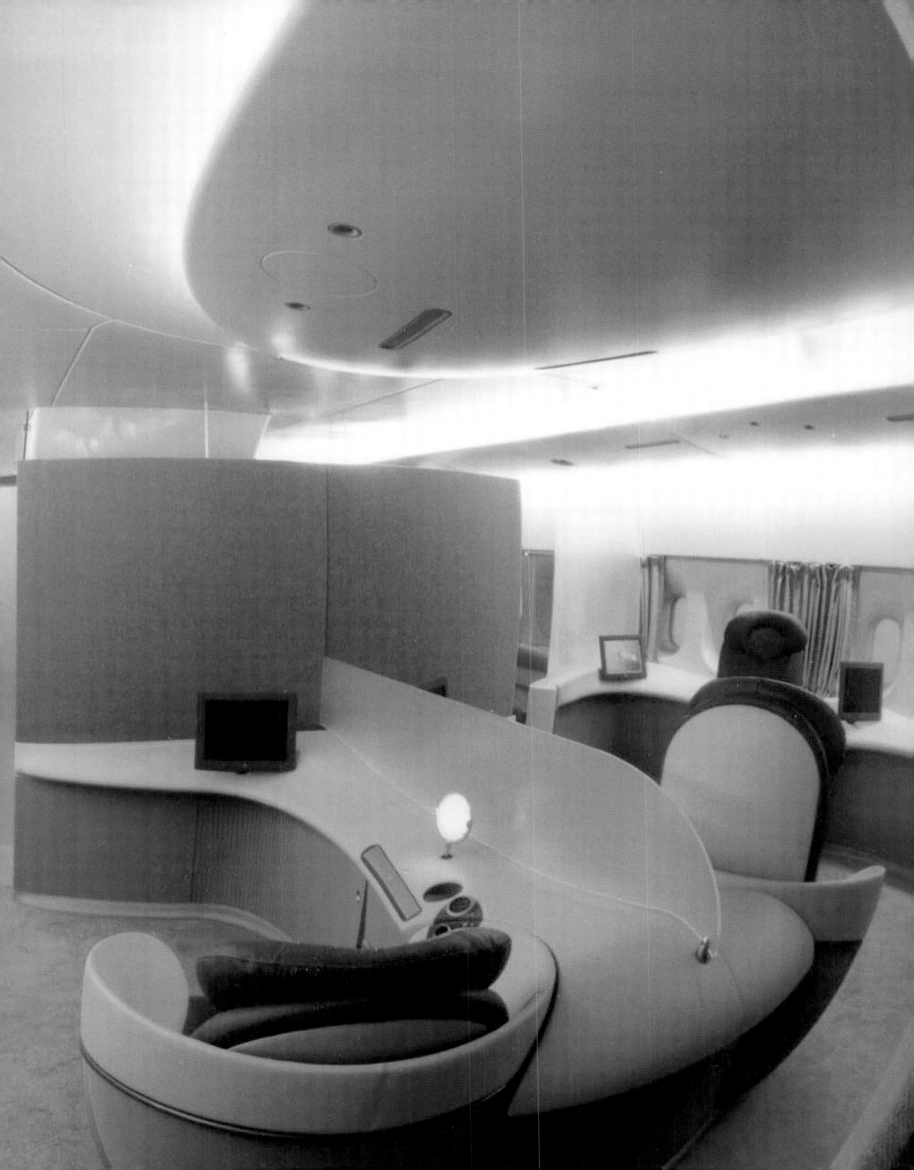

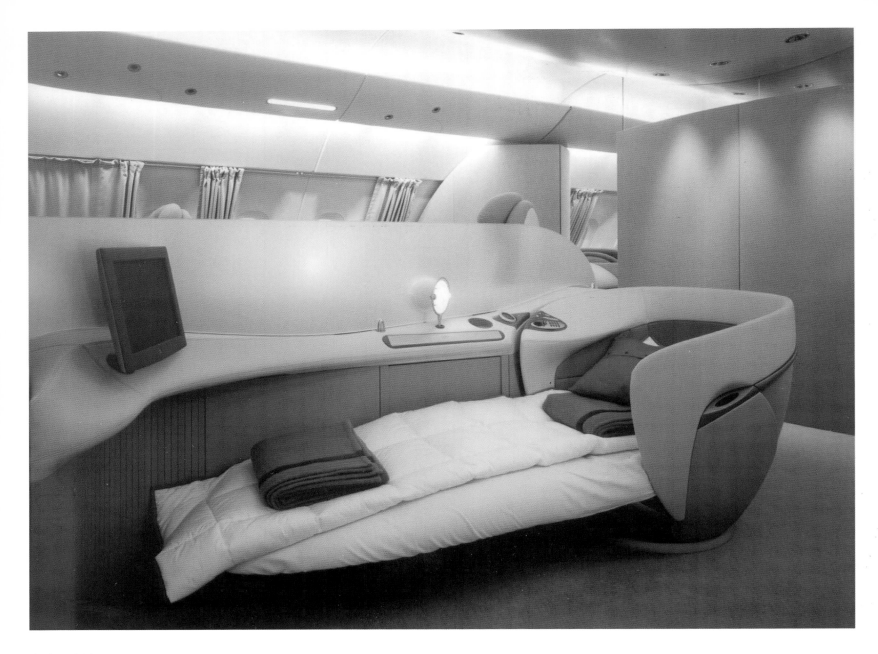

Airbus A380

Pages 122/123: *Airbus A380*

The sheer size of the A380 opens up new possibilities for the services available in flight. With a completely configurable layout based on the airline's wishes, possible options include bars and restaurants, duty-free shops, workout facilities, business centres and sleeping cabins.

Allein die Größe des A380 bietet ungeahnte Möglichkeiten für den Service in der Luft. Mit dem komplett veränderbaren Design, das an die Wünsche der Fluggesellschaft angepasst wird, ist die Einrichtung von Bars, Restaurants, Duty-free-Shops, Fitnessräumen, Konferenzräumen und Schlafkabinen möglich.

La seule taille de l'A380 offre des possibilités insoupçonnées pour le service à bord. Grâce à la conception de sa cabine qui peut être modifiée au gré des besoins des compagnies, il est possible d'y aménager des bars, des restaurants, des boutiques détaxées, des espaces de remise en forme, des salles de conférences et des cabines de repos.

Tan solo el tamaño del A380 ofrece posibilidades insospechables para el servicio a bordo. Con un diseño completamente modificable y adaptable a los deseos de las compañías aéreas, los compartimentos son convertibles en bares, restaurantes, tiendas duty-free, gimnasios, salas de reuniones y dormitorios.

Già le dimensioni dell'A380 garantiscono di per sé una libertà delle prestazioni prima inimmaginabile. La completa flessibilità degli interni, adeguabili alle esigenze delle singole compagnie, permette l'allestimento di bar, ristoranti, Duty-free-Shops, settori per il fitness, sale per conferenza e cabine-letto.

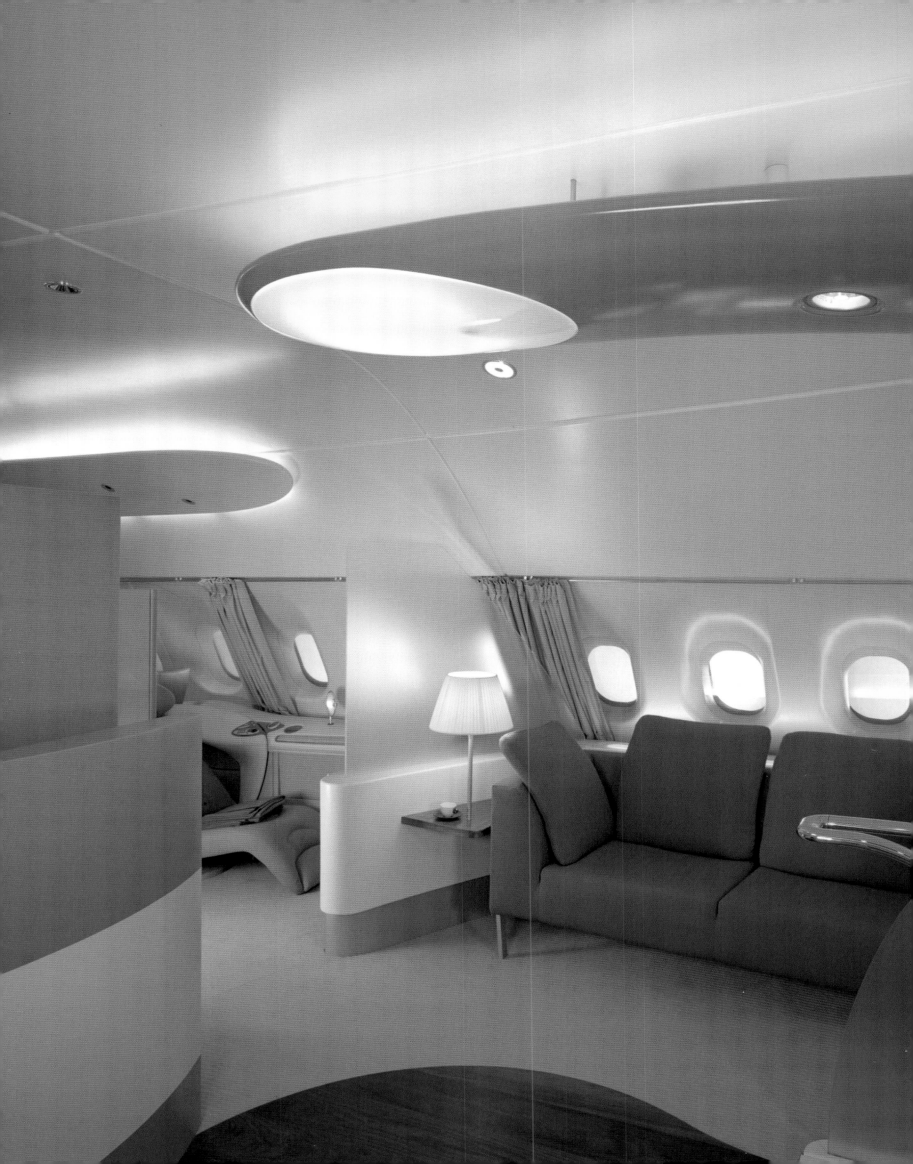

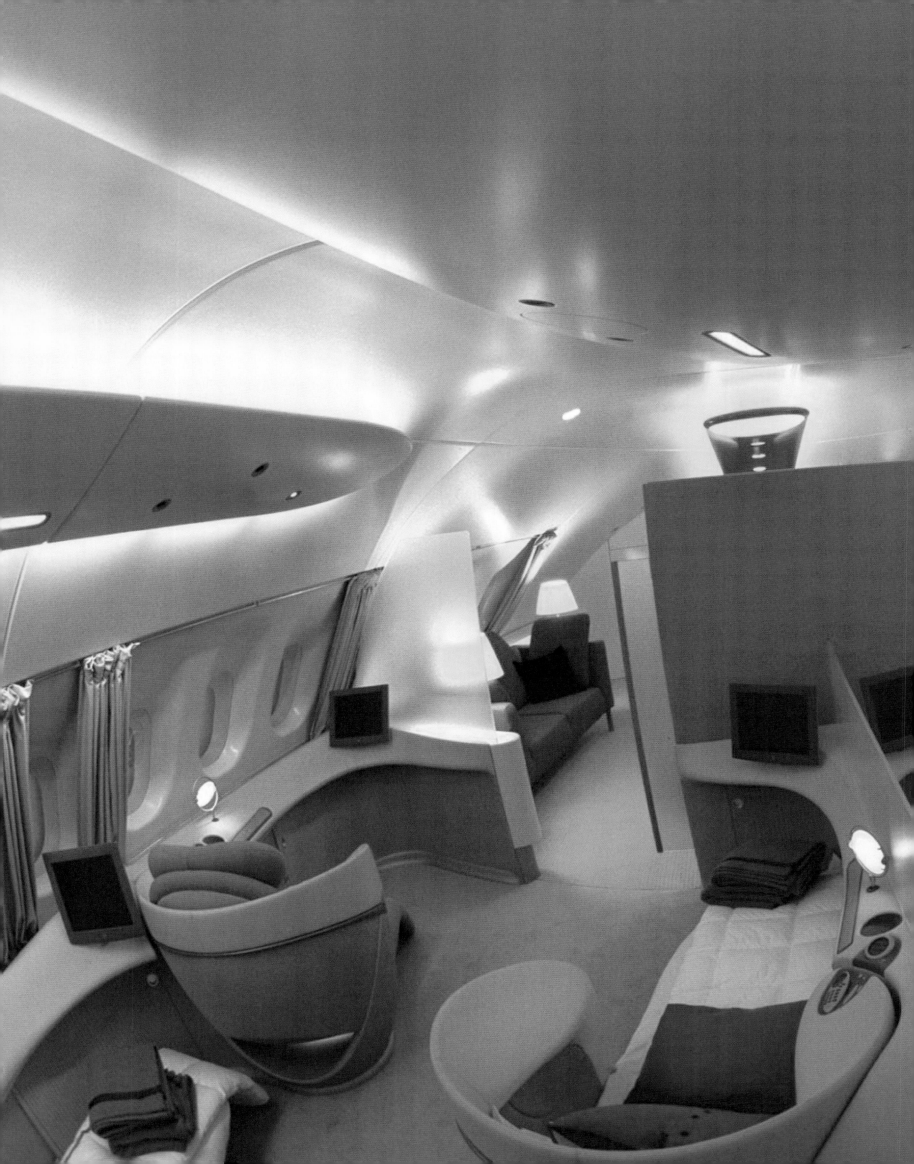

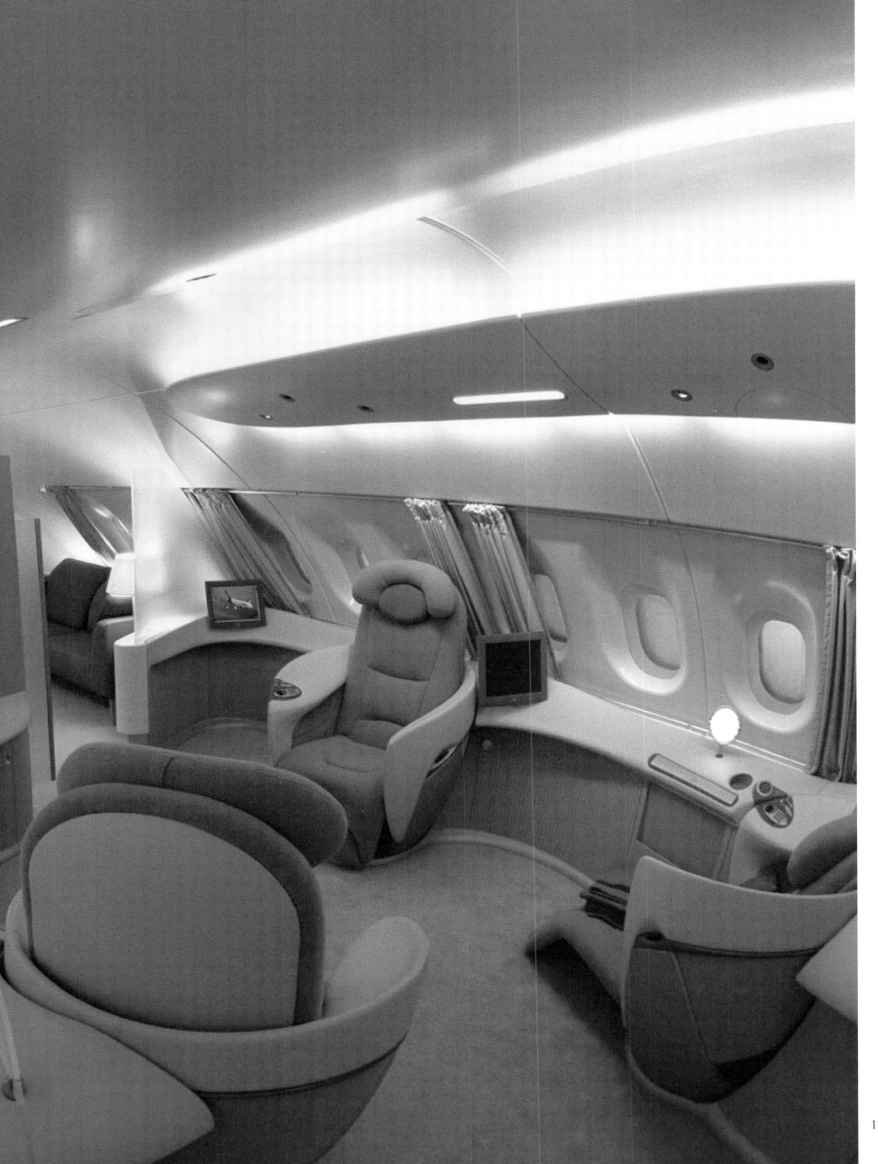

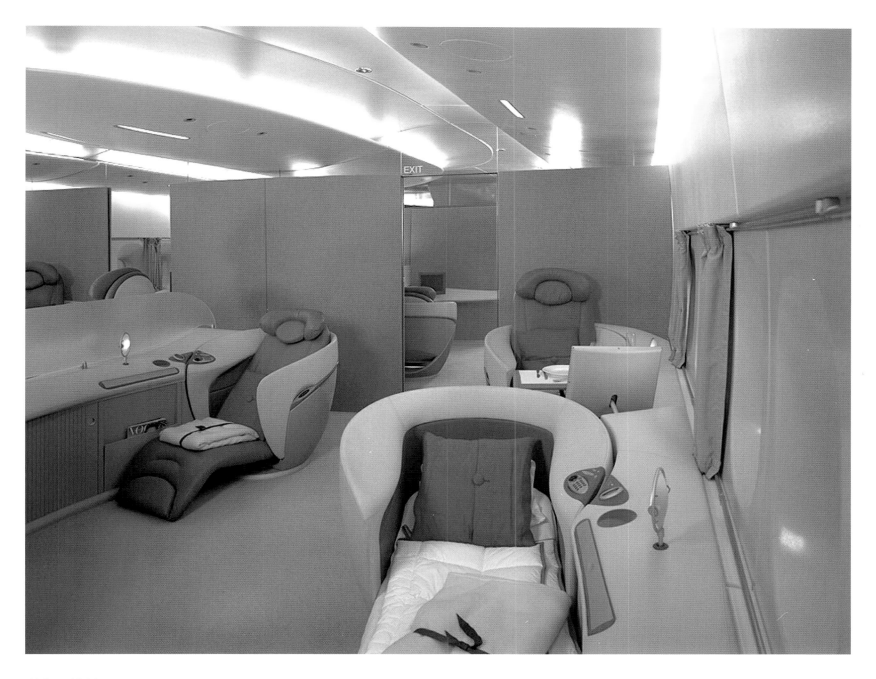

Airbus A380

Whether duty-free shopping or quiet relaxation the Airbus A380 has something for everyone.

Ob Einkaufen im Duty-free-Shop oder Entspannung und Ruhe – der Airbus A380 bietet jedem etwas.

Qu'il s'agisse d'effectuer des achats détaxés ou de se détendre en toute tranquillité, l'Airbus A380 offre à chacun ce dont il a besoin.

Ir de compras en el duty-free o relajarse tranquilamente –el Airbus A 380 ofrece algo a todo el mundo.

Nell'Airbus A380 ce n'è per tutti i gusti, dallo shopping nel Duty-free alla quiete ed al relax.

Customized Comfort

Customized Comfort

Outfitted to the exacting specifications of top-level executives, celebrities and heads of state, the spacious cabins of private jets can be arranged as mobile offices or luxurious suites. Materials used throughout the aircraft, including tabletops and all fabrics, must meet strict industry standards for inflammability.
With space available for a lounge, dining area, meeting room, office and bedroom, an entire team can remain productive during travel.

Exakt an die speziellen Bedürfnisse und Wünsche der Geschäftsleute, Berühmtheiten und Staatsoberhäupter angepasst, bieten die geräumigen Kabinen der Privatjets vielerlei Möglichkeiten der Nutzung – ob als mobiles Büro oder luxuriöse Suite. Alle im Flugzeug verwendeten Materialien – für Tische, Sitze und alle anderen Elemente der Einrichtung – dürfen nicht entflammbar sein, sollen aber dennoch das Gefühl von Luxus und Komfort vermitteln.
Es gibt genügend Platz für eine Lounge, Speiseraum, Konferenzraum, Büro oder Schlafkabine. Ein ganzes Team kann während des Fluges seiner Arbeit nachgehen.

Conçues sur mesure en fonction des besoins spécifiques et des désirs des hommes d'affaires, des célébrités et des chefs d'Etat, les cabines spacieuses des jets privés peuvent être arrangées soit comme bureau mobile ou comme luxueuse suite. L'ensemble des matériaux utilisés dans l'avion – pour les tables, les sièges et les autres accessoires de l'aménagement intérieur – doit impérativement être anti-inflammable, tout en procurant une sensation de confort et de luxe.
Il a suffisamment d'espace pour accueillir un salon, un restaurant, une salle de conférence, un bureau ou une chambre à coucher. Une équipe de travail peut s'affairer à sa mission pendant toute la durée du vol.

Especialmente adaptados a las exigencias y deseos de ejecutivos, famosos y jefes de estado, las espaciosas cabinas de los jets privados ofrecen infinidad de posibilidades –como despacho móvil o suite de lujo. Todos los materiales empleados en el avión para mesas, asientos y demás elementos interiores deben ser antiinflamables y al mismo tiempo capaces de irradiar una sensación de lujo y confort.
Existe amplio espacio para zonas lounge, salón-comedor, sala de reuniones, despacho o cabina dormitorio. Durante el vuelo, los ejecutivos tienen la posibilidad de celebrar reuniones de trabajo.

Essendo pensati per soddisfare i bisogni particolari di uomini d'affari, celebrità e capi di stato, le spaziose cabine dei jet privati garantiscono all'utenza una serie di possibilità, dall'ufficio mobile alla suite lussuosa. Anche se tutti gli elementi dell'arredamento di un aereo, dai tavoli ai posti a sedere e così via, sono di materiale non infiammabile, essi devono comunque trasmettere un senso di lusso e di comfort. C'è spazio a sufficienza per una lounge, una sala da pranzo, una sala conferenze, un ufficio o una cabina-letto. Durante il volo un intero team può così proseguire il proprio lavoro.

Boeing Business Jet 737

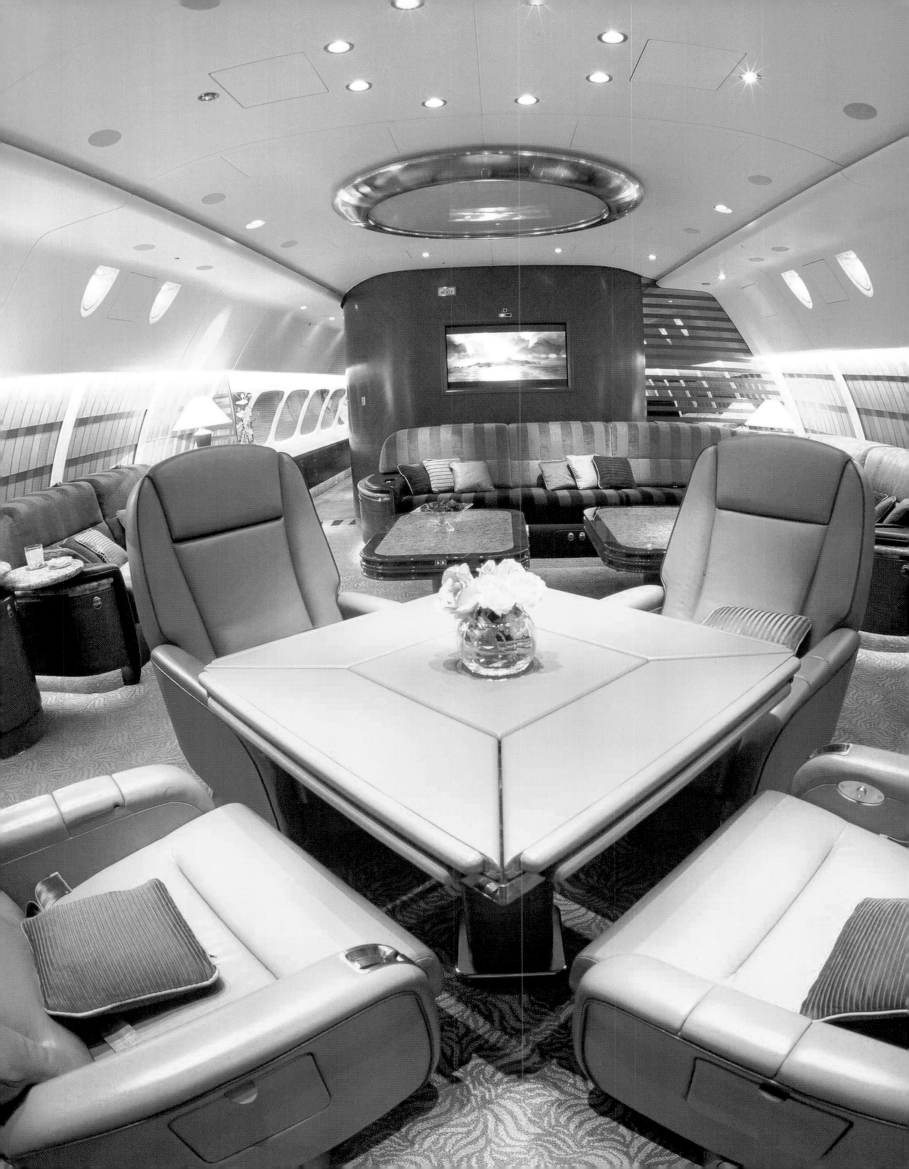

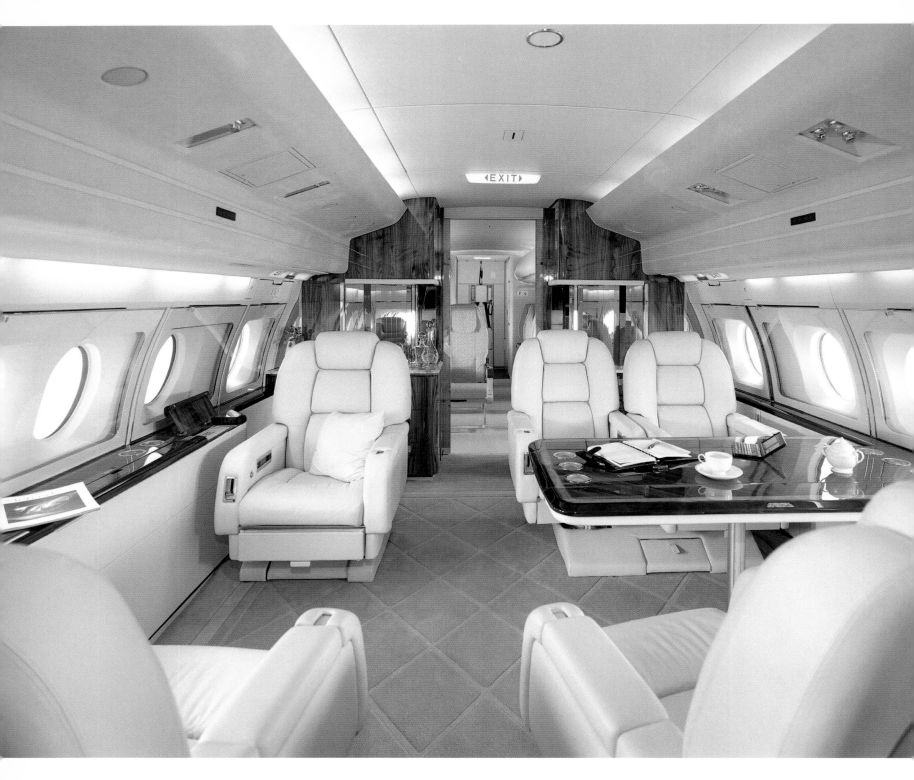

The luxurious VIP interior of a Fokker Stork

right: *Customized interior of a Boeing aircraft*

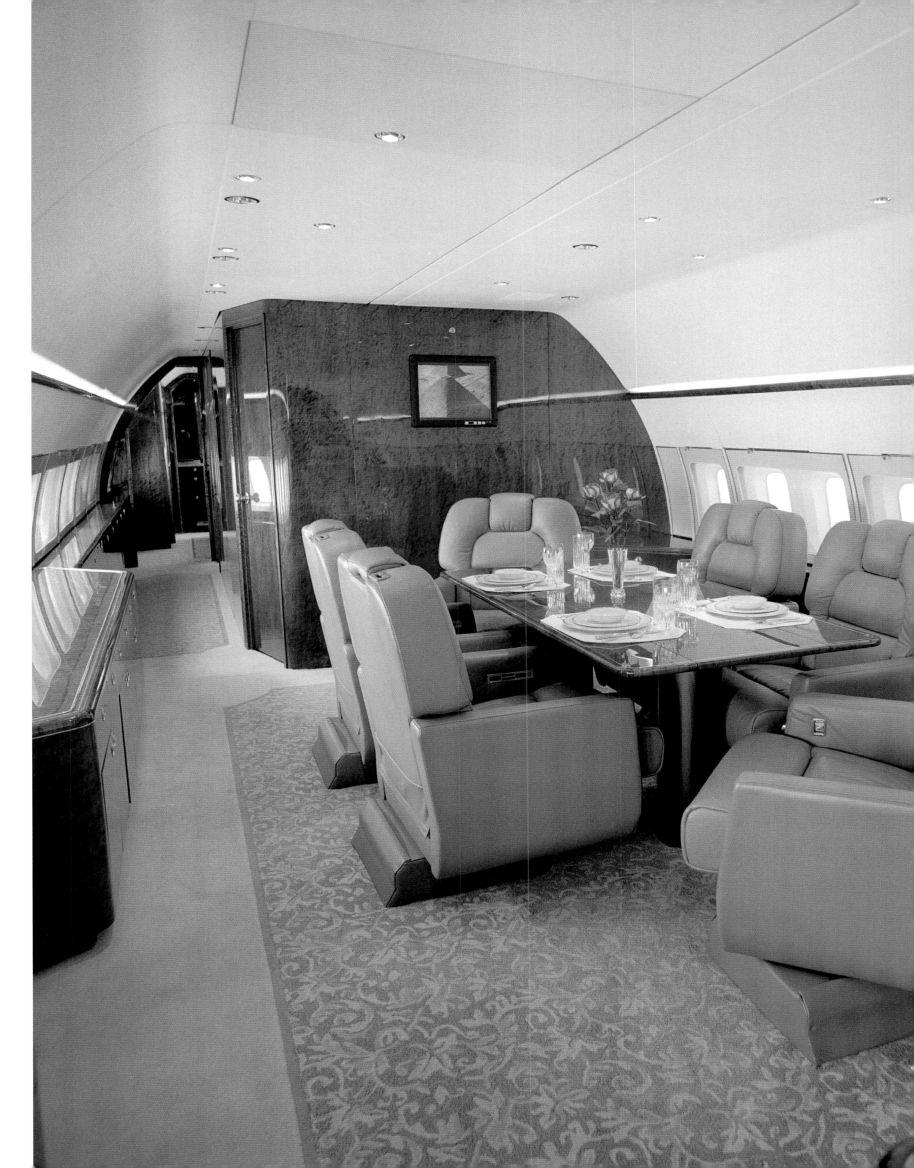

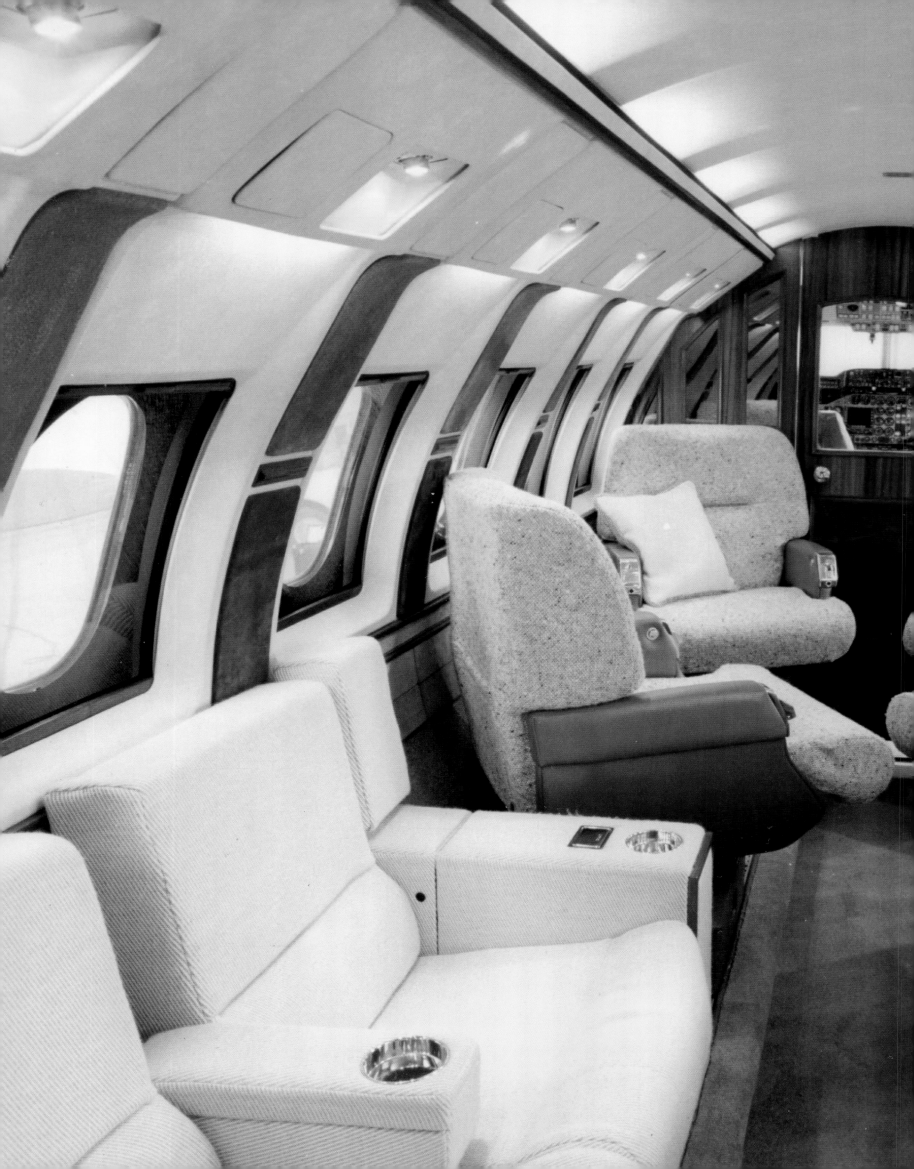

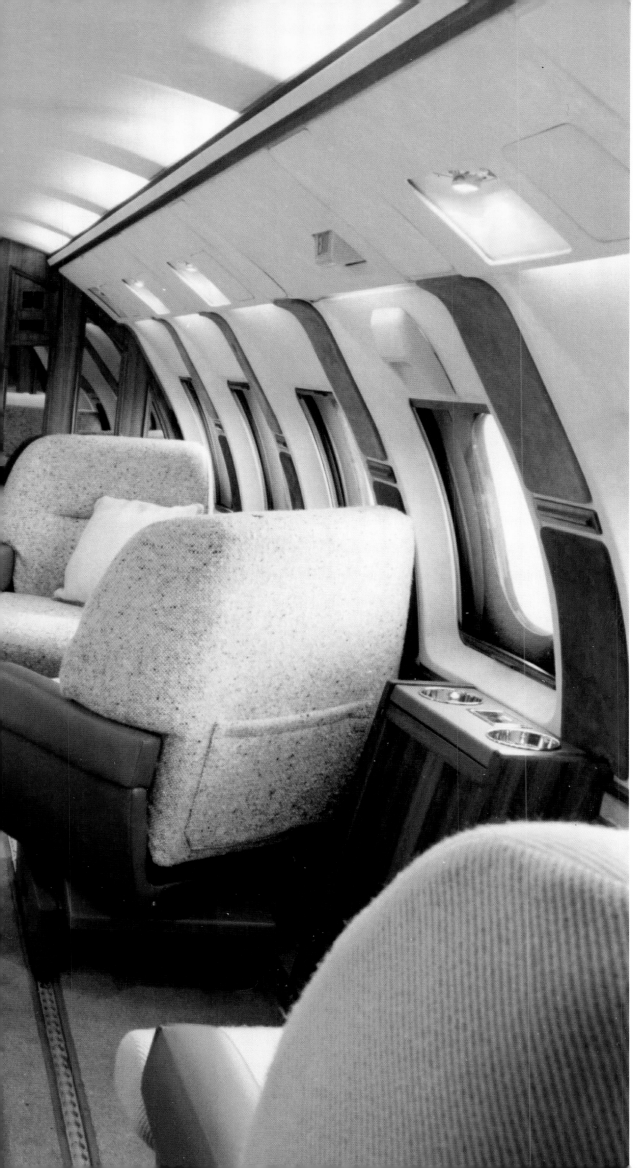

BAe 125-800

Page 134/35: Boeing Business Jet 737

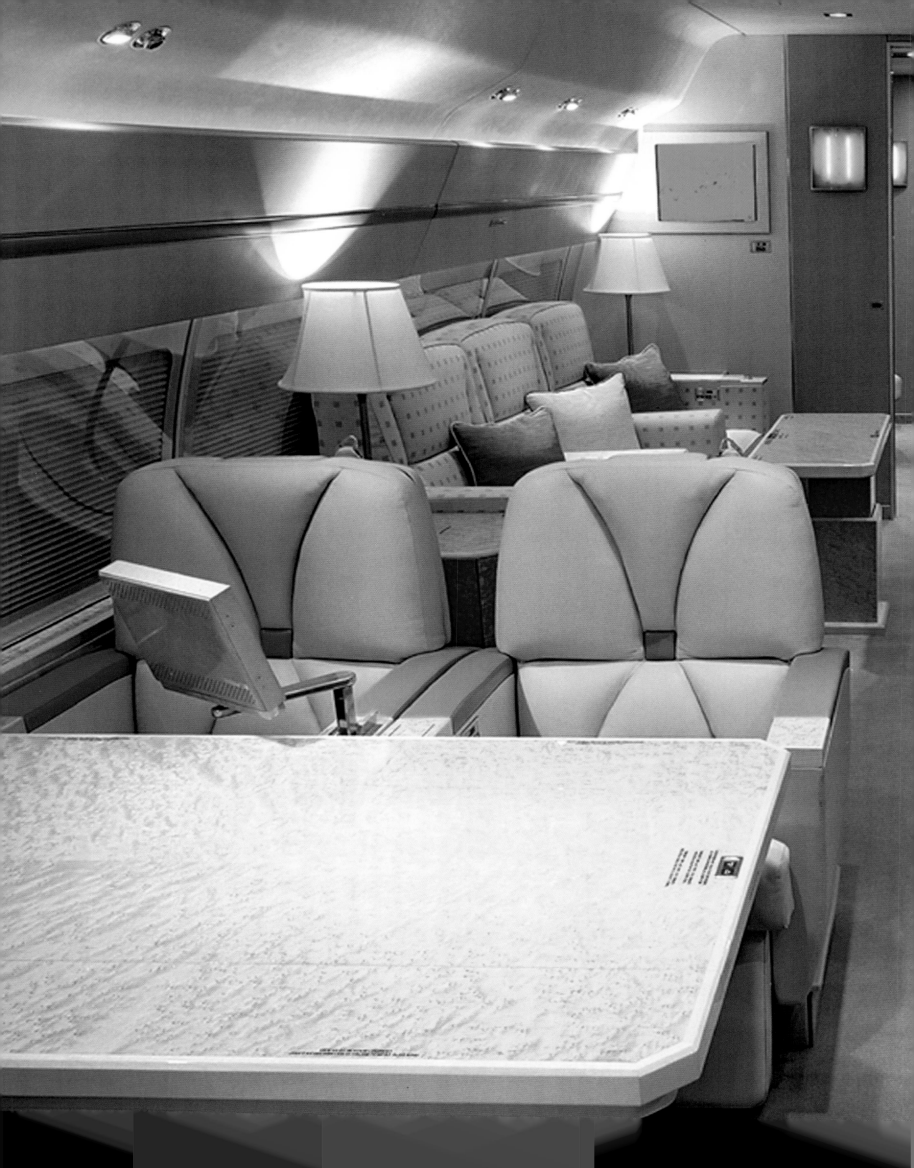

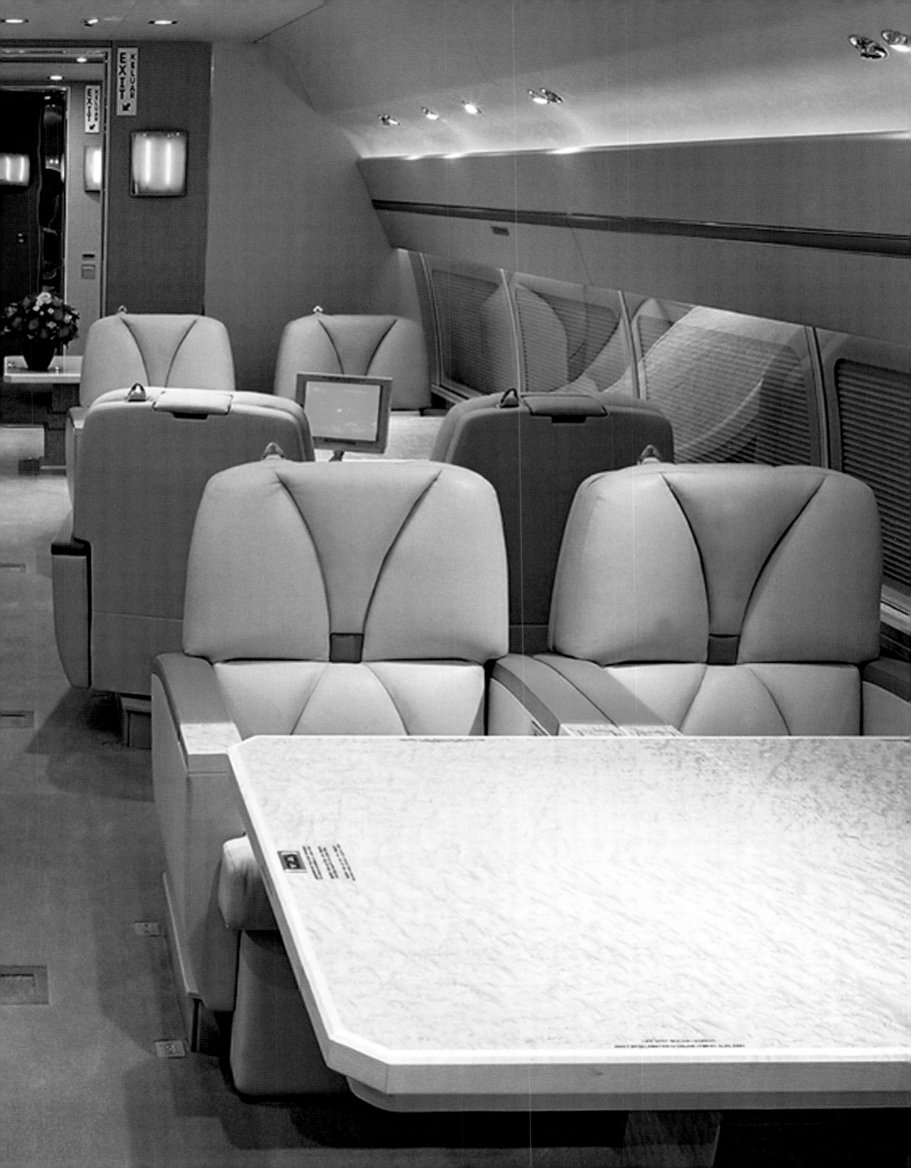

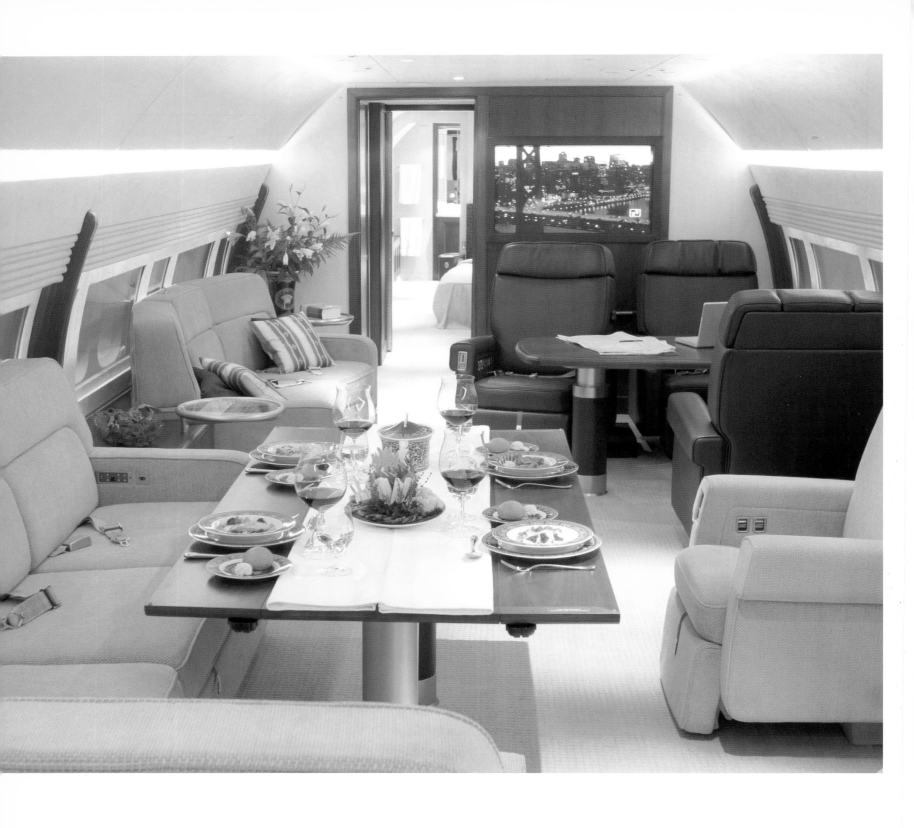

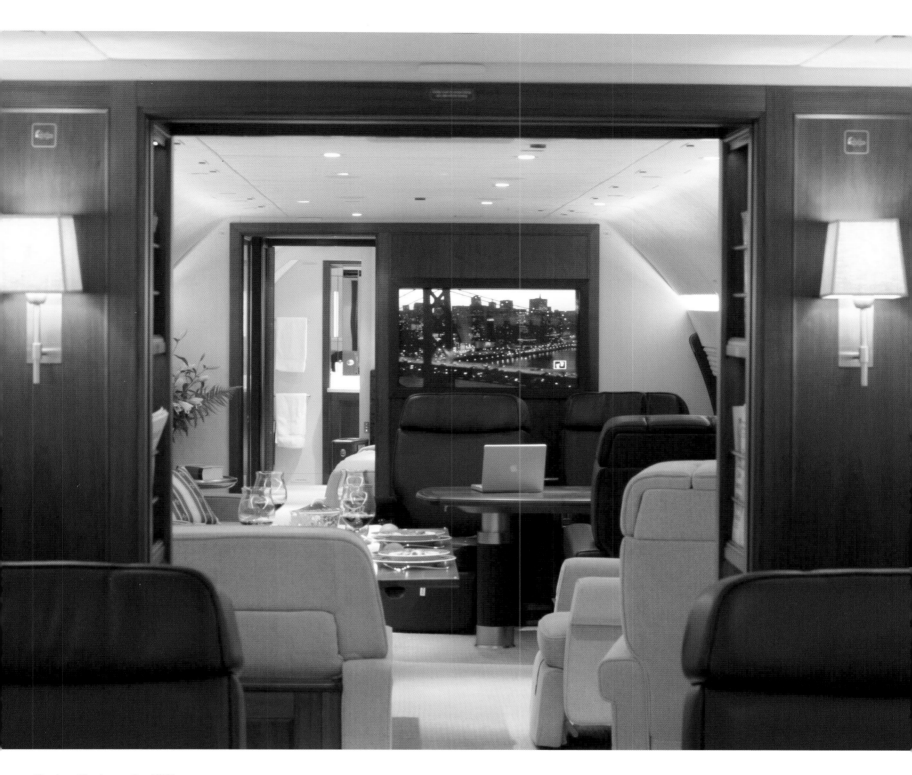

Boeing Business Jet 737

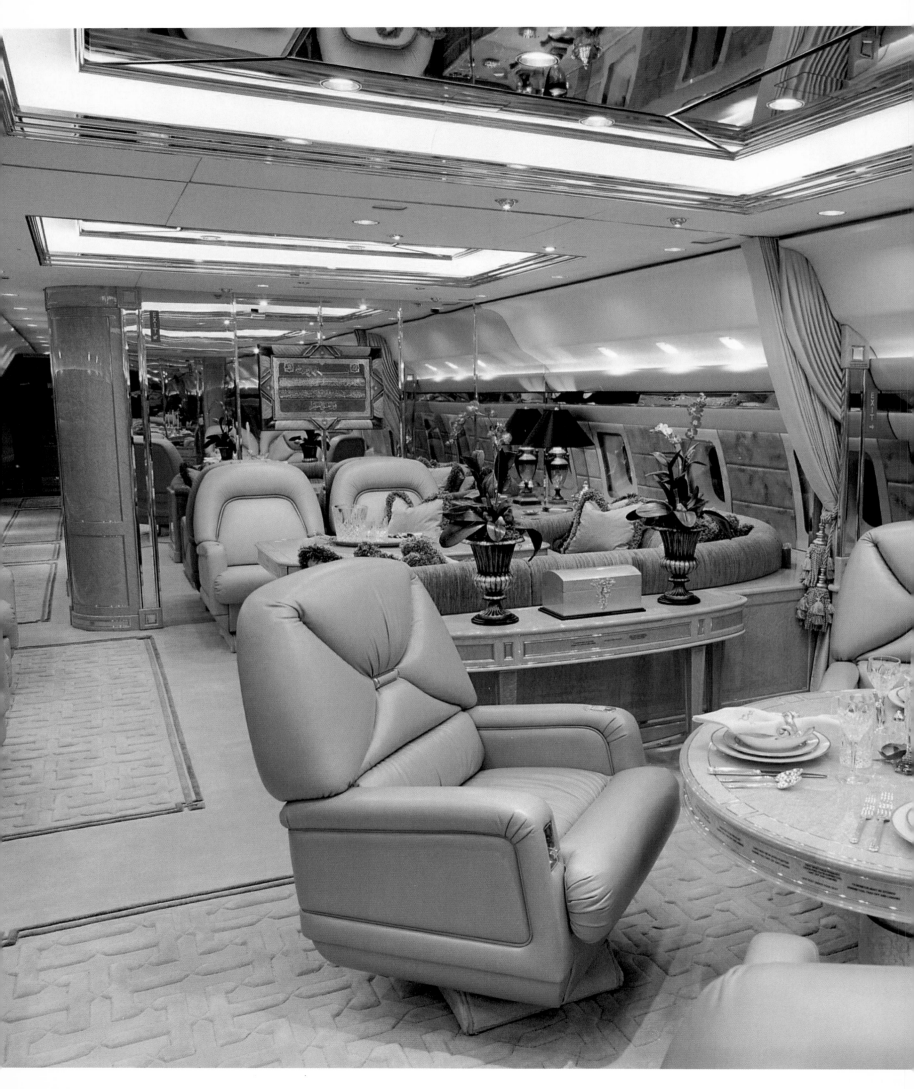

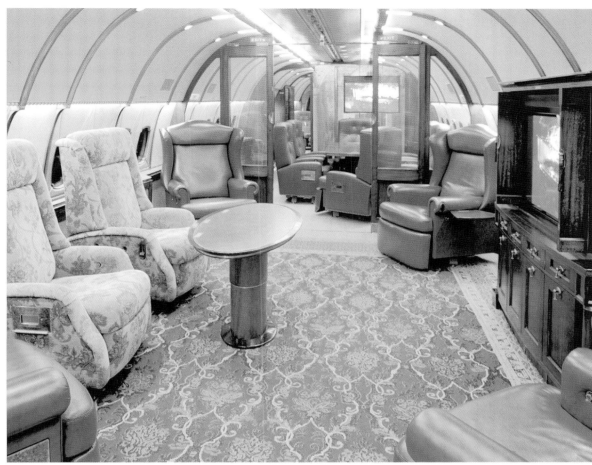

Boeing Business Jet 737

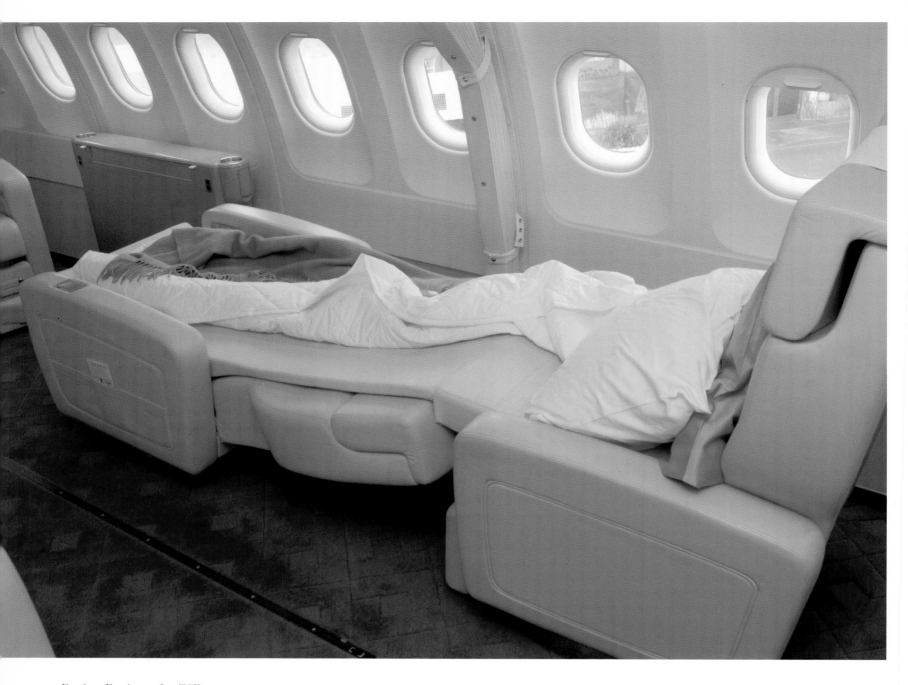

Boeing Business Jet 737

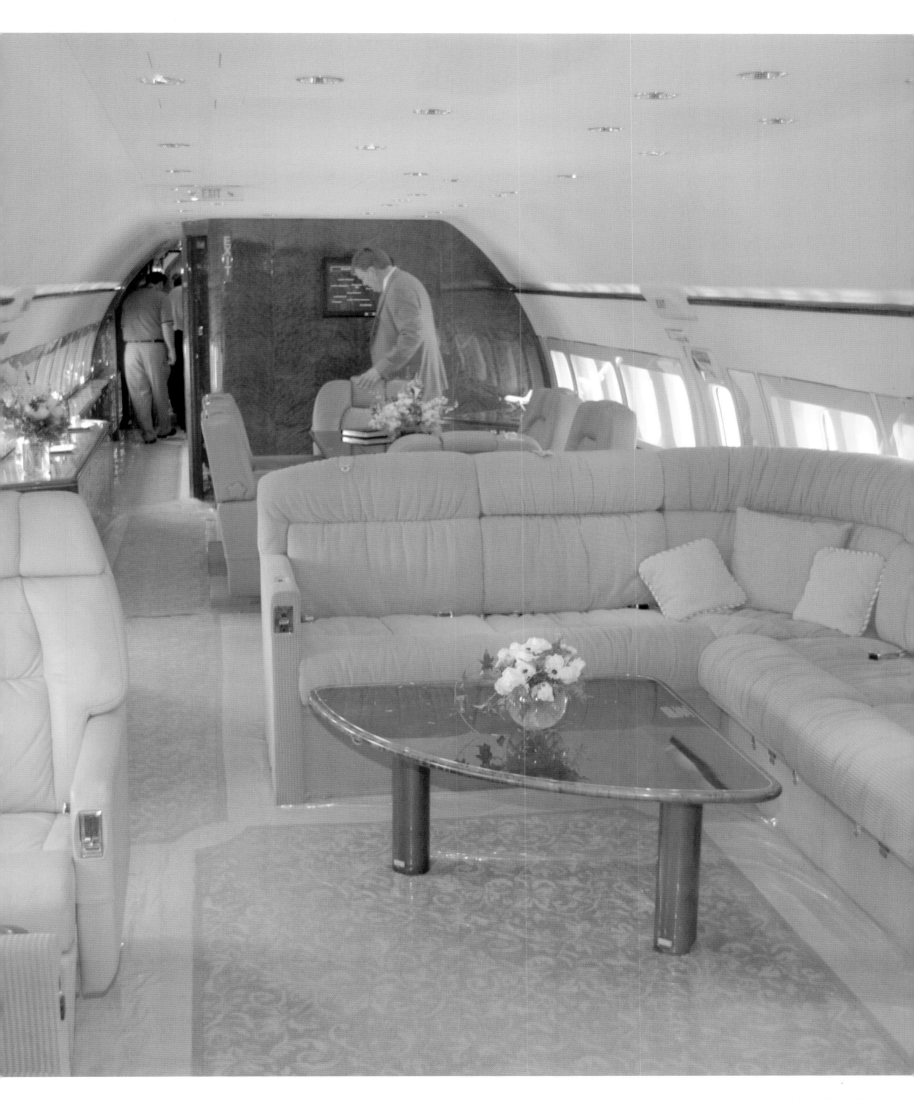

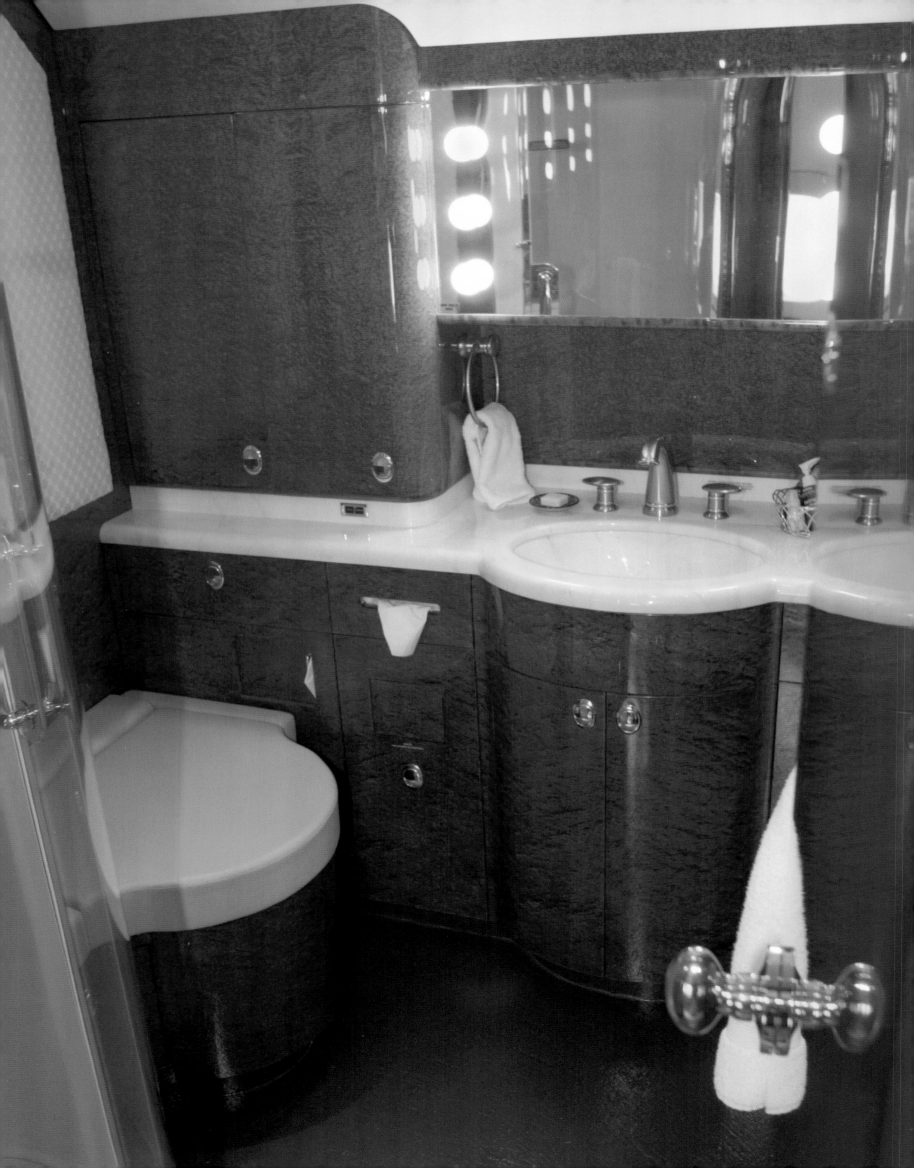

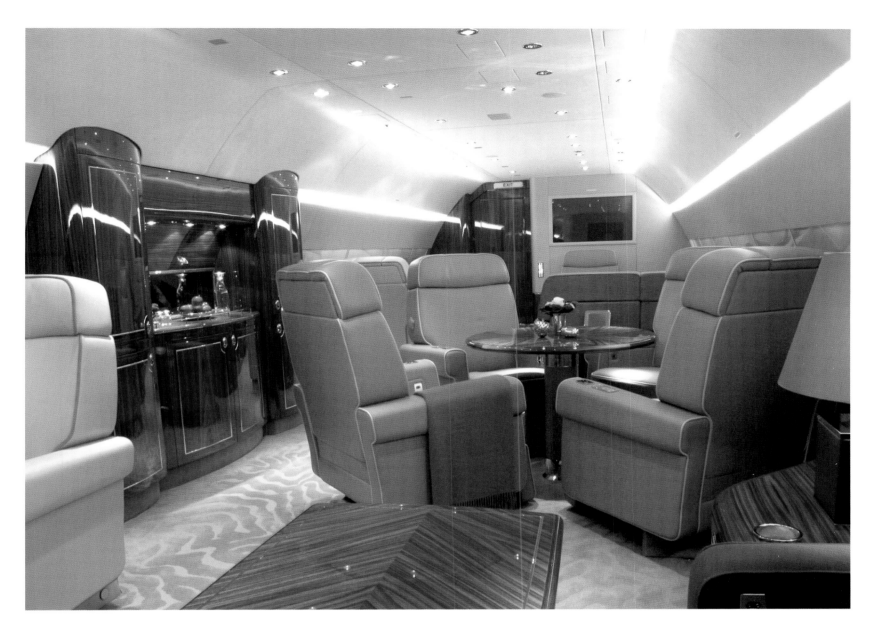

Boeing Business Jet 737

New wider-bodied jets allow for flat floors and multiple rooms. The largest can even accommodate a bedroom suite including a full-size bed, bathroom and shower.

Neuere großräumige Jets bieten genug Platz für breite Gänge und mehrere Räume. Der größte kann auch als Schlafzimmer eingerichtet werden mit einem Doppelbett, Badezimmer und Duschkabine.

Les jets récents à forte capacité offrent suffisamment d'espace pour disposer de larges couloirs et de plusieurs pièces. La pièce principale peut par exemple être aménagée comme chambre à coucher, avec un lit double, une salle de bain et une cabine de douche.

La nueva generación de jets espaciosos ofrecen lugar suficiente para amplios pasillos y numerosos compartimentos. El mayor puede convertirse en dormitorio con cama de matrimonio, baño y ducha.

Nei nuovi, grandi jet c'è spazio a sufficienza per comodi corridoi e l'articolazione di vari settori. Il più grande di essi può venir arredato come camera da letto, con letto a castello, bagno e box doccia.

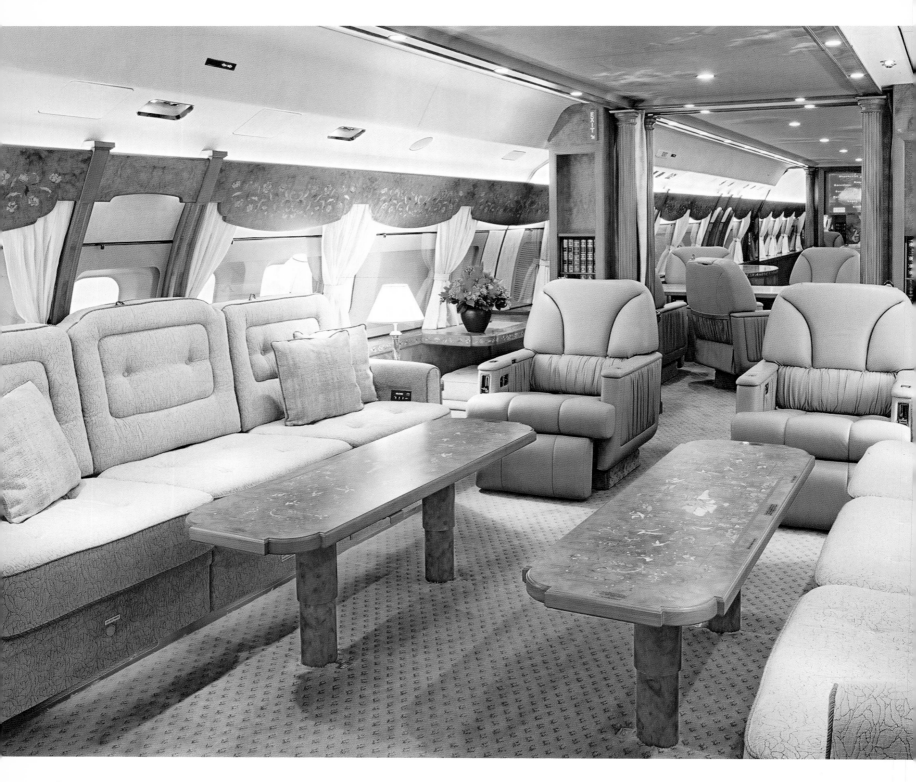

Boeing Business Jet 737

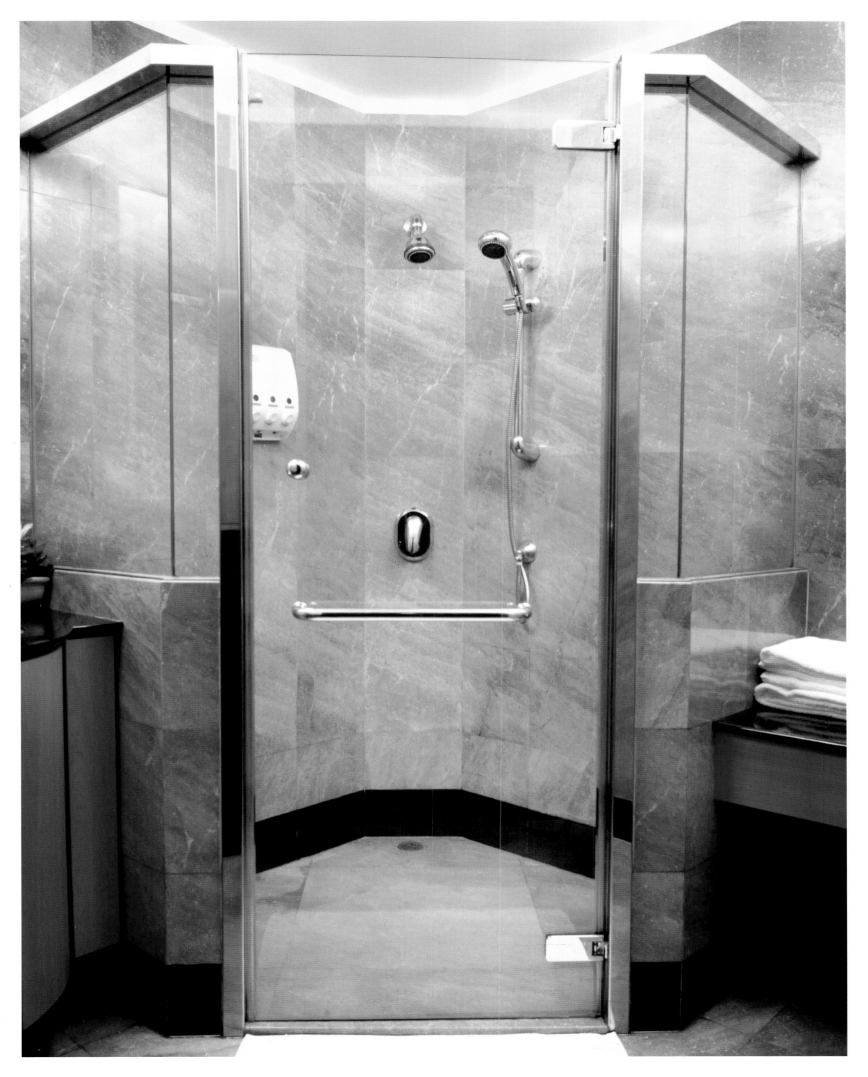

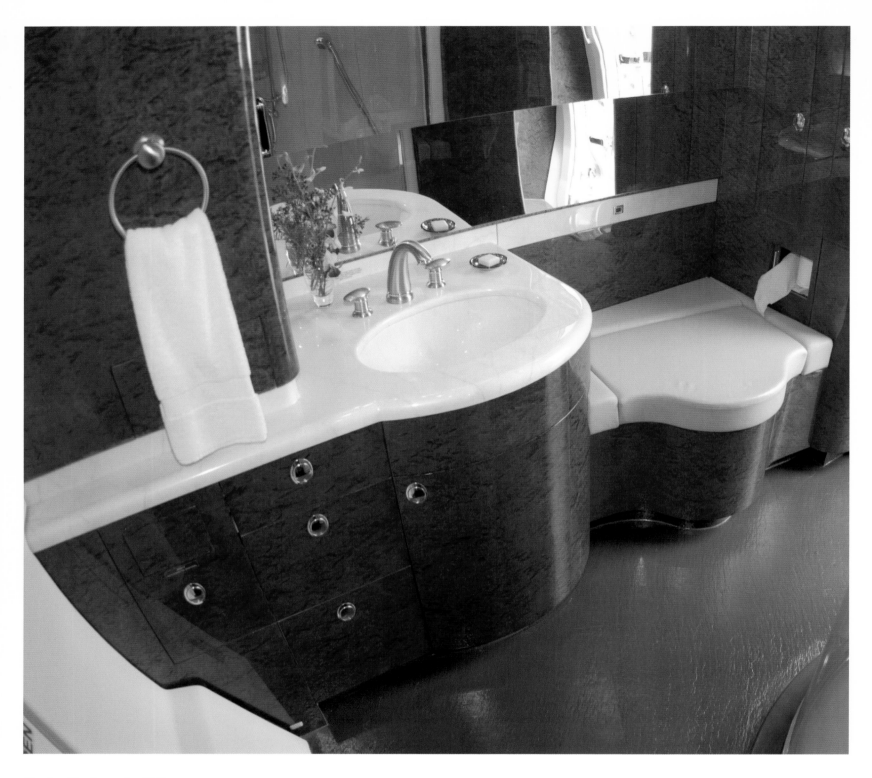

Boeing Business Jet 737

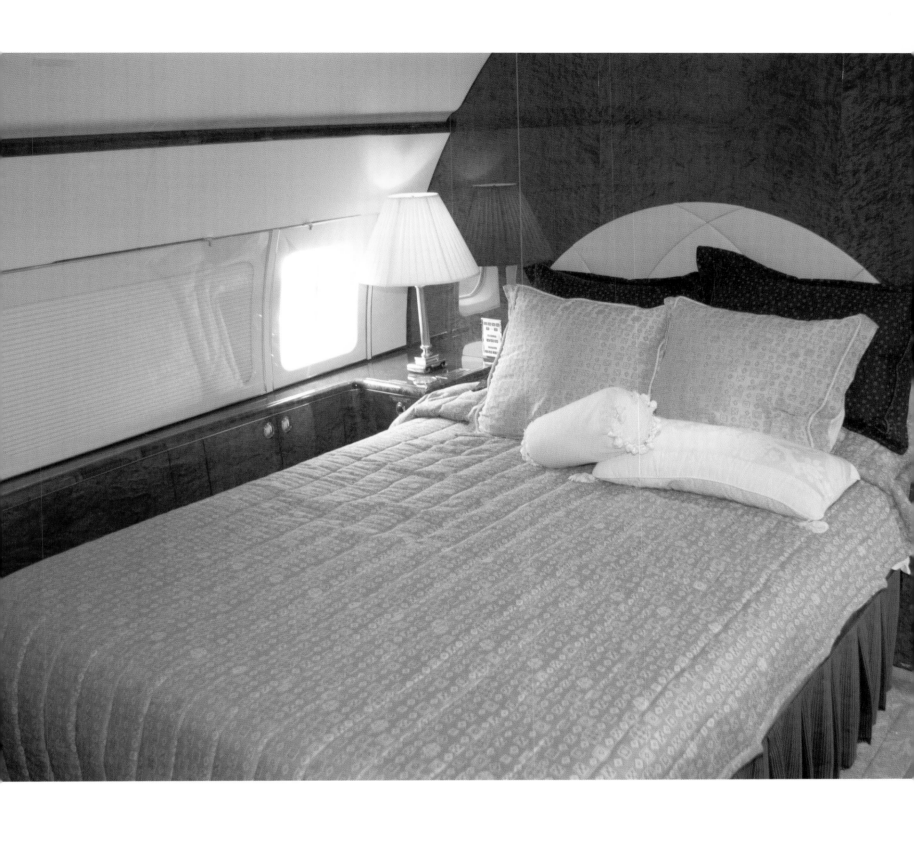

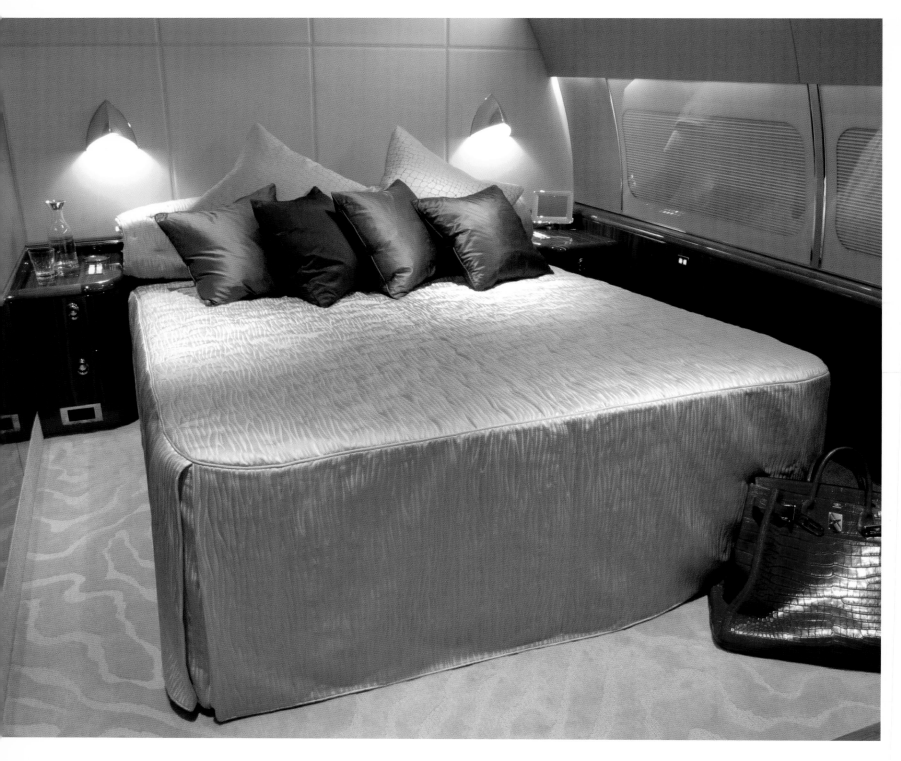

Private bedroom suite of a Boeing Business Jet 737 with room for a queen-size bed and full shower (Reiner Heim Aircraft Interior Design)

Privates Schlafzimmer im Business-Jet Boeing 737 mit ausreichendem Platz für ein großes Doppelbett und Badezimmer (Reiner Heim Aircraft Interior Design)

La suite privée conçue par l'entreprise de design intérieur pour avions Reiner Heim, et installée dans la version avion d'affaires du Boeing 737, a suffisamment de place pour accueillir un grand lit et une salle de bain.

Dormitorio privado en el Jet Business Boeing 737 con amplio espacio para una cama de matrimonio y un baño (Reiner Heim Aircraft Interior Design)

La stanza da letto privata di un business-jet Boeing 737, con spazio in abbondanza per un grande letto matrimoniale ed un bagno (Reiner Heim Aircraft Interior Design).

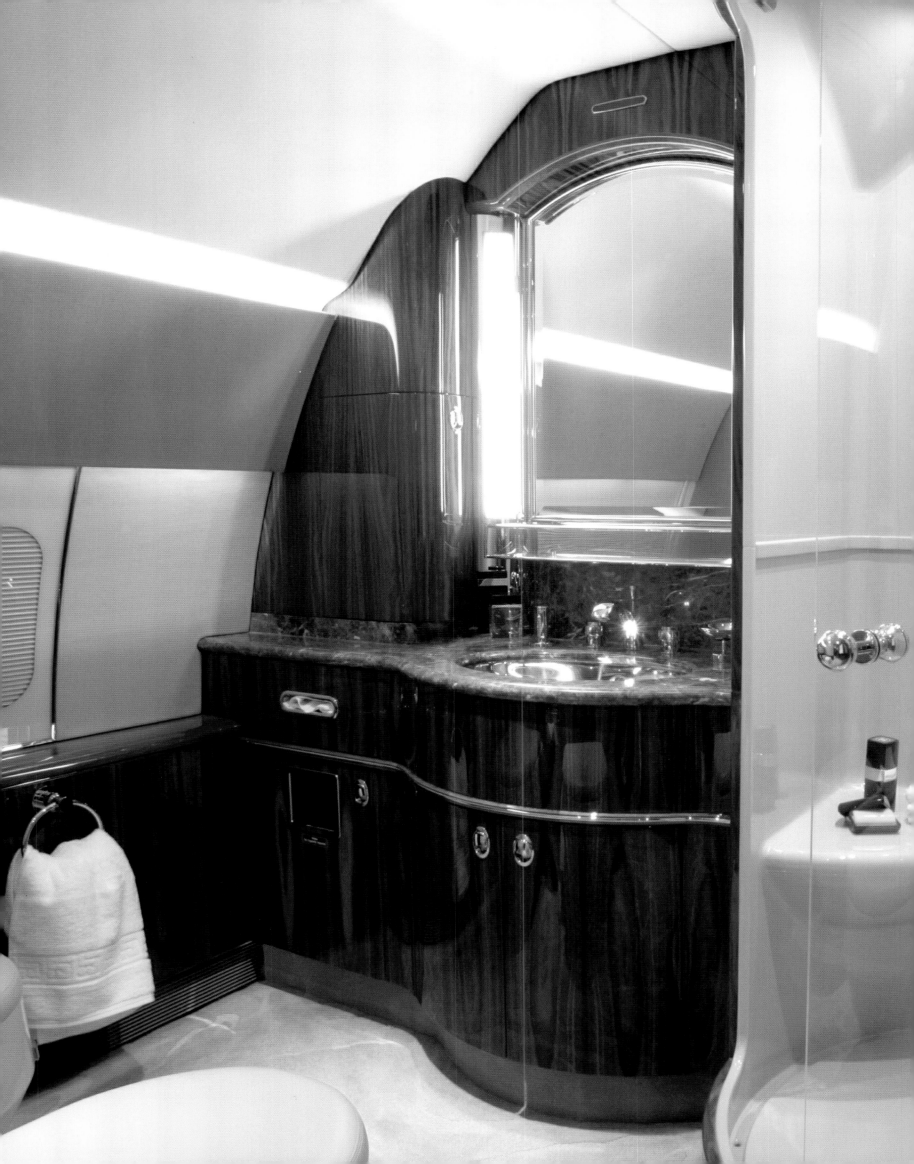

Private Jets

Private Jets

While air travel is simply the most efficient way to get from A to B, even First-Class passengers are subject to the schedules, delays, and hassle of airports. For those travellers who need the utmost in convenience and luxury, a private jet is often the best option. With a complete mobile office, busy executives can fully utilize their flight time, and VIPs can relax in a customized environment.

Die Flugreise ist der einfachste Weg, um von einem Ort der Welt zum anderen zu gelangen. Aber auch Reisende der Ersten Klasse müssen Flugpläne, Verspätungen und Unbequemlichkeiten der Flughäfen in Kauf nehmen. Für Passagiere, die auf größten Komfort und Luxus nicht verzichten wollen, ist der Privatjet die beste Möglichkeit zu reisen. Ausgestattet mit einem kompletten mobilen Büro, können Geschäftsleute ihre Flugzeit für die Erledigung ihrer Arbeit nutzen, und VIPs können im maßgeschneiderten Ambiente entspannen.

Le voyage en avion est la solution la plus simple pour se rendre d'un endroit à l'autre de la planète. Mais même les passagers de première classe doivent s'accommoder des horaires, des retards et des désagréments des aéroports. Pour les passagers qui ne veulent pas se passer du confort et du luxe le plus exigeant, le jet privé est l'idéal pour voyager. Disposant ainsi d'un bureau mobile complet, les hommes d'affaires peuvent utiliser le temps de vol pour poursuivre leur travail, et les VIP se détendre dans un environnement spécialement conçu pour eux.

Un viaje en avión es los la forma más sencilla de llegar de un lugar del mundo a otro. Sin embargo, hasta pasajeros de primera clase tienen que soportar horarios, retrasos y las incomodidades de un aeropuerto. Para aquellas personas que no quieran prescindir de lujo y confort, un jet privado es la mejor alternativa de viajar. Disponiendo de un despacho móvil, los ejecutivos pueden aprovechar la duración del vuelo para trabajar y los VIPs tienen posibilidad de relajarse en un ambiente diseñado a medida.

Benché il viaggio aereo sia il modo più sbrigativo di passare da un punto all'altro del pianeta anche i viaggiatori della prima classe devono fare i conti con gli orari, i ritardi e le scomodità degli aeroporti. Per i passeggeri che non vogliano rinunciare a lusso e comfort, il jet privato rimane il modo migliore di viaggiare. Grazie ad una location mobile, sia essa ufficio o lounge, gli uomini d'affari sono in grado di sfruttare l'intervallo del volo per proseguire il proprio lavoro, mentre i VIP possono dal canto loro rilassarsi in un ambiente fatto su misura.

Learjet 60

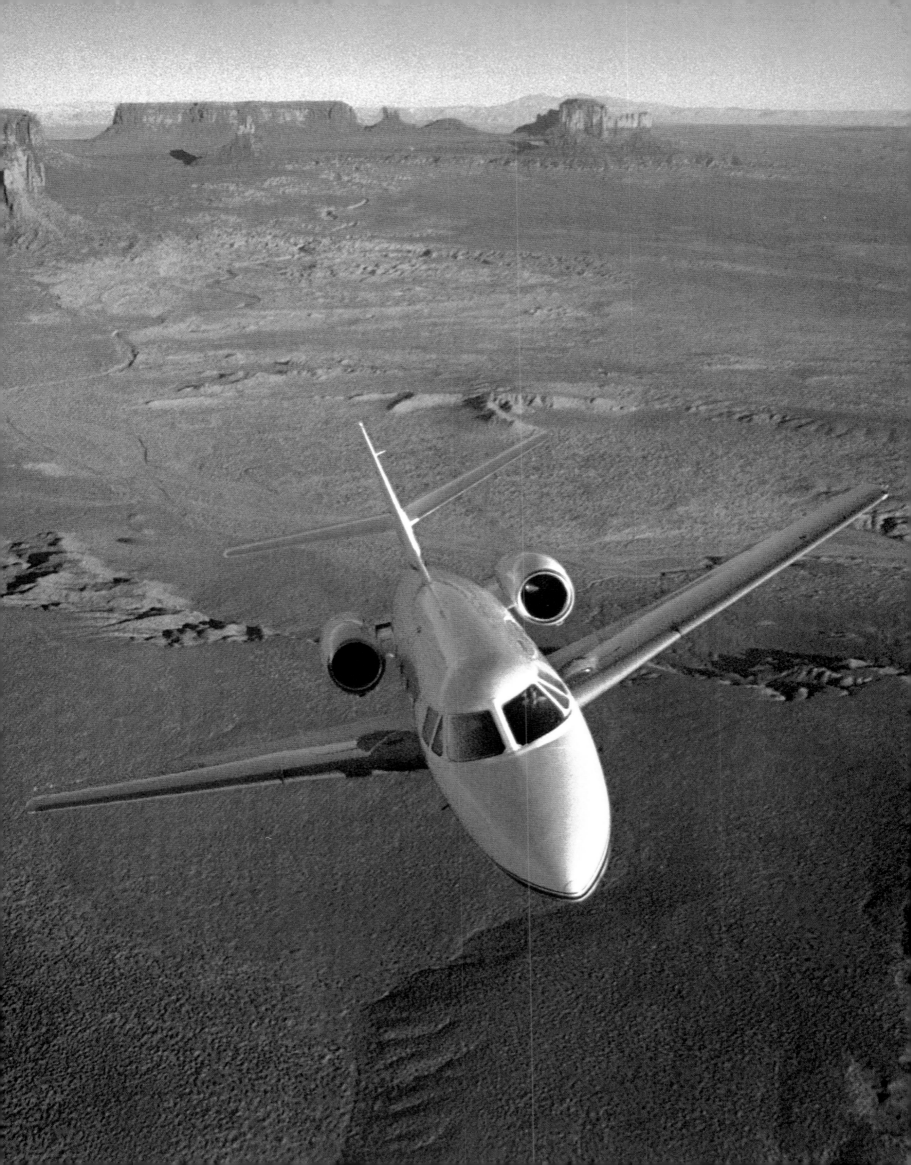

Cessna Citation X

The Citation X is the biggest and fastest jet which Cessna manufactures. With a maximum speed of over 960 km/h this machine is the fastest business travel aircraft in the world and is used for intercontinental flights. The owner of a Citation X has the luxury of a journey of only four hours between New York and Los Angeles, given normal weather conditions. The basic model of the Citation X offers space for nine passengers. Despite its enormous capacity, the machine, which is equipped with two bypass-engines, can run on less fuel then a typical jet.

Die Citation X ist der größte und schnellste Jet, den Cessna herstellt. Mit einer maximalen Geschwindigkeit von über 960 km/h ist die Maschine das schnellste Geschäftsflugzeug der Welt, das für Interkontinentalflüge eingesetzt wird. Der Besitzer einer Citation X kann den Luxus genießen, die Strecke von New York nach Los Angeles bei normalen Wetterbedingungen in nur knapp vier Stunden zurückzulegen. In der Grundausstattung bietet die Citation X Platz für neun Passagiere. Trotz ihrer enormen Leistungsstärke kommt die Maschine, die mit zwei Bypass-Triebwerken ausgestattet ist, mit weniger Treibstoff aus als ein gängiger Jet.

Le Citation X est le plus gros et le plus rapide des jets produits par la firme Cessna. Capable d'atteindre une vitesse de plus de 960 km/h, cet appareil, utilisé pour les vols intercontinentaux, est en fait le plus rapide de tous les avions d'affaires. Le propriétaire d'un Citation X peut savourer le luxe de franchir la distance qui sépare New York de Los Angeles en à peine quatre heures dans des conditions météorologiques normales. Dans sa version standard, le Citation peut emporter neuf passagers. Malgré ses performances remarquables, cet appareil équipé de deux réacteurs by-pass, a une consommation inférieure à celle d'un jet classique.

El Citation X es el jet más grande y rápido fabricado por Cessna. Con una velocidad máxima superior a los 960 km/h, es el avión de negocios más rápido del mundo utilizado para vuelos intercontinentales. El propietario de un Citation X disfruta del lujo de poder volar de Nueva York a Los Ángeles, bajo condiciones meteorológicas normales, en sólo cuatro horas. En la versión estándar, el Citación X brinda espacio a nueve personas. A pesar de su enorme potencia, este avión biturbina gasta menos combustible que un jet normal.

Il Citation X è il più grande e veloce jet prodotto da Cessna. Con una velocità massima superiore ai 960 chilometri orari, questo apparecchio è il business-jet più veloce del mondo ad essere impiegato in viaggi intercontinentali. In condizioni atmosferiche normali il proprietario di un Citation X può godersi il lusso di percorrere il tratto New York – Los Angeles in appena quattro ore. Il modello standard ospita nove passeggeri. Nonostante l'alto livello delle prestazioni, grazie ai due motori bypass l'apparecchio ha un fabbisogno di carburante minore rispetto ai normali jet.

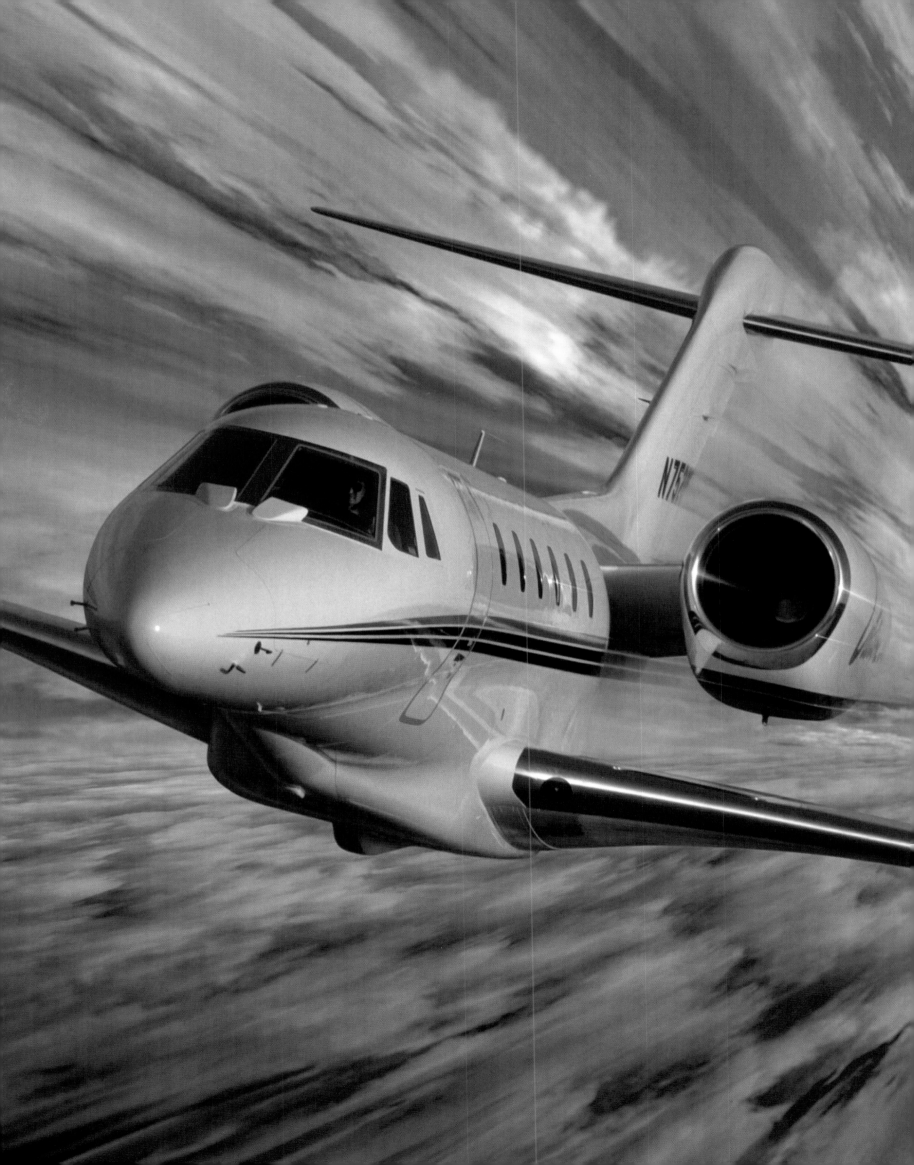

In December 1993 the prototype of the Citation X completed its first test flight. The machine was put on the market in 1996. The first proud owner of a Cessna Citation X was the famous American professional golfer Arnold Palmer who valued the speed and comfort of the Citation X. The development team was awarded the Collier Trophy of the "National Aeronautics Association" in 1997.

Im Dezember 1993 startete der Prototyp der Citation X zu seinem ersten Testflug. 1996 wurde die Maschine auf den Markt gebracht. Der erste stolze Besitzer einer Cessna Citation X war der berühmte US-Golfprofi Arnold Palmer, der die Geschwindigkeit und den Komfort der Citation X schätzte. 1997 erhielt das Entwicklungsteam die Collier Trophy der „National Aeronautics Association".

Le prototype du Citation X a effectué son premier vol d'essai en décembre 1993. Il a été commercialisé à partir de 1996. Très impressionné par le confort et la vitesse de l'appareil, le champion américain de golf Arnold Palmer a été le premier à pouvoir s'enorgueillir d'en posséder un. L'équipe qui l'a mis au point a obtenu en 1997 le trophée Collier de l'association aéronautique nationale (National Aeronautics Association).

En diciembre de 1993 el prototipo del Citación X realizó su primer vuelo de prueba. En 1996 se introdujo el avión en el mercado. El primer propietario del Cessna Citation X fue el famoso campeón de golf estadounidense Arnold Palmer, que apreciaba su velocidad y confort. En 1997, el equipo de desarrollo recibió el trofeo Collier de la "Nacional Aeronautics Association".

Il primo collaudo per il prototipo del Citation X fu effettuato nel 1993. L'apparecchio fu introdotto sul mercato nel 1996 ed uno dei primi, orgogliosi, proprietari fu il famoso golfista Arnold Palmer. Palmer espresse allora il suo apprezzamento per il comfort del Citation X. Il team responsabile per lo sviluppo di questo modello ha ricevuto nel 1997 il premio Collier della "National Aeronautics Association".

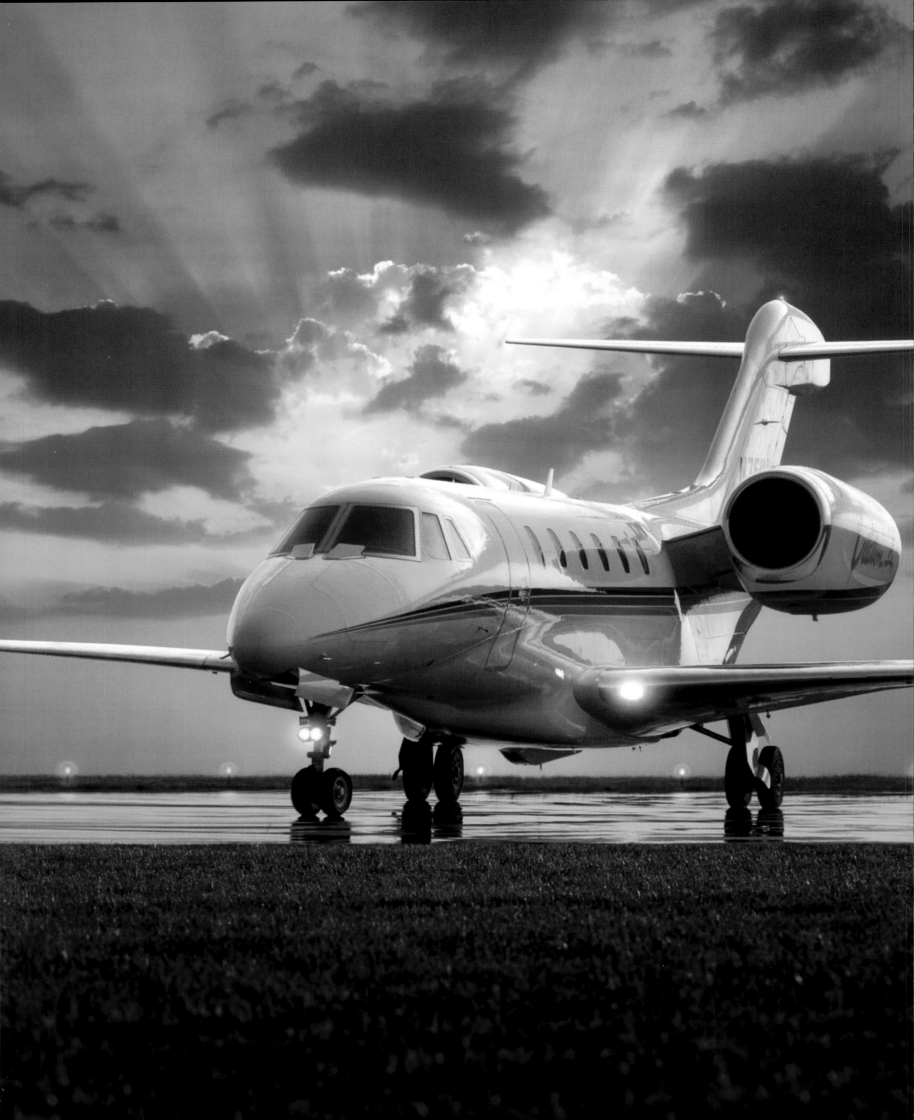

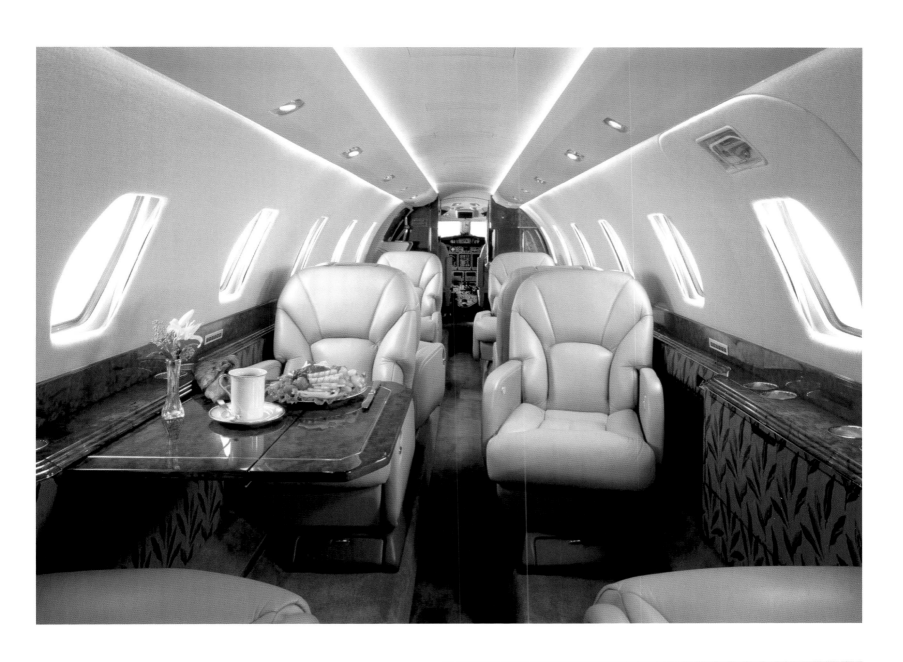

Technical Specifications

Type	Cessna Citation X medium-sized business jet
Manufacturer	Cessna Aircraft Company
Passenger Capacity	12
Engines	Two Rolls-Royce AE 3007C1 Turbofans
Range	6,020 km
Cruise Speed	924 km/h
Max. Cruise Speed	934 km/h
Length	22.00 m
Wingspan	19.40 m
Baggage capacity	2.30 m³
Empty Weight	9730 kg
Price	US $ 20 million

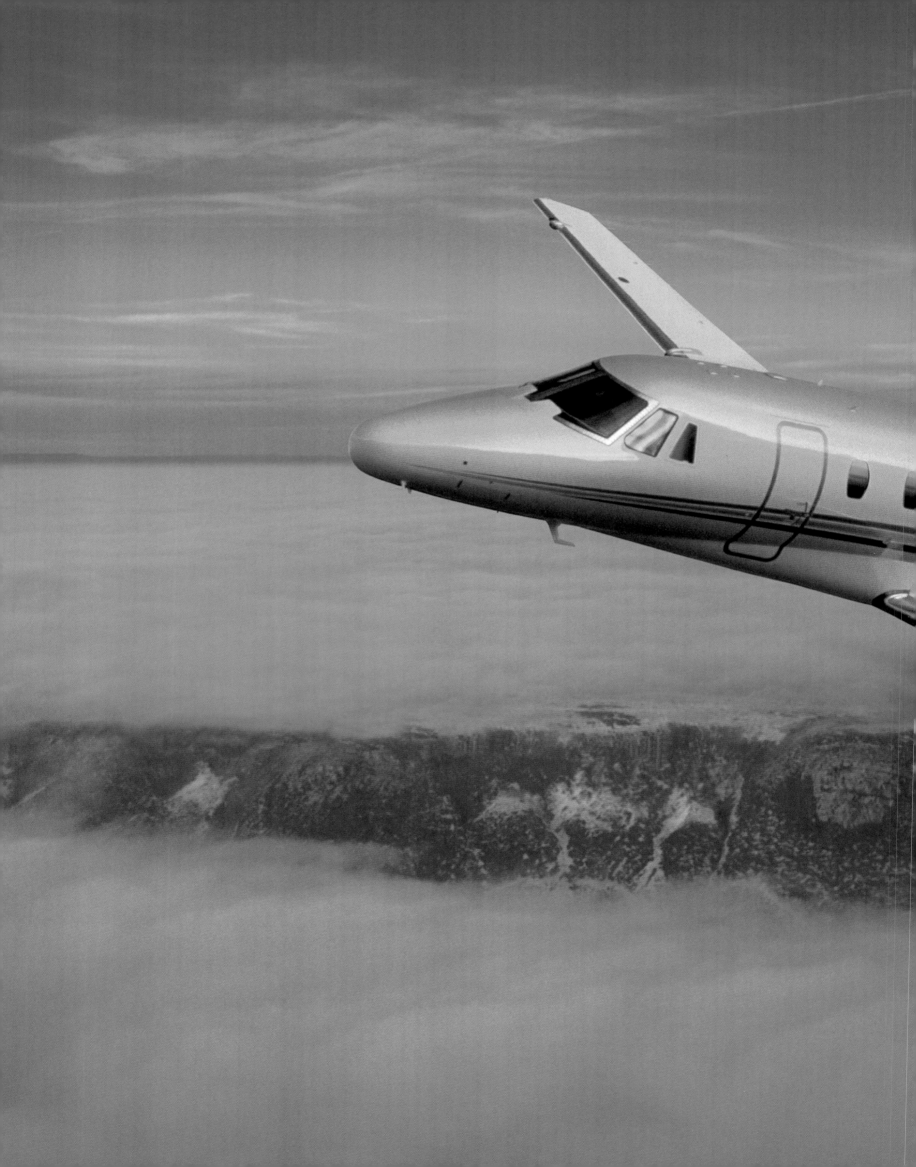

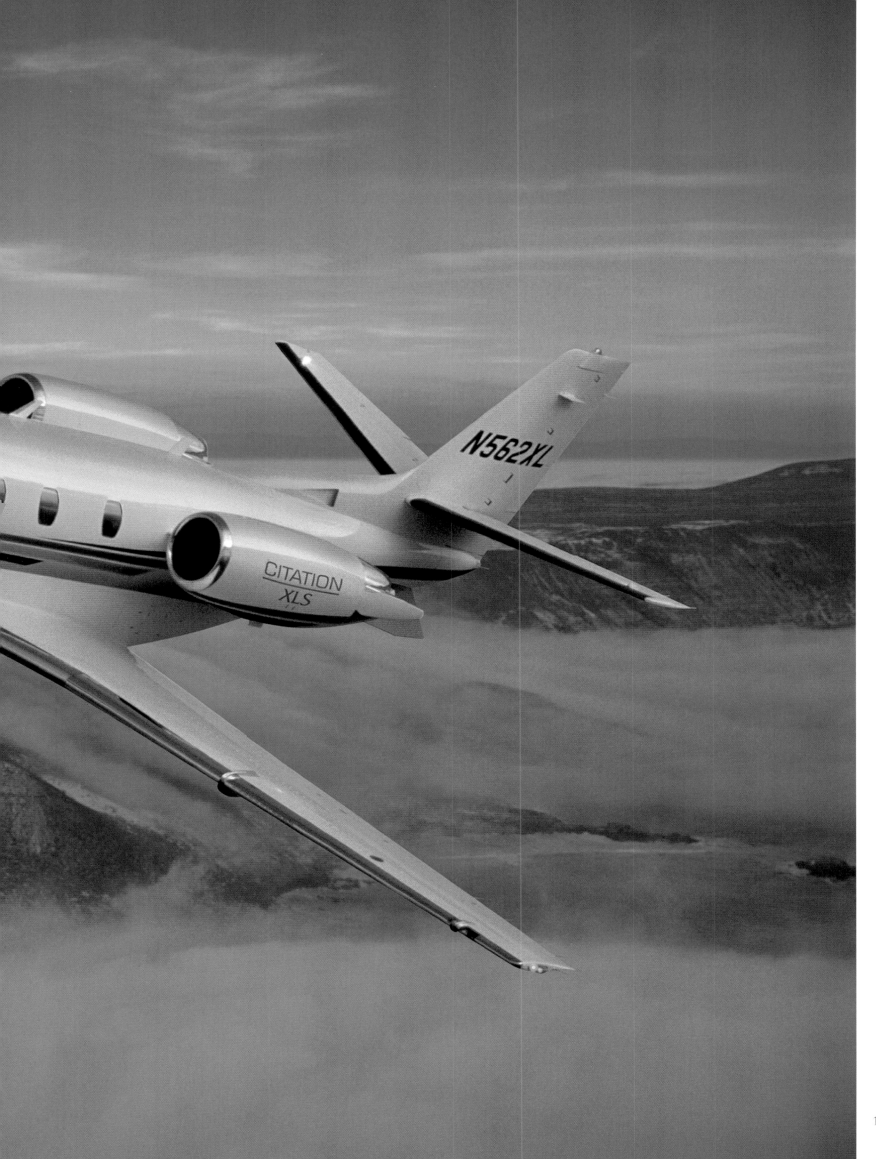

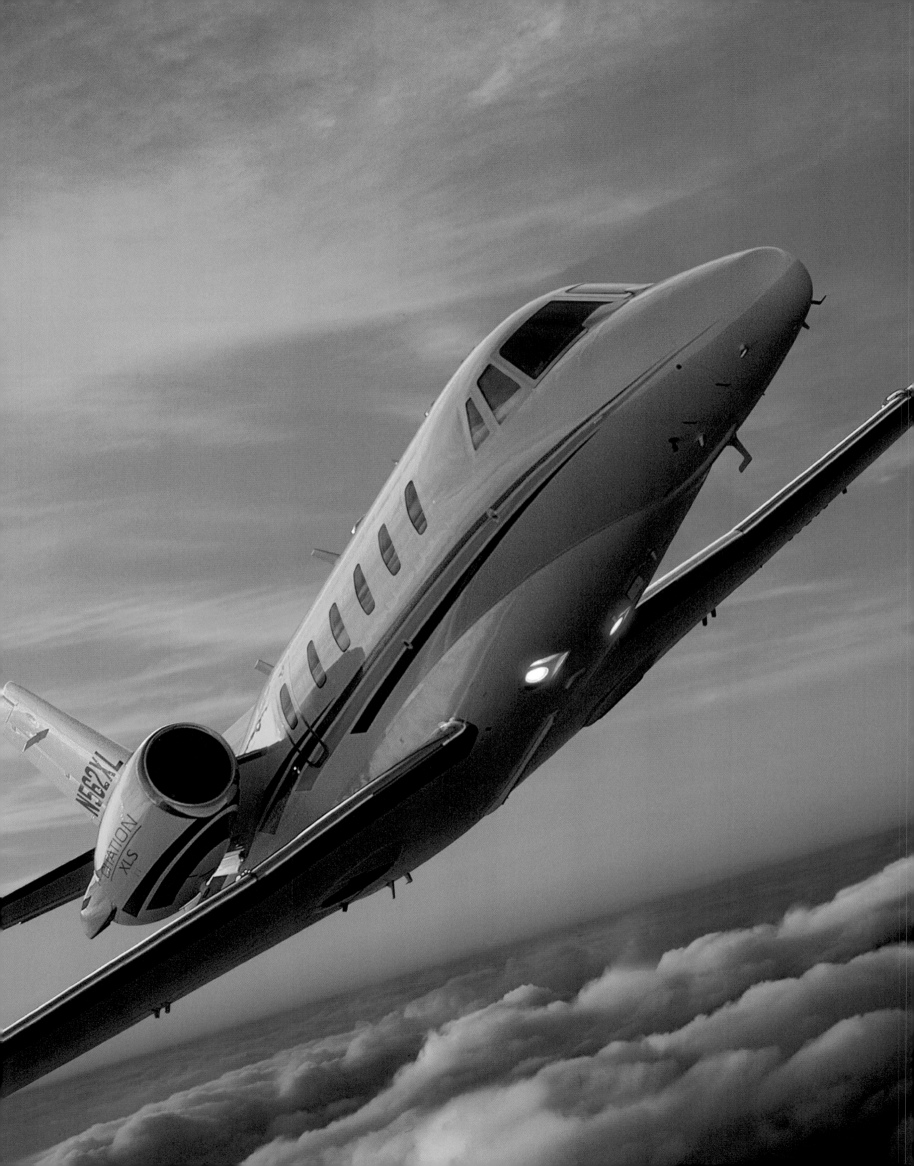

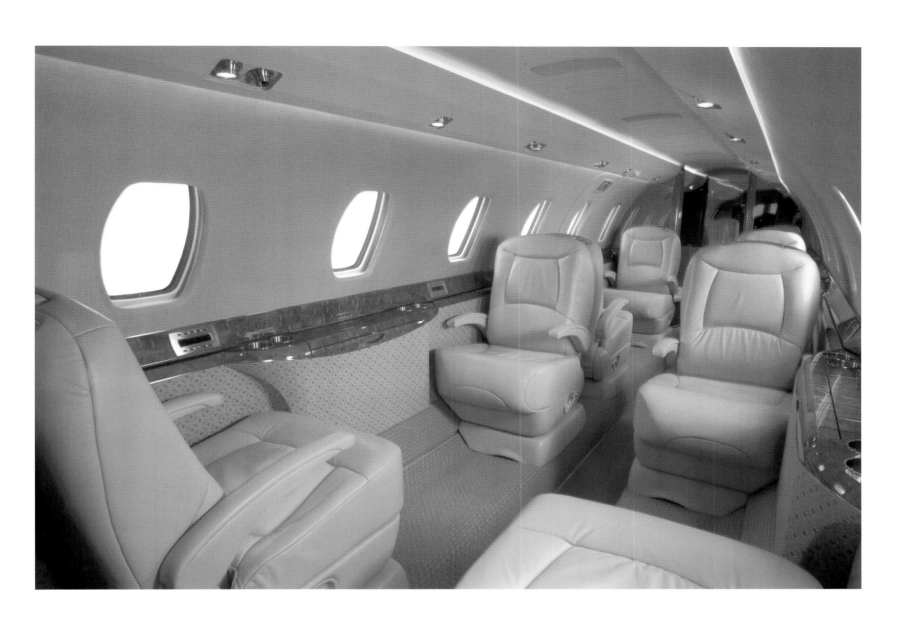

Type	Cessna Citation XLS medium-sized business jet
Manufacturer	Cessna Aircraft Company
Passenger Capacity	8
Engines	Two Pratt&Whitney PW545B
Range	3600 km
Cruise Speed	863 km/h
Max. Cruise Speed	934 km/h
Length	15.79 m
Wingspan	16.98 m
Baggage capacity	2.04 m³
Empty Weight	5.625 kg
Price	US $ 10 million

Cessna Citation Mustang

With the Mustang, constructed within the framework of the "Cessna Group II design development program" Cessna put the lowest priced and most mobile small-bodied airplane on the market. The ultralight business travel aircraft can land on shorter runways than the bigger jets. The machine will be delivered in 2006, and Cessna can already count on 240 fixed reservations.

Mit der Mustang, die im Rahmen des „Cessna Group II design development program" konstruiert wurde, bringt Cessna das preisgünstigste und wendigste Kleinflugzeug der Welt auf den Markt. Das ultraleichte Geschäftsreiseflugzeug kann auf kürzeren Bahnen landen als größere Jets. Die Maschine wird ab 2006 ausgeliefert, 240 feste Bestellungen kann Cessna schon für sich verbuchen.

Avec le Mustang qui a été développé dans le cadre des programmes de développement « Cessna Group II design », Cessna a mis sur le marché l'avion le moins cher et le plus agile au monde dans sa catégorie. Cet avion d'affaires ultraléger peut atterrir sur des pistes plus courtes que les gros jets. 240 commandes fermes ont déjà été enregistrées, et l'appareil sera livré à partir de 2006.

Con el Mustang, construido dentro del programa "Cessna Group II design development programs", la compañía Cessna introduce en el mercado el avión pequeño más económico y versátil del mundo. Este avión ultraligero para ejecutivos puede aterrizar en pistas más cortas que los jets de mayor tamaño. El avión será entregado a partir del 2006, y la compañía Cessna ya dispone de 240 pedidos en fijo.

Con il Mustang – un apparecchio progettato nel quadro dei "Cessna Group II design development programs" – Cessna ha portato sul mercato l'aeroplano più economico e manovrabile del mondo. Questo Business-jet ultraleggero è in grado di atterrare su piste più brevi di quelle necessarie per i jet di maggiori dimensioni. Per l'apparecchio, disponibile dal 2006, Cessna può già contare su 240 ordinazioni.

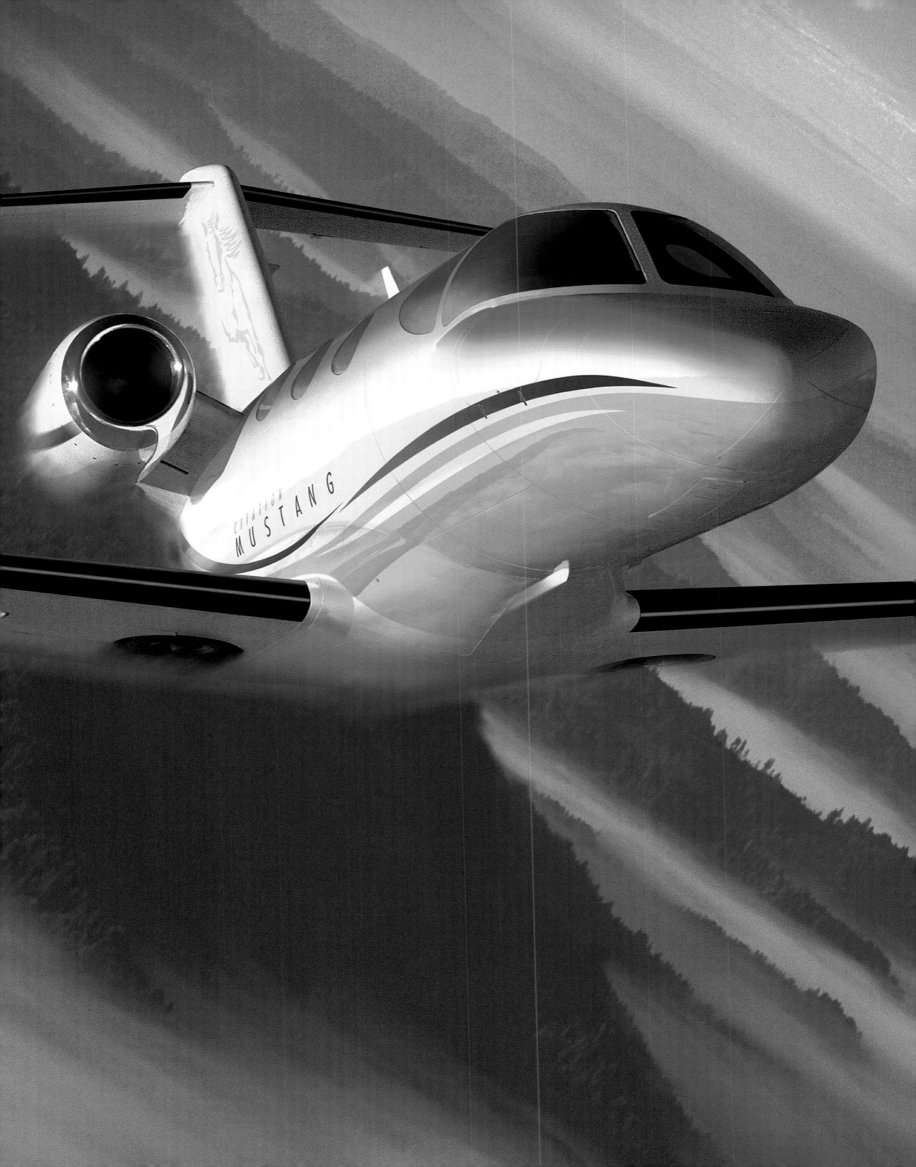

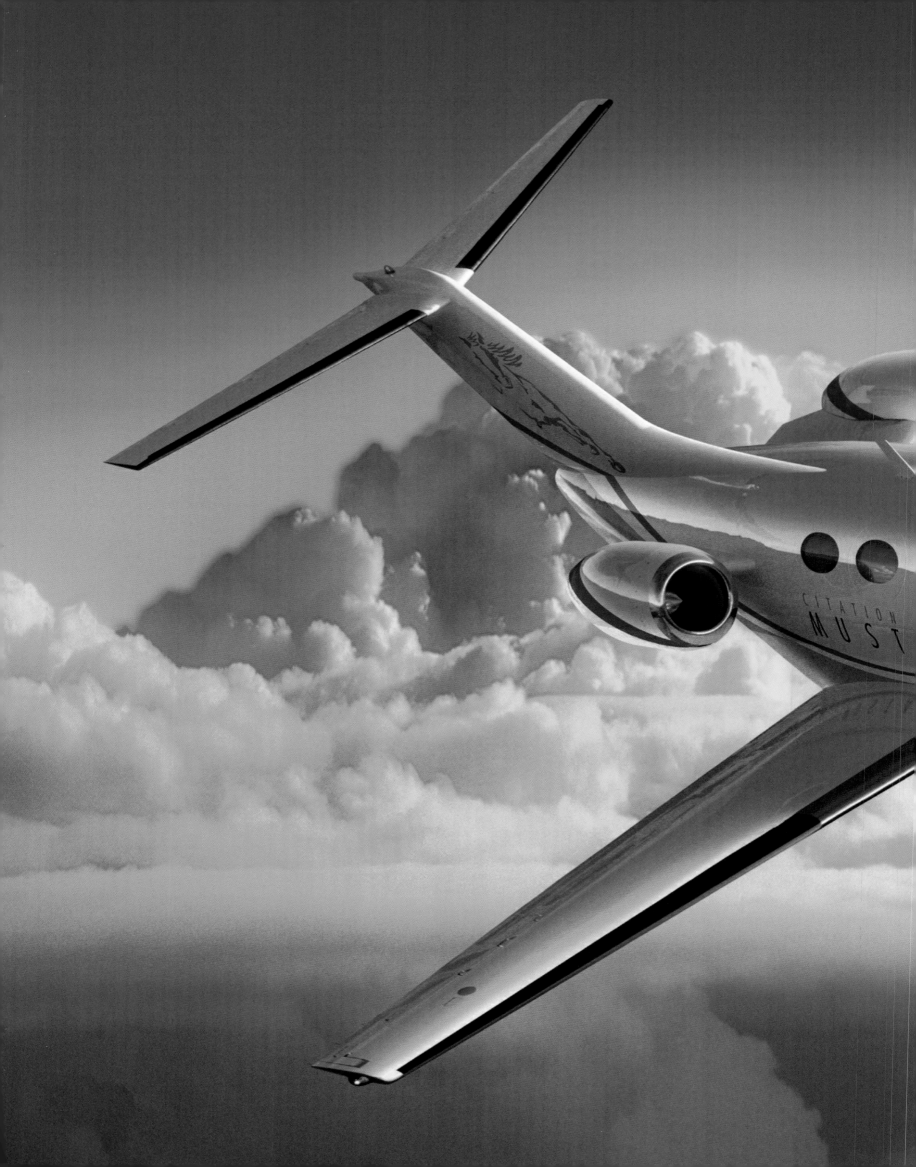

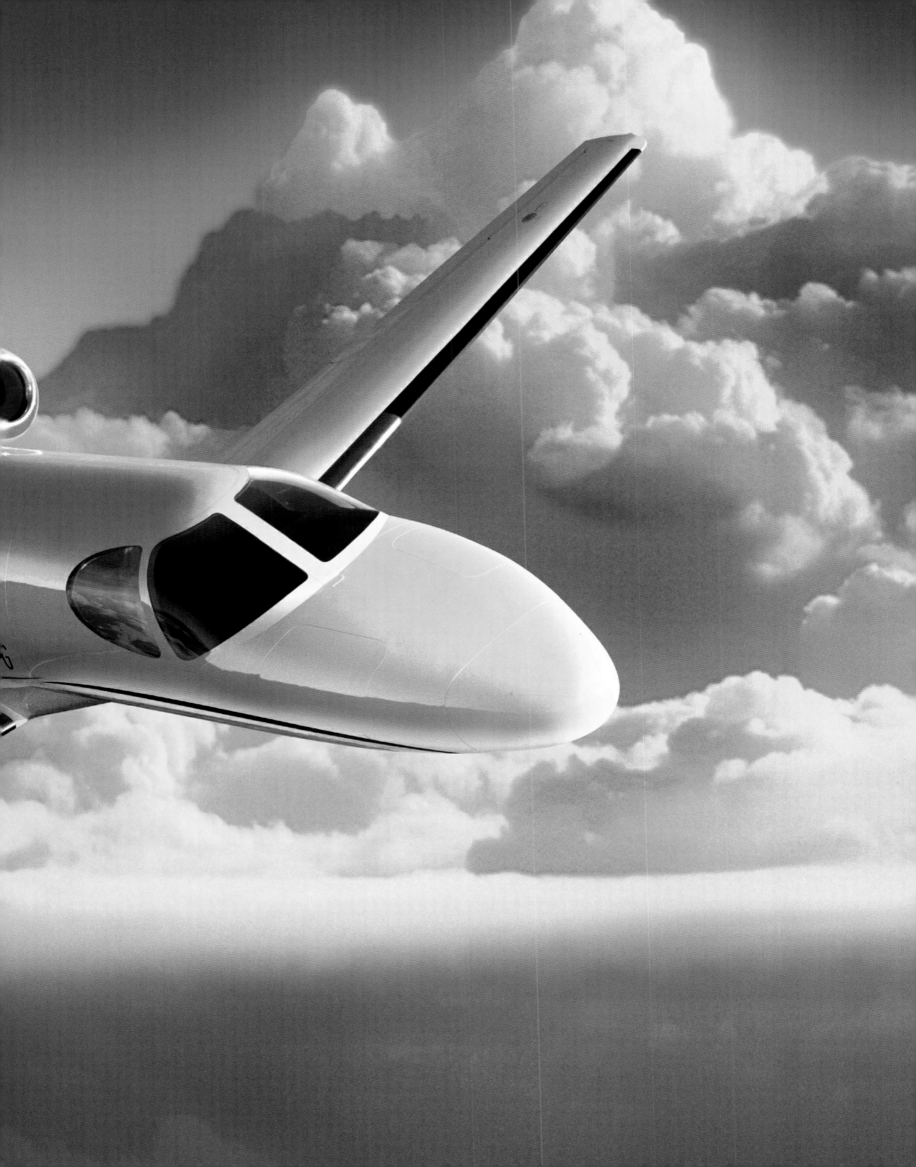

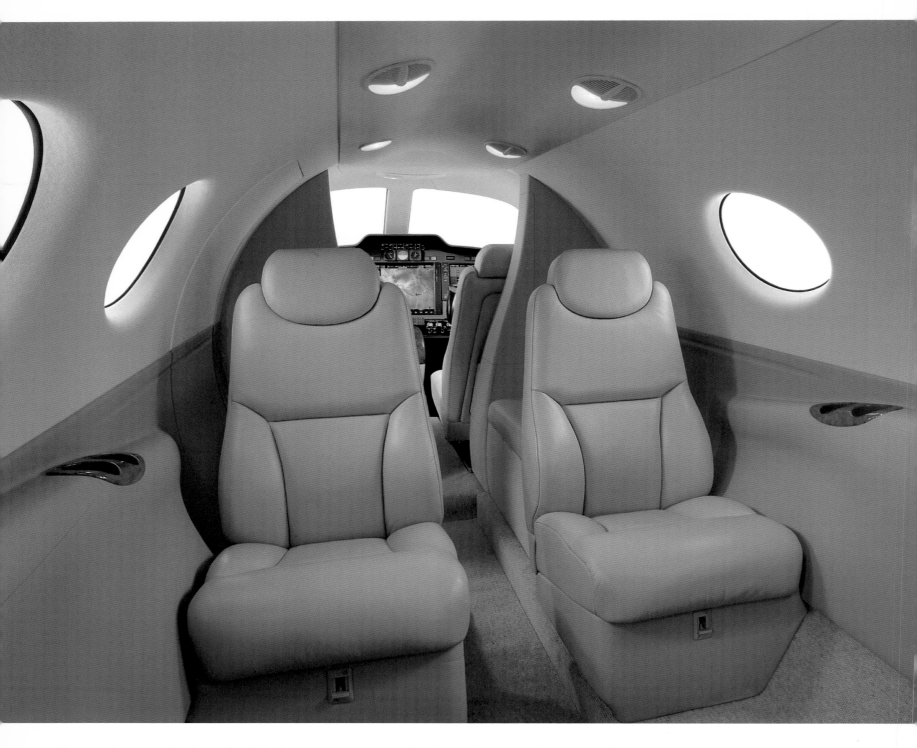

The proud owner of such an ultralight business jet can not only choose the interior but can also fly the machine himself. The basic model is outfitted with a seating group for four passengers, a couch and a private bathroom.

Der stolze Besitzer eines solchen ultraleichten Businessjets kann nicht nur das Interieur bestimmen, sondern die Maschine auch selbst fliegen. In der Grundausstattung verfügt das Flugzeug über eine Sitzgruppe für vier Passagiere, eine Sitzcouch und ein Privatbad.

Le propriétaire d'un avion d'affaires ultraléger de ce type peut non seulement déterminer lui-même la configuration de la cabine, mais il peut aussi le piloter lui-même. Dans sa version de base, l'avion dispose de quatre sièges pour les passagers, d'un canapé et d'une salle de bains.

El flamante propietario de un jet ultraligero de negocios no sólo decide sobre el interior del avión sino que también puede pilotarlo él mismo. En su versión estándar el avión dispone de un grupo de butacas para cuatro personas, sofá y baño.

Oltre a scegliere l'allestimento degli interni, l'orgoglioso proprietario di un Business-jet ultraleggero può anche pilotare da sé l'apparecchio. L'allestimento del modello base prevede un gruppo di quattro posti per i passeggeri, sedili a divano e un bagno privato.

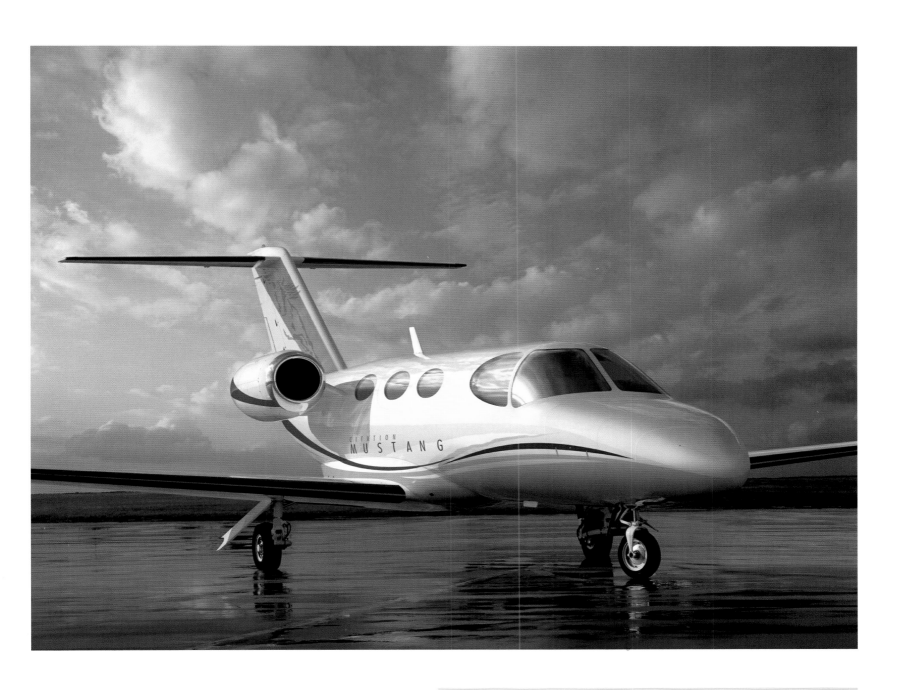

Technical Specifications

Type	Cessna Citation Mustang
	Super light business jet
Manufacturer	Cessna Aircraft Company
Passenger Capacity	4 passengers
Range	2.408 km
Engines	Two Pratt&Whitney Canada PW615F
Cruise Speed	603 km/h
Max. Cruise Speed	815 km/h
Length	11.86 m
Wingspan	12.87 m
Baggage capacity	1.27 m³
Empty Weight	n/a
Price	US $ 2.6 million

Dassault Falcon 50

Introduced in 1976, the Falcon 50 revolutionised private air travel. The Falcon 50 became the first civilian aircraft to fly with a fully optimised wing, now shared by all Falcon aircraft. With three engines, it has a short takeoff and landing requirement that allows landings to be made in places other planes cannot. Capable of transatlantic as well as coast-to-coast flights in the US, it has not only proved popular with busy executives, but has seen military service as well.

Im Jahr 1976 eingeführt, revolutionierte das Geschäftsreiseflugzeug Falcon 50 die private Luftfahrt. Die Falcon 50 ist das erste zivile Flugzeug mit aerodynamisch optimierten Tragflächen, heute Standard in jedem Falcon-Flugzeug. Mit drei Triebwerken ausgestattet, braucht die Falcon 50 wenig Platz für Start und Landung. Deshalb kann sie an Orten landen, wo es anderen Flugzeugen nicht möglich ist. Weil die Falcon 50 für Transatlantikflüge und für Flüge von Küste zu Küste in den USA geeignet ist, wird sie nicht nur von Geschäftsleuten geschätzt, sondern findet auch militärischen Einsatz.

Mis en service en 1976, l'avion d'affaires Falcon 50 a révolutionné le monde de l'aviation privée. Le Falcon 50 a été le premier avion civil disposant d'une voilure optimisée sur le plan aérodynamique et qui équipe désormais tous les Falcons. Ayant trois réacteurs, le Falcon 50 peut atterrir et décoller sur des pistes courtes que d'autres appareils ne peuvent pas utiliser. Dans la mesure où le Falcon 50 est parfaitement adapté aux vols transatlantiques et aux trajets entre les deux côtes des Etats-Unis, il est non seulement très apprécié des hommes d'affaires, mais aussi d'autres utilisateurs civils et militaires.

Lanzado en el año 1976, el jet de negocios Falcon 50 revoluciona la aviación privada. La Falcon 50 es el primer avión civil con alas optimizadas en su aerodinámica, un estándar hoy en todos los aviones Falcon. Equipado con tres reactores, el Falcon 50 requiere poco espacio para despegue y aterrizaje, lo que le permite aterrizar en lugares inaccesibles para otro tipo de aviones. Siendo un avión apto para vuelos transatlánticos o de costa a costa en los EE.UU., el Falcon 50 no sólo es apreciado por ejecutivos sino que también se emplea en operaciones militares o civiles.

Introdotto nel 1976 come aereo per viaggi d'affari il Falcon 50 ha rivoluzionato il mercato dei jet privati. Il Falcon 50 era il primo aereo civile del mondo con un'aerodinamica ottimale delle ali – al giorno d'oggi un requisito standard per ogni apparecchio della serie Falcon. L'apparecchio trimotore Falcon 50 necessita di poco spazio per il decollo e l'atterraggio ed è quindi in grado di atterrare dove altri aerei non possono. Adatto a voli transatlantici e ad attraversate da una costa all'altra degli Stati Uniti l'apparecchio, oltre ad essere sempre stato apprezzato dagli uomini d'affari, è stato anche impiegato dall'esercito.

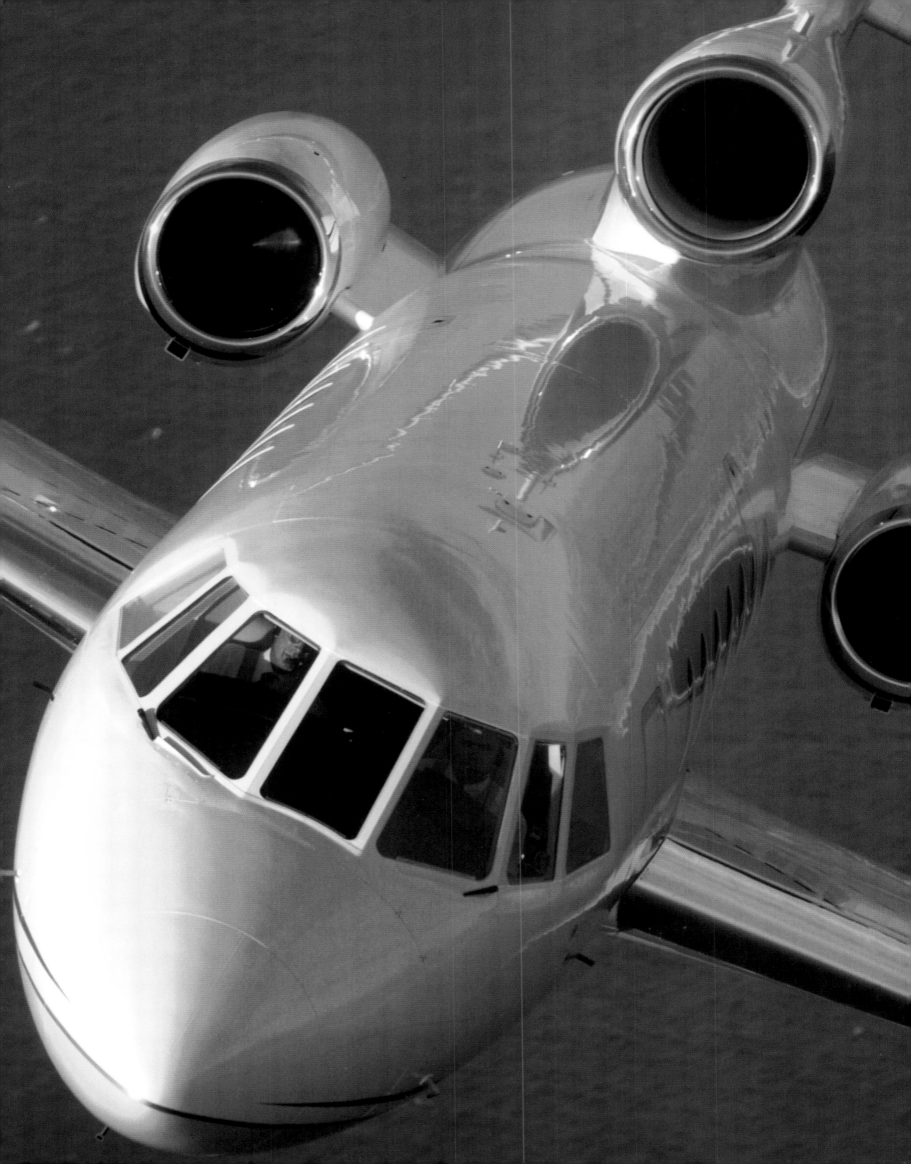

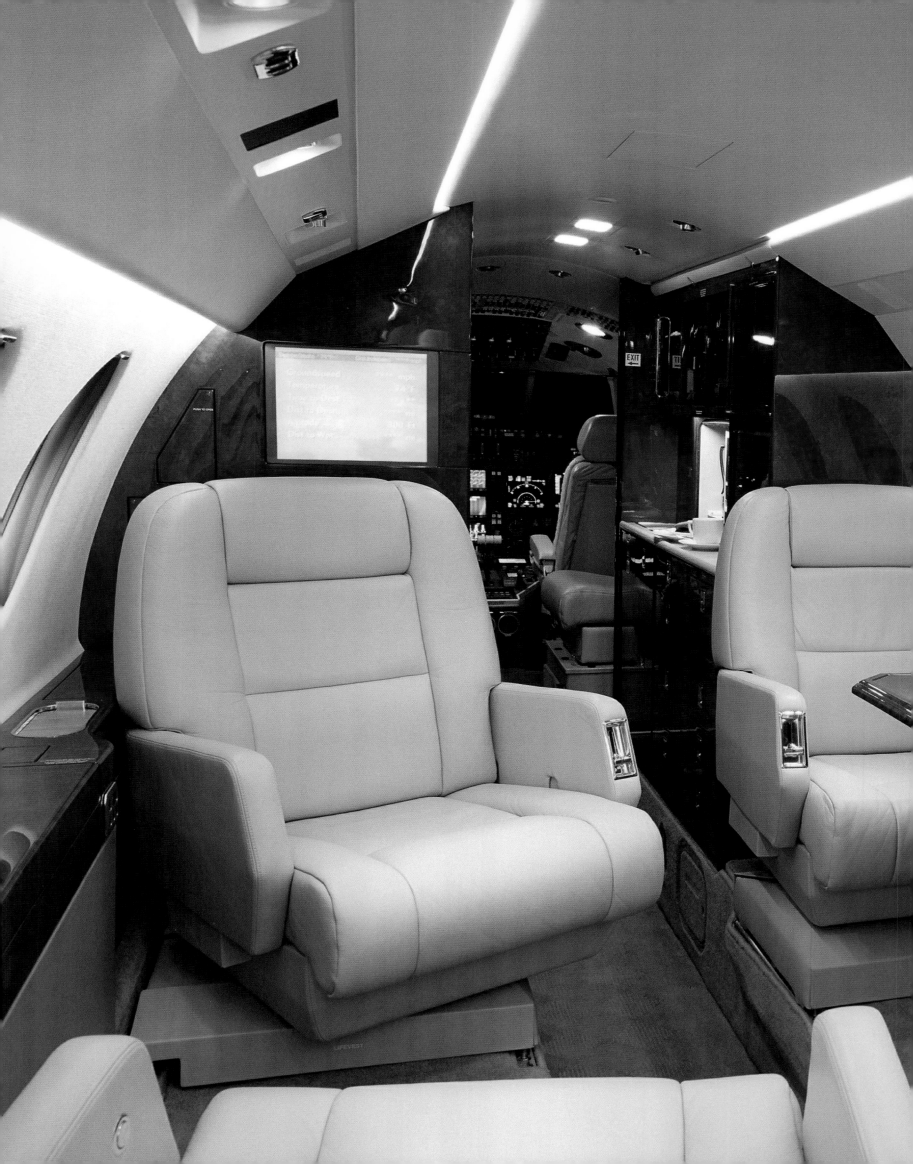

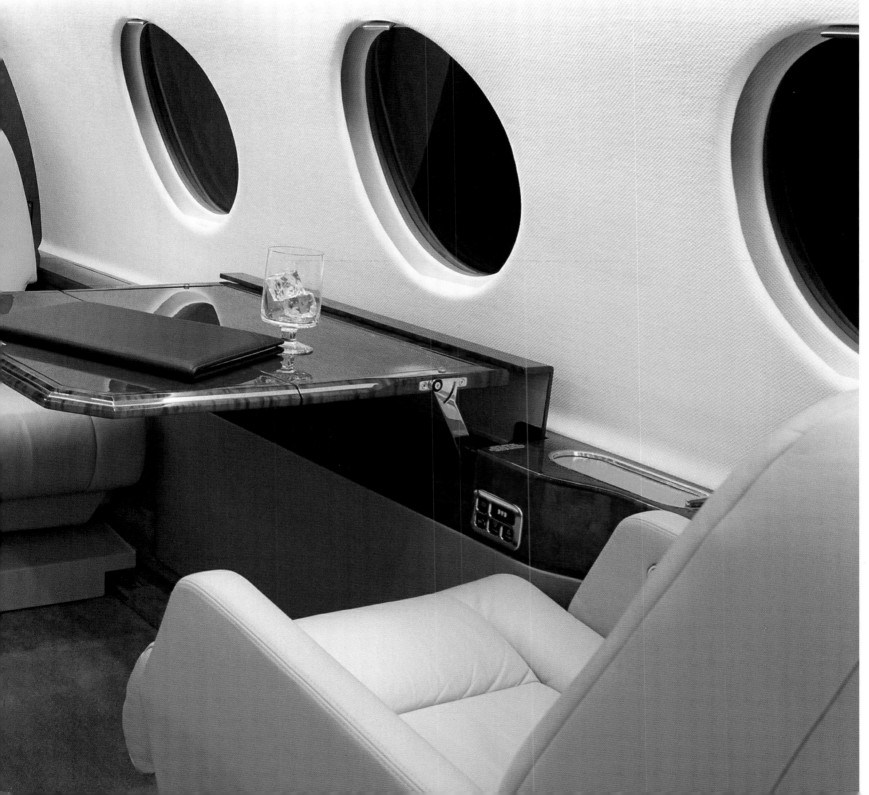

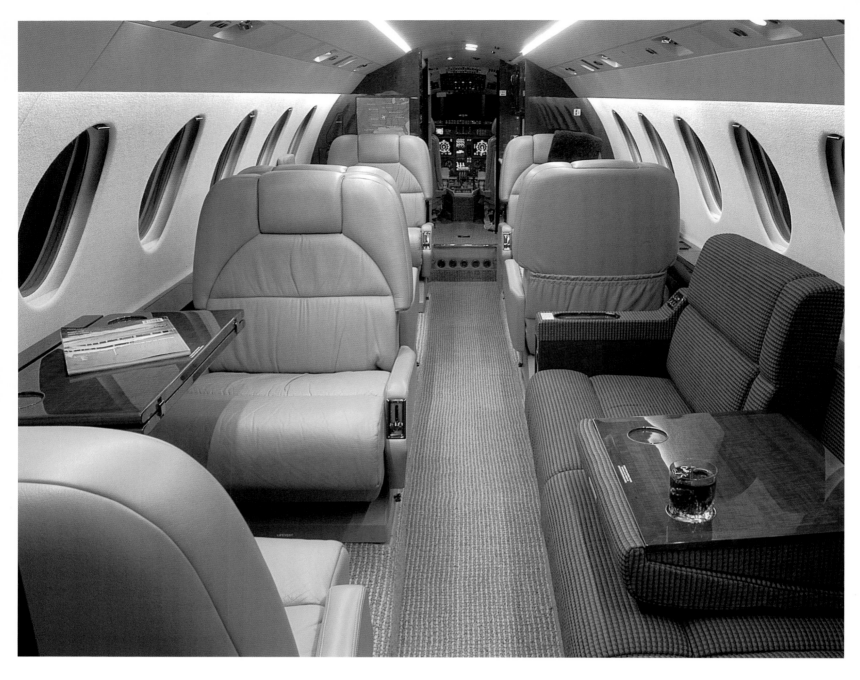

The Falcon 50EX was introduced in 1996 and boasted an increase in range, a new flight deck, and state-of-the-art avionics.

Die 1996 eingeführte Falcon 50EX hat eine größere Reichweite, einen neuen Pilotenraum und verfügt über die modernste Luftfahrtelektronik.

Le Falcon 50EX, mis en service en 1996, dispose d'une plus grande autonomie, d'une nouvelle cabine de pilotage et d'une électronique de bord sophistiquée.

El Falcón 50EX, introducido en el año 1996, dispone de una mayor autonomía, una nueva cabina de mando y la tecnología electrónica más avanzada.

Il Falcon 50EX, introdotto nel 1996, ha una portata maggiore e una nuova cabina di pilotaggio. Esso dispone inoltre della più moderna tecnologia aeronautica.

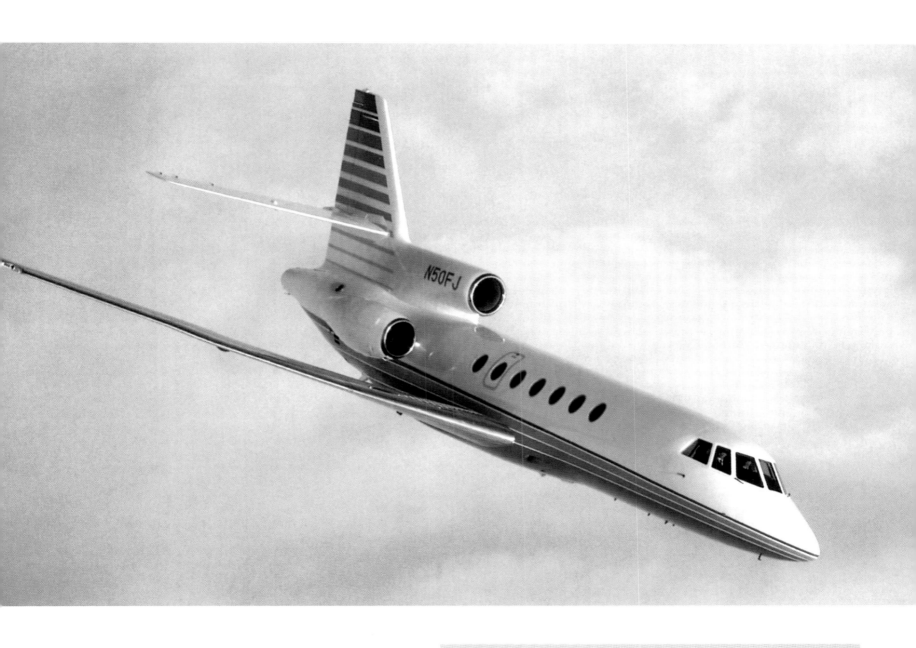

Technical Specifications

Type	Dassault Falcon 50EX
Manufacturer	Dassault Falcon Jet Corp.
Passenger Capacity	8 to 10 passengers
Engines	Three Honeywell TFE731-40
Range	6.090 km
Cruise Speed	797 km/h
Max. Cruise Speed	880 km/h
Length	18.52 m
Wingspan	18.86 m
Baggage capacity	2.55 m³
Empty Weight	9890 kg
Price	On request

Dassault Falcon 2000

As private business flights increasingly became the norm for many firms, they demanded a jet that was not only roomy and comfortable, but also reliable and inexpensive to operate. After consulting 400 jet owners, Dassault created the Falcon 2000. With the wide body of the Falcon 900 and the decreased maintenance costs of using two engines, it is now the most popular mid-size jet used in fractional lease programs. The 2000EX, introduced in 2001, can fly non-stop between New York and Paris, or London and Dubai.

Als private Geschäftsreiseflüge für viele Unternehmen zunehmend üblich wurden, entstand die Nachfrage nach einem Jet, der nicht nur geräumig und komfortabel ist, sondern auch zuverlässig und günstig im Unterhalt. Nachdem 400 Jetbesitzer befragt worden waren, entwickelte Dassault die Falcon 2000. Der großzügig gestaltete Flugzeugrumpf der Falcon 900 bildete die Grundlage für den neuen Flugzeugtyp. Die geringeren Unterhaltskosten durch die Verwendung von nur zwei Triebwerken machten die Falcon 2000 zum meist verbreiteten Jet mittlerer Größe in Teilleasing-Programmen. Die 2001 eingeführte Falcon 2000EX kann ohne Zwischenstopp von New York nach Paris oder von London nach Dubai fliegen.

Lorsque l'utilisation des avions d'affaires s'est répandue, de nombreuses entreprises ont exprimé le besoin de disposer d'un jet non seulement spacieux et confortable, mais aussi fiable et d'un entretien peu onéreux. A l'issue d'une enquête effectuée parmi 400 propriétaires d'avions d'affaires, Dassault a mis au point le Falcon 2000. Son faible coût d'entretien rendu possible par l'utilisation de seulement deux réacteurs en a fait l'avion d'affaires de moyenne taille le plus utilisé dans le cadre des programmes de leasing partiel. Le Falcon 2000EX, mis en service en 2001, peut effectuer un trajet sans escale entre New York et Paris ou entre Londres et Dubai.

Al volverse habituales cada vez más los viajes de negocios privados creció la demanda de un jet no sólo espacioso y confortable sino también fiable y económico en cuanto a su mantenimiento. Después de interrogar a 400 propietarios de jets particulares, la Dassault desarrolla el Falcon 2000. El fuselaje espacioso del Falcon 900 sirvió como base al nuevo tipo de avión. Los bajos costes de mantenimiento se deben al empleo de sólo dos reactores y convierten al Falcon 2000 en el jet de tamaño medio más popular de los programas de cuotas en régimen de leasing. El Falcon 2000EX, introducido en el 2001, es capaz de volar sin escala de Nueva York a Paris o de Londres a Dubai.

Dato l'acquisto sempre più frequente di business-jet da parte di aziende private, è frequente la richiesta di jet che, oltre ad essere confortevoli e spaziosi, siano anche sicuri e il cui mantenimento non sia troppo oneroso. Sulla base di un sondaggio svolto tra 400 proprietari di jet, Dassault ha progettato il Falcon 2000, un nuovo tipo di apparecchio che, con la sua fusoliera finemente lavorata, deriva direttamente dal Falcon 900. Grazie ai costi ridotti – l'apparecchio utilizza solo due motori – il Falcon 2000 è uno dei jet di media dimensione più diffuso nei contratti di leasing. Il Falcon 2000EX, introdotto nel 2001, è in grado di volare senza scalo da New York a Parigi o da Londra a Dubai.

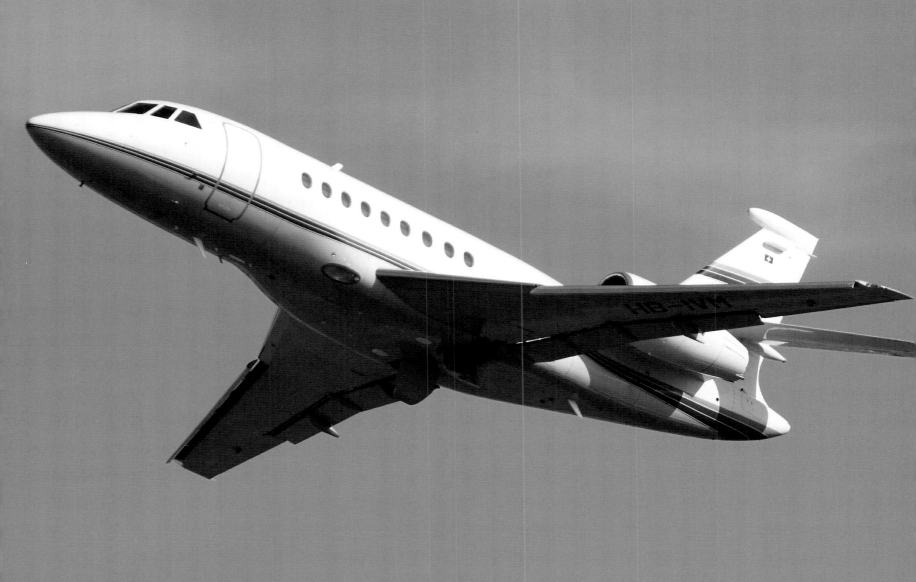

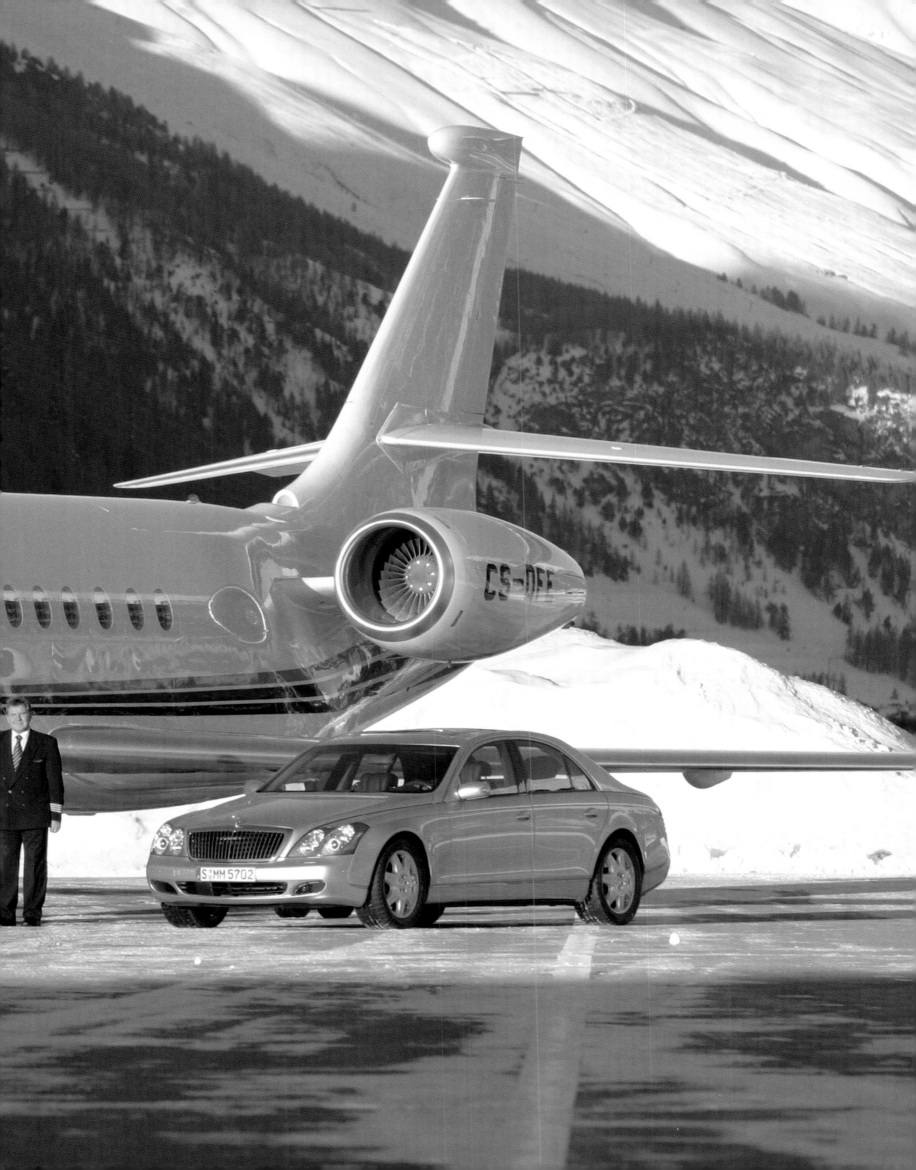

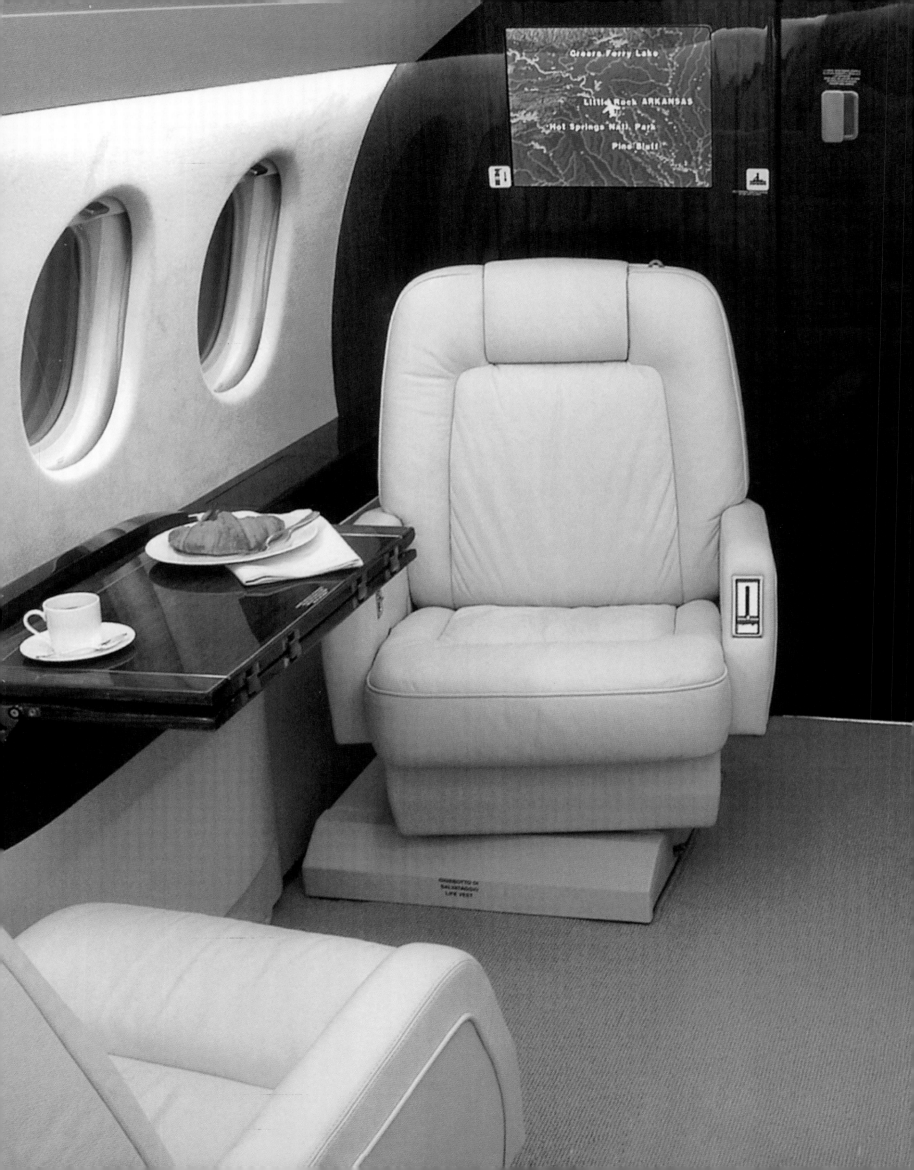

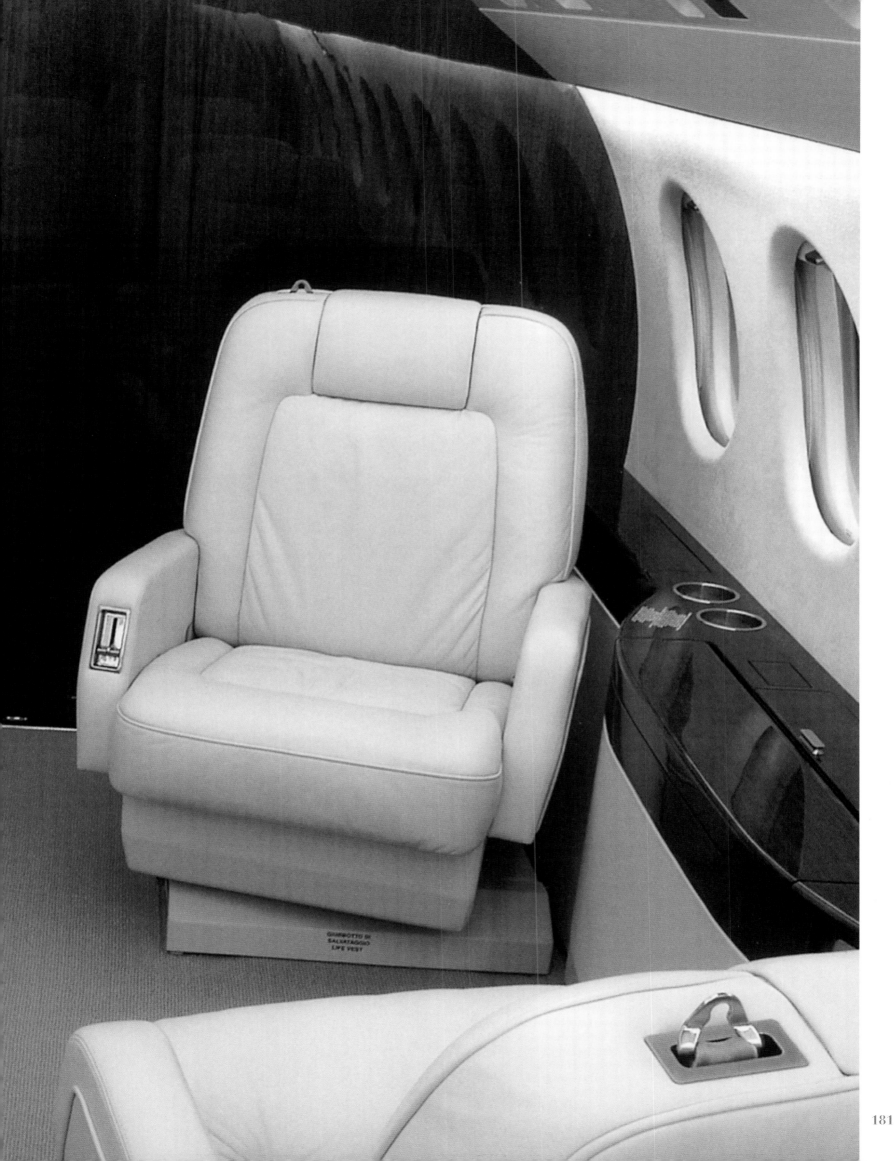

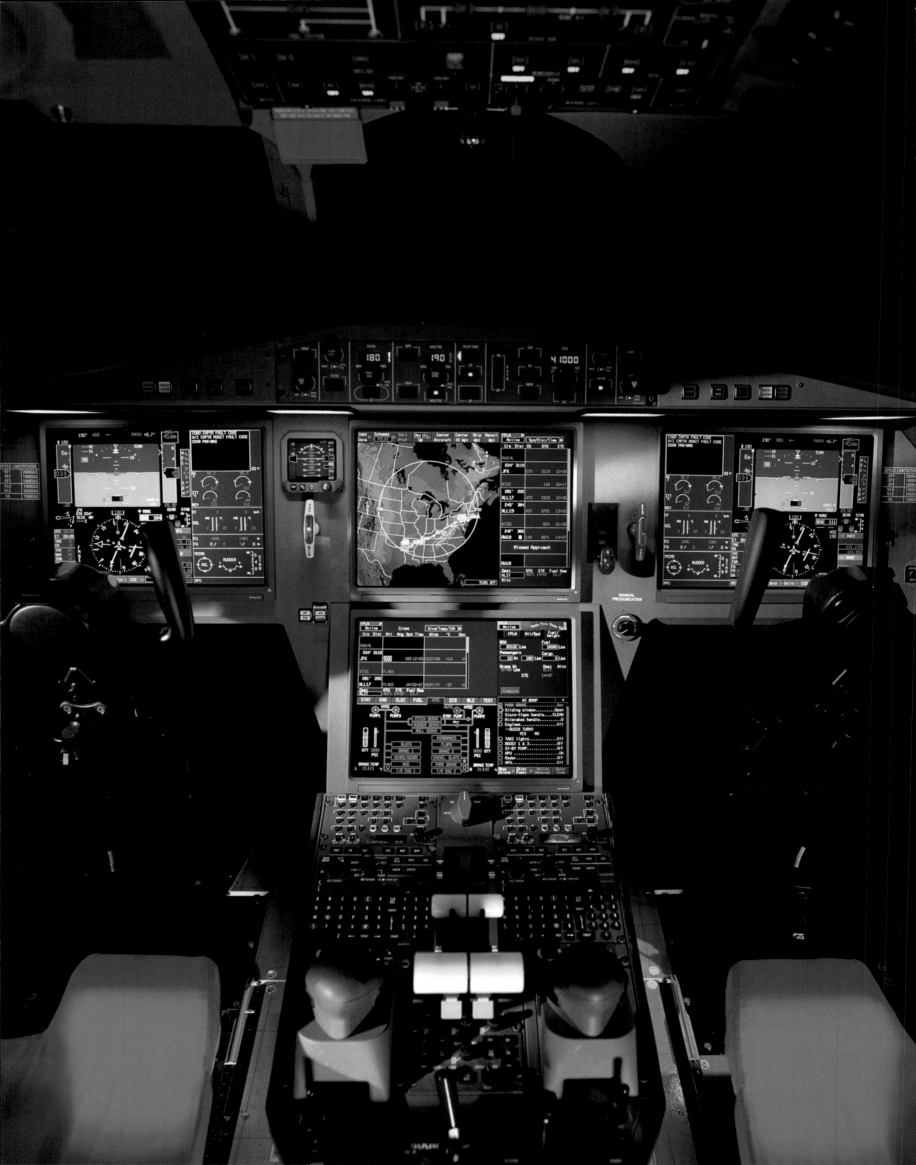

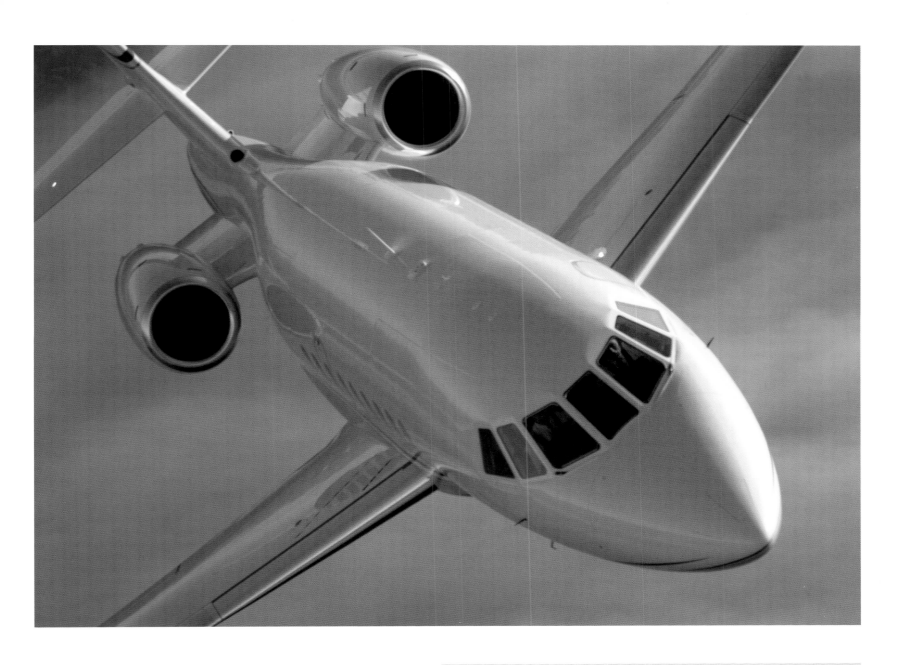

Type	Dassault Falcon 2000EX
Manufacturer	Dassault Falcon Jet Corp.
Passenger Capacity	8 to 12
Engines	Two Pratt&Whitney PW308C
Range	7.165 km
Cruise Speed	761 km/h
Max. Cruise Speed	863 km/h
Length	20.21 m
Wingspan	19.33 m
Baggage capacity	3.7 m³
Empty Weight	10.520 kg
Price	On request

Dassault Falcon 900EX

The extended range required by many business travellers necessitates a cabin with more room and greater comfort. The Falcon 900, introduced in 1986, addresses both of these needs in style. Building on the three-engine design of the Falcon 50, the 900 has a wider cabin which provides nine passengers with a flat floor, three lounge areas and a functional galley. This, combined with its 7,400 km range, has made it a popular choice for many heads of state around the world. It was upgraded to the 900EX in 1994 with quieter and more powerful engines.

Die Möglichkeit, längere Flugstrecken zurücklegen zu können, was von vielen Geschäftsreisenden gewünscht worden war, verlangte nach einem großzügigeren Kabinendesign und mehr Komfort. Bei der Entwicklung der Falcon 900, die 1986 auf den Markt kam, wurde auf diese Bedürfnisse reagiert. Basierend auf der Konstruktion der Falcon 50 mit drei Triebwerken, verfügt die Falcon 900 über eine geräumigere Kabine mit neun Plätzen, einen breiten Gang, drei Lounge-Bereiche und eine funktionale Bordküche. Dieser Komfort und die Reichweite von 7400 Kilometer überzeugt viele Staatsoberhäupter weltweit. Die Falcon 900 wurde 1994 überarbeitet; der Typ 900EX verfügt über leisere und leistungsstärkere Triebwerke.

Le souhait exprimé par beaucoup d'hommes d'affaires de pouvoir faire de longs trajets en avion a nécessité la conception d'appareils dotés de cabines plus spacieuses et plus confortables. Lors du développement du Falcon 900 mis en service en 1986, ce besoin a été pris en compte. Dérivé du même concept que celui du triréacteur Falcon 50, le Falcon 900 dispose d'un volume de cabine plus important pouvant contenir neuf passagers, d'un large couloir, de trois espaces salon et d'une véritable cuisine de bord. Son confort et son rayon d'action de 7400 kilomètres ont facilement convaincu de nombreux chefs d'Etat dans le monde. Une nouvelle version du Falcon 900 a été proposée en 1994 avec des réacteurs plus performants et plus silencieux.

El deseo de poder cubrir trayectos de mayor distancia, formulado por numerosos ejecutivos, exigía un diseño más espacioso y confortable. Con el diseño del Falcon 900, que llegó al mercado en 1986, la compañía respondió a esta demanda. Basado en el modelo del Falcon 50 triturbina, el Falcon 900 dispone de una cabina más amplia con nueve asientos, un espacioso pasillo, tres salas lounge y una cocina funcional. Este confort y la autonomía de 7400 kilómetros convence a muchos jefes de estado del mundo entero. El Falcon 900 fue remodelado en 1994: el modelo 900 EX dispone de reactores más silenciosos y más potentes.

La domanda di apparecchi in grado di percorrere distanze sempre maggiori è molto diffusa tra chi viaggia per affari ed essa presuppone anche un ottimo livello del comfort e del design in cabina. A questi bisogni i costruttori hanno reagito già nel 1989, portando sul mercato il Falcon 900, sviluppato a partire dal precedente modello trimotore, Falcon 50. Il Falcon 900 dispone di una spaziosa cabina a nove posti, un comodo corridoio, tre comparti lounge e una funzionale cucina di bordo. Questo comfort ed una portata di 7400 chilometri hanno convinto più di un capo di Stato. Il Falcon 900 è stato rimodernato nel 1994: il modello 900EX è dotato di motori più silenziosi e potenti.

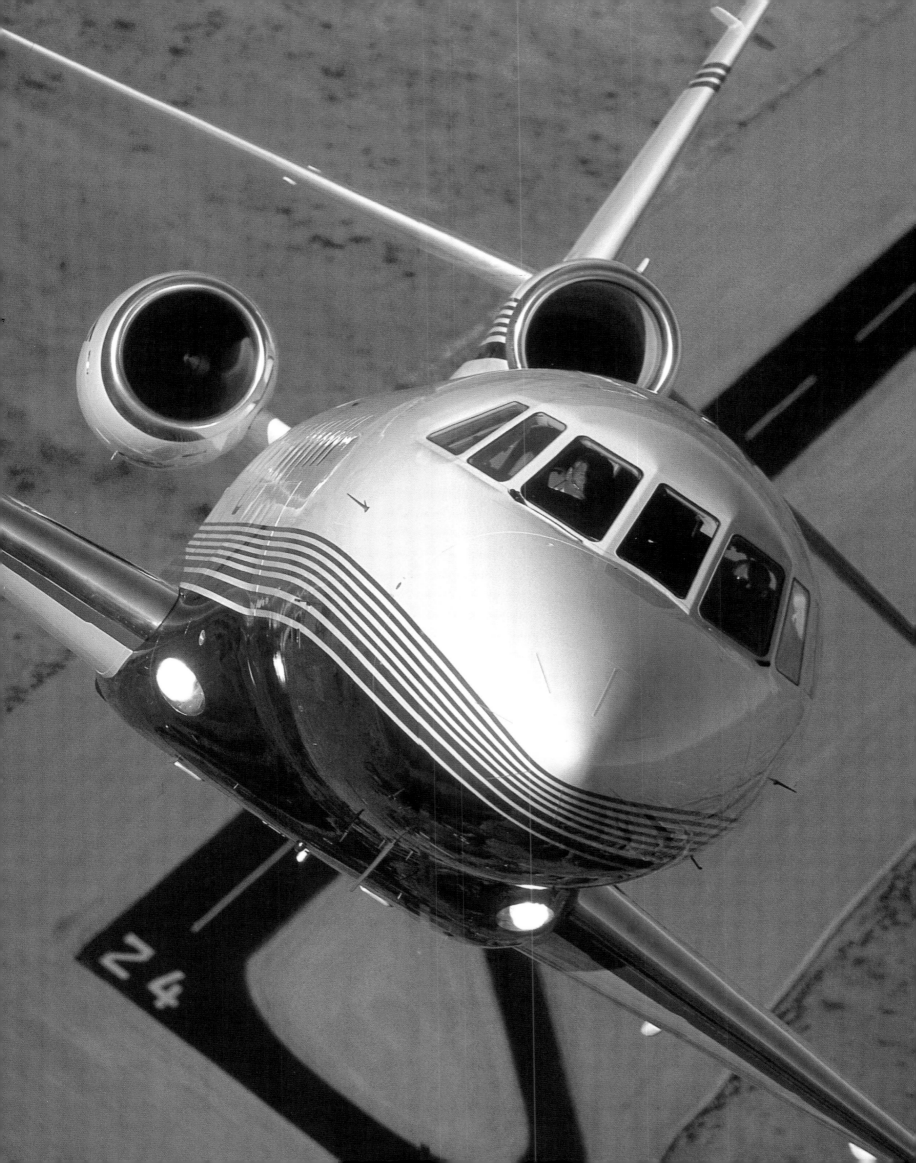

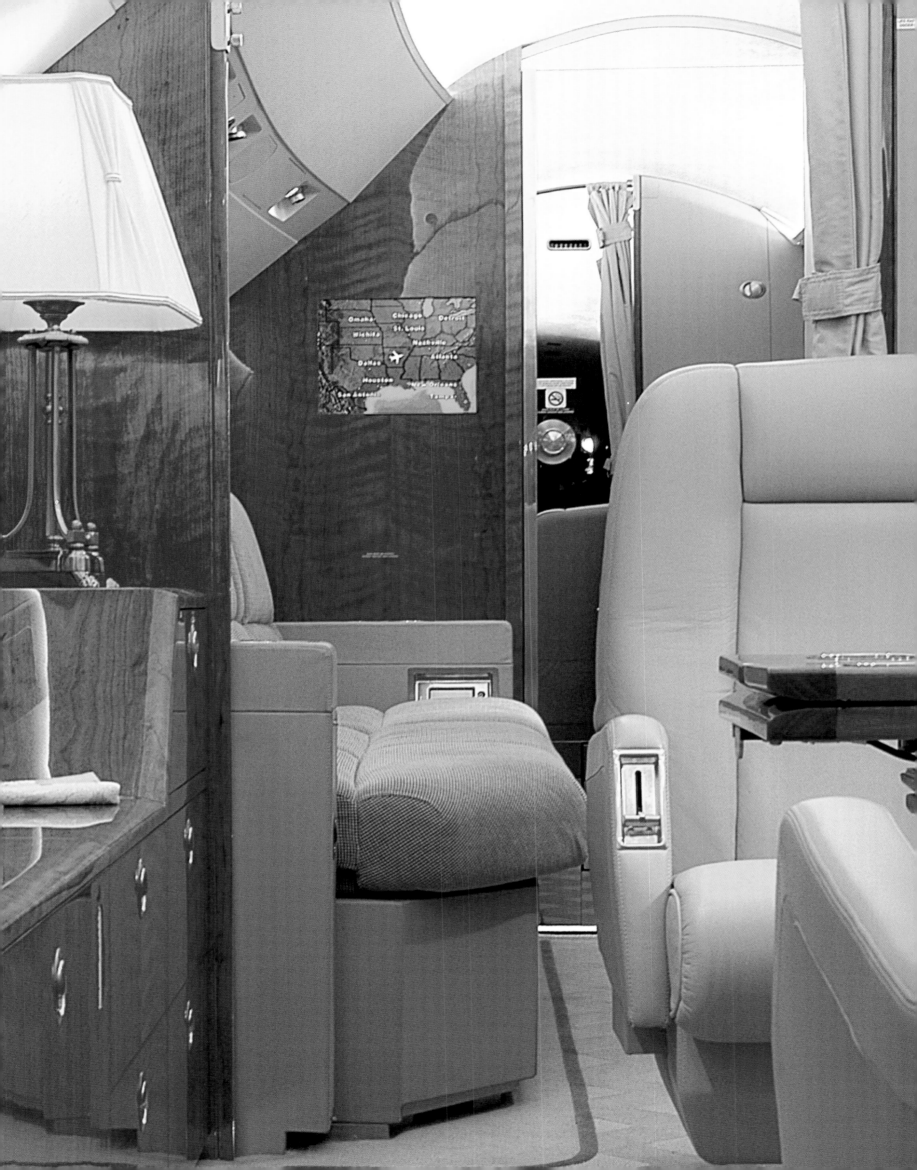

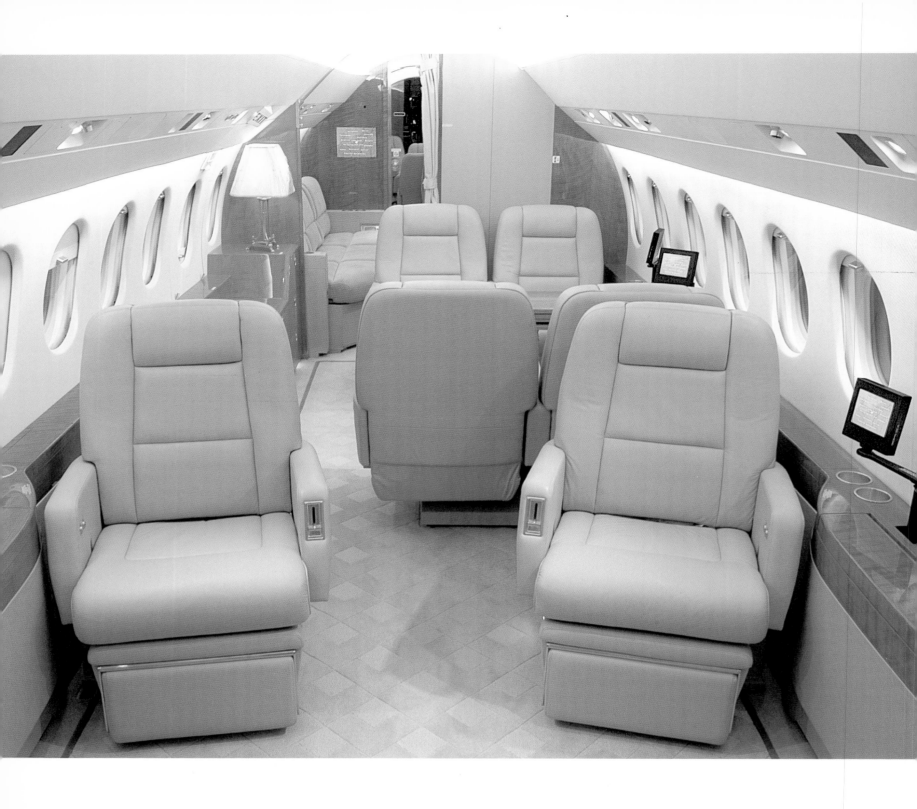

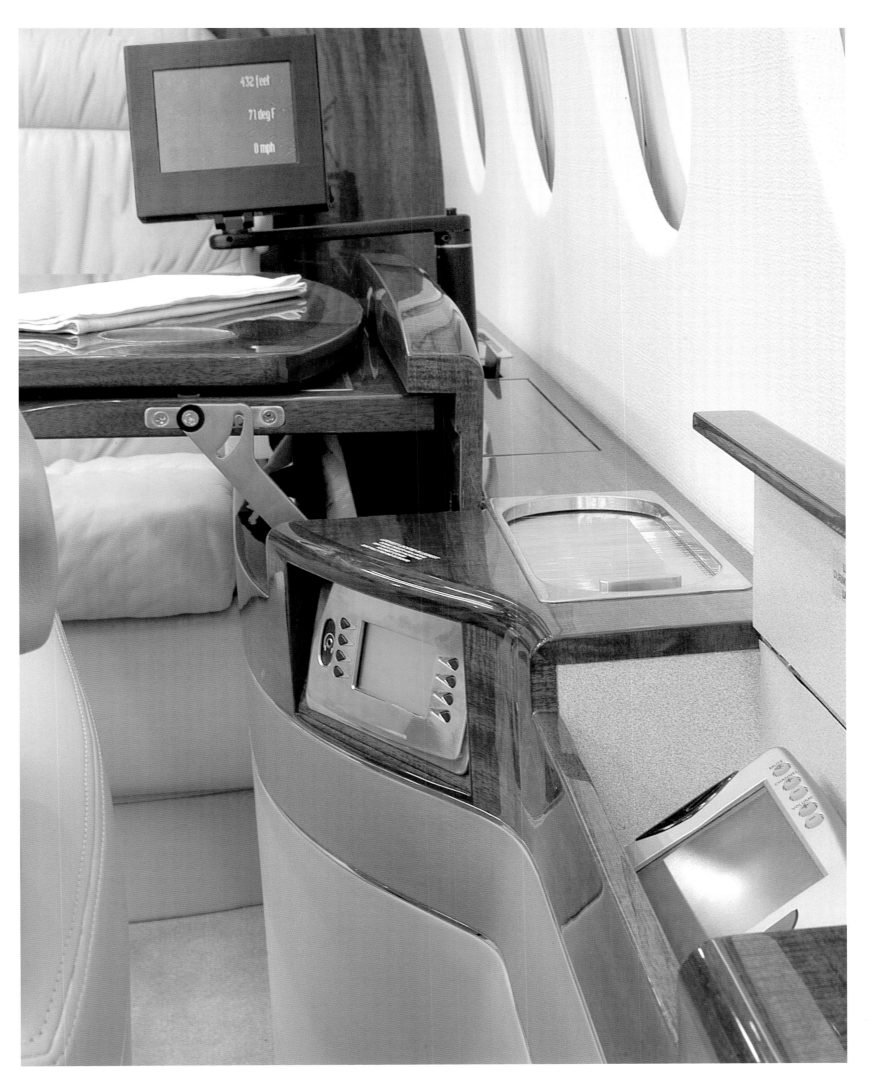

In the monitor: 432 feet / 71 deg F / 0 mph

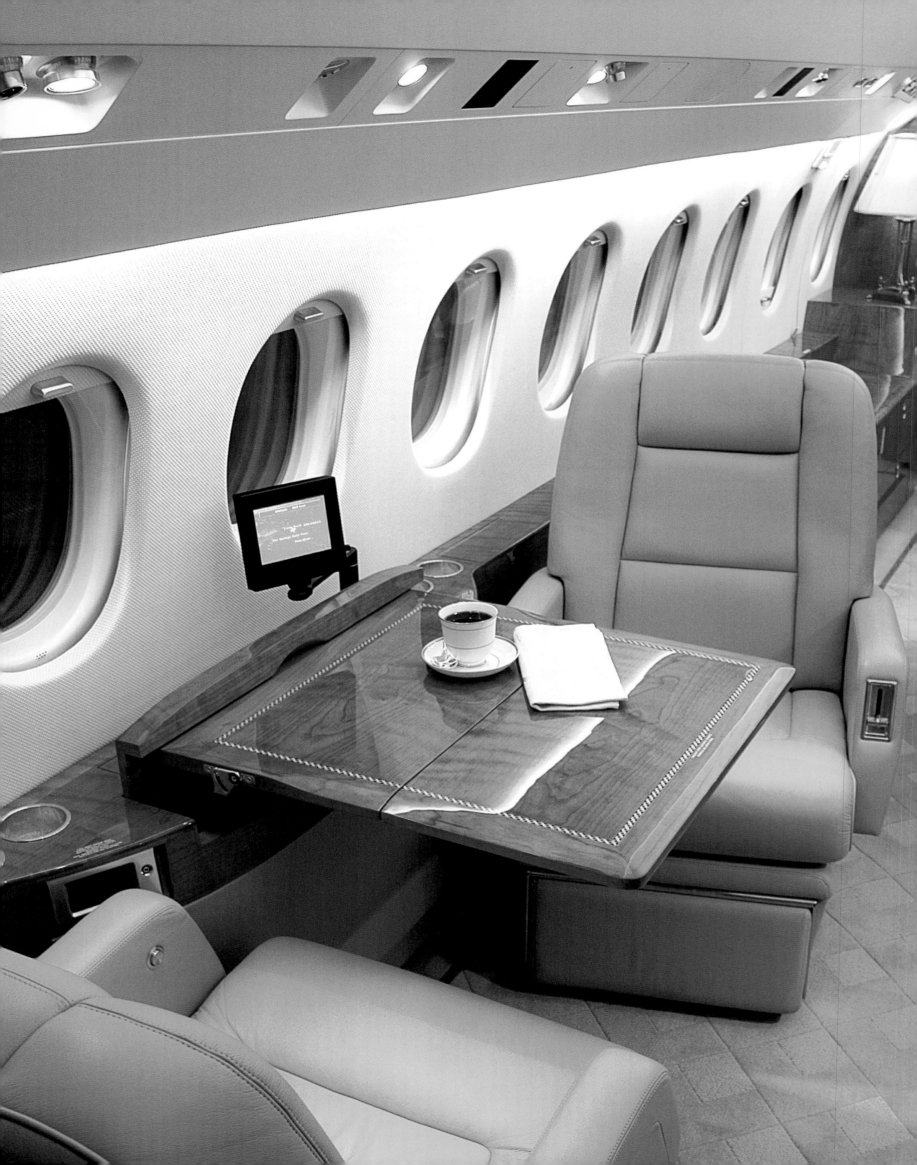

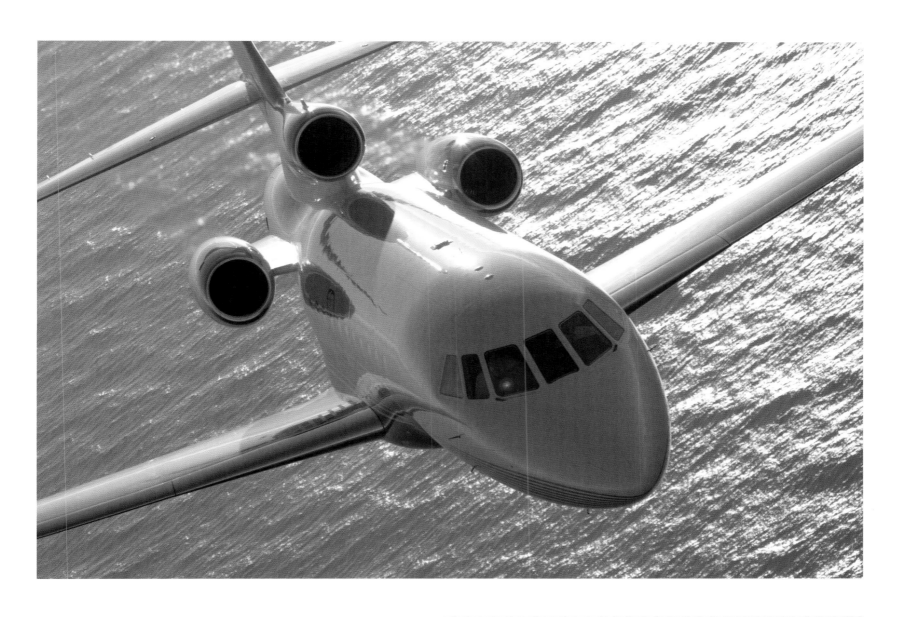

Technical Specifications

Type	Dassault Falcon 900EX
Manufacturer	Dassault Falcon Jet Corp.
Passenger Capacity	8 to 14 passengers
Engines	Three Honeywell TFE731-60
Range	8.340 km
Cruise Speed	761 km/h
Max. Cruise Speed	927 km/h
Length	20.21 m
Wingspan	19.33 m
Baggage capacity	3.60 m³
Empty Weight	11.205 kg
Price	On request

Dassault Falcon 7X

Dassault takes the private jet to an entirely new level with its third-generation Falcon 7X. With completely redesigned aerodynamics and the latest in-flight technology, its first test is planned for 2005. It will be the first business plane with "fly-by-wire" controls allowing it to take off and land in all weather conditions. Its cabin, 20 percent larger than the Falcon 900, has room for three separate living compartments and is illuminated by 27 extra-large windows.

Mit der dritten Generation, dem Flugzeugtyp Falcon 7X, will Dassault den Privatjet ins 21. Jahrhundert bringen. Die Falcon 7X, die mit einer vollständig überarbeiteten Aerodynamik und moderner Bordtechnologie ausgestattet ist, wird im Jahr 2005 getestet. Sie wird das erste Geschäftsreiseflugzeug mit Fly-by-wire (FBW) sein, das Start und Landung bei jedem Wetter erlaubt. In der Kabine, die etwa 20 Prozent größer ist als die der Falcon 900, gibt es Raum für drei separate Wohnbereiche, und 27 extragroße Fenster sorgen für viel Tageslicht an Bord.

Avec le Falcon 7X de troisième génération, Dassault fait entrer le jet privé de plein pied dans le 21ème siècle. L'appareil, doté d'une toute nouvelle aérodynamique et d'une avionique moderne, fait l'objet d'une campagne d'évaluation depuis 2005. Il sera le premier avion d'affaires équipé de commandes de vol électriques lui octroyant une capacité de décollage et d'atterrissage tous temps. La cabine, dont le volume est de 20 pour cent supérieur à celui du Falcon 900, dispose de trois espaces d'habitation séparés, et pas moins de 27 hublots de grande dimension permettent de l'inonder de lumière naturelle.

El modelo Falcon 7X de tercera generación, es la propuesta de Dassault para el jet privado del siglo XXI. El Falcon 7X, con una aerodinámica completamente revisada y equipado con la tecnología electrónica más avanzada, será sometido a prueba en el 2005. Será el primer avión de negocios con el sistema Fly-by-Wire (FBW), capaz de despegar y aterrizar bajo cualquier condición meteorológica. La cabina, un 20 por ciento más grande que la del Falcon 900, ofrece espacio para tres habitaciones separadas bañadas de luz gracias a sus 27 grandes ventanas.

Con la terza generazione del Falcon 7X, Dassault è decisa a portare il jet privato nel ventunesimo secolo. Il Falcon 7X, che verrà collaudato nel 2005, ha un'aerodinamica completamente rielaborata e dispone della più moderna tecnologia di bordo. Si tratta del primo aereo del suo genere con una tecnologia Fly-by-wire (FBW), che permette decollo ed atterraggio anche in condizioni atmosferiche avverse. Nella cabina, all'incirca il 20 per cento più grande di quella del Falcon 900, c'è spazio per tre alloggi separati, mentre 27 oblò di grande dimensione, garantiscono l'apporto di molta luce naturale.

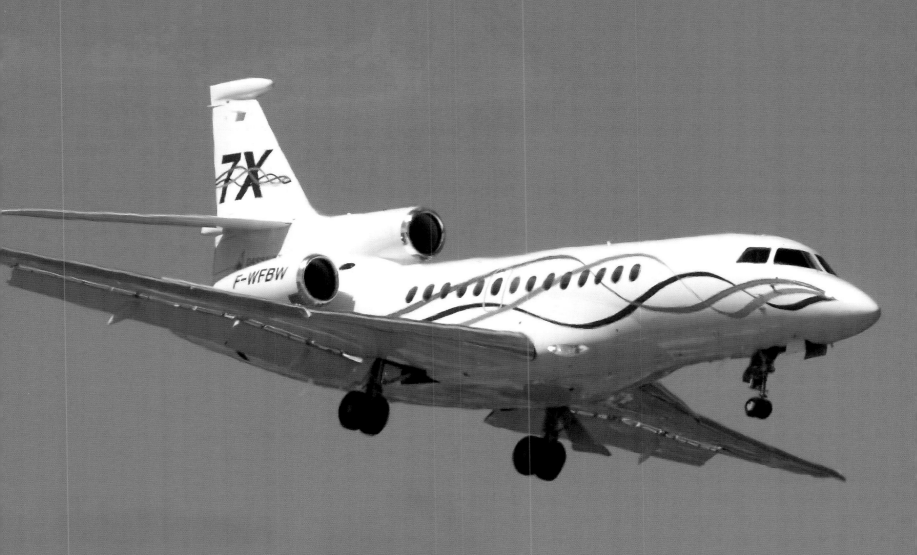

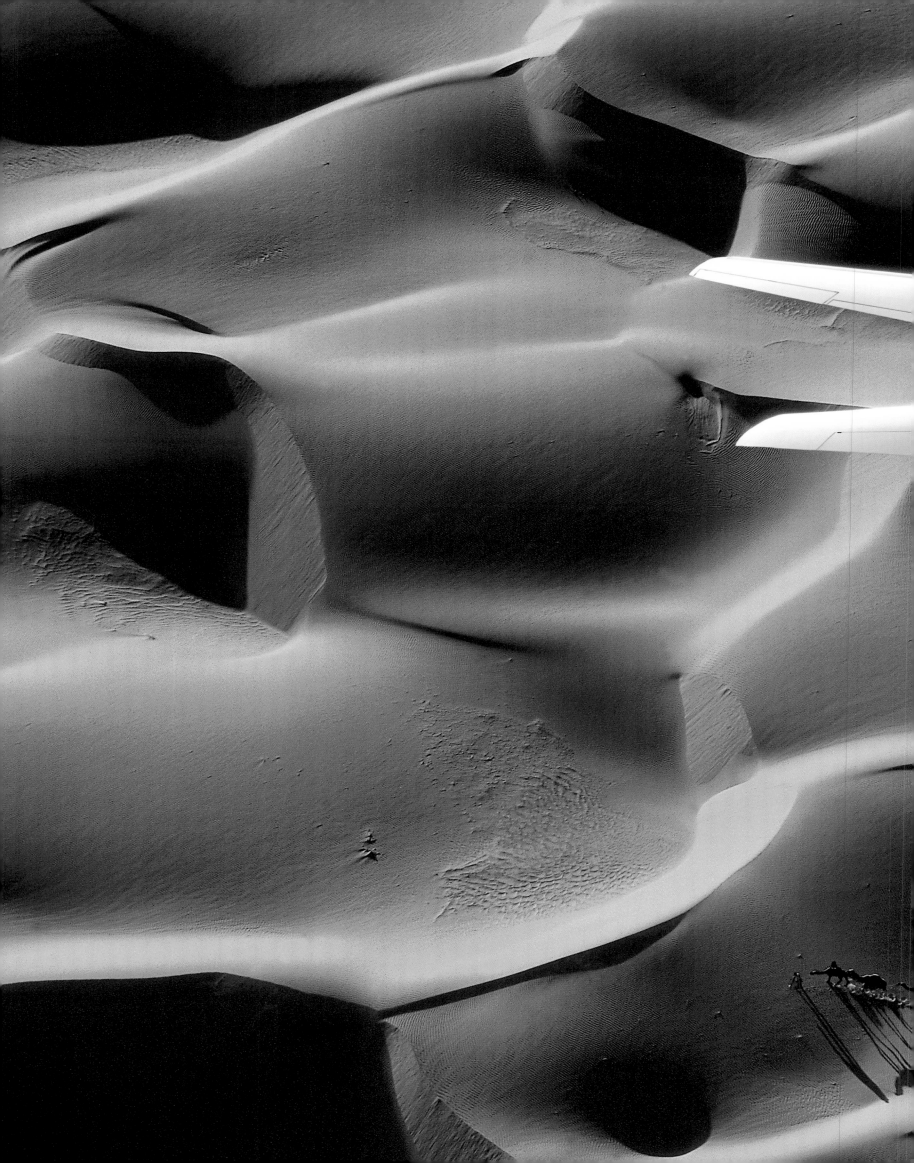

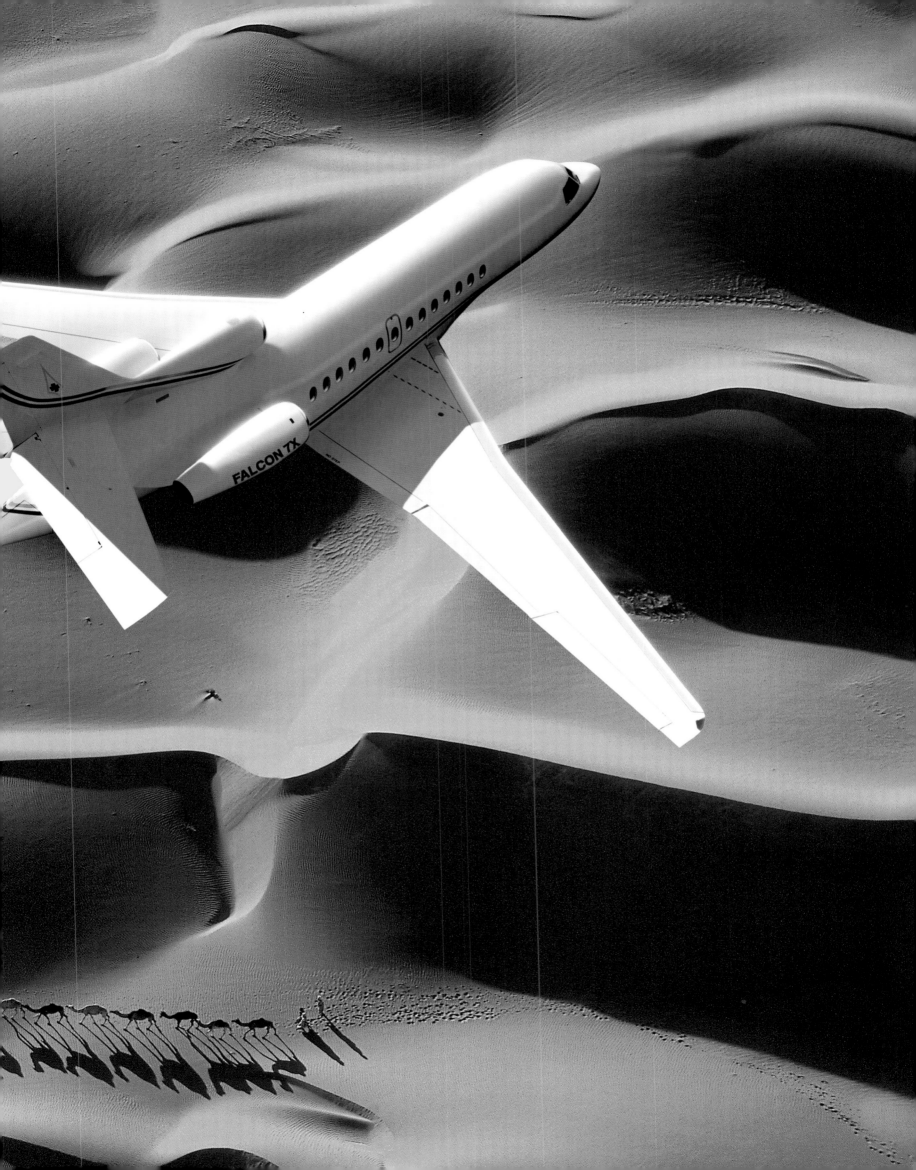

A formation of Dassualt Falcons

With a range of 10.500 km and a maximum speed of Mach 0.9, the 7X may well be the business jet of the future.

Mit einer Reichweite von 10500 Kilometern und einer maximalen Geschwindigkeit von Mach 0.9 könnte die Falcon 7X der Business-Jet der Zukunft sein.

Grâce à un rayon d'action de 10500 kilomètres, et à une vitesse maximale de Mach 0.9, le Falcon 7X pourrait bien être l'avion d'affaires du futur.

Con una autonomía de 10500 kilómetros y una velocidad máxima de Mach 0.9 el Falcon 7X podría llegar a ser el jet de negocios del futuro.

Con una portata di 10500 chilometri ed una velocità massima pari a Mach 0.9, il Falcon 7X potrebbe diventare il Business-Jet del futuro.

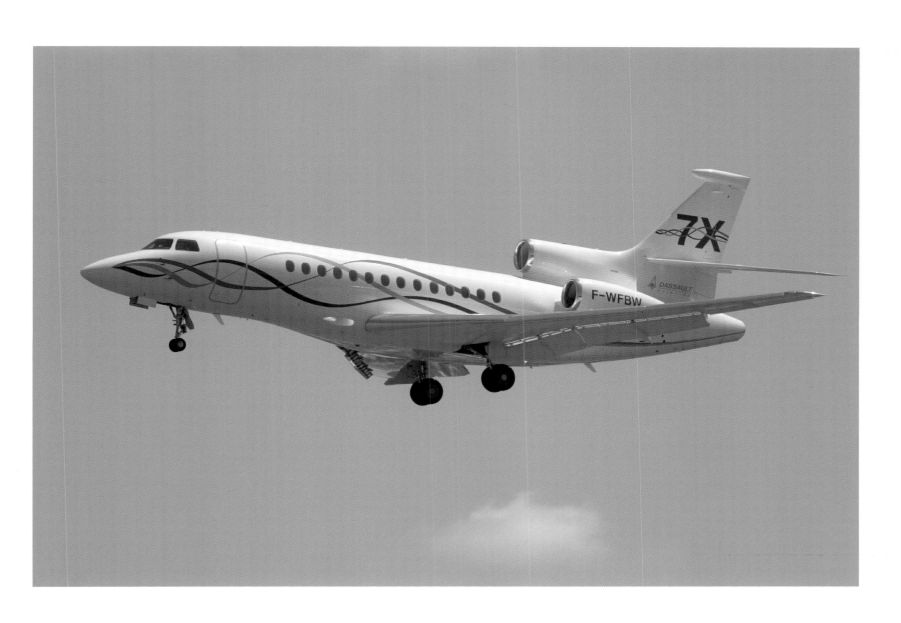

Type	Dassault Falcon 7X
Manufacturer	Dassault Falcon Jet Corp.
Passenger Capacity	8 to 19
Engines	Three Pratt&Whitney PW307A
Range	10.565 km
Cruise Speed	863 km/h
Max. Cruise Speed	914 km/h
Length	23.19 m
Wingspan	25.14 m
Baggage capacity	4.45 m³
Empty Weight	15.014 kg
Price	On request

Gulfstream V

An extended version of the Gulfstream IV, the Gulfstream V has a range of over 12,000 km, making it a popular choice for intercontinental travellers. It is equipped with a six-screen computerized flight deck, making the pilot's job safer and easier. Since its launch in 1997, it has broken numerous distance and speed records.

Die erweiterte Version der weit verbreiteten Gulfstream IV hat eine Reichweite von über 12000 Kilometer. Dies macht die Gulfstream V zur beliebten Wahl für Interkontinentalreisende. Die Maschine ist mit einem Cockpit ausgerüstet, das über sechs computergesteuerte Displays verfügt, um die Arbeit der Piloten zu erleichtern und sicherer zu machen. Seit dem ersten Start 1997 hat die Gulfstream V zahlreiche Weiten- und Geschwindigkeitsrekorde gebrochen.

La version allongée du Gulfstream IV, très utilisé dans le monde entier, dispose d'un rayon d'action de plus de 12 000 kilomètres qui fait du Gulfstream V un appareil tout indiqué pour les voyages intercontinentaux. Son cockpit est équipé de six écrans informatisés qui facilite son pilotage et le rendent plus sûr. Depuis son premier vol en 1997, le Gulfstream V a battu de nombreux records du monde de distance et de vitesse.

La versión ampliada del Gulfstream IV tiene una autonomía de más de 12000 kilómetros, lo que convierte al Gulfstream V en la elección favorita para viajes transcontinentales. El avión está provisto de una cabina de mando equipada con seis pantallas de control electrónico digital para facilitarles el trabajo a los pilotos y aumentar el índice de seguridad. Desde su primer despegue en 1997, el Gulfstream V ha batido numerosos récords de distancia y velocidad.

La versione perfezionata del diffusissimo Gulfstream IV ha un'autonomia maggiore ai 12000 chilometri, fatto che rende il Gulfstream V una scelta obbligata per i viaggi intercontinentali. La cabina di pilotaggio dell'apparecchio è dotata di diversi display collegati a un computer, in modo da facilitare e rendere ancora più sicuro il lavoro dei piloti. Dal suo primo decollo nel 1997 il Gulfstream V ha infranto molti record di velocità e di portata.

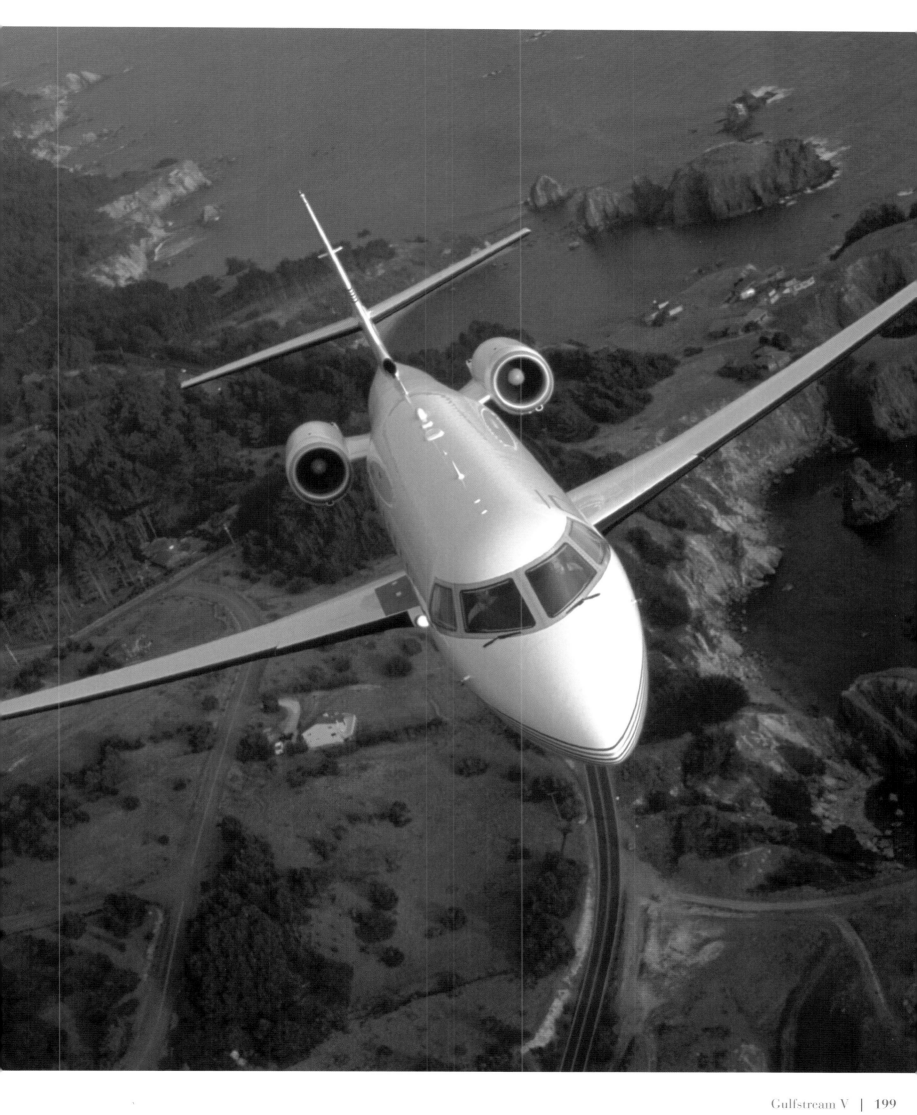

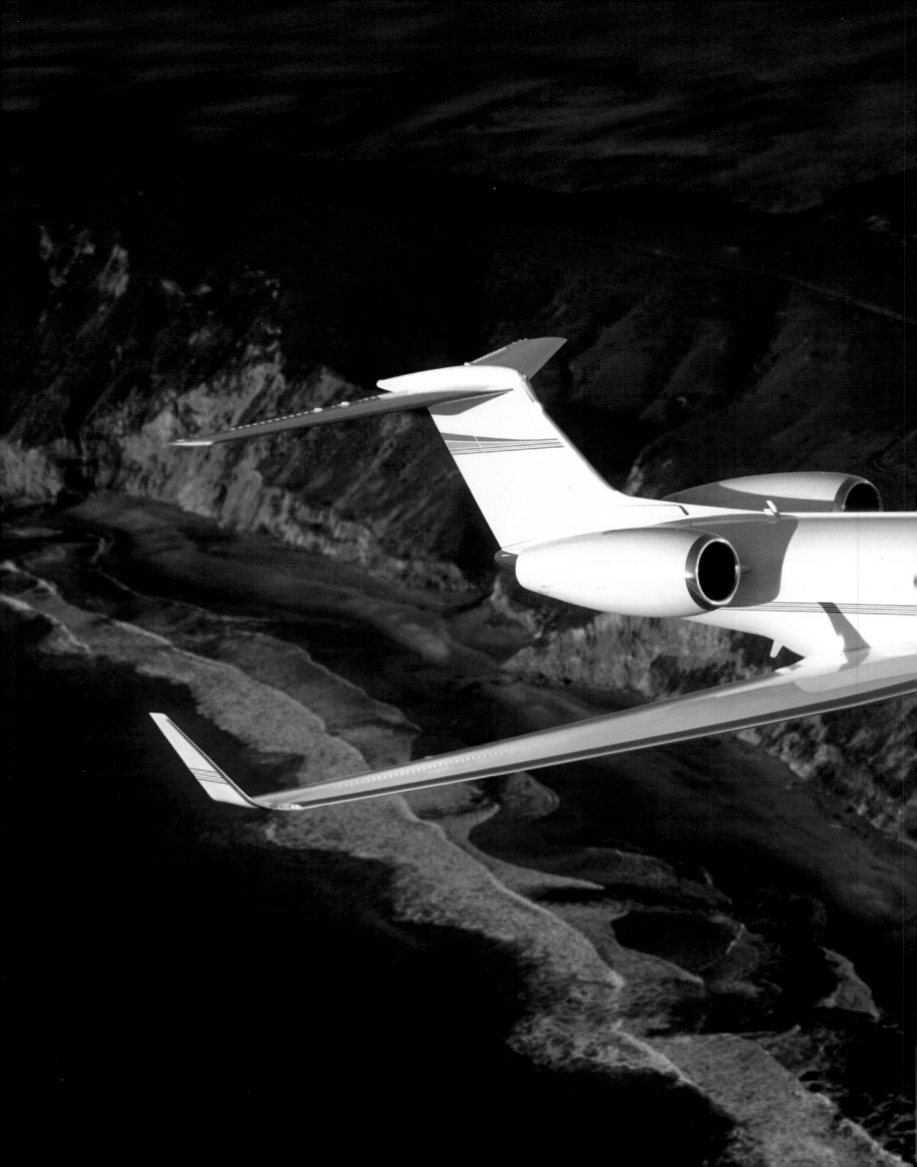

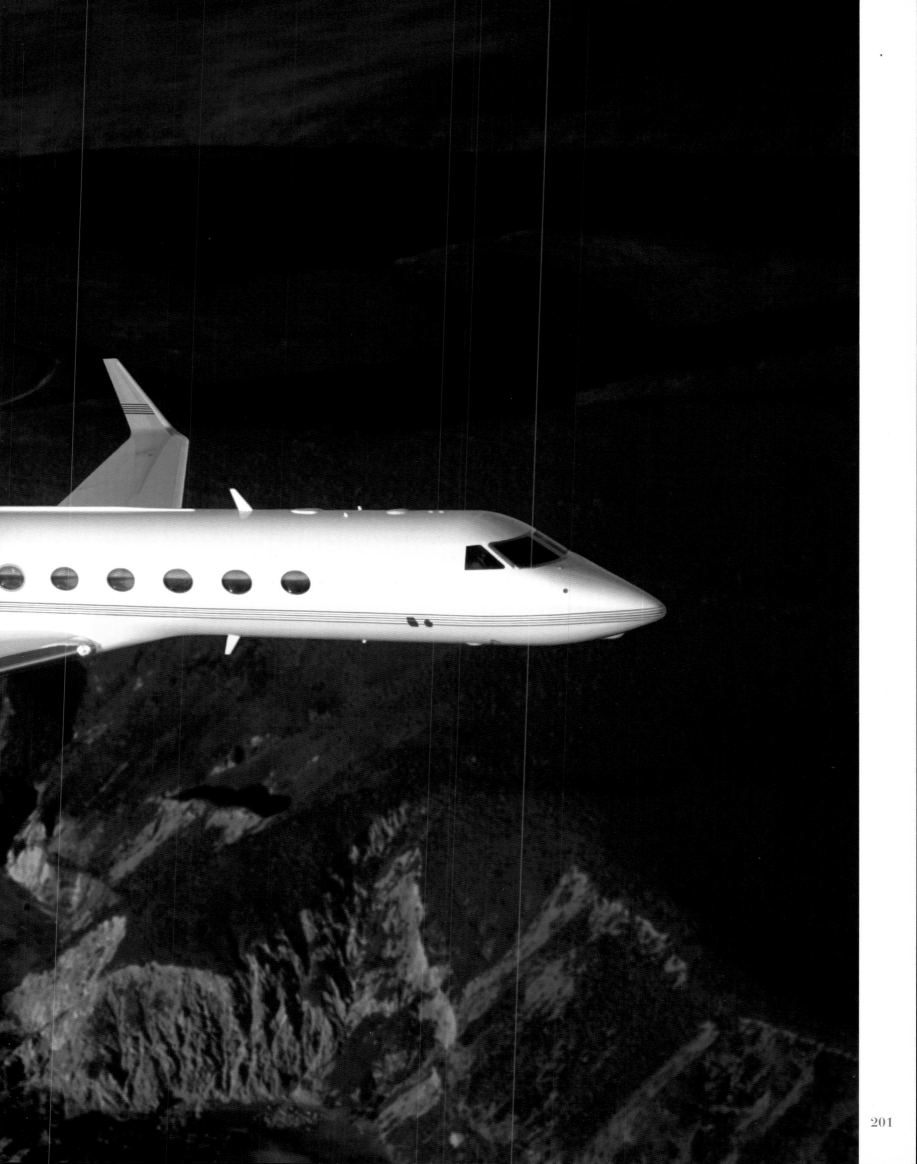

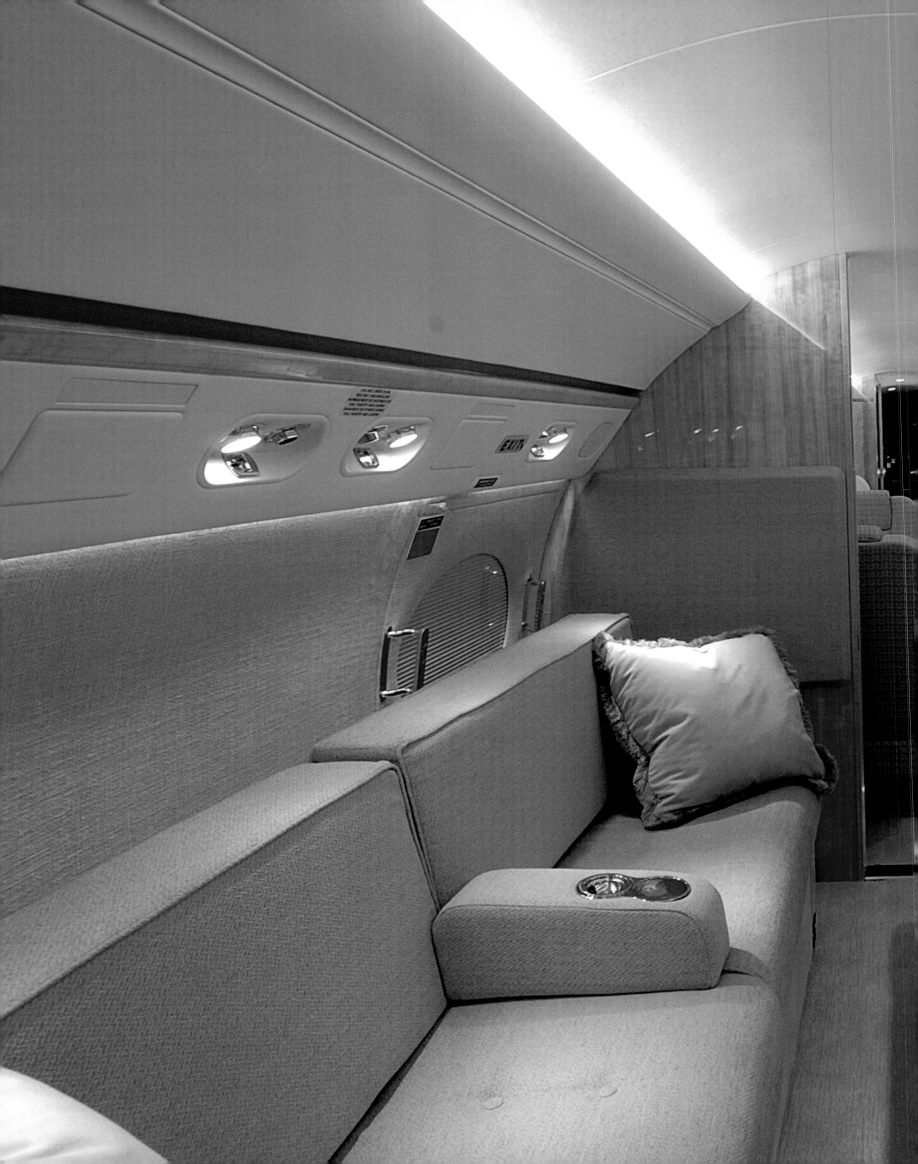

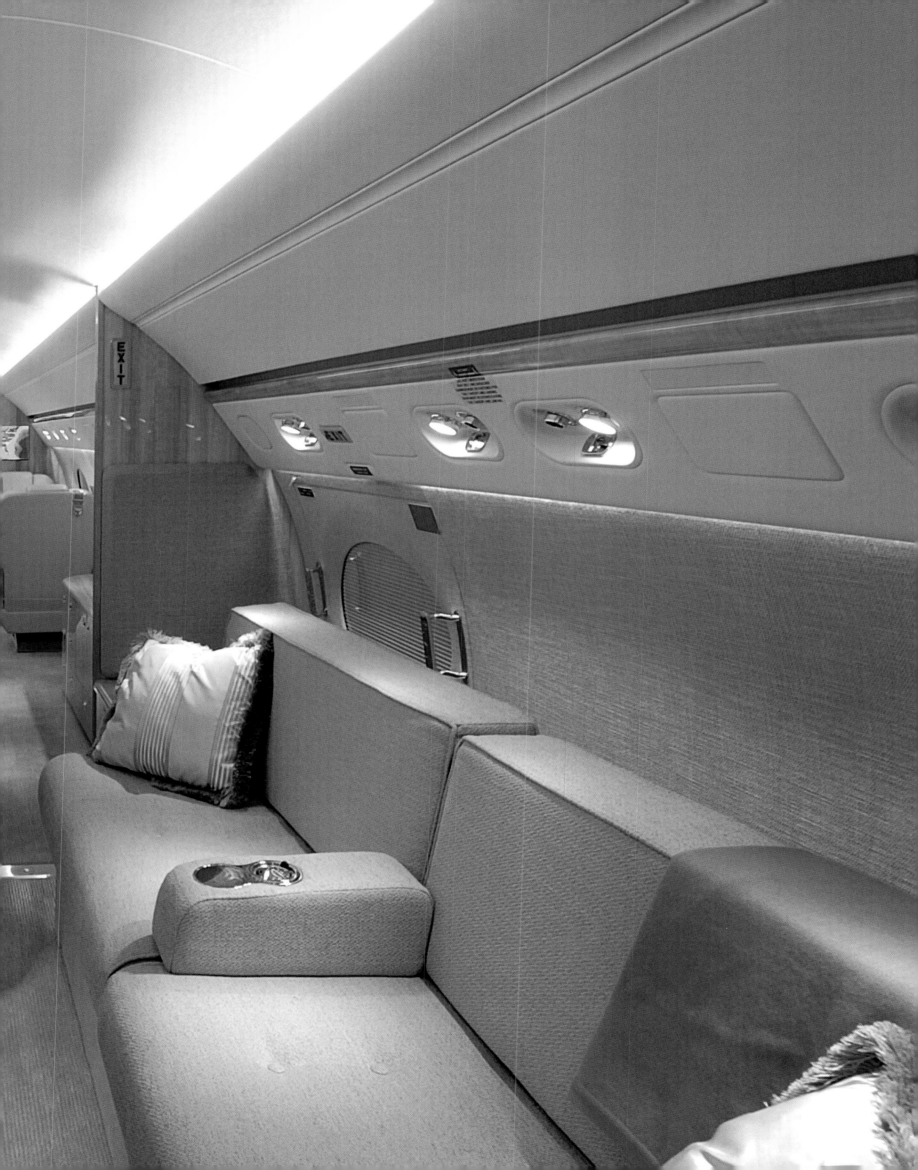

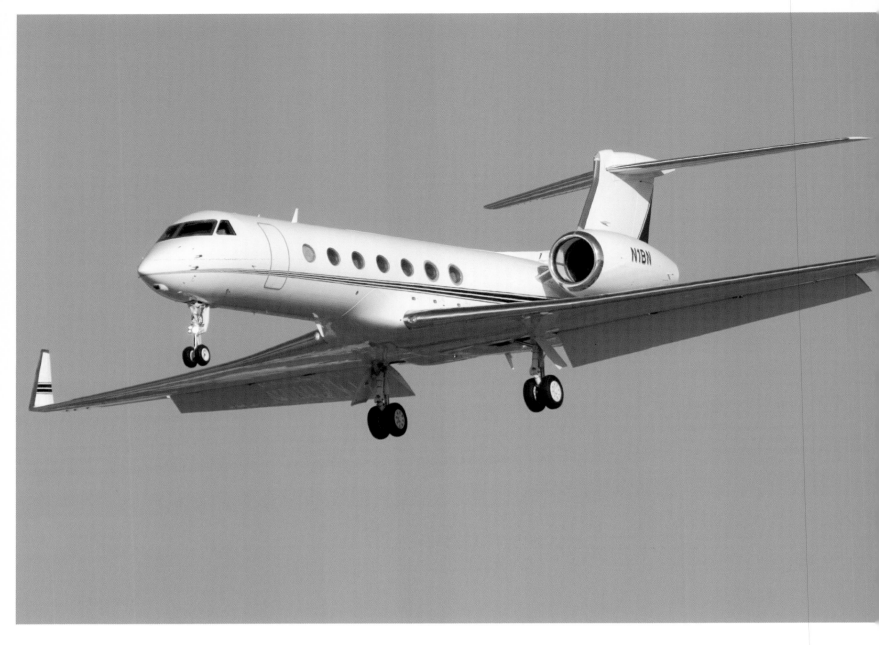

Up to 15 passangers can travel comfortably in the cabin of the Gulfstream V, making it a great option for larger groups who must remain productive during the flight.

Bis zu 15 Passagiere können in der Kabine der Gulfstream V eine komfortable Reise erleben. Damit ermöglicht diese Maschine einem ganzen Firmenteam, seine Arbeit während des Fluges fortzusetzen.

Jusqu'à 15 passagers peuvent voyager comfortablement dans la cabine du Gulfstream V. Il est optimal pour une équipe désirant travailler durant la durée du vol.

La cabina del Gulfstream V está capacitada para transportar cómodamente hasta 15 personas, lo que permite a un equipo entero de ejecutivos trabajar durante el vuelo.

Fino a 15 passeggeri possono trascorrere un viaggio confortevole nella cabina del Gulfstream V. In questo modo l'apparecchio consente ad un intero team aziendale di proseguire la propria attività durante il volo.

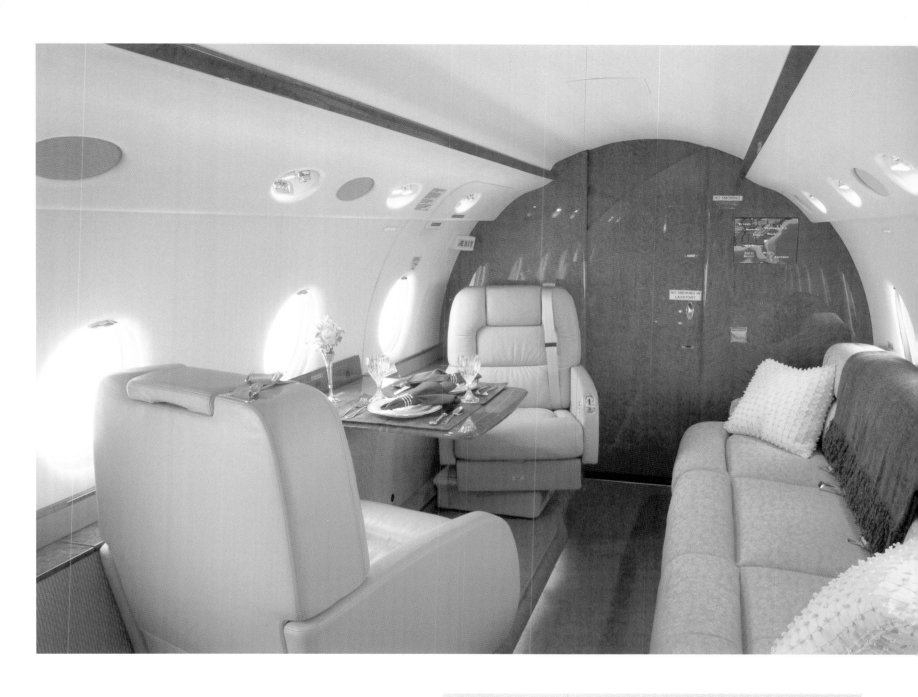

Technical Specifications

Type	Gulfstream V
	ultra-long range business jet
Manufacturer	Gulfstream Aerospace Corporation
Passenger Capacity	12–15
Engines	Rolls-Royce BR 710
Range	12.046 km
Cruise Speed	851 km/h
Max. Cruise Speed	930 km/h
Length	29.4 m
Wingspan	28.5 m
Baggage capacity	6.4 m³
Empty Weight	42.130 Lbs
Price	US $ 36 million

Bombardier Learjet

The Learjet was the first executive jet on the market in the mid-1960s and its name remains synonymous with style and luxury. Founded in Switzerland by William P. Lear, it remains an industry leader in small to medium size jets. The Learjet 60 is its latest and largest model, with room for six to nine passengers.

Der Name Learjet steht für Stil und Luxus. Mitte der 60er-Jahre auf den Markt gebracht, war die Learjet die erste Privatmaschine. Das von William P. Lear in der Schweiz gegründete Unternehmen ist auch heute noch in dem Segment der der kleinen und mittelgroßen Jets führend. Der Learjet 60 ist das neueste und größte Modell, das Platz für sechs bis neun Passagiere bietet.

Le nom de marque Learjet est devenu le symbole même du style et du luxe. Mis sur le marché au milieu des années 60, le Learjet a en fait été le tout premier jet privé. L'entreprise fondée en Suisse par William P. Lear, est toujours leader sur le segment des avions d'affaires de petite et de moyenne taille. Le Learjet 60, qui peut emporter de six à neuf passagers, est le plus gros et le plus récent des modèles de la gamme.

El nombre de Learjet es sinónimo de estilo y lujo. Introducido en el mercado en los años 60, el Learjet fue el primer jet privado. La empresa fundada en Suiza por William P. Lear sigue encabezando el sector de los jets pequeños y medianos. El Learjet 60 es el último modelo de la serie, siendo a la vez el más amplio, con capacidad para seis a nueve personas.

Il nome Learjet sta per stile e lusso. Immesso sul mercato negli anni sessanta, il Learjet è stato il primo degli apparecchi privati del suo genere. Il marchio, fondato in Svizzera da William P. Lear, è ancora oggi alla guida nel settore della produzione dei jet di piccole e medie dimensioni. Il modello più recente, il Learjet 60 è l'apparecchio più grande in commercio ed ospita da 6 fino a 9 passeggeri.

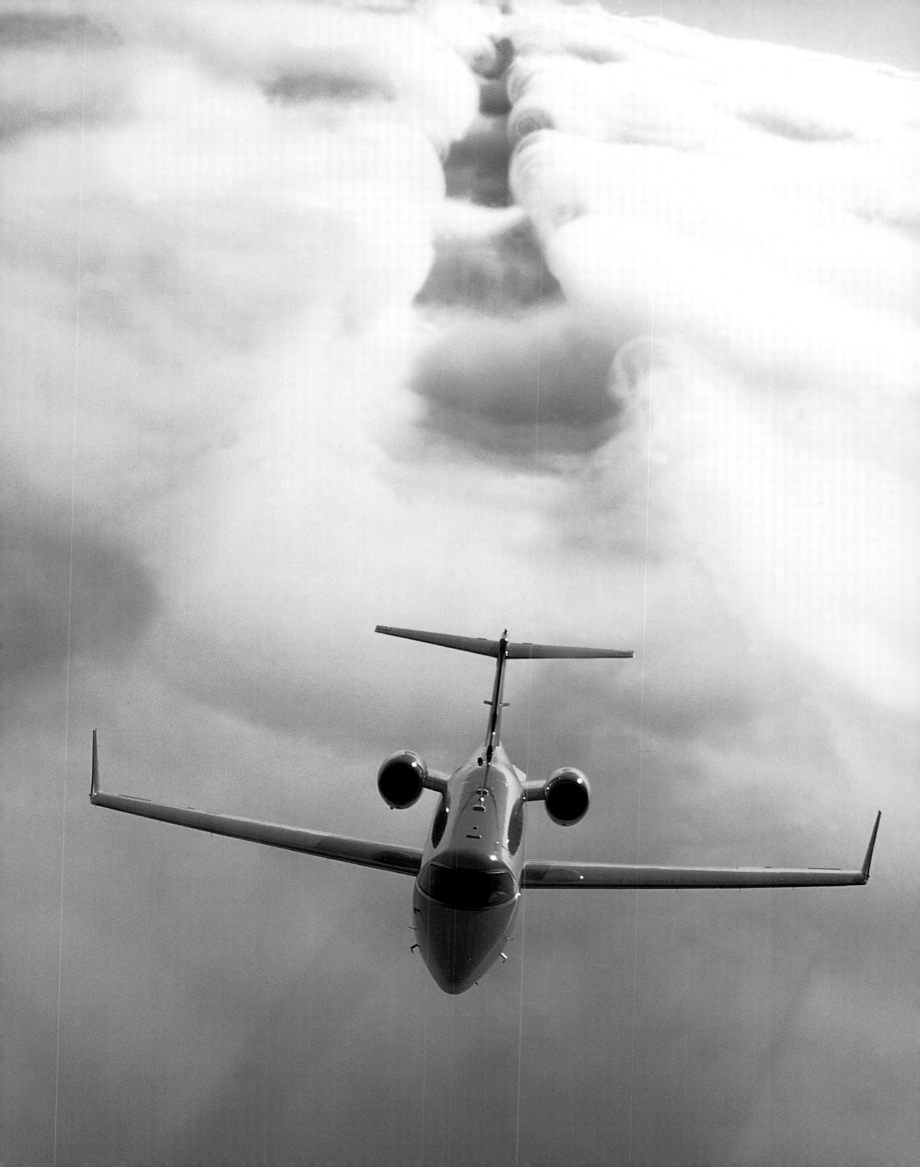

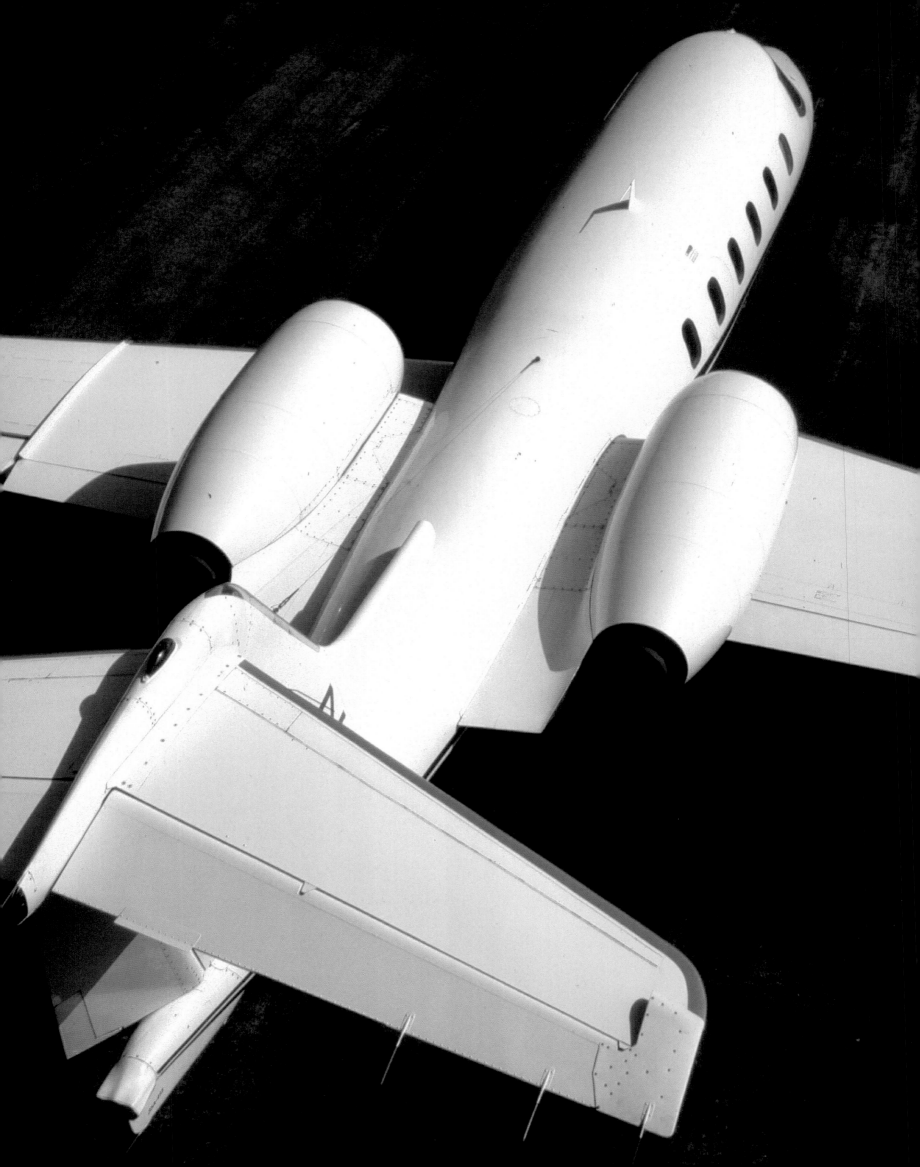

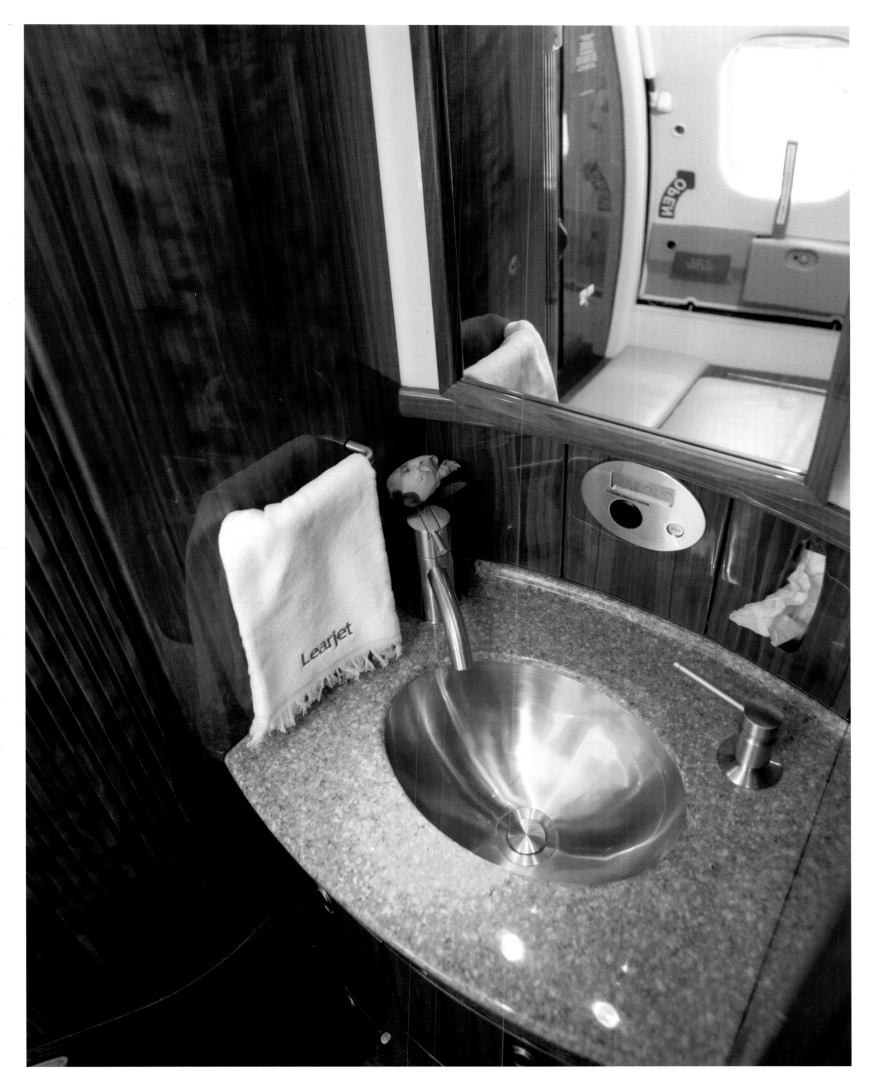

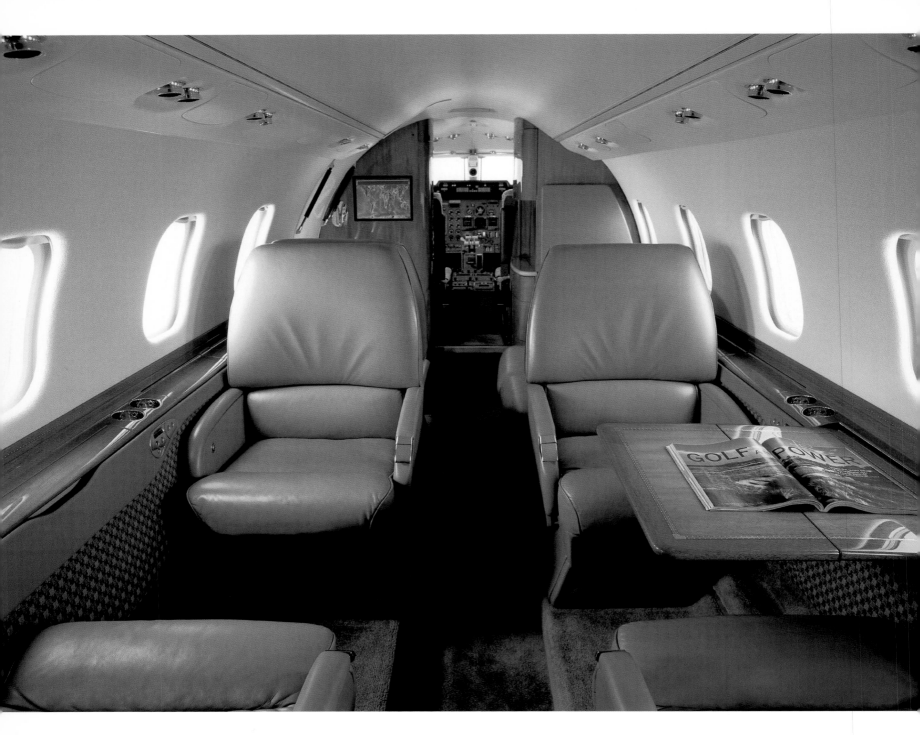

Its distinctive fuselage design and winglets make the Learjet a standout on tarmacs around the world.

Mit ihrem markanten Design von Flugzeugrumpf und Flügeln kann die Learjet auf jeder Landebahn der Welt aufsetzen.

Grâce au design très caractéristique de son fuselage et de sa voilure, le Learjet peut se poser sur n'importe quelle piste dans le monde.

Con su fuselaje y sus alas de diseño acentuado, el Learjet es capaz de aterrizar en cualquier pista del mundo.

Il Learjet, caratteristico per la forma pronunciata della fusoliera e delle ali, è in grado di atterrare su qualsiasi pista del mondo.

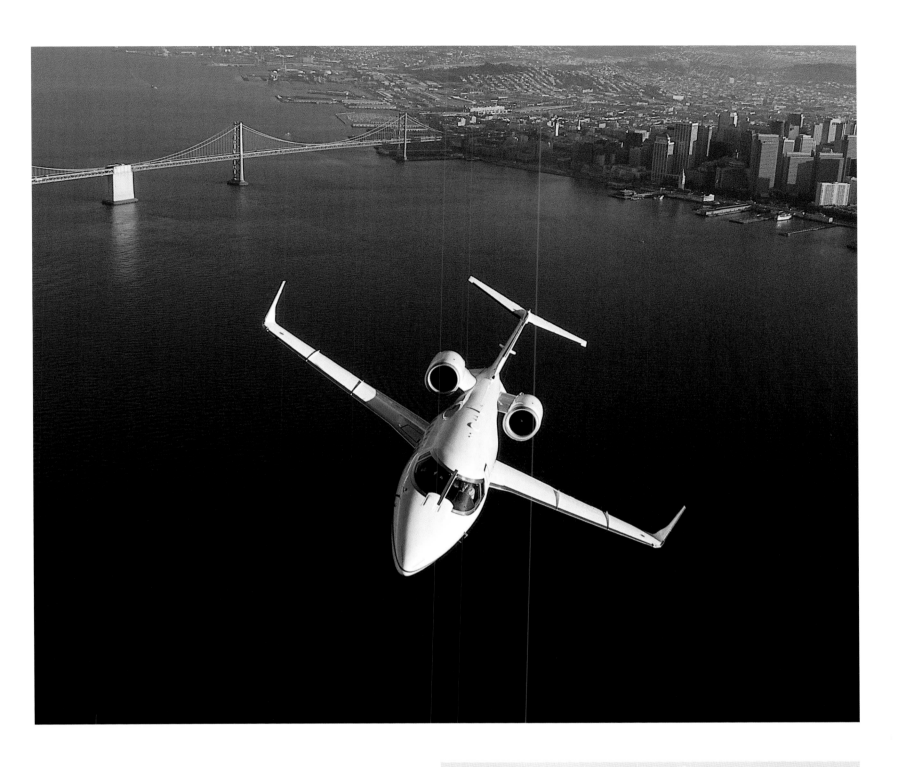

Type	Learjet 60
Manufacturer	Bombardier
Passenger Capacity	up to 8 passengers
Engines	Pratt&Whitney Canada PW305A turbofans
Range	4.617 km
Cruise Speed	846 km/h
Max. Cruise Speed	859 km/h
Length	17.89 m
Wingspan	13.34 m
Baggage capacity	1.7 m³
Empty Weight	6282 kg
Price	US $ 13 million

Embraer EMB-135

The Embraer "Legacy" is a modern jet for short and middle distance flights, which has been produced by the Brazilian aircraft manufacturer since 1999. There are two versions: the machine based on the ERJ-135 offers space for 37 passengers and has a range of 2,650 kilometers, while the ERJ-140LR has space for 44 passengers and a range of 3,019 kilometers.

Die Embraer „Legacy" ist ein moderner Jet für Kurz- und Mittelstreckenflüge, der seit 1999 von dem brasilianischen Flugzeughersteller ausgeliefert wird. Es gibt zwei Versionen: Die auf der ERJ-135 basierende Maschine bietet Platz für 37 Passagiere und hat eine Reichweite von 2650 Kilometern. Die ERJ-140LR mit 44 Passagieren bietet sogar eine Reichweite von 3019 Kilometern.

L'Embraer « Legacy » est un jet d'affaires moderne proposé depuis 1999 par le constructeur brésilien pour les vols de courte et moyenne distances. Il en existe deux versions : Celle qui est dérivée du ERJ-135, peut transporter 37 passagers et franchir 2650 kilomètres. Et la version ERJ-140LR, qui peut emporter 44 passagers sur une distance pouvant dépasser 3019 kilomètres.

El Embraer "Legacy" es un jet moderno de corto y largo alcance fabricado desde 1999 por el constructor de aviones brasileño. Existen dos versiones: el avión basado en el ERJ-135 tiene cabida para 37 personas y una autonomía de 2650 kilómetros. El ERJ-140LR con capacidad para 44 personas tiene una autonomía de hasta 3019 kilómetros.

L' Embraer "Legacy" è un moderno jet per voli a raggio medio-lungo. Prodotto dal 1999 da un costruttore brasiliano, è disponibile in due versioni: l'apparecchio costruito secondo il modello dell'ERJ-135 ospita 37 passeggeri ed ha una portata di 2650 chilometri; l'ERJ-140LR, per 44 passeggeri, raggiunge addirittura una portata di 3019 chilometri.

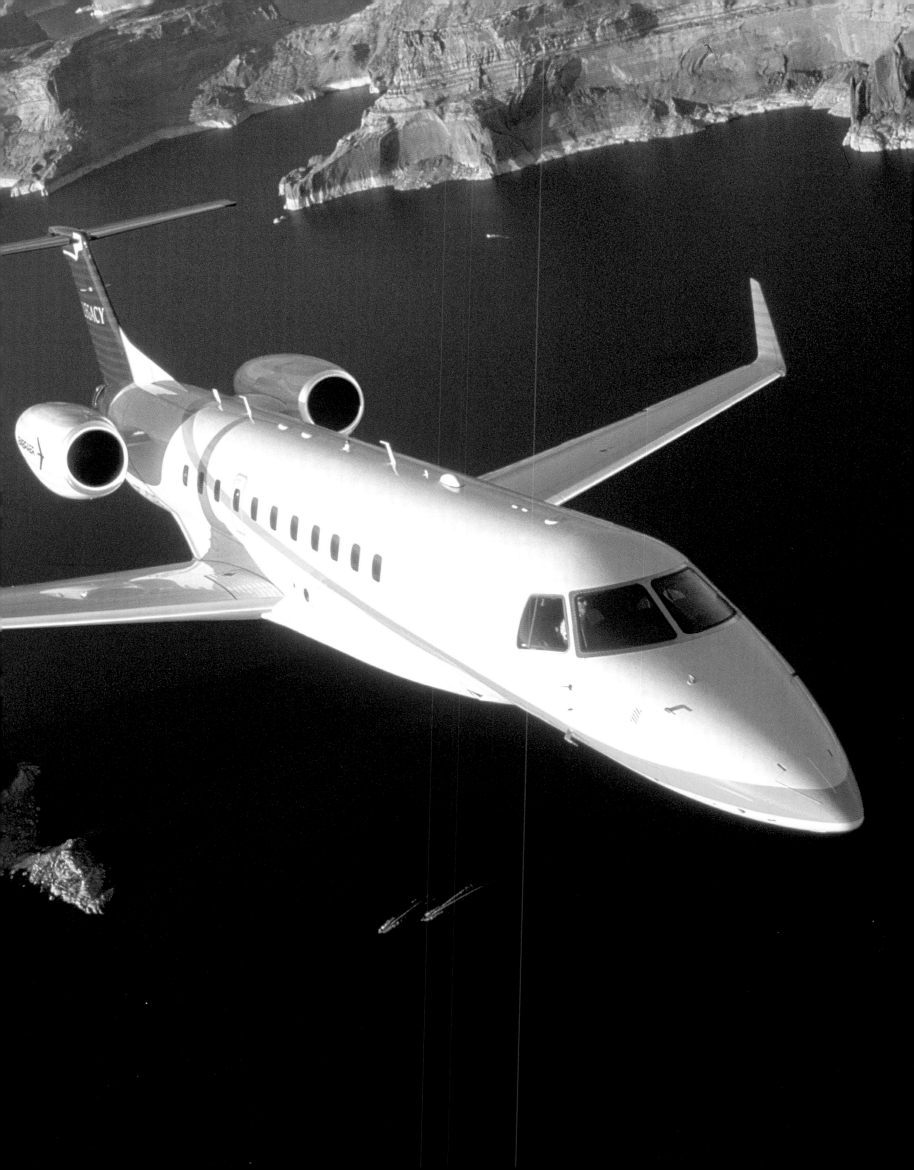

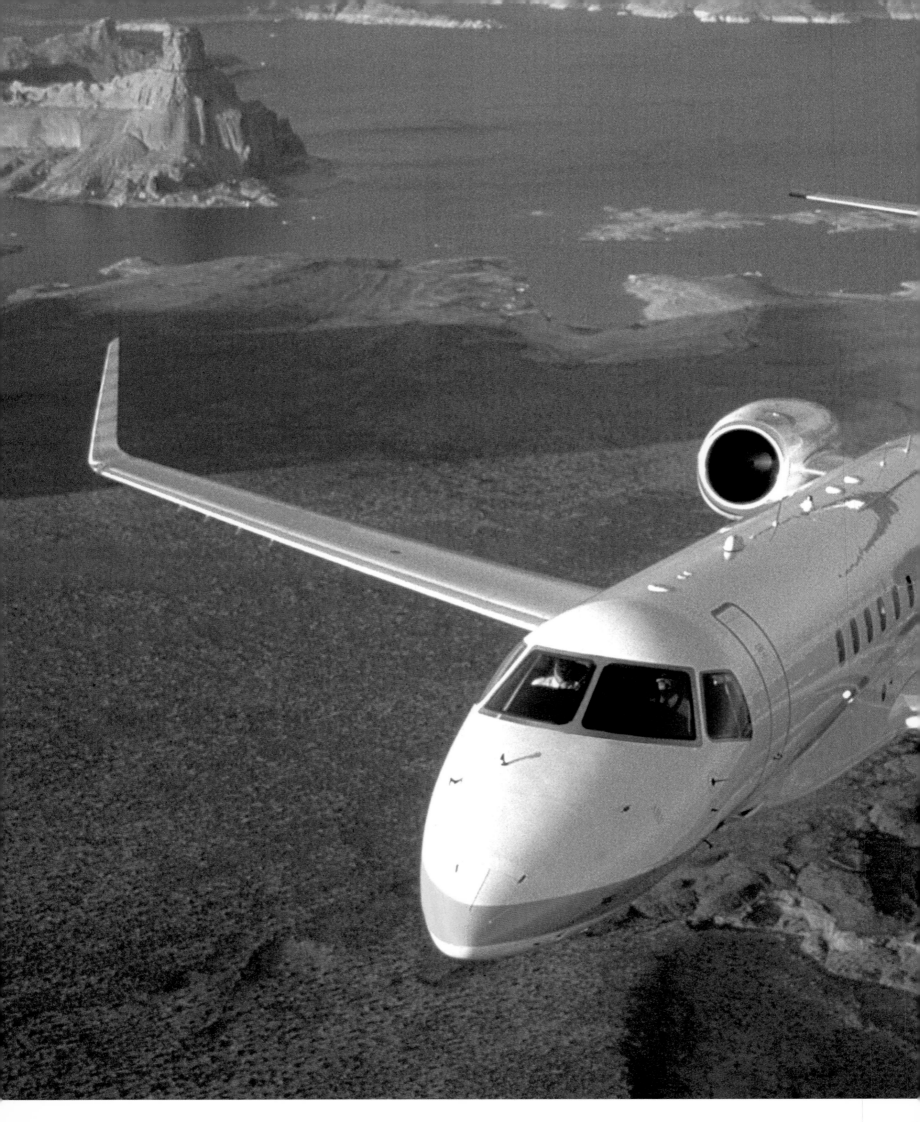

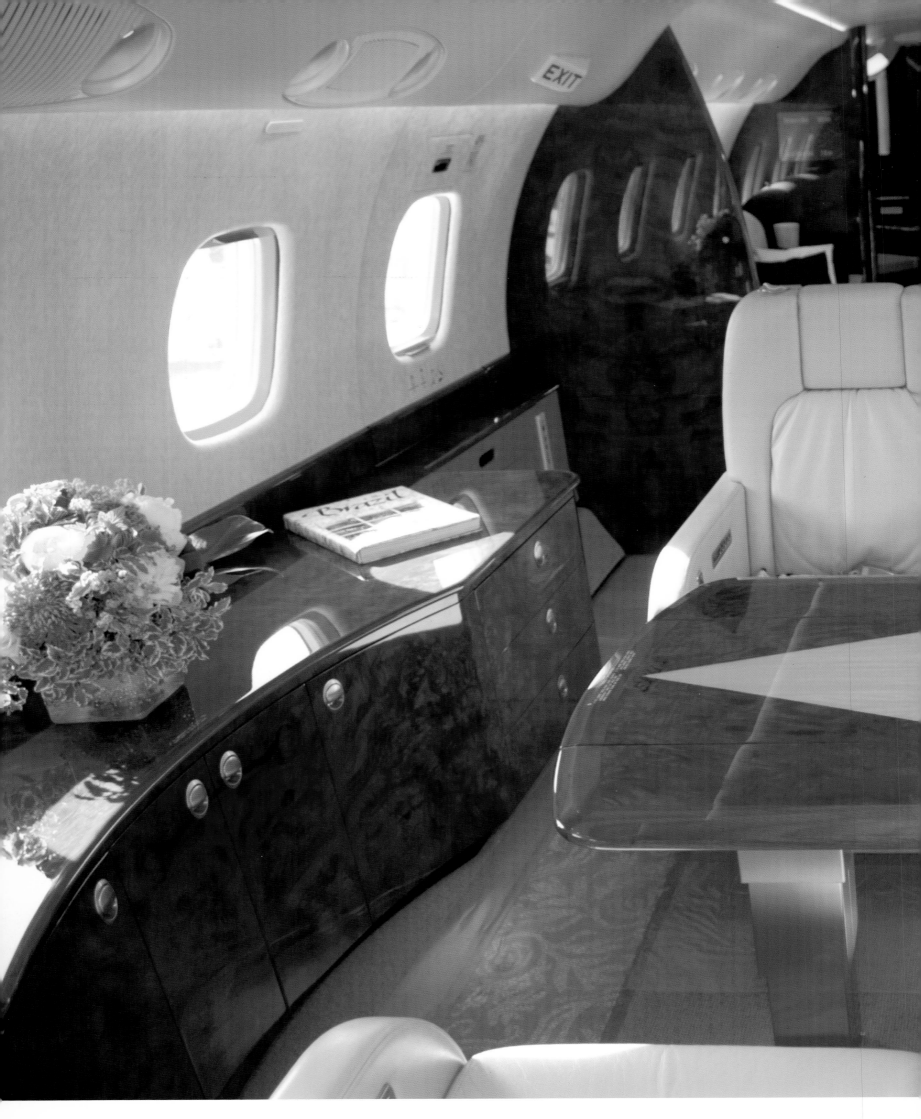

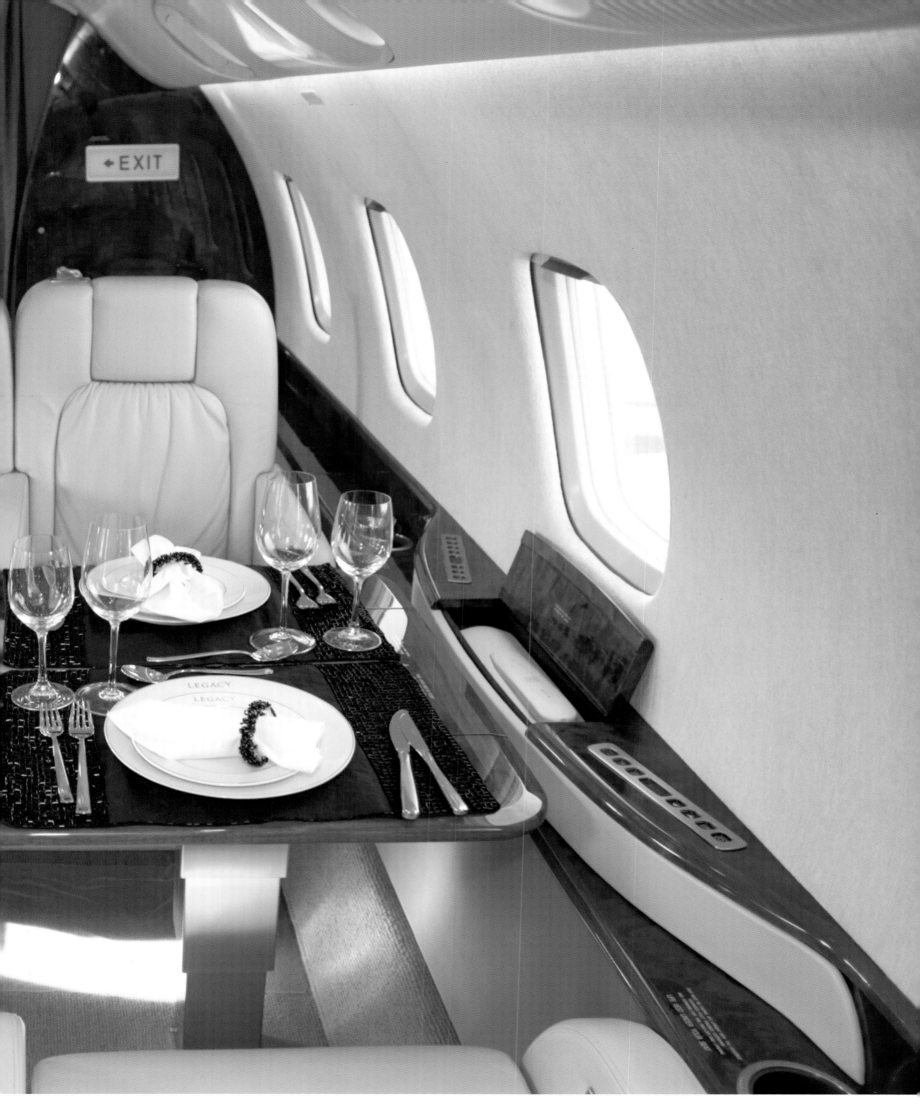

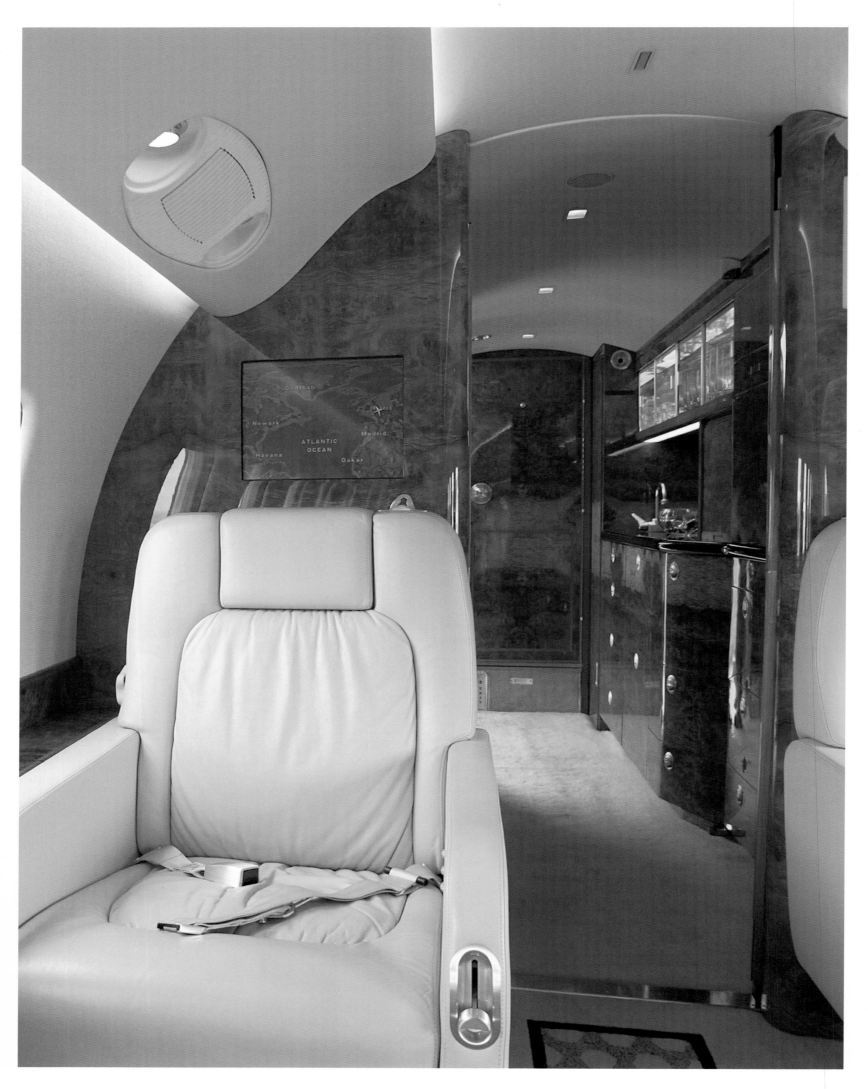

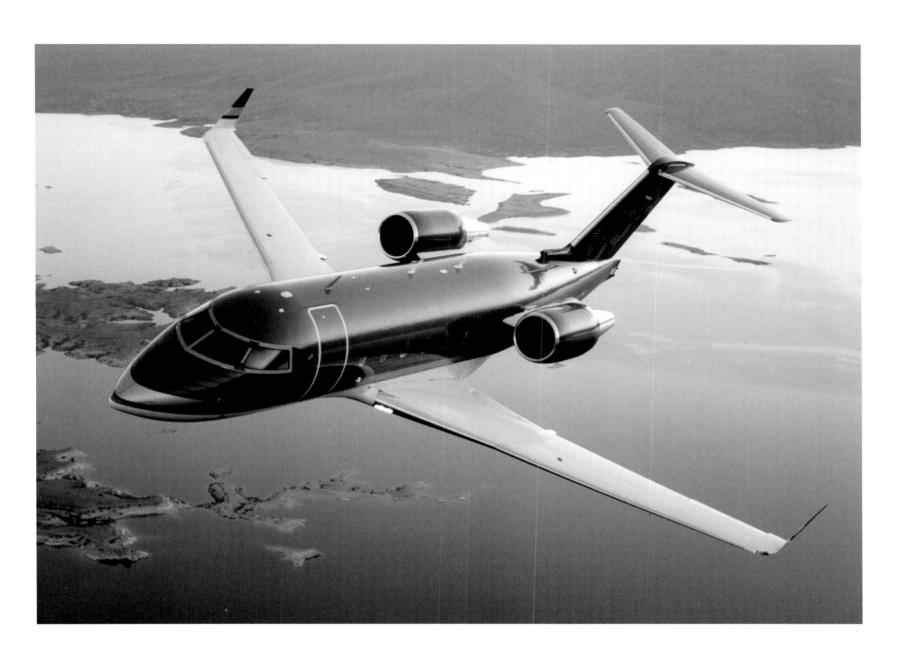

Type	Embraer 135 BJ Legacy
Manufacturer	Embraer
Passenger Capacity	10 passengers
Engines	Rolls Royce AE-300 7A tourbofans
Range	5.930 km
Cruise Speed	n/a
Max. Cruise Speed	834 km/h
Length	26.34 m
Wingspan	20.04 m
Baggage capacity	6.80 m³
Empty Weight	10.684 kg
Price	US $ 21 million

Photo Credits

Aena - Aeropuertos Españoles y Navegación Aérea: 24/25, 28/29
Air Canada 2005: 31
Air France Museum Collection: 65, 67, 78, 86, 94, 102
AirTeamImages/ www.airteamimages.com: 177, 193, 197, 204, 218
Airbus S.A.S 2005: 115, 117, 118, 125
Fototeca Alitalia: 64
Bernardo Andrade: 96
Aviation Images/ www.aviation-images.com: 13, 60/61, 76/77 (P. Jarrett),
73 (J. Dibbs),
57, 78, 140, 142, 146, 147 (M. Wagner), 111 (RAeS), 116, 119, 120/121, 122/123,
124
Aviation Picture Library, Austin J. Brown/ www.aviationpictures.com: 90/91, 92,
104, 106, 208, 219
Bundesverband der Deutschen Luft- und Raumfahrtindustrie e.V.: 129
The Boeing Company: 93, 105, 114, 131
Bombardier Inc./ Learjet: 207, 210, 211
Cessna Aircraft Company: 7, 11, 15, 155, 156, 157, 158, 159, 160, 162, 163, 165,
166/167, 168, 169
Copenhagen Airports A/S: 26
The Cowin Collection: 32/133
The Czarska Group: 32
Courtesy Dallas Historical Society, Used by permission: 62, 63
Dassault Aviation and Dassault Falcon Jet Corp., 2005. All rights reserved: 9, 153,
171, 172/173, 174, 175, 180/181, 182, 183, 185, 186/187, 188, 189, 190, 191,
194/195
Deutsche Lufthansa AG: 39, 40, 43 (Bernd Hollin), 42 (Ingrid Friedl), 59, 66,
69/70, 75, 103 (Frieder Blickle), 107, 109, 110, 113
Deutsche Lufthansa Technik: 136, 137
Embraer S.A. All rights reserved: 213, 214/215
Emirates. All rights reserved: 100, 101
Fokker Services B.V.: 130
Gulfstream Aerospace Corporation, A General Dynamics Company. All rights
reserved: 199, 200/201, 202/203, 205
Stuart Haigh: 94
Markus Herzig: 178/179
Hollin Radoske Architekten: 41, 44/45, 46/47, 48/49, 50/51, 52/53
Jet Aviation Business Jets AG: 134, 138, 139, 144
KLM Royal Dutch Airlines: 58, 74
Los Angeles World Airports. All rights reserved: 20, 21, 22/23
Newscast/ British Airways: 38, 80/81, 97
Patkau Architects Inc.: 36, 37
Reiner Heim Aircraft Interior Design: 143, 148, 149
Rolls-Royce plc 2005: 75
Royal Brunei Airlines: 34, 35
Singapore Airlines Ltd.: 84/85, 145
Teague, Seattle: 88/89
Miguel Snoep: 82, 83, 86, 209, 216/217
Skidmore, Owings & Merrill LLP (SOM): 19, 27
TRH Pictures/ www.trhpictures.co.uk: 108, 112
Virgin Atlantic Airways Ltd. All rights reserved: 30, 98/99